↠ WHAT HAPPENS TO HISTORY ↞

WHAT
HAPPENS
TO
HISTORY

The Renewal of Ethics
in Contemporary Thought

Edited by

Howard Marchitello

Routledge
Taylor & Francis Group
New York London

First published in 2001 by
Routledge
711 Third Avenue
New York, NY 10017

Published in Great Britain by
Routledge
2 Park Square, Milton Park
Abingdon, Oxon OX14 4RN

Library of Congress Cataloging-in-Publication Data

What happens to history : the renewal of ethics in contemporary thought / edited by Howard Marchitello.
 p. cm.
 Includes bibliographical references and index.
 ISBN 0-415-92561-4 (alk. paper) — ISBN 0-415-92562-2 (pbk. : alk. paper)
 1. History, Philosophy. 2. Historiography—Moral and ethical aspects.
 3. Holocaust, Jewish (1939–1945)—Historiography. 4. Culture. 5. Postmodernism.
 6. Ethics, Modern—20th century. I. Marchitello, Howard.

D16.9.W458 2000
901–dc21

 00-028616

CONTENTS

Introduction

Remembering Ethics

Howard Marchitello

Ethics, like history, is once again in order. In his introduction to a recent special topic issue of *PMLA*, "Ethics and Literary Study" (to identify just one site), Lawrence Buell suggests that "Ethics has gained new resonance in literary studies during the past dozen years, even if it has not—at least yet—become the paradigm-defining concept that textuality was for the 1970s and historicism for the 1980s."[1] But assertions such as Buell's about the recent emergence of ethics as a critical and interpretive category for literary study do not serve only to mark an important movement (perhaps a shift) in new critical work; they also serve to situate an urgent and important question: Is this emergence of ethics in effect something new, or is it, rather, something more like a *re*-emergence? Is the turn to ethics (or history) in fact a *re*-turn? Buell writes,

> Perhaps a certain desultoriness is to be expected of an emerging discourse, or congeries of discourses, struggling with self-definition. A matter of more open dispute is whether the ethical turn, to the extent that it offers something substantively new, is an advance or a retrogression. (Buell 11)

This return both *to* and *of* ethics—neither wholly new nor wholly old—bears more than a metaphorical resemblance to memory. For it is the memory—of any given event, let us say, or experience—that returns to us as neither completely new nor completely old: the *remembered* thing is clearly both. It is new in that it fully occupies the present moment; it is present to us when and as we remember. At the same time, the remembered thing is old, familiar to us as some residual piece of a past that is itself no longer present to us. It is this dynamic of memory occupying both the present and the past that figures the idea of ethics proposed in this volume: Ethics is that which comes back to us in the model of remembering.

And yet, in order for ethics to be remembered—a call to action that stands as a founding imperative for a great many contemporary works on ethics, including the present collection of essays—ethics must first, in some form or other, have been forgotten so that new discussions are construed as "returns to" or (in the present case) "renewals of" ethics. But what is the particular nature of this forgetting, and what can this forgetting tell us about the relation between ethics and remembering—or, in a larger sense, between ethics and history—so as to make the remembering of ethics desirable or possible?[2]

The essays collected here together constitute new answers to some of these questions, new ways of understanding the forgetting of ethics, as well as its return or renewal in contemporary thought. These essays also serve to indicate the remarkable degree to which the turn to ethics of which Buell speaks in fact characterizes not only contemporary literary studies, but a much wider range of critical work. And as such this volume contributes to what is emerging in the fields of literary, historical, and cultural studies as a general turn to the questions of ethics. I can offer as evidence of this turn a number of recent books that, in their particular disciplinary (or, frequently, multidisciplinary) ways, address the questions of ethics. In history, for example, Dominick La Capra's *History and Memory after Auschwitz* and several recent studies by Tzvetan Todorov, including (among others) *The Morals of History*, *Facing the Extreme*, and *A French Tragedy*; in history and religious studies, Edith Wyschogrod's *An Ethics of Remembering: History, Heterology, and the Nameless Others*; in literary studies, J. Hillis Miller's *The Ethics of Reading*, Geoffrey Harpham's *Getting It Right: Language, Literature, and Ethics*, and Rey Chow's *Ethics after Idealism*; in philosophy and women's studies, Kelly Oliver's *Family Values: Subjects Between Nature and Culture* and *Ethics, Politics, and Difference in Julia Kristeva's Writings*. This list offers merely the briefest of hints of the range of work under way that addresses the concerns of ethics for today's readers, scholars, and critics; we could easily add to it such important figures as Martha Nussbaum, Richard Rorty, and Charles Taylor, or point to the sustained interest in the works of Emmanuel Levinas, a philosopher of major importance to contemporary discussions of ethics.

Even as it testifies to the urgency of a reconsideration of the questions of ethics across the disciplines, this collection constitutes compelling evidence that the turn to ethics as a newly vitalized interpretive or critical category is *not* a retrograde but rather a progressive attempt to interrogate the complex dynamics at stake within our various critical and theoretical

practices. This work represents the general attempt to recover by rein-
vention the *critical* category of the ethical that does not derive from any
dependence upon fully transcendent (or theological) values; if there
emerges in the work assembled here any notion of the ethical as a value-
category, we must be careful to distinguish it from its more familiar—and
more problematical—philosophical forebears. The judgment upon which
ethical evaluations are based—the determination, for example, that totali-
tarianism in any guise is an evil, or the assertion that the concentration
camps represent a profound instance of the fundamental violation of their
victims' humanity—is never a transcendent category. Indeed, this work
depends in part upon what Tzvetan Todorov describes as the distinc-
tion between theologically derived thought and humanistically derived
thought (what he refers to as the Kantian shift from a culture of "het-
eronomy" to a culture of "autonomy"). In the former, the universals upon
which judgments are based are thought to exist as pure emanations from
the sacred; in the latter, universals emerge dialectically, the result of the
very dialogue the historian seeks to initiate and sustain, the dialogue that
is placed "above the preservation of the sacred past."

In the first two essays in this volume, those by Tzvetan Todorov and
Richard J. Golsan, the very possibility of ethics is predicated upon a
rethinking of the proper *uses* of memory. Todorov's essay, "The Uses and
Abuses of Memory," begins by noting that memory is the acknowledged
enemy of totalitarian regimes. But rather than allowing this to open onto
an unqualified celebration of memory—and, at the same time, arguing
that "the stakes involved in remembering are too important to be left to
enthusiasm or anger"—Todorov calls for a reassessment of the *uses* to
which recovery of the past (memory) can—and ought—to be put. Given
the well-known problems associated with attempts at universal formu-
lations of the good—and, for that matter, the bad—uses of memory,
Todorov redirects our attention from the group to the individual: "A
moral action depends entirely on the position it occupies in an intersub-
jective exchange." From this Todorov derives a "principle concerning
[the] morality of action" that allows the identification of four principal
roles one may occupy within the intersubjective exchange: the benefactor
or the one who benefits from the act, and the evildoer or victim. For his
primary (though not exclusive) example—which he elaborates in striking,
and perhaps controversial, fashion—Todorov turns to the example of
France's part in World War II. But, in spite of the various histories con-
sidered here—including Verdun, Hiroshima, Nanking, among others—
Todorov's essay is finally more philosophical and political in nature: what

are the (moral) limits of the rituals of commemoration and of the desire for the monument? And, how can we best use memory—and forget-fulness—to prepare ourselves for the decisive and rapid recognition of analogous situations in our own time (and here Todorov instances the contemporary versions of racial and ethnic warfare)? How do we move from a duty to memory to the active—and moral—service of the present?

The historical particularities Todorov examines—especially concerning the French response to the question and problem of its roles in World War II—forms the core set of concerns for Richard J. Golsan's essay, "History and the 'Duty to Memory' in Postwar France: The Pitfalls of an Ethics of Remembrance." The "duty to memory" in question is a function of French attempts to answer two imperatives: to commemorate appropriately the victims of the Vichy regime and to punish perpetrators (both German and French) of war crimes and crimes against humanity—most recently the Nazi Klaus Barbie and two French collaborationists, Paul Touvier and Maurice Papon. In addition to providing an insightful discussion of the legal problems associated with these trials, as well as the strident support for them by the so-called memory militants, Golsan analyzes a second-level controversy. The critiques over the legal and ethical status of these trials produced by this "duty to memory" are fueled not only by individuals who fear distortion of history, but also by prominent French intellectuals and critics who argue that the "duty to memory" is paralytic and prevents France from comprehending the past and the nation from taking a proactive role in Europe today—even in the face of ethnic wars in the former Yugoslavia.

The essays by Kelly Oliver, Krzysztof Ziarek, Lowell Gallagher, and Howard Marchitello work to interrogate the practices and the possibilities of historiographical writing in the postmodern moment and the ethics that such practices both propose and contest. Kelly Oliver begins her article, "Witnessing Otherness in History," with a brief discussion of the work of psychoanalyst Dori Laub for the Video Archive for Holocaust Testimonies at Yale University. Laub describes an interpretive conflict between historians and psychoanalysts over one survivor's eyewitness account of the prisoner uprising in Auschwitz, during which the camp was set on fire. Listening for the empirical facts of history (the precise number of chimneys that were destroyed by the fire was contradicted by other evidence), the historians, Laub claims, were unable to hear precisely what the psychoanalysts did: that the "import of these testimonies was unrecognizable." It is this "something beyond comprehension" (in this case, the seemingly unimaginable idea of prisoner rebellion within the

death camp) that Oliver wants to excavate in her discussion of the nature of witnessing as that alone which allows access to "that which cannot be reported by the eyewitness, the unseen in vision and the unspoken in speech, that which is beyond recognition in history." For Oliver, there is a significant way in which the truth of history cannot be reported by the eyewitness; to the contrary, "only witnessing to what cannot be seen—the process of witnessing itself—makes ethics possible." The final movement of Oliver's essay proposes the replacement of the Hegelian notion of subjectivity founded upon recognition by a newer theory founded upon the non-antagonistic model of witnessing.

Krzysztof Ziarek's essay, "The Ethos of History," offers a critical rereading of philosophical understandings of the notion of ethics in the aftermath of the Levinasian idea of ethics as a first philosophy in which ethics has ceased to be a matter of various (and often conflicting) sets of rules and norms that regulate and prescribe behavior and become, instead, a matter of responsibility to the other. Ziarek rereads this in light of Heidegger's thinking on *ēthos*, which distances itself from the idea of an ethics that originates from within or "beyond" the world and offers, rather, an understanding of ethics as the "unfolding" or "articulation" of that world itself. In order to achieve this redefinition (or relocation) of ethics, Ziarek argues that *ēthos* has precisely to do with a different understanding of history—particularly upon the critical distinction between *Historie* and *Geschichte*, the historicist approach to history as a varying set of social and cultural circumstances, and the idea of history as event. For Ziarek, *ēthos* is the "locus of rethinking the relation between history and ethics, as a site where the very idea of historiality acquires an ethic significance."

Lowell Gallagher's "Merleau-Ponty's Chiasm and the Ethical Call of Situated Criticism" begins by noting the perhaps surprising coincidence of a dismissal of Merleau-Ponty's existential-phenomenological description of embodied subjectivity—especially the concept of the "chiasm"—offered by both Hannah Arendt and Jean-François Lyotard for being a dangerously utopian figure of plentitude. This critique, on Gallagher's account, falters in two important ways: on the one hand, in failing to take adequate notice of the rhetorical and biblical cultural history of the chiasmus, and on the other hand, in failing to understand the "encrypted status" of the chiasmus as a principal figure of both philosophical and political concerns that are central to postmodernity. Merleau-Ponty's chiasm, Gallagher argues, can emerge in current discussions as "an exemplary figure for the ethical challenges faced by postmodernist cultural practice for the task of writing

history without foundations." The first part of the essay details the philosophical life of the chiasmus in biblical and rhetorical tradition, which is, for Gallagher, concerned primarily with an "ethics of responsiveness" lodged in the figure of the chiasmus—an ethics governed by both the "call" of the sacred text and the call to accept risk as the very condition of meaningful choice. The second part of the essay offers a rereading of such thinkers as Levinas, Arendt, De Man, Lyotard, and Derrida reading the figure of the chiasmus. The essay concludes with a turn to Merleau-Ponty's notion of the "good error" that resides at the heart of chiastic perception. For Gallagher, chiastic participation in history offers us the chance to see anew that the work of situated criticism necessarily and productively entails "gestures of incalculable risk."

In "Heterology and Post-Historicist Ethics," Howard Marchitello offers a critique of the "limits of rationalist heterology": the notion that the other exists only rationally, only in the aftermath of (my) thought. As an alternative conception of both the other and the heterological discourse dedicated to the experience and the expression of self-other encounter, Marchitello argues that a necessary first step is the careful rethinking of notions of space and the relation between space and its (forms of) representation. Traditional methods of conceiving of space and the space of the other are determined by a more or less complete and essentially unquestioned faith in sequence and temporality. It is this "carefully policed distinction between time and space" that stands in need of revision. As a proposed new model, Marchitello offers a description of an ethics "all at one point."

The final three essays—by David E. Johnson, Marshall Sahlins, and Gayatri Chakravorty Spivak—move from theoretical considerations of the nature of ethics and, especially, the relation between ethics and history and historiography, and turn to considerations of ethics and its relation to culture and individual and cultural identity. For David E. Johnson, in "Mexico's Gas, Mexico's Tears: Expositions of Identity," the question of a "properly Mexican" cultural identity—as traced through a wide range of cultural and literary artifacts—depends precisely upon the successful renegotiation of suspicions of a "derivative European identity," on the one hand, and the desire "to wave off the lingering remains of Amerindian spirit," on the other hand. Johnson's essay begins with a polarizing reading of two of the most popular Mexican novels of the twentieth century: Juan Rulfo's *Pedro Páramo* and Laura Esquivel's *Como agua para chocolate*. Johnson then considers the two versions of Mexican cultural history and identity remarked above in figures of repetition, imitation, and translation in the work of a variety of Mexican writers and critics,

including Octavio Paz and Carlos Fuentes. Johnson's next move is to place these readings alongside two recent attempts "to reground the fundamental place of Indianness in the discourses of Mexicanity": Guillermo Bonfil Batalla's *México profundo* and the *documentos y comunicados* of the Zapatistas (the EZLN, *Ejército Zapatista de Liberación Nacional*). The essay concludes with a re-examination of the "watershed of post-Revolution Mexican history," the October 2, 1968, massacre at Tlatelolco, and a discussion of Elena Poniatowska's *La noche de Tlatelolco*.

In his essay, "Reports of the Death of Culture Have Been Exaggerated," Marshall Sahlins reconsiders what he calls "'despondency theory,' the logical and historical antecedent of dependency theory." In anthropology through the 1950s and 1960s, Sahlins notes, there was a "lugubrious certainty" that as a result of centuries of Western imperialism—with its "long development of underdevelopment"—and as a consequence of certain modernization theories, the world's once-aboriginal peoples had been all but devastated, or soon would be. The typical response, Sahlins suggests, to this "realization" was a "serious concern with the destruction of the Other, probably with some hope that good would come from the documentation of global capitalism's cultural cannibalism." The problem with this in actual (anthropological) practice, however, is that the discourse of despondency effectively denies any form of real cultural autonomy and historical agency to the (indigenous) others. It was in this way, then, that "the anthropologies of the world system became too much like the colonization they justifiably condemned." In this process, "the critics of Western hegemony were creating an anthropology of neo-historyless peoples." But even in the face of such a dynamic—with its attendant claims about the relentless disappearance of the world's aboriginal peoples—was the steadily accumulating evidence about peoples and cultures "not so easily decultured." As an attempt, then, to account for the simultaneous development of both global integration and local differentiation, and as something of a call for anthropology to renew itself "through the discovery of unprecedented patterns of human culture," Sahlins offers a critique of the "end of culture" argument and replaces it with a recognition that "culture" has "taken on a variety of new arrangements, that it is now all kinds of things we have been slow to recognize." Sahlins pays special attention to the example offered by the "transcultural" experiences of Tongan sociologist and anthropologist, novelist and essayist, Epeli Hau'ofa.

Gayatri Chakravorty Spivak concludes the volume with her essay, "A Moral Dilemma," which takes up a discussion of the politics of gender

within globalization and the emergence of new figurations of global alliances of feminisms. This piece argues for a reassessment of the set of two aporias that disclose the problem in ethical thinking: First, that radical alterity appears to require imaging that is the figuration of the ethical as the impossible, and second, that the relation between electronic capital(ism) and global culture has yet to be theorized. In order to address the ways in which these aporias are foregrounded in the postmodern global moment and how they connect to imagining the other woman, Spivak attempts to figure ways in which to "imagine or figure the other as another self" without falling into "global-local" binaries.

This collection of essays took its first shape in the 1996–97 lecture series entitled "History and Ethics: The Question of the Other," at Texas A&M University, sponsored by what is now the Center for Humanities Research, and was at the time known as IGHLS—the Interdisciplinary Group for Historical Literary Study. I would like to express my thanks to the following friends and colleagues for their support and assistance: First, to Larry J. Reynolds, who was instrumental in organizing the lecture series and who for ten years served as the guiding figure of IGHLS; to the former director of IGHLS, Jeffrey N. Cox, for his work on the series and his insightful comments on this project; to J. Lawrence Mitchell, head of the Department of English at Texas A&M University and a long-time friend and supporter of IGHLS/Center for Humanities Research; to James Rosenheim, director of the Center for Humanities Research; to members of the Center's Advisory committee, for help in funding work toward this collection; and to Julie Aipperspach, for assistance with transcriptions. I would also like to thank Richard J. Golsan for his support of and contribution to this volume. Also, thanks—as ever—to Lynne Vallone.

Earlier versions of portions of chapter 8 appeared in "'Sentimental Pessimism' and Ethnographic Experience," in *Biographies of Scientific Objects*, ed. Lorraine Daston (Chicago: University of Chicago Press, 2000), 158–202. Used by permission.

Notes

1. Lawrence Buell, "In Pursuit of Ethics," *PMLA* 114: 1 (January 1999): 7.
2. To invoke memory as something of an analog to ethics is a complicated gesture, particularly in that the nature and status of memory itself (as several essays in this collection demonstrate) is a much-debated issue today. One instance of this

contemporary rethinking of memory can be found in Edith Wyschogrod's recent book, *An Ethics of Remembering*, in which what I am calling the forgetting of memories can be located within modern informational culture:

> Memories themselves have become ownerless, commodified in a global culture of information. No longer are memories carried forward as the shared experience of peoples but instead circulate as timeless information in a global system of information. (Edith Wyschogrod, *An Ethics of Remembering: History, Heterology, and the Nameless Others* [Chicago: University of Chicago Press, 1998], p. 217)

The genealogical argument that would trace this virtualization of memory—the mass production, that is, of memory as dislocated and finally un-locatable exempla of inert timelessness—could well look to the work of Walter Benjamin who (presciently) warned against both the loss of the aura of the work of art in the age of mechanical (and we can now add "digital") reproduction and the emergence of a new and perhaps unrecognizable subject within the modern culture of information. Or, the genealogical argument could look to the work of Jean Baudrillard, for whom the real has been (irrevocably) lost by virtue of its (technological) transformation—and this is certainly not offered as an instance of progress—into the hyperreal: the world, emptied of objects and events and fully saturated with only images and simulacra, emerges as the world of total simulation. Both versions (and there are others yet) are powerful analyses of contemporary culture. At the same time, they are essentially elegiac in nature, lamenting what can only be characterized as a series of grievous losses—of storytelling and objects, to be sure, but also of the event and of history.

THE USES AND ABUSES OF MEMORY

Tzvetan Todorov

Translated by Lucy Golsan

Totalitarian regimes of the twentieth century have revealed the existence of a danger never before imagined: the blotting out of memory. These twentieth-century tyrannies have understood that the conquest of men and territories could be accomplished through information and communication and have created a systematic and complete takeover of memory, hoping to control it even in its most hidden recesses. These attempts have sometimes been blocked, but it is certain that, in other cases (which, by definition, we are unable to verify), traces of the past have been successfully eliminated.

The traces of what once existed have been either erased or doctored and transformed, lies and inventions replace reality, searching out and spreading the truth is forbidden, and any means is acceptable to accomplish this. In concentration camps bodies are dug up in order to burn them and later scatter the ashes. Photographs, claimed to be authentic, are cleverly altered to prevent worrisome memories. History is rewritten with every change of those in power, and encyclopedia readers are invited to cut out any pages which have become undesirable. It is said that the gulls from the Solovki Islands are shot down so they cannot carry back messages from the prisoners.

It is easy to understand from this why memory has such importance in the eyes of the enemies of totalitarianism, why every act of remembering, however small, could be useful in resisting it. Perhaps it is because of the influence of a few talented writers living in totalitarian countries that the original context of the importance given to memory and the condemnation of forgetting have widened in the last few years. Nowadays, we often hear criticism of Western Europe's and North America's liberal democracies for also contributing to the extinction of memory and the dominance of

forgetting. Forced to consume information more rapidly, we must also go about forgetting it at a rapid pace. Cut off from our traditions and deadened by the demands of a leisure society, deprived of spiritual curiosity and familiarity with the great works of the past, we are condemned cheerfully to celebrate forgetting and be content with useless pleasures of the moment. In this less brutal but ultimately more efficient way, since it incites little resistance and instead makes us consenting agents in this march toward forgetting, the democratic countries are leading their people toward the same end as totalitarian regimes: toward the rule of barbarism.

But in generalizing this way, unconditionally praising memory and discrediting forgetting, problems are raised. The emotional burden of everything that has to do with a totalitarian past is great, and those who experience it are doubtful about efforts at clarification and calls for an analysis that would bring about justice. The stakes involved in remembering are too important to be left to enthusiasm or anger.

We must first of all keep in mind the fact that memory is in no way the opposite of forgetting. The two terms that contrast with each other are *disappearance* (forgetting), and *preservation*. Memory is always and necessarily an interaction of these two. The complete reconstitution of the past is obviously an impossibility (but something a Borges could imagine in a story like "Funes el memorioso"), and moreover, it is frightening. Memory itself is necessarily a selection. Certain characteristics of the event will be retained, while others are immediately or progressively set aside and thus forgotten.

To preserve without choosing has not yet become the role of memory. What we blame Hitler's and Stalin's butchers for is not that they retain only certain elements of the past, for we ourselves cannot do otherwise, but that they appropriate for themselves the right to control the choice of the elements retained. No government superior should have the power to say that you do not have the right to search for the true facts and that those who do not accept the official version will be punished. It is a question of the very definition of life in a democracy. Individuals, as well as groups, have the right to know and therefore to be familiar with their own history and to tell others about it. It is not up to a central government to forbid or allow this.

Keeping this in mind, an important distinction needs to be made between the *recovery* of the past and its subsequent *use*. No automatic device links these two acts. The insistence on recovering the past, on remembering, does not guide us in the use made of it. Each of these procedures has its own characteristics and paradoxes. There is certainly

discontinuity here: a misleading use of memory cannot be justified by the necessity to remember. Nothing should prevent the recovery of the past. This is the principle that applies to the first process. But no formula this simple can apply to the second one, the use made of memory—and, as a result, the role the past ought to play in the present. The possible uses of the past, or the memory we have of it, need to be examined more closely.

Even the most superficial look immediately reveals that societies have very different solutions to these problems. As we know, since the Renaissance and especially since the end of the eighteenth century, a type of society was created in Europe that no longer unconditionally honored tradition and the past, and that, as the utopian Saint-Simon pointed out, tore the golden age from the past and placed it in the future, downgrading memory in favor of other faculties. In this sense, those who deplore the lack of regard for memory in Western societies are right. These societies, and they alone, do not use the past as a privileged way of legitimizing something and accord no special place of honor to memory. It must be added that this aspect of our society is a part of its very identity and there would be no way to set aside one without profound changes in the other.

Memory's place and the role of the past are not the same in the different spheres of our social life; they are part of different configurations. Philosophers claim that in our general conception of public life we have moved from heteronomy to autonomy, from a society whose legitimacy comes from tradition, something outside the will of each individual, to a society based on the contract model to which each one gives—or does not give—his adhesion. Science is another sphere in which memory has lost many of its prerogatives. It would not be false to say that at the time of the Renaissance, modern science progressively freed itself from memory's overly fastidious yoke, and here we are reminded of the famous pronouncements of Montaigne or Descartes. Western art is different from other great artistic traditions, such as those of China and India, because of the importance of innovation, invention, and originality. Culture, according to the meaning ethnologists give to the word, is basically a matter of memory; it is the recognition of a certain number of codes of behavior and the ability to abide by them. But Western cultures have yet another distinction, first of all because, in spite of the ethnocentricity of their members, they have for a long time recognized the existence of other cultures and have mixed with them. Also, Western cultures, at least since the eighteenth century, have recognized the value of a capacity for breaking away from one's original culture.

It serves little purpose to continue with an enumeration of these

spheres, for, whatever the place of memory in a detailed account of each, several general certainties stand out: First, the very plurality and diversity of the spheres. Next, the certainty that memory acts along with other guiding principles—will, consent, reasoning, creation, liberty. Finally, that in Western societies memory, as a general rule, does not occupy a dominant position.

We do not look for a simple affirmation of memory in personal life, either. For example, in psychoanalysis, we hope to recover the memory of certain facts in the past which could have caused a traumatic occurrence, but once these facts are recaptured by consciousness, they can be forgotten, a phenomenon very different from repression. From yet another point of view, Jorge Semprun, in *Writing or Life,* tells how at a certain moment in his life he was saved by forgetting his experience in the concentration camps. Each individual has the right to decide. It is the same with the individual offenses we might have suffered.

If we turn now to public uses of memory, we can easily see that it has not always been used advisedly. In fact, in the modern world, the cult of memory has rarely served good causes, and we should not be surprised at this. As Jacques LeGoff reminds us, "The commemoration of the past was carried to new heights in Nazi Germany and fascist Italy," and Stalin's Russia could be added. It was a carefully chosen past, certainly, but nevertheless a past, which flattered national pride and compensated for a declining ideological faith. In 1881, it was the founder of the League of Patriots, Paul Déroulede, who shouted: "I know of those who believe that hate is dying down. But no! Forgetting has not entered our hearts," thus paving the way for the butchery of Verdun. And think of the war which has just ravaged the former Yugoslavia: no one among those fighting wants to forget or forgive. I saw this in the newspaper only a few days ago: "Sunday, November 26. In a cemetery in Ilidza, mothers whose sons had been killed at the front promised to commit a collective suicide if their neighborhood was returned to Bosnian government troops."

Since it is clear that all uses of the past in the present are not defendable, a new question arises: How can we judge and how can we distinguish the good uses from the bad? Several responses come easily to mind but it is not certain that they are completely satisfactory. Each and every one of us uses recall of the past to serve his own interests, and this is no less true of groups than of individuals. But if judging according to personal interest were the only possible form of judgment, there would be no point in speaking of morals or ethics, or of debating these subjects. The

only thing that would count would be the strength of the one expressing himself. Faced with this endless conflict of interests, this chaos of divergent opinions, traditional morality attempted to formulate principles applying to everyone, such as "You shall not kill." Standing on this principle, we could declare that any evocation of the past which incites war is bad and peace, good. But it is not certain that such a far-reaching principle would be applicable in all circumstances. Isn't it possible to believe that wars can also be just and even necessary, and therefore the murders that this implies? Certain nations believe that, even in times of peace, all forms of causing death should not be prohibited, and thus we have the death penalty, murder institutionalized by the law.

In order to make the instrument of our judgment a little more efficient, we must analyze the moral judgment itself in relation to the identity of the person who formulates it. How can we recognize the good? First of all, in realizing that it exists only within the human community, not in an individual taken in isolation. "It is only in becoming social that man becomes a moral being," rightly remarked Rousseau who, however, cherished solitude. Outside of society, no morality. Next, in identifying the good *you* is still favored in relation to *I*. "The more his efforts are consecrated to the happiness of others," continued Rousseau, "the less [man] will be mistaken about what is good or evil." A moral action depends entirely on the position it occupies in an intersubjective exchange. The same act can point to selfishness if I am the beneficiary of it, or to generosity, if the beneficiary is another. Or rather, even if the acts are identical, it is not the same act in both instances; the identity of the receiver is a basic element. That is why Kant insisted on the impossibility of transposing the elements that he called the moral aims of man: "my own perfection" and "the happiness of others." If I am concerned only with my own happiness, I would be nothing more than a selfish person. If all my efforts aimed at the perfection of someone else, I would be one of these unbearable moralists who see the mote in the eye of another but not the beam in my own. To treat my neighbor as myself is justice; to treat him better, either out of love or a sense of duty, is to move into the realm of morality.

How can we use the principles of moral justice in evaluating the past? If I mention an event in my past with the idea of drawing a moral lesson from it, I can point out a good or bad one, a positive or negative act, and I can see myself as agent or patient in this act. This allows us to distinguish four principal roles. I can have been the benefactor or the beneficiary of this act, or I can be the evildoer or his victim. At first glance, two

of these roles, the benefactor and the evildoer, are clearly marked on the map of values. The two others, the beneficiary and the victim, remain neutral because they are passive. Actually, these last two roles also have a moral connotation because of their relationship to the first two. To be a beneficiary of an action is less glorious than being the agent because it demonstrates our powerlessness; to be the victim of a misdeed is more respectable than to be responsible for it. Therefore, two of these roles, the benefactor and the victim, are favorable to the *I*, while the roles of evildoer and beneficiary are unfavorable.

The preceding principle concerning morality of action, once established, can now be applied to the totality of roles in which we can find ourselves. If, when we speak of our past, we identify ourselves as positive figures, that of the hero-benefactor or of the innocent victim, we are satisfied in giving ourselves the good role. It is the same if, at the same time, we place others in the role of a powerless beneficiary of a heroic action or in that of an evildoer. The situation is very different, however, if the distribution of roles is reversed. To remember an action in which I was the cause of something bad or in which I benefited from another's heroic exploit, to see these others as victims or benefactors, brings me no direct benefit. However, it is only in this way that I can put the happiness of others and my own perfection above personal interest and engage in a moral act. In other words, there is no moral benefit possible for the subject, whether he be an individual or a group, if his remembering the past puts him in a sympathetic role (hero or victim), but only if, on the contrary, it makes him realize his weaknesses and his follies.

My classification of roles and of their moral effects could seem quite abstract, but it takes only one example to see that they meet the intuitive reactions of every person. Let us take the example of France's part in World War II. If I am French myself, I take pleasure in assuming either the role of the hero or that of the victim. I could then say, on the one hand, that the Resistance and Free French forces made the liberation of 1944 possible. Or, on the other hand, that all the evil came from the hands of the Germans, and the French were satisfied to be the objects of repeated violence. But this version, as ritualistic as it is agreeable, produces no increase in morality for those who insist on it. If, on the other hand, still speaking as a French person, I recall the military weakness of France at that time and its enormous dependence on the Allied Forces, or, yet again, the participation of the French in the accomplishment of what we today perceive as evil (the Collaboration), I can then engage in a

critical examination of my collective identity as a way of morally perfecting myself without, by so doing, *guaranteeing* moral perfection.

The commemoration of various episodes of the Second World War in 1994 and 1995 in countries other than France has shown how difficult it is for groups to follow this path. Take the example of the first atomic bomb dropped on Hiroshima by the American military. On the American side, the war veterans' associations and other pressure groups made a united effort to prevent the *Enola Gay* exhibition organized by the Smithsonian Institute, an exhibition considered offensive to the memory of events because it did not place Americans in the role of hero-benefactor, conqueror of Japanese militarism, but instead suggested that they were responsible for a massacre that was not entirely justified.

On the Japanese side, in Hiroshima, people were satisfied to assume the role of victim without raising any question about the responsibility of the government in the unleashing and pursuit of the war, or about the inhuman treatment suffered by war prisoners or conquered populations at the hands of the Japanese. In the middle of a large park stands a museum and a monument containing the names of 176,964 victims of the bomb, permitting 1,500,000 yearly visitors to commemorate this event with feeling. But, the monument to the memory of 20,000 Koreans, who, as forced workers in the same place were killed at the same moment, is not on official land. Nothing in Hiroshima, which was essentially a military city before the war, commemorates the Nanking massacres carried out in China in 1938 by the Japanese army, notably the garrisons stationed in Hiroshima, and whose victims are estimated at 300,000.

There could be an objection here that there might be a danger in submitting too much to the demands of morality in historical research and in remembering. Perhaps it is a more moral position to be critical of oneself, but if, in reality, I were a hero, or a victim, should I falsify the truth in order to conform to morality? Isn't there a reverse kind of hypercriticism in attributing to my country and to my people the worst sins on earth— the politics of imperialism, for example—to make myself seem more moral? In doing this, I will have accomplished another immoral act by distorting the truth.

Such an objection is not absurd. However, one can meet it by once again recalling the distinction between recovering the past and making use of it. The first procedure requires only the establishment of truth, even if we know that it affords us only a guiding principle and a horizon rather than a terrain on which to settle permanently. This is what we

expect to find in a historical work, even when we know that the historian's ideological choices have influenced the selection and the arrangement of the material to be studied. However, only a part of this recovered past will be put to use in present society. Moreover, all uses are not moral and do not contribute to raising or lowering esteem of the individual who uses it. Other uses are political and concern the common good rather than the sanctification of their subject. To raise the courage of the French during the Occupation, de Gaulle found it useful to remind them of Joan of Arc and not their past betrayals and cowardices. The political context of recollection should never be neglected. On the other hand, it is misleading these days to remember only the black pages in the history of a country if this history stretches over several centuries. Such a systematic distribution of roles would show the Manichean spirit of the author rather than the consistency in his account. Nevertheless, it is still true that a critical attitude can give birth to a moral act while indulgence in the identification of heros and victims cannot.

The past is made up of multiple events and of contradictory meanings, and it is a decision of those acting in the present that certain ones are chosen for commemoration and others are passed over. This being so, we conduct evaluations whose moral value is not similar. May 9, 1945, is a day of final victory over Nazi fascism for the Russians, the end of a war that cost the nation more than twenty-six million dead. Therefore, Russians today are anxious to emphasize the celebration of their own heroic role. But for the people of Eastern Europe, this date symbolizes the beginning of life under Russian rule, a new slavery and not a liberation. Remembering this facet of the past would have been, for the Russians, an act of superior moral value. For the French, the same is true of May 8, 1945. It is a day of national pride, since the French generals participated alongside their American, English, and Russian partners in the signing of the German surrender. Much less attention is given on this anniversary date to the memory of the victims of the Sétif massacres, members of the Algerian population who naively had believed that the hour of liberation was at hand for them also, victims whose numbers are still very uncertain since estimates vary between fifteen and forty-five thousand.

What attitude should we adopt in considering this state of affairs? Ought we to be satisfied to condemn others for what we would not hesitate to do in their place—that is, to revel in acquiring the name of former hero or victim? This would mean taking the position of moralist-giver-of-lessons, not a very likeable position. I would suggest instead a response

in two phases. First, it is essential from the beginning that memory be recovered, that the truth be told and written, and that the value of heroes and the suffering of victims be publicly recognized. Otherwise a current injustice would be added to past ones, and this is unthinkable. It is only at a later date, after this public acknowledgment, that we can hope to help former heroes and victims to cease identifying themselves exclusively in these roles that have been theirs in the past. Further, it must immediately be pointed out that, to have any chance of success, such an incitement should come from members of the community that identifies itself symbolically with these roles. The French could be advised not to represent themselves always as heroes or victims, but this appeal will not be heeded unless it comes from a French person and preferably one who is a confirmed former hero or victim. If a German suggested this, he would have no chance at all of success.

We can use our rule for morality—preferring the *you* to the *I* in yet another way. What are the dangers that weigh on the survival of the past in the present? The first one, as we have seen, is that represented by totalitarian nations: the entire control of the past and the possibility of erasing it forever. Our consumer society also contributes to this, although in a different way. There exists a second danger, however, more appealing because it comes from undeniably good intentions, but just as real. It consists in enclosing the past event within itself and making it sacred, cutting it off from every other event in the history of the world. The remembering of this special past, exclusive of any connections, can then serve to reinforce the identity of the individual or group that claims it. But it does not increase their moral virtue, for this would demand, as a prerequisite, openness toward others. It is often right to want to erect a monument to the past in order not to forget, in order to preserve the memory. But it is even better that it become at the same time an instrument to help us think and live better in the present. Both individuals and groups need an identity to assure survival, but for their moral edification, an affirmation of identity is not enough. In order to ensure the latter, an opening for dialogue becomes necessary.

To put this another way, in place of contiguous associations, a characteristic of sacralization that encloses the event within its identity and its literalness, associations by likeness can be arrived at by way of analogy. This allows an event to be read in the light of another one without, however, the two becoming confused. The literal preserves, but finding a pattern liberates. A literal use, which ultimately renders the earlier event

impossible to dispense with, in the long run makes the present a slave to the past. The pattern or model use, on the other hand, allows the past to be used with the present in mind and serves as an example of experienced injustices that may help to combat those taking place today, a way of abandoning the self in learning to reach out to others.

Putting a particular fact in relation to other analogous facts calls for a new distinction, however, since a final danger for memory, its vulgarization, makes its appearance here. The day that "Nazi" becomes an insult synonymous with "bastard," the history of Nazism will have ceased to teach us anything. The past event must not be reduced to its own identity nor become diluted in endless generalization. Patterns need to be substituted for both identity and vulgarization.

Here is one example of this "patterning." Vassily Grossman was a Soviet writer of Jewish origin, politically orthodox, who became a war correspondent in World War II. Under these conditions he learned of the massacre of the Jews by Nazis that took place on Soviet soil. Among the victims was his mother who was assassinated in her native village of Berdichev. Grossman told the story of these terrible facts in his reports, and in collaboration with Ily Ehrenburg, he helped to gather a series of witness accounts and reports about the genocide of the Jews, which later became *The Black Book*, published shortly after in the United States but only recently in Russia and elsewhere.

After the war, Grossman published a novel describing the heroic experience of the Russian soldiers and it received the highest honors. But Grossman himself could not stop there. Little by little he became convinced that communist totalitarianism was an evil comparable to Nazism, even if the two were not technically the same. He consecrated his great novel, *Life and Destiny*, to this subject. It was never published during his lifetime and it brought about his disgrace. Recently we learned that Grossman continued until his death to write to his murdered mother, and in his letters, he told her that his fight against the tyranny of communism was made in the name of a son's love, and *Life and Destiny* is dedicated to her. This terrible pain felt by the son was not limited to the one event but inspired him to struggle against yet another evil, one which had nothing to do with his mother's death but which continued to poison the world. Furthermore, shortly before his death, Grossman went to Erévan after hearing through a spokesman for Armenians whom he had encountered of the magnitude of the Armenian genocide in Turkey. He promised himself that, if he had the strength, he would someday write their story. An old Armenian, moved to tears, promised to do as much for the Jews.

It is important to realize that, in our day, when we hear appeals to "the duty of memory" or "against forgetting," most of the time it is not a task of recovering memory we are asked to do (nothing or no one, in a democratic country like France, can prevent anyone from establishing the facts of the past), but rather the defense of a particular selection from among these facts, one that assures its protagonists of maintaining the roles of hero or victim when faced with any other selection that might assign them less glorious roles.

The sacralization of the past is not the best possible way of making it live in the present. Nowadays we need something besides pious images. When commemoration freezes into permanent forms that cannot be changed without cries of sacrilege, we can be certain that it serves the particular interests of its defenders and not their moral edification. Here, I would like to give a last example taken from today's events. Shortly before his death, the German dramatist Heiner Müller went to Verdun at the invitation of a local theater to take part in the preparation of a play. After a visit to some ruins and monuments, he replied to journalists who wanted to know his impressions: "The staging of locations kills emotion. These monuments are expressions of an art for the dead, a gigantic art, but worth nothing. Truly great art is created for the living." As expected, these statements provoked violent indignation from the associations devoted to the memory of this sacred site, and the city of Verdun threatened to cut off funding for the theater and cause it to close if it continued its collaboration with Müller. I have no personal opinion about the commemorative monuments at Verdun, having never visited them, but Müller is right in principle. In our world today, it is human values that ought to be sacralized, not monuments.

We must keep alive the memory of the past, not just to boast about it or demand reparations for offenses suffered, but to be alerted to new but analogous situations. Racism, xenophobia, the kinds of exclusion that strike others, are not identical to those of fifty, a hundred, or two hundred years ago. But precisely because of this past, we should react in the present. In our day, the memory of the Second World War is alive in Europe, kept alive by innumerable commemorations, publications, radio broadcasts, and television programs, but the ritualistic repetition of "we must not forget" has had no visible effect on the process of "ethnic" purification nor on the massive torture and executions that are going on at the same time even within Europe.

Those who, in one way or another, know the horror of the past have a duty to raise their voices against another horror taking place now a few

hundred kilometers away—indeed, several dozen meters from their home. Far from remaining prisoners of the past, we must put it to the service of the present, just as memory—and forgetting—should be used in the service of justice.

Note

The beginning and end of this article contain ideas expressed in my work *The Abuses of Memory* (Arléa, 1995).

HISTORY AND THE "DUTY TO MEMORY" IN POSTWAR FRANCE

The Pitfalls of an Ethics of Remembrance

Richard J. Golsan

For anyone interested in modern France, it is by now almost clichéd to assert that the French are a people passionately involved with their past, even to the point of obsession. At a very early age, French schoolchildren are fully aware of the glorious reign of the "Sun King," Louis XIV; the republican and democratic heritage of the French Revolution; the exploits of Napoleon; and the greatness of the leader of the Free French during World War II and the founder of the Fifth Republic, Charles de Gaulle. But while these names and events are suggestive of distant moments of past national glory or struggles with generally happy outcomes, the reality of France's relation to its past, especially over the last two decades, has become increasingly problematic and often quite traumatic in nature. Controversy continues to swirl around events as old as the Dreyfus Affair or even the status of the memory of soldiers who refused to fight rather than fall victim to the bloodbath of trench warfare during World War I. In late 1998, during commemorations of the Allies' costly victory over the Germans in 1918, the French president, Jacques Chirac, and the prime minister, Lionel Jospin, found themselves at odds over whether the mutineers of the battle of Charleroi should now be included among the victims commemorated for their sacrifices or whether they should instead continue to be ostracized by the nation. Similar disagreements, born of profound political, social, and cultural differences, also affect the nation's memory of its colonial past and the consequences of that colonialism. The best evidence of these differences and their continuing impact on contemporary France can be found in the seemingly endless controversy caused by the electoral successes of the racist and anti-immigrationist National Front.

But the troubling moments in the nation's past just alluded to pale in comparison with the conflicted memory of the Vichy years, that period in history which, as the historian Robert Paxton once wryly observed, interests the French more than money or sex.[1] Paxton's comment is not intended to imply, however, that the Vichy past is simply a source of titillation, raw entertainment, or *divertissement*, as the French would say. Rather it is a *lieu de mémoire*, a contested site of memory, which, more than fifty years after the end of World War II, is capable of provoking scandal on a national scale and of generating historical as well as moral, ethical, and legal debates that strike at the heart of France's national identity, past, present, and future. Vichy has become, as the title of a recent book on the subject suggests, a "past that will not pass."[2]

As one might expect, there have been as many efforts to explain the obsession with Vichy as there are new "eruptions" of what the historian Henry Rousso aptly labeled the "Vichy Syndrome" in a book published by that name in the mid-1980s.[3] For his part, Rousso attributes the tenacity of the troubled memory of Vichy to the fact that the "black years" between 1940 and 1944 constitute a historical anomaly that no amount of historical research or knowledge seems capable of integrating into the *continuity* of the nation's past.[4] Robert Paxton argues that the "black years" haunt the French because the specter of a collaborationist and pro-Nazi Vichy regime threatens to erode the nation's memory of having earned "a legitimate place among the victors in World War II." This is especially traumatic at a time when France's prestige and cultural hegemony are declining in the face of the onslaughts of globalization.[5] In an interview published just before the opening of the trial of former Vichy functionary Maurice Papon, charged with crimes against humanity for his role in the deportation of Jews during the war, Pierre Nora argued that Vichy remains very much in the public conscience in France because it is so completely antithetical to what Nora sees as the reigning ideology of the *bien pensants*: the "ideology of the rights of man."[6]

All these perspectives are certainly valid, and the merits of each become clearer once one takes into account what *precisely* the memory of Vichy in France today comprises. In his classic study *The Vichy Syndrome*, Henry Rousso traces the memory of Vichy through its various stages and metamorphoses from the Liberation of France in 1944 up to the present. From 1944 to 1954, the French went through a period of "unfinished mourning," dominated by the purge trials of former collaborators and the first amnesty laws, as well as other efforts to come to terms with—and move beyond—the horrors and animosities generated by the

German Occupation and the brutal final years of the Vichy regime. Rousso labels the next phase, covering the period between 1954 and 1971, the period of "Repressions," when the majority of the French found comfort in the Gaullist-inspired myth of Resistance, which held that only a small group of traitors and opportunists supported Vichy and the Germans while the overwhelming majority supported de Gaulle and his Free French as well as the domestic Resistance. Ironically, this line of (wishful) thinking was given intellectual ballast by none other than Jean-Paul Sartre, no supporter of de Gaulle or Gaullism, in his classic essay, "What is a collaborator?"[7]

In 1971, according to Rousso, the "mirror broke," and the comforting illusion that France was a nation of resisters was shattered first by the 1971 release of Marcel Ophuls's classic film, *The Sorrow and the Pity,* which painfully underscored the reality of collaborationism and even pro-Nazi sentiment in virtually all walks of French life. Louis Malle's portrait of a young French collaborator in *Lacombe Lucien* (1974) also challenged the Resistance myth and went even further by suggesting, in the opinion of many,[8] that in reality not much separated resistance from collaboration. In fact, the young antihero of the film first tries to join the Resistance, and then falls in with the French Gestapo by accident. It is clear, however, that he would have served either master willingly and happily.

At the same time, new histories of the Vichy years, especially Robert Paxton's *Vichy France: Old Guard and New Order,* published in France in 1973, were challenging the notion that Vichy collaborated against its will and that it served as a "shield" which protected the French from the Germans while de Gaulle and the Free French acted as the "sword" striking at the German occupier. Paxton's research revealed not only the full extent of French servility in dealing with the Germans, but in *Vichy France: Old Guard and New Order* and in a subsequent book Paxton coauthored with Michael Marrus, *Vichy France and the Jews,* it underscored France's willing complicity in the Final Solution beginning in the spring of 1942. It also emphasized Vichy's own independent and autonomous measures to persecute the Jews in the infamous Jewish Statutes of 1940 and 1941.[9] Rousso argues in *The Vichy Syndrome* that since 1974 the memory of Vichy has become a veritable obsession with the French, and moreover, that the memory of the period is increasingly shaped by Vichy's homegrown anti-Semitism and its willing complicity in the Nazi destruction of the European Jews. Thus the memory of Vichy has, according to Rousso, become increasingly "judeocentric" in its focus.

From a number of perspectives, and especially that of the historian, the

"judeocentrism" of the memory of Vichy is highly problematic. In narrowing one's historical focus exclusively to Vichy's anti-Semitic practices and its role in the deportation of the Jews, and condemning Vichy justifiably but unilaterally, one loses sight of the larger context. There is more to understand about Vichy than its racism, and its racism is best understood when Vichy's own ideological predispositions, as well as the powerfully coercive presence of the Nazis, are taken into account. Moreover, the demonization of the Vichy regime to the exclusion of all other aspects of the French experience during World War II, including the struggles of the Resistance and the efforts of individual French men and women to save Jews, constitutes, in effect, the *criminalization* of the nation's past, and Rousso recently has expressed concern as to the effect this will have on the nation's self image in the present and future.[10] One is of course walking a fine line here, because to *de-emphasize* Vichy culpability for whatever reason runs the risk of serving the interests of Vichy's apologists or worse, inadvertently helping to prepare the ground for another round of what the French call *le négationnisme*—the Holocaust denial.

It is against this backdrop that during the last two decades the notion of a "duty to memory" has developed in France and has taken hold among a number of intellectuals and public figures. The duty to memory has been debated at length in the media and in scholarly and intellectual reviews as well. Specifically, the expression refers for the most part to the memory of the Jewish victims of the Shoah and primarily those deported from France under the aegis of the Vichy regime. Silent or ignored in the immediate postwar years, these victims or their relatives and friends have become increasingly vocal in their demands that France's role in carrying out the deportation not be consigned to oblivion, and that those responsible for the deportations and other crimes against the Jews be punished for their actions, even half a century after the conclusion of the war. So the so-called duty to memory entails not only a preservation, and in some cases a *reconstruction* of the past, but an *ethics* in the present as well. Those deeply committed to fulfilling the nation's duty to memory are referred to—sometimes derisively—as "memory militants."

The struggle waged in the name of the duty to memory has been carried out on a number of different fronts. Pressure from memory militants and others has resulted in the designation of days of national commemoration and the establishment of museums to the victims of the Shoah. For example, on July 16, 1992, a ceremony attended by leading dignitaries, including then president François Mitterrand, occurred in Paris's Fif-

teenth Arrondissement on the site of the infamous bicycle racing velodrome, the *Vélodrome d'Hiver,* to commemorate the arrest and deportation of more than twelve thousand Jews who, fifty years earlier, had been rounded up by French police and interned in abominable conditions in the *Vél d'Hiv* before being sent to Nazi death camps to the east. Almost two years after the *Vél d'Hiv* commemoration, in April 1994, Mitterrand inaugurated a museum honoring the Jewish children hidden in the village of Izieu and deported to the death camps of Auschwitz II and Reval on the orders of SS officer Klaus Barbie, known as the Butcher of Lyon. Finally, on July 16, 1995, again on the occasion of commemorative ceremonies at the *Vélodrome d'Hiver,* the new president Jacques Chirac acknowledged "the responsibility of the French state" in the persecution of the Jews and spoke as well of the "collective sin" of the French people.

As Rousso and Éric Conan point out, Chirac's words concerning French guilt and French responsibility "marked a sharp break with his predecessors' tradition," and were "greeted with satisfaction by the great majority of the public."[11] But not everyone shared in this satisfaction. Apart from Vichy's apologists—admittedly a small minority on the extreme right—the duty to memory as articulated in Chirac's speech also offended a number of former Gaullists and Resisters. For the latter, the "memory" of the war was not inscribed in the remembrance of the criminality of the Vichy regime—a regime whose very legitimacy de Gaulle and the Gaullists never acknowledged—but rather in the heroic struggle against the Nazi oppressor. So the fulfillment of a specific "duty to memory," or to put it somewhat differently, the practice of a particular "ethics of remembrance" ran into trouble in this instance precisely because the memory in question was not the *only memory*, and the discursive institutionalization by Chirac of one memory was perceived as suppressing another—the Gaullist memory. The irony is of course that when the Gaullist Myth of Resistance held sway earlier in the 1950s and 1960s, it was precisely the Jewish memory of the Shoah that disappeared beneath its shadow.

If the duty to memory or the ethics of remembrance runs into difficulty when confronted with other, divergent memories of the war, its fulfillment becomes even more problematic once efforts are made to carry out its imperatives in ways other than commemorations or the construction of museums, monuments, and so on. In recent trials in France for crimes against humanity involving two Frenchmen, Paul Touvier and Maurice Papon, and the former SS Officer Klaus Barbie, the duty to

memory—which required in essence that these three men be judged *and convicted* for specific crimes committed during the Occupation—ran afoul of historical truth as well as the exigencies and practices of French justice. For many, the resulting conflicts, played out within the legal system and courts and even within the government itself, have produced unfortunate distortions of the historical record and, perhaps more importantly, the manipulation and *reductio ad absurdum* of the law itself.

In order to understand how and why these conflicts developed, it is necessary to sketch out briefly the convoluted history of crimes against humanity in French law and how, precisely, that history has been affected by the (occasionally competing) demands of the duty to memory. In December 1964, with the statute of limitations about to expire on war crimes committed during the Occupation, the French legislature, not wishing to allow the worst of the *German* war criminals to get off should they ever be caught, voted unanimously that crimes against humanity as defined in the statutes of the International Military Tribunal and applied partially at Nuremberg would henceforth be imprescriptible in French law. The International Military Tribunal defined these crimes as consisting of the "murder, extermination, enslavement, deportation, and other inhumane acts committed against any civilian population, before or during the war, or prosecutions on political, racial, or religious grounds." Those considered liable under the law included "leaders, organizers, instigators, and accomplices participating in the formulation or execution of a common plan or conspiracy to commit any of the foregoing crimes." It should be emphasized that the actual text of the statutes was not included in the 1964 French law, so, strangely enough, the definition of the crime being declared imprescriptible was not actually spelled out in a text that, in effect, made it unique in French law.

Even at the time that the crimes against humanity statutes were drawn up to deal with the particular horrors perpetrated by the Axis powers, many were uncomfortable with laws that invented new grounds of incrimination and that were created in order to be applied retroactively. Others argued that the statutes were too vague and were applied too parsimoniously at Nuremberg. As for the 1964 inclusion of these statutes in French law, other problems arose. First, did this sort of incrimination fit into the framework of French domestic law, which as a result of the formulation of the 1964 measure had no codified definition of the crime in question? Second, what court would hear cases involving charges of crimes against humanity, since the International Tribunal had ceased to function following the conclusion of the Nuremberg trials? Third, given

that crimes against humanity had only been incorporated in French law in 1964, twenty years after the conclusion of hostilities, the problem of the retroactive application of the law was even more acute than it had been at Nuremberg. Finally, a question of legal consistency arose because, although France was willing to declare crimes against humanity imprescriptible under the law, it was not willing to accord the same status to war crimes, as other countries had been willing to do.[12]

All these initial problems were in fact surmounted or circumvented over the course of time. But as the individual cases of Barbie, Touvier, and Papon moved through the justice system, into the courtroom, and, perhaps most significantly, before the public eye, new pressures were brought to bear in each case that resulted in significant modifications of the law. Arrested in 1983 in Bolivia and secreted back to France by French police, Klaus Barbie, Gestapo chief in Lyons during the Occupation, had waged a merciless war against the Resistance and the Jews and was responsible not only for deporting the Izieu Children discussed above but also for the torture and death of Jean Moulin, France's greatest Resistance hero and martyr. Once preparations for Barbie's trial began, the legal problems in the case became evident. While trying Barbie for the deportation of the Jewish children of Izieu posed no problem because crimes against humanity were imprescriptible, Barbie's crimes against the Resistance—technically war crimes—could not be included under the same definition. As long as the law remained as it was, the memory of the Resistance and the desire to punish Moulin's murderer would be submerged—in fact legally erased—by a prosecution that of necessity would be built exclusively on Barbie's participation, through his actions at Izieu, in the Final Solution.

In order to circumvent this potentially explosive situation, in December 1985 the Criminal Court of Appeals rewrote the definition of crimes against humanity to include, among the victims of these crimes, members of the Resistance. Henceforth, crimes against humanity included "inhumane acts and persecutions" committed systematically on behalf of a nation practicing a politics of ideological hegemony "not only against individuals because they belonged to a racial or religious group *but also against the adversaries of this policy, whatever may be the form of their opposition*" (my emphasis).

Once launched down the slippery slope of modifying the law in accordance with external pressures of the moment, French justice found itself in the extraordinarily uncomfortable position of changing the law to fit the crime, or the criminal, at hand. Moreover, if the victims could bring

pressure to bear in order to change the law to suit their purposes, why shouldn't the accused benefit from the same advantage? This, in fact, was the line of reasoning taken by Barbie's lawyer, Jacques Vergès, who argued that if his client's crimes were crimes against humanity, so, too, were the actions of the French military who tortured FLN members and others during the Algerian War. Vergès was ultimately unsuccessful in securing both the acquittal of his client and the application of the statutes concerning crimes against humanity to *French* crimes in Algeria. But the duty to memory where Barbie's Resistance and Jewish victims were concerned, and its impact on the law, clearly raised new legal difficulties and invoked troubling memories where the French themselves had difficulty recognizing themselves in the role of either victims or heroes.[13]

The case of Paul Touvier, first accused of crimes against humanity in November 1973, raised a whole new series of difficulties in the conflict between the exigencies of memory and the law. Moreover, when Touvier was finally tried for crimes against humanity in the spring of 1994, his conviction was secured only at the expense of a blatant distortion of the historical record, so now justice and history were at odds.

Touvier had been, as Mitterrand once described him, political "rabble" who had spent the latter part of the Occupation as an intelligence officer for the *Milice*, or Militia, a fanatical, fascistic, paramilitary force created by Vichy in 1942 to fight against an ever-growing internal resistance. Like many of his fellow Militiamen, Touvier was not only pro-Nazi and anti-Semitic, he was also a murderer and a thief who killed and stole from his victims, Jews and Resistance members alike.

In June 1944, the Resistance in Paris murdered Vichy's Minister of Propaganda, Philippe Henriot, a man very close to the Militia and whose death they vowed to avenge. Apparently acting on his own initiative, Touvier ordered his men to arrest hostages to be executed in reprisal for the death of Henriot, and before dawn on the morning of June 29, seven Jewish hostages were taken to the cemetery at Rillieux-la-Pape near Lyon, lined up against the wall, and executed. This would prove to be the crime for which Touvier would finally stand trial for crimes against humanity— more than twenty years after the initial charges were filed.

After the Liberation, Touvier went into hiding and, with the help of a number of high-ranking figures in the Catholic Church, avoided arrest, prosecution, and imprisonment for over forty years. Touvier survived as a petty thief and confidence man, hiding out with his family in various sympathetic monasteries within France, before finally being arrested in a right-wing monastery in Nice in 1989.

Touvier's extraordinarily lengthy life-on-the-run certainly says a good deal about a reluctance in certain quarters to bring him to justice. However, it is the period following his arrest and leading up to and through his trial that brings into sharp focus the opposing demands of memory, history, and justice. As a sign of more serious problems to come, in the summer of 1991, the Indictments Division of the Paris Court of Appeals ordered Touvier released from prison on his own recognizance, on the grounds that his continued detention was "no longer necessary to the discovery of the truth." But the "real" reason, the court let it be known, was that Touvier's health (he suffered from prostate cancer) made his further detention too risky. To an outraged French public already preoccupied with the memory of Vichy, its crimes, and the increasing visibility of its apologists, the release of a man who had come to symbolize Vichy racism and brutality at its crudest—and who had already proven his remarkable talent for evading arrest outside of prison—the court's magnanimity vis-à-vis Touvier was viewed as misguided, to say the least. Although Touvier's release on medical grounds was legitimate in legal terms (a similar decision would be made later during the trial of Maurice Papon), many began to wonder, on whose side was the French justice system? Whatever the merits of these speculations, it was clear that the exigencies of memory and the court's application of the law in Touvier's case were at odds.

If Touvier's medical release in the summer of 1991 provoked consternation and controversy, the reaction was infinitesimal compared to the veritable storm of protest that followed the April 1992 decision by the Paris Court of Appeals to acquit Touvier on all charges. This time the decision went to the heart of the historical and legal debates surrounding crimes against humanity in France. In order to acquit Touvier, the Court concluded, first, that Touvier was an agent of Vichy, and second, that Vichy ideology, such as it was, was an inchoate body of "political animosities" and "good intentions." The court further reasoned that if Vichy's ideology was incoherent, by definition the regime itself could not practice a "politics of ideological hegemony"—and here was the catch. As the definition of crimes against humanity elaborated during the Barbie case made clear, crimes of this nature could be committed *only* in the name of a regime practicing a "politics of ideological hegemony." So by definition, Touvier, an agent of Vichy, could not be guilty of crimes against humanity. Hence his acquittal.

There is little doubt, in retrospect, that as the distinguished jurist Jean-Denis Bredin remarked at the time "the court proceeded in order to acquit,"[14] but the real damage, so to speak, lay elsewhere. In arriving at

its decision to acquit Touvier, the Paris Court of Appeals massively distorted the historical realities of the Vichy regime and particularly its ideology. In the wake of the April 1992 acquittal, historians have argued convincingly that Vichy did possess a coherent ideology and did in fact practice a "politics of ideological hegemony."[15] But when a higher court partially overturned the April 1992 verdict in November of the same year, it *did not* challenge the lower court's flawed reading of Vichy and its ideology. In effect, this meant that when Touvier was tried in Versailles in 1994, his conviction could only be secured if he could be shown to have acted as a *German* agent. The irony of the situation was only too apparent. Now the duty to memory where *Vichy's* crimes were concerned resulted in encouraging the court to do violence to the very historical realities that the duty to memory was intended to preserve and foreground in the first place.

As if the violence done to historical truth as a result of Touvier's conviction under the circumstances just described was not enough, there was one further, and perhaps equally troubling, consideration, which suggested the possibility of a miscarriage of justice where the application of the law itself was concerned. In *Vichy: An Ever-Present Past*, Henry Rousso and Éric Conan question whether the murders at Rillieux, brutal and cold-blooded as they were, could actually be labeled "crimes against humanity." Even if one accepted the (dubious) notion that Touvier acted as a German agent, the murders at Rillieux certainly appeared to be less a part of a "concerted plan"—in this case, the Final Solution—to persecute or exterminate than an independent and fairly isolated act of reprisal ordered by an individual known for his brutality. As such, it fit *neither* the spirit of the definition of crimes against humanity used at Nuremberg *nor* the French definition elaborated in 1985 in the context of the Barbie case. The latter stipulated, in fact, that these crimes be "committed systematically." As a final irony, even if one were to insist the Rillieux murders were crimes against humanity, they certainly were not part of Vichy's role in the implementation of the Final Solution in France. And it was primarily the executors of the Final Solution in France that the "memory militants"—and French public opinion—wished to see punished, because during the postwar purge trials, it was this dimension of Vichy's criminality that went largely unaddressed.

When Maurice Papon, former Vichy functionary in Bordeaux and, in the postwar years, Prefect of Paris Police under de Gaulle and Minister of Finance under Valéry Giscard d'Estaing, went on trial for crimes against

humanity in October 1997 for organizing convoys of Jews deported to their deaths from Bordeaux during the war, many of those dissatisfied with the Touvier trial and verdict took heart. In the person of Papon, one was dealing with a powerful Vichy bureaucrat—and not simply a racist thug—who had participated directly in the Final Solution and was accused of complicity in the deaths of more than fifteen hundred individuals. Papon's crime, as one of the lawyers for the prosecution, Michel Zaoui, argued, was "an office crime" and all the more insidious and dangerous because the killer killed by a stroke of the pen and never saw his victims. Almost anyone would be capable of this sort of crime, or at least so reasoned Zaoui.

From the outset of the trial, the opposition between the duty to memory and the application of the law was apparent within the courtroom as well as in the contrast between the proceedings and debates therein and the protests occurring on the courthouse steps outside. Almost immediately after calling the court to order, the president of the court (the equivalent of the presiding judge in the United States) announced that Papon, who according to French law was to be incarcerated during his trial, was to be released due to ill health, even though the seriousness of his condition was open to debate. The decision itself was controversial enough: one of the prosecuting lawyers, Arno Klarsfeld, stormed out of the court in protest. But a more disturbing consequence of the president's decision was that even if Papon were convicted of crimes against humanity, under the law his medical release guaranteed that he could not be imprisoned until all of his appeals were exhausted. Given that Papon was eighty-seven years old and the wheels of French justice had already proven themselves to turn notoriously slowly, Papon would probably never go to prison. Hence the man who for many had come to symbolize the worst of Vichy's crimes likely would receive, if convicted, nothing more than a symbolic sentence. It did not help that once released under these circumstances, Papon dined at the finest restaurants in the Bordeaux region before "dropping in" on his own trial in the afternoon.

Although many of the French found the president of the court's decision and Papon's behavior outrageous, the fact was that the decision to release the accused was certainly in keeping with the spirit of the law, even if it seemed nothing less than a deliberate and even obscene provocation to those who championed the memory of Papon's victims. But for the latter, Papon's guilt and conviction were a foregone conclusion, and while lawyers, judges, and the accused debated within, outside the court

memory militants solemnly read off the list of names of the deportees from Bordeaux who had lost their lives at Auschwitz and elsewhere. At times, in fact, the sort of commemorative activities associated with the memory militants penetrated into the courtroom itself, as lawyers for the civil parties demanded and were occasionally granted permission to project old photographs of victims of the deportations—men, women, and children, now dead for over a half century—for the jury to see. Whatever emotional effect these photos may have created, their projection was of course not necessary to the prosecution of the case in legal terms nor to the discovery of historical truth. The fact that fifty-year-old (or older) photographs were shown to jurors, some of whom were, as Tzvetan Todorov has remarked, "young enough to be Papon's great-grandchildren,"[16] did, however, heighten an already palpable sense of anachronism surrounding the trial.

If the Papon trial succeeded in pitting the exigencies of memory against the requirements of the law, or, in more abstract terms, the ethics of remembrance against the demands of justice as interpreted by the court, like the Barbie trial it also succeeded in stirring up two divergent memories which threatened to further unsettle the legal and historical parameters of the trial. From 1958 to 1967, Papon, having successfully bridged the gap from wartime service to Vichy to postwar service in the Fourth and Fifth Republics, and having continued his administrative climb, was now ensconced as Prefect of Paris Police. In that capacity, on the night of October 17, 1961, at the height of Algerian conflict, Papon ordered the suppression of an Algerian demonstration in the streets of Paris. Heavily armed Parisian police attacked the protestors. Thousands of protestors were rounded up and sent off to predetermined detention centers where, according to at least one commentator, conditions were as terrible as they had been at the *Vel d'Hiv* some twenty years earlier when Jews were rounded up by French police for deportation. Other Algerian protestors were beaten, and at least fifty were killed. Some were thrown into the Seine, where their bodies were dredged up days later. After these events, the entire affair was squelched by Gaullist authorities. But when Papon's career was rehearsed before the court in Bordeaux—a rehearsal that is an integral part of Assizes court procedures in France—the entire tragedy resurfaced. Questioned about his role in October 1961, the defendant minimized the number of individuals killed and denied police responsibility for the deaths, claiming that the murdered Algerians were killed as a result of conflicts between rival Algerian liberation groups.

Papon presented no evidence to back up his claims, and the spectacle of his blatant dishonesty on the stand, when aired widely in the media, provoked outrage on a national level. Commemorations for the victims of October 1961 and demonstrations at the original sites occurred around Paris. Such was the outcry that government officials promised to open government archives to researchers in order to determine what really happened in 1961, what Papon's role had been, and how many people were killed. Whatever the outcome of the investigation, it was clear that another dark moment from France's past, the Algeria war, was now at center stage and that, as in the case of the Vichy years, the Algerian past was also a contested site of memory that had not been successfully integrated into the continuity of French history. To make matters worse, the distinguished historian Pierre Vidal-Naquet argued in a large-circulation national magazine that Papon should be tried for crimes against humanity for his brutal suppression of Algerians in 1961 as well. While Vidal-Naquet's argument could certainly be justified from a human and a moral perspective, the legal and historical implications of this line of reasoning were freighted with danger. If the excesses of the Fourth and Fifth Republics could be labeled crimes against humanity, then in legal terms they amounted to the same thing as Vichy's participation in the Final Solution, a proposition that called into question the very basis and evolution of the jurisprudence concerning crimes against humanity in France. Historically, the equation was also highly dubious. Both the Fourth and Fifth Republics were democratically elected regimes, and both were at war with Algerian liberation fighters. This in no way excuses the brutality of French authorities against Algerians, but brutality between combatants is not the same as the deportation of unarmed men, women, and children to their deaths—men, women, and children who are not, moreover, fighting against the authorities. Besides, it must be remembered that Klaus Barbie's lawyer, Jacques Vergès, adopted the same argument concerning French crimes against those they colonized in order to dilute the specificity of his client's—and the Nazis'—crimes.[17]

The legal and historical quandaries associated with crimes against humanity trials in France suggest that the cost of fulfilling the nation's duty to memory is very high indeed, and it is not surprising therefore that a number of intellectuals, historians, and others have denounced what Charles Maier has labeled in a different context a "surfeit of memory."[18] During the early stages of the war in the former Yugoslavia, Alain Finkielkraut, a fierce advocate of European involvement on behalf of

Croatian independence, denounced his compatriots for "contemplating the navel" of their Vichy past rather than dealing responsibly with the pressing realities of the present. Specifically, Finkielkraut denounced French outrage over the April 1992 decision in the Touvier case while ignoring the Serb slaughter of their enemies in a country an hour away by plane.[19] Later, Finkielkraut wrote an editorial in *Le Monde* expressing similar views on the Papon trial under the heading of "Papon: Too Late."[20] Bernard-Henry Lévy, also an outspoken advocate of increased French and European involvement in Yugoslavia and other trouble spots, also denounced the cult of memory where the Vichy past was concerned while acknowledging to his chagrin that the duty to memory might be the only source of social and cultural cohesion left in contemporary France.[21] Following up on an essay published in a 1994 issue of *Esprit* entitled "The Weight of Memory," Tzvetan Todorov published a small book whose title, *The Abuses of Memory,* summed up his own skepticism over the cult of memory for memory's sake. (See his essay here.) Among historians, Henry Rousso and Éric Conan have specifically denounced the cult of memory where Vichy is concerned not only because it leads to the distortion of the past but because it results in a kind of scandal-mongering in the media that is profoundly at odds with responsible historical research.

While in many ways these criticisms of the duty to memory are entirely justified, in others they are exaggerated in their claims and occasionally inadvertently self-contradictory in their articulation. For example, can the duty to memory and the efforts of the memory militants be held entirely responsible not only for bringing about the trials for crimes against humanity in the first place but for the disheartening incoherence that resulted from the confrontation of the contradictory demands of memory, history, and justice? In a recent essay in *Le Débat*, the legal scholar Jean de Maillard offers an entirely different take on what motivated the trials and what we should learn, in particular, from the condemnation of the accused. According to Maillard, what the trials reveal in the first instance is a complete loss of faith in the nation-state as an arbiter of justice in the contemporary world. Klaus Barbie, Paul Touvier, and René Bousquet, who was murdered in 1993 just before he could stand trial on similar charges, were all in the final analysis servants of the nation-state, and the crimes of each, in one form or another, were carried out under the auspices of or in keeping with the ideology of the nation-states they served. Given the complicity of the nation-state in the crime, is it any wonder that the plaintiffs in these cases bypassed government authorities and institutions—tainted, in these plaintiffs' eyes, as integral parts and creations of the nation-state—

in order to make their case directly to a judge? For Maillard, this process has little to do with the fulfillment of a duty to memory or the practice of an ethics of remembrance and everything to do with a new waning of the power, authority, and legitimacy of the nation-state in the age of globalization. The fact that Papon was convicted of complicity in the crime but found innocent of knowingly sending the deportees to their deaths confirms the extent to which the verdict found the state guilty and diminished the responsibility of the independent agent and individual human being Maurice Papon by relegating him to the role of a dehumanized cog in the monstrous machinery of the nation-state. Whether or not one accepts Maillard's thesis, it certainly suggests that memory militancy alone cannot explain these trials and all their implications.[22]

As for the self-contradictory position in which those who denounce the excesses of memory occasionally find themselves, it is worth noting that in the same book in which Finkielkraut deonounces the obsession with memory in the Touvier case, he nevertheless invokes that memory polemically in comparing French inaction in Croatia to Vichy's passivity a half century before and in insisting that at the heart of this passivity and indifference is a disdain for those outside France, especially the inferior and insignificant peoples to the east. Bernard-Henry Lévy, for his part, compares Serb ethnic cleansing to the Final Solution and argues that in the nineties Western democracies were even more culpable than during World War II because this time, they knew. So while Finkielkraut and Lévy do not hesitate to condemn the memory militants' focus on the past, they themselves are happy to indulge in references to it in order to spur action of a different sort in the present. To each his or her own.

These remarks are not intended either to contribute to the condemnation of the memory militants or the duty to memory nor, conversely, to take sides against their adversaries. What they are intended to demonstrate, however, is the degree to which crucial historical, legal, political, and ethical debates in France today are inflected by what Raul Hillberg calls "politics of memory." The question, then, is whether the ethics of remembrance serves a positive or negative role in finding constructive solutions to these debates. To return to the language of the courtroom, the answer, it would appear, needs to be determined on a case-by-case basis. As for the long-term impact of the duty to memory on France's attempts to come to terms with its past and confront the realities of the present and future, the jury is still out. It could be that the exhaustive and exhausting obsession with Vichy will finally force the French to turn away from a past they both adore and despise. This eventuality, however, seems unlikely.

Notes

1. Robert O. Paxton, "Symposium on Mitterrand's Past," *French Politics and Society* 13:1 (Winter 1995): 19.

2. The French title of Éric Conan's and Henry Rousso's 1994 book on the scandal of Vichy in the 1990s was *Vichy, un passé qui ne passe pas [Vichy, A Past that does not pass]*. The book was translated into English by Nathan Bracher as *Vichy: An Ever-Present Past* (Hanover: Dartmouth/UPNE, 1998). All further references will be to the English translation.

3. Henry Rousso, *The Vichy Syndrome: History and Memory in France Since 1944* (Cambridge, Mass.: Harvard University Press, 1991).

4. Conversation with the author, October 1997.

5. Robert Paxton, foreword to *Vichy: An Ever-Present Past*, 11.

6. Pierre Nora, "Tout concourt aujourd'hui au souvenir obsédant de Vichy," *Le Monde*, 1 October 1997.

7. Jean-Paul Sartre, "Qu'est-ce qu'un collaborateur?" *Situations III* (Paris: Gallimard, 1949), 43–61.

8. I personally disagree with this assessment of the film. See the chapter on *Lacombe Lucien* in my *Vichy's Afterlife: History and Counterhistory in Postwar France* (Lincoln: University of Nebraska Press, forthcoming).

9. Along these lines see also Richard Weisberg's *Vichy Law and the Holocaust in France* (New York: New York University Press, 1996).

10. Lecture to a group of American high school teachers in Caen, Normandy, 21 July 1998.

11. *Vichy: An Ever-Present Past*, 226.

12. The best detail on the history of the convoluted history of crimes against humanity can be found in the chapter on the Touvier trial in *Vichy: An Ever-Present Past*. See also my introduction in *Memory, the Holocaust, and French Justice* (Hanover: Dartmouth/UPNE, 1996).

13. The best discussion of the Barbie trial, the shenanigans of Barbie's lawyer, and the implications of the trial for crimes against humanity in France can be found in Alain Finkielkraut's *Remembering in Vain* (New York: Columbia University Press, 1989).

14. Bredin's essay on the 1992 Touvier acquittal is in *Memory, The Holocaust, and French Justice*, 109–13.

15. See François Bédarida, *Touvier: Le dossier de l'accusation* (Paris: Seuil, 1996), 11–43.

16. Tzvetan Todorov, "Letter from Paris: The Papon Trial," *Salmagundi* 121/122 (Winter/Spring 1999): 5.

17. For a discussion of the October 1961 events and their role in the Papon trial, see my "Memory's *bombes à retardement*: Maurice Papon, Crimes against Humanity and 17 October 1961," *Journal of European Studies* 28:1/2 (March/June 1998): 153–72.

18. Charles Maier, "A Surfeit of Memory? Reflections on History, Melancholy, and Denial," *History and Memory* 5 (1993): 136–51.

19. Finkielkraut's writings on the war in the former Yugoslavia will be published in English by the University of Nebraska Press in fall 1999 under the title *Dispatches from the Balkan War*, Peter S. Rogers and Richard J. Golsan, translators.

20. The editorial appeared in *Le Monde* on 14 October 1997.

21. Bernard-Henry Lévy, *La Pureté dangereuse* (Paris: Grasset, 1994), 199–204.

22. Jean de Maillard, "A quoi sert le procès Papon?" *Le Débat* 101 (September/October 1998): 32–42.

WITNESSING OTHERNESS IN HISTORY

Kelly Oliver

Dori Laub, a psychoanalyst interviewing survivors as part of the Video Archive for Holocaust Testimonies at Yale, remarks on a tension between historians and psychoanalysts involved in the project. He describes a lively debate that began after the group watched the taped testimony of a woman who was an eyewitness to the Auschwitz uprising in which prisoners set fire to the camp. The woman reported four chimneys going up in flames and exploding, but historians insisted that since only one chimney exploded, her testimony should be discredited in its entirety because she proved herself an unreliable witness. One historian suggested that her testimony should be discounted because she "ascribes importance to an attempt that, historically, made no difference" (Felman 61). The psychoanalysts responded that the woman was not testifying to the number of chimneys destroyed but to something more "radical" and more "crucial," namely, the seemingly unimaginable occurrence of Jewish resistance at Auschwitz, that is to say, the *historical truth* of Jewish resistance at Auschwitz. Laub concludes that what the historians could not hear, listening for empirical facts, was the "very secret of survival and of resistance to extermination" (Felman 62).

While the historians were listening to hear confirmation of what they already knew, the psychoanalysts were listening to hear something new, something as yet beyond comprehension. While the historians were trying to recognize empirical facts in the survivors' testimonies, the psychoanalysts were trying to acknowledge that the import of these testimonies was as yet unrecognizable. Although undeniably powerful in their impact, the empirical facts of the Holocaust are dead to that which cannot be reported by the eyewitness, the unseen in vision and the unspoken in speech, that which is beyond recognition in history, the process of witnessing itself. The process of witnessing, which relies upon address and

response—always in tension in eyewitness testimony—complicates the notion of historical truth and moves us beyond any easy dichotomy between history and psychoanalysis.

Witnessing is defined as the action of bearing witness or giving testimony, the fact of being present and observing something, from *witness* which is defined as to bear witness, to testify, to give evidence, to be a spectator or auditor of something, to be present as an observer, to see with one's own eyes (*OED*). It is important to note that witnessing has both the juridical connotations of seeing with one's own eyes and the religious connotations of testifying to that which cannot be seen, or *bearing witness*. By exploiting the double meaning of witnessing, I hope to expand the type of witnessing that counts as historical evidence. For there is an important sense in which the truth of history cannot be reported by eyewitnesses. I will argue that, on the contrary, only witnessing to what cannot be seen—the process of witnessing itself—makes ethics possible.

Eyewitness Testimony and Transference

Traditionally, the eyewitness is privileged by historians because, as Joan Scott points out, they presume that "knowledge is gained through vision; vision is a direct, unmediated apprehension of a world of transparent objects.... Seeing is the origin of knowing. [And] writing is reproduction, transmission—the communication of knowledge gained through (visual, visceral) experience" (Scott 22–23). Scott argues that when experience is taken as an origin and evidence is based on eyewitness testimony or the vision of the individual, then questions about how that experience is produced are left aside (25). Scott claims that even progressive historians who want to make visible the experience of those traditionally made invisible merely reproduce the terms through which the visible and invisible support each other: "Making visible the experience of a different group exposes the existence of repressive mechanisms, but not their inner workings or logics; we know that difference exists, but we don't understand it as constituted relationally. For that we need to attend to the historical processes that, through discourse, position subjects and produce their experiences" (25). The processes of subjectivity and experience are left out of a notion of evidence which presumes that eyewitnesses have direct access to an experience that exists in itself and can be translated directly into testimony. Indeed, the necessity of interpretation or elaboration is missing from a history that privileges eyewitness testimony.

Scott and other progressive historians and theorists of history are con-

cerned with the possibility of writing histories of groups who traditionally have been ignored or objectified by Western historians. As Scott argues, it is not as simple as getting eyewitness testimony from members of those groups. Certainly, it is not as simple as observing those groups from the outside. Rather, as Scott suggests, eyewitness testimony must be accompanied by analysis that brings to light the processes through which group identity and exclusionary practices operate in the practice of writing history.

Dominick LaCapra addresses some of the same problems by employing psychoanalytic theory in his discussion of history and the possibility of writing a history of "the other." LaCapra argues that transference is at work in the writing of history; historians engage in transferential relationships with the "objects" of their study. LaCapra maintains that any history of the other requires examining and acknowledging the operations of transference. LaCapra loosely defines his use of "transference" as a "modified psychoanalytic sense of a repetition-displacement of the past into the present as it necessarily bears on the future" (*History* 72). One of the primary implications of his extension of transference to history is a sense of both time and theory as repetition. Insofar as theorists or historians are necessarily involved in transferential relations with the object of their analysis (if they are the least bit interested in their work), problems can arise if the transference is not acknowledged or interpreted. "Transference causes fear of possession by the past [or the object of study] and loss of control over both it and oneself. It simultaneously brings the temptation to assert full control over the 'object' of study through ideologically suspect procedures that may be related to the phenomenon Freud discussed as 'narcissism'" (72).

LaCapra diagnoses two extreme reactions caused by transference: 1. totalizing, controlling identification with the other, or 2. total disassociation with the other who is seen as radically and completely different. Both the attempt to completely assimilate the other (or the past) and the attempt to deny any connection between the self and the other (the present and the past) are symptoms of an undiagnosed and uninterpreted transference. "The difficulty," says LaCapra, "is to develop an exchange with the 'other' that is both sensitive to transferential displacement and open to the challenge of the other's 'voice'" (72–73). My purpose in this essay is to elaborate a notion of witnessing at the heart of subjectivity that will enable a discussion of *othered* subjectivity. By doing so, I hope to open history onto *otherness* in such a way that challenges dominant history's use of "the other."[1]

LaCapra suggests that, just as in the clinical setting, in order to make the transferential relation transformative, there must be interpretative diagnoses that move the subject, group, or culture from acting-out (mere repetition), to working-through (internal change). LaCapra expands on Freud's notions of working-through and acting-out. Freud describes acting-out in "Remembering, Repeating and Working-Through": "the patient does not remember anything of what he has forgotten or repressed, but acts it out. He reproduces it not as a memory but as an action; he repeats it, without, of course, knowing that he is repeating it" (Freud 150). For Freud, the goal of analysis is to turn acting-out into memory by providing interpretations and allowing the patient time to "work-through" his resistances to interpretation (154–56).

Edward Bibring develops Freud's theory of repetition by explaining how acting-out alone does not lead to change (Bibring 501). Bibring makes a distinction between defense mechanisms like acting-out through which tensions are pushed aside, abreaction through which tension is discharged directly, and what he calls "working-off" through which tensions are dissolved. He says that "working-off mechanisms of the ego are directed neither toward discharge [abreaction] nor toward rendering the tension harmless [acting-out]; their function is to dissolve the tension gradually by changing the internal conditions which give rise to it" (502). Although Bibring himself does not elaborate on the internal conditions that give rise to repetition, or explain how working-off changes them, his theory is suggestive for the purpose of imagining how acting-out or iteration becomes structural change. Bibring's theory promises the reality of overcoming the repetition compulsion and breaking the cycle of repetitions by changing the very conditions which make the repetition possible. Building on Freud's theory that "working-through is undoubtedly a repetition albeit one modified by interpretation and—for this reason—liable to facilitate the subject's freeing himself from repetition mechanisms," Bibring emphasizes the role of interpretation in binding unbound psychic tension and thereby changing the structure of repetition (Laplanche and Pontalis 488; see also Freud and Bibring).

Daniel Lagache further develops Bibring's notion and describes various modes of working-off:

> the transition from the action of repetition to recollection by thought and word ... the transition from identification, where the subject fails to distinguish himself from his lived experience, to objectification, where he stands back from this experience; the transition from dissociation to inte-

gration; the detachment from the imaginary object, brought to completion with the change of object; that familiarization with phobic situations which replaces the anxious expectation of the traumatic and phantasy-dominated situation; the substitution of control for inhibition, of experience for obedience—in all these examples, the defensive operation [acting-out] is only neutralized in so far as a working-off operation is substituted for it. (Laplanche and Pontalis, 487)

We might also note that in all of Lagache's examples, working-off is substituted for acting-out through the catalyst of interpretation. Through interpretation or diagnostic elaboration of acting-out, repetition is transformed from compulsory behavior into more open possibilities.

Working-through requires interpretation born out of self-critical reflection and dialogue. For LaCapra, the critical distance necessary for diagnostic interpretation to lead to transformation is based in acknowledging transference and retrieving what has been repressed (*Representing* 175).[2] Recall that according to Freud, Bibring, and Lagache, what is repressed is merely acted-out, while what is remembered is the result of working-through or working-off. In a sense, we could say that working-through is the process of acknowledging that our own subjectivity is not our own but the result of dialogic and transferential relations with others. Working-through is the process of articulating and diagnosing the ways in which we totalize or deny otherness; its aim is transforming our relations with others and otherness. To return to Scott's analysis, we could say that treating eyewitness testimony as the direct transmission of experiential truth without situating or interpreting it tends to result in acting-out prejudices and preconceptions instead of working-through them in order to transform our sense of ourselves and others.

Vigilance and Reverse Causality or The Future Anterior

Taken alone, however, working-through—and its transformative power of interpretation or elaboration—is insufficient for opening ourselves onto otherness. Vigilance is also necessary. Vigilance in self-elaboration, self-analysis, self-interpretation, is necessary for a history of otherness. That is to say, vigilance in elaborating, analyzing, and interpreting the process through which *we* become who *we* are, the process through which *we* become subject and other. Vigilance in testifying and witnessing, vigilance in listening for the performance beyond meaning and recognition. Vigilance in listening to the performance not just as a repetition of the

law of exclusion but as a repetition of an advent of what is impossible to perform. Vigilance in listening to the silences in which we are implicated and through which we are responsible to each other.

This is a vigilance that Emmanuel Levinas suggests is necessary to recover the saying in the said. In other words, vigilance is necessary to recognize the unrecognizable in the process of witnessing itself. To demand vigilance is to demand infinite analysis through ongoing performance, elaboration, and interpretation. Infinite analysis is the affirmation of the process of witnessing that makes subjectivity possible. The demand for infinite analysis is the ethical imperative of subjectivity conceived in witnessing beyond recognition.

Vigilance is defined in terms of watchfulness, alertness of observation, wakefulness, insomnia, from *vigilant* which is defined as wakeful and watchful, keeping steadily on the alert, attentively or closely observant (*OED*). Following Levinas's thoughts on insomnia, I would like to suggest a second, radically different, meaning for vigilance. Just as witnessing can mean both seeing and not seeing, vigilance can mean both keeping watch and responding to something beyond your own control. Whereas keeping watch or observing is something that one intends to do, the wakefulness of insomnia is not intended but rather appears as a response to something or someone beyond oneself. Insomnia is not the vigilance of a self-possessed watchman but the vigilance of a self opened onto otherness itself. Otherness keeps me awake. Vigilance as insomnia is a response to the demands of otherness. This is vigilance as response-ability.

For Levinas, the vigilance or wakefulness of insomnia is "not equivalent to *watching over* . . . , where already the identical, rest, sleep, is sought after. . . . Insomnia—the wakefulness in awakening—is disturbed in the core of its formal or categorical *sameness* by the *other*, which tears away at whatever forms a nucleus, a substance of the same, identity, a rest, a presence, a sleep. . . . The other is in the same, and does not alienate the same but awakens it" (Levinas 156). Levinas describes this awakening as a demand from the other. In vigilance the response to this demand is neither self-destruction nor the destruction of the other. As Levinas says, "Insomnia . . . does not get inscribed in a table of categories from a determining activity exercised on the other as given by the unity of the same (and all activity is but the identification and crystallization of the same against the other, upon being affected by that other)" (1987, 156). Rather, Levinas describes the relationship between the self and other as one of response-ability in which vigilance is a response to the other. In order to

avoid this language of subjects and others that leads Levinas to talk about hostages, I would say subjectivity is a responsiveness to otherness and vigilance is a movement beyond ourselves toward otherness.

In *Otherwise Than Being*, Levinas maintains that justice and responsibility are inherent in the saying which makes the said possible: "It will be possible to show that there is question of the said and being only because saying or responsibility require justice" (1974, 45). Jacques Derrida takes over the Levinasian notion of vigilance when he discusses the future of justice. As Derrida's work suggests, justice is a process that never ends, not because human limitations keep us from our goal or because time is infinite, but because justice is never within the realm of the possible.[3] Justice is response-ability itself, the infinite need to respond which can never be fulfilled once and for all in history. History is precisely what the vigilance inherent in demands for justice must continually call into question. History is of the past while justice is of the future. History is of the *actual* while the future is of the *possible*, or, in Derrida's terms the *impossible*. Whereas historians work in past tenses—it was, it had been—justice works in the future anterior—it will have been. It will have been in the past so that it might become in the future. The future anterior blurs the distinction between past and future and suggests that time does not just flow in one direction from past to future but also from future to past.

Following Levinas, Derrida talks about a future yet to come, always deferred, in which the impossible becomes possible. This is why in order to open up different possible futures, more particularly to open up a future in which it is possible to think the impossible, we need to rethink history. Rather than embrace the historian's past as actual, we need to rethink that past as possible. This is to say, we need to find the conditions of the possibility for justice—for the impossible to become possible in the future—in the past. This implies a reverse causality whereby the future affects the past. The image of a better future affects the past that makes it (the future) possible. In a sense, we revisit the past for the sake of a different future. And, only by reading the conditions of the possibility of that future into the past (it will have been) can we open up alternatives to the present. In order to imagine the present impossibilities becoming possible in the future, we need to imagine them as possible in the past: the future opens onto otherness only insofar as the past does too. But, this requires a vigilance, an insomnia, that refuses to sleep the dogmatic slumber of historical facts inhabiting a determinant past in a world where the past has already caused the future and the future is just like the past.

In *Archive Fever*, Derrida argues that history, or the archive, is more about the future than the past. The meaning of history is always in the future, determined by the future, never determined by the past, which implies that its meaning is open and never closed (Cf. Derrida 1996, 36). Derrida says of the archive, "It is a question of the future, the question of the future itself, the question of a response, of a promise and of a responsibility for tomorrow" (1996, 36). Derrida's analysis suggests that there are at least three ways in which the past or archive is determined by the future. First, archive fever or the passion for keeping records is driven by a responsibility for tomorrow, a responsibility to remember for the sake of the future. Second, history is always interpreted after the fact, which is to say in the future. For this reason, the meaning of history or the archive of history is always deferred. Third, the archive or recorded history must repeat the process of archivization over and over again: "The archivist produces more archive, and that is why the archive is never closed. It opens out of the future" (Derrida 1996, 68).

The performance of archivization inscribes the archivist and his future into the past which he interprets. In the context of analyzing Freud, Derrida says, "The strange result of this performative repetition, the irrepressible effectuation of this *enactment*, in any case what it unavoidably demonstrates, is that the interpretation of the archive ... can only illuminate, read, interpret, establish its object, namely a given inheritance, by inscribing itself into it, that is to say by opening it and enriching it enough to have a rightful place in it" (1996, 67). Derrida insists that what is at issue in this performative repetition is not the past but the future, more precisely, an affirmation of the future to come (1996, 68).

Dominick LaCapra takes a similar tack when he argues that what he calls "repetitive temporality" necessitates an open future and open debates over the status of the past. He maintains that "a psychoanalytically informed notion such as repetitive temporality (or history as displacement) ... counteracts historicist teleology and redemptive or messianic narratives, and it has a hypothetical, revisionary status that is always in need of further specification and open to debate" (1994, 9). As we have seen, LaCapra complicates the notion of history by insisting on the transference or displacement relationship between theorist or historian and the past.

Derrida further complicates the relationship between past and future by insisting that history is not *of* the past but *of* the future. Turning a corner with Derrida's analysis, we could say that the performative repetition of the archivist is an attempt to inscribe the future into the past so that the conditions of possibility necessary for the future desired by the

archivist are available from the past. Imagining otherness, then, is a matter of archiving the other into history so that causality between past and future becomes reversible. Derrida's insistence on the connection between justice and the future anterior (what will have been), and what I read as the reversibility of the past and future, moves us toward thinking the time of otherness.

Just as we have to imagine that the future can change the past and that the past is a matter of possibilities, vigilance also demands that we imagine the present as past. Chandra Talpade Mohanty suggests that in order to work for social change it is necessary to imagine a future in which present injustice is past. For Mohanty, although this future is yet to come, which is the nature of the future, political and social activism requires imagining the determinant future in which our present becomes a history lesson. She concludes her essay "Feminist Encounters" by insisting that the place from which we seek to know what is just and from which we work for social change must be an imaginary encounter with a possible future in which we see the present as already past, as the future anterior, *will have been*:

> I *know*—in my own non-synchronous temporality—that by the year 2000, apartheid will be discussed as a nightmarish chapter in Black South Africa's history, the resistance to and victory over the efforts of the U.S. government and multinational mining conglomerates to relocate the Navajo and Hopi reservations from Big Mountain, Arizona, will be written in elementary-school textbooks, and the Palestinian "homeland" will no longer be referred to as the "Middle-East question"—it will be a reality. But that is my preferred history: what I hope and struggle for, I garner as *my* knowledge, create as the place from where I seek to know. (Mohanty 42)

When Mohanty talks about "*my* knowledge" she is not proposing that she or anybody else can assume a position of transcendence in relation to justice. In fact, she is insisting that all knowledge and understanding is positional in relation to socio-political and economic histories. She argues that it is this positionality that is not addressed by traditional notions of history as linear and teleological, moving between the two poles of origin and end. Following Shiv Visvanathan, Mohanty suggests that the "diagnostic classification[s] along the linear, irreversible continuum of Time/Progress" is itself a position determined by its own historical conditions (30). Using Visvanathan's analysis of the museum, Mohanty describes how the notion of history as an irreversible continuum assumes a Eurocentric notion of evolution from primitive to civilized where

"progress is defined as the ordained linear movement across this sequence" and "as a result, other civilizations or tribal cultures are seen as 'contemporary ancestors,' the past the West has already lived out" (30). Within this Eurocentric history, the poles of origin and end correspond to subject and other insofar as *the other* is the *primitive origin* of the Western *subject* who occupies the position of *telos*.

Historicity and History, Temporality and Time

Mohanty points to a difference between history and historicity. Whereas history operates according to a "Eurocentric law of identical temporality" and is in some sense always already written, historicity can never be written in that sense because it is a dynamic process of negotiating the positions or perspectives that make writing history possible. These negotiations can be contentious or conciliatory, but in either case they are made possible by the response-ability of subjectivity. And, the categories of subject, object, and other perpetuated by traditional notions of history are complicated by analyses of the historicity of the categories themselves. Mohanty, Joan Scott, and others have argued that opening history to otherness requires more than writing alternative histories of cultures or groups; it requires historicizing notions of identity and difference both in the abstract and in their particular embodiments.

Strangely resonant with Levinas, Mohanty quotes Bernice Reagon's contribution to *Home Girls: A Black Feminist Anthology*: "The only way you can take yourself seriously is if you can throw yourself into the next period beyond your little meager human-body-mouth-talking all the time" (Mohanty 40). Mohanty argues that "we take ourselves seriously only when we go 'beyond' ourselves, valuing not just the plurality of differences among us but also the massive presence of the Difference that our recent planetary history has installed. This 'Difference' is what we see only through the lenses of our present moment, our present struggles" (40). While in Reagon's analysis this "going beyond ourselves" seems to be working for a better future for future generations, for Mohanty going beyond ourselves means an encounter with Difference, which takes us beyond the struggle of identity politics toward a historicity of identity and difference that begins when we bring temporality back into discussions of history, identity, and difference. She maintains that "the notion of a temporality of struggle defies and subverts the logic of European modernity and the 'law of identical temporality.' . . . It suggests an insistent, simultaneous, non-synchronous process characterized by

multiple locations, rather than a search for origins and endings which as Adrienne Rich says, 'seems a way of stopping time in its tracks'" (41).

For Mohanty, if we are not vigilant about the temporality of experience, we take experience as a given and risk stopping time in its tracks. Only by attending to the temporality of experience can we restore historicity to history. Only this vigilance will prevent us from overlooking the positions from which we experience identity and difference, the historicity of identity and difference.

Temporality, then, is what is missing from history. In *Otherwise Than Being*, Levinas makes a distinction between history and temporality as a lapse of (linear, historical) time, or immemorial time. He characterizes this distinction as one between diachronic and synchronic elements of time which correspond to the saying and the said: "For the lapse of time is also something irrecuperable, refractory to the simultaneity of the present, something unrepresentable, immemorial, pre-historical.... The immemorial is not an effect of a weakness of memory, an incapacity to cross large intervals of time, to resuscitate pasts too deep. It is the impossibility of the dispersion of time to assemble itself in the present, the insurmountable diachrony of time, beyond the said ..." (Levinas 1974, 38). The lapse of time—the passing of time—is temporality or immemorial time while history is the recognition and assimilation of temporality into linear narratives. Yet, in Levinas's analysis there is something about temporality which resists such narratives, what he calls the saying in the said.

Using a distinction developed by Derrida from J. L. Austin, we could say that the saying, or the temporality of time, corresponds to the realm of *performance*, while the said, or history, corresponds to the realm of the *constative*. In order to elaborate the process through which subject positions become heirarchized or empowered, it is necessary to attend to the temporality of time or the performative element of any signification. It is in the performance, for example, that the historian's own transferential relationship is acted out. Therefore, in order to make history transformative, it is necessary to attend to the performative aspect of history-making. By vigilantly attending to the performative, we can begin to elaborate the unrepresentable temporality of time.

This suggests that what is transformative about the performative is not just the differences that result from performing at time t_1 and then again at time t_2. Rather, it is by returning temporality to history that the performative becomes transformative. In other words, performativity destabilizes history by showing that the constative element central to historical truth is dependent upon the process of temporality, which can never be

fully captured in that constative element.[4] Echoing Mohanty, we could say that interpretation of how the performative challenges the constative, or how temporality challenges history, returns the *historicity* of struggles over social norms to history.

Attending to historicity requires a vigilance in witnessing to the process, the saying, the response-ability (or lack of it), which creates the conditions of possibility for the construction of historical evidence in the first place. Attention to the temporality of the performative, along with interpretation of the performance, and vigilance in insisting on the impossibility of ever fully recognizing otherness, are three elements that open subjectivity onto otherness. My analysis of performance, interpretation, and vigilance in developing a theory of open subjectivity and "othered" subjectivity is itself intended as a testimony to the necessity of witnessing to subjectivity.

In a discussion of temporality and the move away from subject-centered philosophy toward otherness, it is impossible not to gesture toward Heidegger's analysis of temporality as the fundamental characteristic of Being and therefore of *Dasein*'s relation to Being. In fact, Heidegger's association of the moment with an *Augenblick* takes me back to my discussion of the eyewitness.[5] *Augenblick* connotes the blinking of the eye. We might say that the moment takes place in the blink of an eye. But, as Heidegger points out, insofar as the present moment takes place in the blink of an eye, we are not its eyewitnesses. Rather, it is the blinking of the eyes that prevents us from seeing what is happening at every instant. It is the *Augenblick*, the blinking of the eye, the temporality of the moment, that makes us unreliable eyewitnesses. And it is only a vigilance in investigating our blindness—what is for us beyond recognition—that keeps us aware of our response-ability, of our need to respond to what for Heidegger is a calling. In the Heideggerian move, vision gives way to hearing, history gives way to temporality, and the historian's eyewitness is blind to as much as he sees. The blink challenges the link between the eyewitness and history. Perhaps we could say that for Derrida and philosophers such as Judith Butler, Heidegger's blink becomes a wink, a parodic performance that displays the importance of blinking—not seeing—to witnessing.[6]

Witnessing to the Impossibility of Witnessing

Shoshana Felman's analysis of eyewitness testimonies of the Holocaust might enrich the notions of performance, elaboration, and vigilance and begin to give us a theory of witnessing that moves us toward a history of

otherness. Felman's analysis suggests that there is a difference between the narration of historical facts by just anyone and the narration of history by those who lived through it. Of course, historians and our legal system also privilege eyewitness testimony, but what is it about that testimony that is unique? Felman locates the uniqueness of eyewitness testimony in the performance of testimony, which goes beyond the first-hand, conscious knowledge of the witness. The performance of testimony says more than the witness knows, and only the supplement of this more-than-knowledge can speak the truth of experience, a truth repeated and yet constituted in the very act of testimony. Felman asks, "What does it mean that the testimony cannot be simply reported, or narrated by another in its role as testimony? ... What does testimony mean, if it is the uniqueness of the *performance* of a story which is constituted by the fact that, like an oath, it cannot be carried out by anybody else?" (Felman 205–6).

I began with an example of historians discounting an eyewitness testimony because of its inaccuracy. In this case, historians were listening for what was impersonal in the testimony, what could be repeated by anyone else. But, as Felman points out, if history is impersonal, then anyone should be able to testify to the truth of facts; eyewitnesses would have no privilege. Felman suggests, however, that there is something other than historical accuracy at stake in testimony. It is the *performance* of testimony and not merely what is said that makes it effective in bringing to life a repetition of an event; not a repetition of the facts of the event, nor the structure of the event, but the silences and the blindness inherent in the event that, at bottom, also make eyewitness testimony impossible. This is to say, what makes testimony powerful is its dramatization of the impossibility of performing the event. And, what makes witnessing possible is its testimony to the impossibility of witnessing the event. Discussing Claude Lanzmann's film *Shoah*, Felman says, "The *necessity of testimony* it affirms in reality derives, paradoxically enough, from the *impossibility* of testimony that the film at the same time dramatizes" (224).

To continue to use the Levinasian distinction, the saying challenges the said—not just because the saying performs the unspoken conditions of the possibility of the said, but because the saying *enacts* the impossibility of really ever *having said* what happened. Vigilance and witnessing are necessary because of the impossibility of having said. Both are necessary, not in order to get at the truth, but more importantly to maintain the possibility of the process of witnessing.

The paradox between the necessity and impossibility of testimony, the paradox of the eyewitness, is the productive tension at the foundation of

the notion of witnessing. The tension between history and testifying to what one knows from first-hand experience, on the one hand, and psychoanalysis and witnessing to what is beyond knowledge or recognition, on the other, produces the possibility of getting beyond a mere repetition of either history or trauma. History and psychoanalysis, testimony and witnessing, are necessarily strapped together to create the tension that supports historical truth and the very structure of subjectivity itself. Witnessing means both testifying to something you have seen with your own eyes and testifying to something that you cannot see. We have both the juridical sense of witnessing to what you know from experience as an eyewitness and the religious sense of witnessing to what you believe through blind faith. Subject positions and subjectivity are constituted through the possibility of witnessing in this double sense. The tension inherent in witnessing is the tension between subject positions, which are historically determined, and subjectivity, which is an infinite response-ability.

Oppression and domination work on both levels of witnessing to restrict or annihilate the possibility of subject positions and to undermine or destroy the structure of subjectivity, both of which are necessary to a sense of agency. Oppression and domination succeed by undermining, damaging, or annihilating what Laub identifies as the inner witness necessary for the process of witnessing to support itself. The inner witness operates as a negotiating voice between subject positions and subjectivity. The inner witness is the necessary condition for the structure of addressability and response-ability inherent in subjectivity. The witnessing structure or subjectivity is a necessary condition for assuming a subject position as active agent.

Both Felman and Laub conclude from their analysis of survivors' testimonies that the events of the concentration camps and mass murders became a Holocaust because they annihilated the possibility of witnesses. Laub explains that

> the historical reality of the Holocaust became, thus, a reality which extinguished philosophically the very possibility of address, the possibility of appealing, or of turning to another. But when one cannot turn to a "you" one cannot say "thou" even to oneself. The Holocaust created in this way a world in which one could not bear witness to oneself. The Nazi system turned out therefore to be fool-proof, not only in the sense that it convinced its victims, the potential witnesses from the inside, that what was

affirmed about their "otherness" and their inhumanity was correct and that their experiences were no longer communicable even to themselves, and therefore perhaps never took place. This loss of the capacity to be witness to oneself and thus to witness from the inside is perhaps the true meaning of annihilation, for when one's history is abolished, one's identity ceases to exist as well. (Laub 82; cf. 211)

As Felman points out, although there were eyewitnesses to the Holocaust, they could not really see what was going on. From the inside, victims were not only empirically annihilated as witnesses—murdered—but also cognitively and perceptually destroyed as witnesses because they were turned into objects and dehumanized. As inhuman objects they are unable to speak. Moreover, to speak, to witness to the world their dehumanization is to repeat it. From the outside, the Nazis made sure that the world did not see what was happening; they hid the death camps. Those involved in the killings were ordered with the threat of death not to refer to the victims as victims or people or even corpses but to call them *figuren* or *Schmattes*, puppets or rags (Felman 210). Even those who saw could not see because it was impossible to grasp a world that was not a world, a world that was inhuman (232). For some of the soldiers in the Allied forces, seeing the concentration camps meant going blind; they literally lost their sight at the sight of the incomprehensible world of the Holocaust.

Felman asks, what would it mean to witness to the Holocaust? To witness from the inside, from the experience of the victims? She argues that it would mean first bearing witness from the inside to the desire *not* to be inside (Felman 228). Also, it would mean testifying from inside the very binding of the secret that made victims feel like they were part of a secret world (229). It would mean testifying from the inside to a radical deception by which one was separated from the truth of history even as one was living it (229). Moreover, it would mean testifying from inside otherness, bearing "witness from inside the living pathos of a tongue which nonetheless is bound to be heard as noise" (231). Felman concludes that it is impossible to testify from inside. From the inside the possibility of address and an addressable other was eliminated. Yet, in order to reestablish subjectivity and in order to demand justice, it is *necessary* to bear witness to the inarticulate experience of the inside. This is not the finite task of comprehending it; this is the infinite task of encountering it (cf. Felman 268). It is the tension between finite understanding linked to historical facts and historically determined subject positions and infinite

encounter linked to psychoanalysis and subjectivity as infinite response-ability that produces a sense of agency. Such an encounter necessarily takes us beyond recognition and brings with it an ethical responsibility.

Witnessing History

We are obligated to witness beyond recognition, to testify and to listen to testimony—to encounter each other—because the results are subjectivity and humanity. That is to say, subjectivity and humanity are the result of response-ability. That which precludes a response destroys subjectivity and thereby humanity. As Laub concludes, "The absence of *an addressable other*, an other who can hear the anguish of one's memories and thus affirm and recognize their realness, annihilates the story. And it is, precisely, this ultimate annihilation of a narrative that, fundamentally, *cannot be heard* and of a story that *cannot be witnessed*, which constitutes the mortal [eighty-first] blow" (Felman 68).

Laub's analysis of his involvement with Holocaust survivors and their testimonies teaches us about all human relationships and the nature of subjectivity. As Laub points out, witnessing engages a joint responsibility. It takes two. It is impossible to bear witness without an addressee. Response-ability is never solitary. In describing the Video Archive project at Yale, Laub says, "The interviewer-listener takes on the responsibility for bearing witness that previously the narrator felt he bore alone, and therefore could not carry out. It is the encounter and the coming together between the survivor and the listener, which makes possible something like a repossession of the act of witnessing. This joint responsibility is the source of the reemerging truth" (Felman 85). The lesson of this limit experience is that without an addressee, without a witness, *I* cannot exist. I am by virtue of responsibility. Truth is itself a process of emergence and reemergence between response-able subjects.

Subjectivity requires the possibility of a witness, and the witnessing at the heart of subjectivity brings with it responsibility—response-ability and ethical responsibility. Subjectivity as the ability to respond is linked in its conception to ethical responsibility. Subjectivity is responsibility. It is the ability to respond and to be responded to. Responsibility, then, has the double sense of opening up the ability to response—response-ability—and ethically obligating subjects to respond by virtue of their very subjectivity itself. Reformulating Eva Kittay's analysis of relations of dependency, a subject who "refuses to support this bond absolves itself

from its most fundamental obligation—its obligation to its founding pos-
sibility."[7] Response-ability is the founding possibility of subjectivity and
its most fundamental obligation.

Although historical, the reemerging truth produced in witnessing is
not just empirical truth. It is not accurate because "accurate" cannot be a
criterion for this type of truth. In a sense, this truth is the truth of sub-
jectivity itself. It is the truth of the ethics of subjectivity. Although sub-
ject to repetition in the psychoanalytic sense, this truth is not one that
can be simply reported or repeated by just anyone. It is not the truth of
history books. Yet, it is precisely witnessing to the historicity of history
that gives history truth for life.

As Laub maintains, "What ultimately matters in all processes of wit-
nessing, spasmodic and continuous, conscious and unconscious, is not
simply the information, the establishment of the facts, but the experience
itself of *living through testimony*, of giving testimony" (Felman 85). The
emphasis on living through testimony suggests not only the significance
of living through this particular experience of testimony but also the fact
that *we live through witnessing*. Yet, it is this *living-through* that historical
facts conceal. Historical facts conceal the process of witnessing and the
performance of testimony. As Felman argues:

> As the extinction of the subject of the signature and as the objectification of
> the victim's voice, "history" presents itself as anti-testimony ... to make
> truth happen as a testimony through the haunting repetition of an ill
> understood melody; to make the referent come back, paradoxically, as
> something heretofore unseen by history; to reveal the real as the impact of
> a literality that history cannot assimilate or integrate as knowledge, but that
> it keeps encountering in the return of the song.... We "*sing again*" what
> we cannot know, what we have not integrated and what, consequently, we
> can neither fully master nor completely understand. (Felman 276)

This is why when looking for something comprehensible and accurate,
the historians involved in the Video Archive project could not hear any
truth, anything valid or significant, in the eyewitness testimony of the
woman who had been at Auschwitz.

What we could call the psychoanalytic truth, or the truth of perform-
ance, is concealed in dead historical facts. More specifically, the truth of
trauma and victimization is lost even in the most astounding statistics.
The lived experience of being othered and objectified is lost to history
and regained only through the testimony of witnesses. As Laub notes,

"The testimony aspires to recapture the lost truth of that reality, but the realization of the testimony is not the fulfillment of this promise. The testimony in its commitment to truth is a passage through, and an exploration of, differences, rather than an exploration of identity, just as the experience it testifies to—the Holocaust—is unassimilable because it is a passage through the ultimate difference—the otherness of death" (Felman 91). I would add, the otherness of the inhuman, the otherness of the object. To various degrees, all experiences of objectification and subordination are the inarticulable experiences of inhumanity that can be only repeated in testimony or performed in various ways but never fully reported in historical facts.

More importantly, it is through witnessing and reestablishing the inner witness who had been damaged by objectification and subordination that we can move beyond repetition of trauma to elaboration and interpretation. It is the witness, ultimately the repair of the inner witness, that allows us to be both *inside* and *outside* our own oppression and victimization at the same time. And, as Felman so forcefully argues, there is no voice from inside victimization. Testifying to a witness opens up the space to step outside. For this reason, it is in the process of testifying that the victims first come to "know" their own experience, which is all the more reason why the process of witnessing is one of joint responsibility— for the very possibility of experience itself comes only through representation, elaboration, and interpretation (cf. Felman 57). In addition, because witnessing is a process of reinventing experience (of making experience what it is), through witnessing, the logic of repetition driving the psyche, particularly the psyche of victimization, is transformed. The performance of witnessing is transformative because it reestablishes the dialogue through which representation and thereby meaning are possible. This representation allows victims to reassert their own subjective agency and humanity into an experience in which it was annihilated or reduced to guilt and self-abuse.

Testimony and Transformation

Mae Gwendolyn Henderson describes the importance of testimony in the transformation from victim to agent in her essay "Speaking in Tongues: Dialogics Dialectics, and the Black Woman Writer's Literary Tradition." Here, Henderson develops a notion of *speaking in tongues* in order to articulate what I call *othered subjectivity*, the subject position and subjectivity of those othered by oppression and domination. Henderson's analy-

sis of Mikhail Bakhtin's notion of inner speech or inner dialogue res-
onates with Laub's insistence on the possibility of an inner witness.
Henderson concludes, "Consciousness becomes a kind of 'inner speech'
reflecting 'the outer world' in a process that links the psyche, language,
and social interaction" (Henderson 146). She argues that because of their
marginal status in relation to both race and gender, the negotiation of
inner and outer voices is more explicit for black women; the negotiation
of voices or tongues is a project for black women in a way that it isn't for
others for whom this negotiation is less necessary for daily survival.

Her notion of speaking in tongues brings together what she sees as
Bakhtin's model of the multiplicity of speech in a dialogics of difference
based on struggles, and Gadamer's model of a unity of understanding in a
dialectics of identity based on consensus (150). She associates the dialog-
ics of difference with social negotiations with others, and she associates
the dialectics of identity with the inner voice—which marks a particular
location in the social sphere that is *me* or *myself* or sometimes *we* or *us*.
For Henderson, the negotiation between speaking different multiple lan-
guages and speaking secret inner languages makes us who we are.
Moreover, she maintains that conceiving of identity and difference in a
dialogic dialectical relationship opens up the possibility of speaking in
tongues, that is to say, speaking from the place of otherness, or what I am
calling othered subjectivity. She says that:

> in their works, black women writers have encoded oppression as a dis-
> cursive dilemma, that is, their works have consistently raised the problem
> of the black woman's relationship to power and discourse. Silence is an
> important element of this code ... it is not that black women, in the past,
> have had nothing to say, but rather that they have had no say. The
> absences of black female voices has allowed others to inscribe, or write, and
> ascribe to, or read, them. The notion of speaking in tongues, however,
> leads us away from an examination of how the Other has written/read
> black women and toward an examination of how black women have written
> the other(s) writing/reading black women. (151)

Like Felman and Laub, Henderson discusses the difficulty of witness-
ing from inside the experience of oppression. Whereas Laub describes the
way that oppression can destroy the inner voice or inner witness neces-
sary for subjectivity and therefore necessary for any kind of witnessing,
and Felman discusses the paradoxes of the extreme oppression that ren-
der the inside speechless, Henderson describes a dialogic dialectical rela-
tion of inside to outside which problematizes witnessing in a different

way. As she describes it, black women experience two conflicting voices, inner and outer, which confound their sense of themselves as agents. In terms of my earlier analysis, we could say that the socially constrictive subject position of black women produces an othered subjectivity whose agency is on trial.

Henderson uses the example of Zora Neale Hurston's character Janie from *Their Eyes Were Watching God* to show how the position from which black women witness requires that they speak in tongues, that they "speak at once to a diverse audience about [their] experience in a racist and sexist society where to be black and female is to be, so to speak, 'on trial'" (Henderson 148). Henderson argues that Janie's courtroom discourse in the trial scene at the end of the novel "emblematizes the way in which the categories of public and private break down in black women's discourse" (149). She says that in this scene "testimonial discourse takes on an expanded meaning, referring to juridical, public, and dominant discourse as well as familial, private, and nondominant discourse. Testimonial, in this sense, derives its meaning from both 'testimony' as an official discursive mode and 'testifying' ... in which the speaker gives verbal witness to the efficacy, truth, and power of some experience" (149).

Henderson's analysis suggests that black women's testimony is always on trial; their testimony brings public juridical standards to bear on private familial or domestic experiences. Her point is that black women survive by learning to speak in tongues, to speak differently to different groups. In addition to speaking in tongues, when black women's discourse is continually put on trial, it forces black women into the paradoxical situation of both insisting on their legitimacy and the truth of their experience while at the same time doubting that their experience is legitimate or real. Certainly one reason why the public and private cannot be separated neatly in the lives of black women is because of the ways in which public policy and juridical institutions affect and discipline their everyday private lives. Speaking in tongues may be as much a matter of negotiating different aspects of social, political, and cultural life in which inner and outer are always intertwined.

Like Felman and Laub, Henderson points to an aspect of testifying or witnessing that takes us beyond the juridical notion of testimony or eyewitness. It is this aspect of witnessing beyond recognition that, in a sense, reconnects inner and outer voice, or private and public discourse, even as it problematizes that distinction. Although they employ the distinction between inner and outer in different ways and in different contexts, Felman's, Laub's, and Henderson's insistence on the split between the

two raises some of the same questions: How can we translate from inner to outer in order to witness to our experience? In the case of the Holocaust, how is any witnessing possible if either the inner voice is destroyed or it is impossible to witness from the inside? How does the inside become outside? In the case of Henderson's analysis of black women's experience, how can what she calls the secret language of inner experience ever be articulated? Isn't the very notion of speaking in tongues associated with an inarticulate other who cannot testify to her own experience?

Analyses by Felman, Laub, and Henderson suggest that witnessing to extreme experiences of oppression, subordination, and objectification leave the victim/survivor in a paradoxical relation to witnessing. Witnessing to one's own oppression is as paradoxical as it is necessary. The heart of the paradox is that oppression and subordination are experiences that attempt to objectify the subject and mutilate or annihilate subjectivity— that is to say, one's sense of oneself, especially one's sense of oneself as an agent. Rendered an object, the victim of oppression and subordination is also rendered speechless. Objects do not talk. Objects do not act. Objects are not subjects or agents of their own lives. So, witnessing to the ways in which one was or is rendered an object is paradoxical in that objects cannot testify. While the act of witnessing itself is a testimony to one's subjectivity, the narrative of oppression tells the story of one's objectification and silence. How can we speak the silence of objectification?

This paradox takes us back to Derrida's use of J. L. Austin's distinction between the performative and the constative. In the case of witnessing to your own oppression, the performative is in special tension with the constative element of speech. The performance is one of a human subject in a dialogic relation with another human subject while the constative element—what is said—tells the tale of dehumanization and objectification. The content of testimonies of oppression reinscribe the survivor as victim and object even while the act of testifying restores subjectivity to the experience of objectification.

It is the paradoxical nature of witnessing to oppression that makes it so powerful in restoring subjectivity and agency to an experience that shamefully lacks any such agency. The act of witnessing itself can help restore self-respect and a sense of oneself as an agent or a self even while it necessarily recalls the trauma of objectification. Witnessing enables the subject to reconstitute the experience of objectification in ways that allow her to reinsert subjectivity into a situation designed to destroy it. Even so, the paradoxical nature of witnessing to one's own oppression makes it difficult and painful to testify.

Although witnessing to torture or enslavement may be necessary for working through the trauma and avoiding merely repeating it in forms of the repetition compulsion, witnessing to one's own oppression and degradation also recalls the trauma of that experience. Along with the pain of remembering physical abuse and torture, there is a special pain involved in recalling the ways in which one was made into an object. Most victims of torture and abuse feel ashamed to tell their stories. Holocaust survivors, rape survivors, and survivors of slavery all report shame in the experience and shame in witnessing to it. What is the source of this feeling of shame? Why would a victim feel ashamed of a wrong committed by the victimizer?

I propose that the feeling of shame is caused by being made into an object. Even in a situation where one has no choice, where one is not strong enough to resist, the experience of becoming a mere object for another produces feelings of shame. Along with the memories of physical pain and torture, witnessing recalls memories of being an object, of losing one's sense of self as agent, of losing one's subjectivity and ultimately one's humanity. The shame involved in experiencing and testifying to one's own oppression is the result of being something not human, an object for another. The experience of testifying to one's oppression repeats that objectification even while it restores subjectivity. Therefore, insofar as on the constative level witnessing makes one an object over again, the act of witnessing can also produce shame. In addition to the more obvious reasons why it is painful for victims of violence and degradation to testify to their experiences, there is also the paradox of subjectivity inherent in witnessing to one's own oppression.

In sum, it is impossible to witness to becoming an object, since objects have nothing to say. Becoming an object means becoming inarticulate. Only by testifying, by witnessing to objectification, can survivors reinscribe their subjectivity into situations that mutilated it to the point of annihilation. Another aspect of the paradox of witnessing to one's own oppression is expressed by Henderson as the way in which testimonies of those oppressed (by sexism and racism) are always "on trial." If testimonies of oppression are presented from within the oppressive culture, then the dominant culture judges those testimonies; their credibility is always at issue. As Henderson argues, testimony of personal experience is put "on trial" in a way that renders all testimony juridical as well as personal. She says that the testimony of black women in a sexist and racist culture is always "on trial," always put to a test, always suspect. This will

be true of the testimony of any form of oppression, subordination, or objectification so long as the culture within which one speaks continues its oppressive practices.

When testimony is put on trial and personal experience is judged as credible or not by public institutions, then the speaker is in the paradoxical position of justifying her status as subject. Once again, the performance of speaking proves subjectivity even while the social context calls it into question. This kind of questioning and the continual call to legitimate oneself as a self, to legitimate one's right or ability to speak, makes witnessing to one's own oppression even more painful and problematic. The right or ability to speak is accorded to those who have been accepted as legitimate subjects. To speak from the position of othered or oppressed flies in the face of a culture that silences people by making them "the other" and reducing them to inarticulate objects.

Perhaps Felman's, Laub's, and Henderson's analysis of testimony can provide a point of departure for theorizing othered subjectivity. Moreover, by taking the othered as a point of departure, perhaps we can begin to establish and reestablish the conditions of addressability and response-ability that make subjectivity and human experience possible in moving toward an ethics of history. Addressability and response-ability are the conditions for subjectivity. The subject is the result of a response to an address from another and the possibility of addressing itself to another. Oppression, domination, and torture undermine subjectivity by compromising or destroying the response-ability necessary for subjectivity. Witnessing can restore subjectivity by restoring response-ability. Restoring response-ability is an ethical responsibility to our founding possibility as subjects.

This notion of subjectivity begins to go beyond the categories of subject and object, self and other, which work within scenarios of dominance and subordination. Like Derridian undecidables—pharmakon, hymen, supplement, and so on—the notion of witnessing with its double sense opens up the possibility of thinking beyond binaries—subject-object, psychoanalysis-history, constative-performative. The relation between historically determined subject positions and infinitely response-able subjectivity insists that we reconceive of history, objectivity, and the constative in relation to subjectivity, psychoanalysis, and the performative. The double meaning of witnessing, as both eyewitness testimony based on first-hand knowledge and testimony to something beyond recognition that cannot be seen, is at the center of subjectivity, which is maintained in

the tension between these two meanings. The oppositional pull between the force of historical facts and the force of historical (psychoanalytic) truth both positions the subject in history and necessitates the infinite responsibility of subjectivity. Subjective agency is produced between knowledge and truth. The double meaning of witnessing can be exploited as the productive tension at the center of subjectivity, the tension between historically determined subject positions and infinitely response-able subjectivity. Insofar as this productive tension between forces opens up the possibility of subjectivity itself, it should not be conceived as a rigid binary.

Witnessing works through—both operationally and in the psychoanalytic sense of working-through—the forces whose oppositional pull work together to make subjectivity possible and ultimately ethical. Subjectivity is held together by the tension between forces of finite history and infinite responsibility. The paradoxical forces of witnessing are not the forces of oppression and domination that pull subjectivity apart and undermine agency. On the contrary, the paradoxical forces of history and analysis, of historically determined subject positions and infinitely responsible subjectivity, of the constative and performative, provide the productive tension that moves us beyond the melancholic choice between dead historical facts or traumatic repetition. The paradoxical forces of witnessing maintain subjectivity through their equilibrium, which is never static and only precariously stable.

By taking othered subjectivity as a point of departure, we can reestablish the conditions of addressability and response-ability that make subjectivity possible and ethical. Witnessing and responding, testifying and listening, transform our reality, the realness of our experiences. As Laub suggests, experiences are constituted and reconstituted in the process of witnessing. Reality and experience are themselves processes continually transformed through witnessing. In fact, both individual and social change are possible through the transformative power of witnessing, the power to (re)inscribe humanity and subjective agency into both social and psychic life.

What the process of witnessing adds to a set of historical facts is a commitment to the truth of subjectivity as addressability and response-ability. Witnessing is addressed to another and to a community; and witnessing—in both senses, as addressing and responding, testifying and listening—is a commitment to embrace the responsibility of constituting communities, the responsibility inherent in subjectivity itself. In this

sense, witnessing always bears witness to the necessity of the process of witnessing and to the impossibility of the eyewitness. An ethics of history requires vigilance in witnessing to that which cannot be seen, in witnessing to the process of witnessing itself.

Notes

1. For a more developed argument see my *Witnessing: Beyond Recognition* (University of Minnesota Press, forthcoming).
2. LaCapra also argues that extreme theories of performative free play can lead to narcissistic obliteration of the other as other and the tendency to act-out one's own obsessions (1994, 34). LaCapra diagnoses Lacan's insistence on the impossibility of overcoming the repetition compulsion, or what Lacan calls repetition automation, as acting-out. Lacan himself often describes his performance as one of acting-out the unconscious. LaCapra diagnoses these types of extreme theories as acting-out as denials of the possibility of the other as other.
3. In "Psyche: Invention of the Other," Derrida says that "deconstruction loses nothing from admitting that it is impossible ... for a deconstructive operation *possibility* would rather be the danger, the danger of becoming an available set of rule-governed procedures, methods, accessible approaches" (*Acts of Literature* 1992, 327–28).
4. Cf. Derrida: "Performativity is necessary but not sufficient.... The deconstruction I am invoking only invents or affirms, lets the other come insofar as, while a performative, it is not only performative but also continues to unsettle the conditions of the performative and of whatever distinguished it comfortably from the constative. This writing is liable to the other, opened to and by the other, to the work of the other; it is writing working at not letting itself be enclosed or dominated by that economy of the same in its totality" (Derrida 1992, 342–43).
5. Thanks to Krzysztof Ziarek for suggesting this connection to me.
6. For associations between Heidegger, Levinas, and Kierkegaard on the blink and the wink, see John Llewellyn's *Emmanuel Levinas: The Genealogy of Ethics* (New York: Routledge, 1995).
7. Eva Kittay, "Welfare, Dependency, and a Public Ethic of Care," *Social Justice*, 25:1, Issue 71 (Spring 1998): 131.

Texts Cited

Bibring, Edward. "The Conception of the Repetition Compulsion." *Psychoanalytic Quarterly*, vol. 12 (1943): 486–519.

Derrida, Jacques. "Psyche: Invention of the Other." In *Acts of Literature*, edited by D. Attridge. New York: Routledge, 1992.

———. *Archive Fever*. Trans. Eric Prenowitz. Chicago: University of Chicago Press, 1996.

Felman, Shoshana, with Dori Laub. *Testimony: Crises of Witnessing in Literature, Psychoanalysis, and History*. New York: Routledge, 1992.

Freud, Sigmund. "Remembering, Repeating and Working-Through," *Standard Edition of the Complete Works of Sigmund Freud*. Vol. 12 (1914).

Heidegger, Martin. *Being and Time*. Trans. J. Macquarrie and E. Robinson. New York: Harper, 1962.

Henderson, Mae Gwendolyn. "Speaking in Tongues: Dialogics Dialectics, and the Black Woman Writer's Literary Tradition." In Butler and Scott, ed. *Feminists Theorize the Political*. New York: Routledge, 1992.

LaCapra, Dominick. *History and Criticism*. Ithaca: Cornell University Press, 1985.

———. *Representing the Holocaust: History, Theory, Trauma*. Ithaca: Cornell University Press, 1994.

Laplanche, J., and J.-B. Pontalis. *The Language of Psychoanalysis*. Trans. D. Nicholson-Smith. New York: Norton, 1973.

Laub, Dori. "Bearing Witness or the Vicissitudes of Listening," and "An Event Without a Witness: Truth, Testimony and Survival." In Felman, ed., *Testimony*. New York: Routledge, 1992.

Levinas, Emmanuel. "God and Philosophy." In *Complete Philosophical Papers*. Trans. and ed. Alphonso Lingis. Boston: Nijoff, 1987.

———. *Otherwise Than Being*. Trans. Alphonso Lingis. Boston: Nijoff, 1991.

Mohanty, Chandra Talpade. "Feminist Encounters: Locating the Politics of Experience." In *Copyright*. 1987.

Scott, Joan. "Experience." In *Feminists Theorize the Political*. Ed. Butler and Scott. New York: Routledge, 1992.

THE ETHOS OF HISTORY

Krzysztof Ziarek

The fundamental character of historicity does not depend on the fact
that the human being has a history; rather, all history depends on the
originary temporality and historicity of the human being.
—*Hans-Georg Gadamer, "Geschichtlichkeit"*[1]

One way to approach the relation between history and ethics would be to
see ethics as a response to the past and its influence on the "reality"
around us, a response to a world where actions and events rarely, if at all,
seem to be motivated by ethical conduct and are driven, instead, by eco-
nomic, social, and political forces. There is plenty of evidence that this is
indeed the case, as the current interest and need to reassess the question
of ethics and history seems to be motivated by two primary historical fac-
tors: on the one hand, the atrocities and catastrophes of our century—the
two world wars, the Holocaust, the war in Bosnia, the famine in Ethiopia,
the genocide in Rwanda, and so on—and, on the other, the unprecedented
interrogation of the cultural and political meaning of differences in race,
gender, ethnicity, or class. In many of those cases, ethics intersects and
meshes with politics, looking to history for various lessons that would pre-
vent the recurrence of the unethical, say in politics, the economy, or gen-
der relations, and perhaps allow for a different, more "ethical," future. To
the extent that history is seen in these debates as discursively mediated, as
a product of representational construction, language and representation
play prominent, if not decisive, roles in thinking the relation between
ethics and history. In such approaches, though, ethics is a priori cast into
a form of response to a world that is *given*—albeit historically and cultur-
ally, thus, also as transient and discursively formed—produced as a result
of other, non-ethical forces. In this context, ethics's role comes to be
defined in terms of providing guidelines for how to intervene into such an

essentially *non-ethical* world, how to counter, change, and rectify what is unethical in it. Ethics comes "after the fact," as it were, in the aftermath of a non-, and, thus, often un-ethical, historical reality. Is the relation between history and ethics therefore an "arbitrary" one, in the specific sense that ethics functions as a human insertion of codes and rules for proper and moral behavior into a flux of ethically indifferent situations and events? The question could be phrased differently: Is there anything ethical at all about history itself, about the historical unfolding of experience, or does history simply *occur*, indifferent or non-ethical, and ethics serves as a way of making this occurrence non-indifferent? Perhaps history, the past, becomes ethical only by way of the present's *relation* to it, when the past gets "used" to help us articulate, or cover, the problems of the present.

It is not at all clear what makes it possible to think about history in ethical terms, beyond the explanation which points to the ethical claims that the injustices and barbarism of history place repeatedly upon the present. But this idea does not help explain what makes it possible to relate to the past in the first place or to see what no longer exists as an ethical claim on the present. Do we have first an ethically neutral relation to history, a non-ethical inheriting of the past, so to speak, and only then raise the question of the ethical significance of the past and of our obligations to and because of this past? Or is ethics one of the parameters of how we relate to history, and our own "time" in it, to begin with? Is there something in our historical mode of being that renders our relation to history ethical? What interests me, in other words, is the point of entry of ethics into history, the site or moment within the interstices of historical happening that makes ethics possible in the first place. What, if anything, within the very phenomenon of experience *as* historical accounts for the rise of ethics? This is not a question about the historical-cultural origin of ethical thinking but an inquiry into the possibility of thinking jointly about history and ethics. The problem that I want to explore here is whether history—specifically, historical occurring itself, not just particular historical incidents or situations—can be seen not as "mere being," ethically indifferent, but in terms of opening or inaugurating the possibility of ethics as such. This entails reconsidering also the ways in which we have to (re)think both history and ethics to be able to develop such an ethical relation between them.

In "Letter on 'Humanism,'" Heidegger explains that the modern Western idea of ethics comes from the Greek notion of *ēthos*, which "means an abode, a dwelling place,"[2] and has to do with the horizons or

parameters of how humans inhabit the world. In its modern articulations, ethics functions as morality and refers to a set, or often competing sets, of rules and norms that regulate behavior in terms of prescribed and prohibited practices. More recently, in the wake of Levinas's philosophy and poststructuralist critiques, ethics has become primarily a matter of responsibility to "the other" or of an acknowledgment of difference, which exceeds and calls into question the idea of a rule-governed morality: the other's irreducible difference "bends" the rules, so to speak, as it disquiets the *idea* of the other, which lies at the origin of moral norms. The asymmetry in the relation to the radical other produces a certain curvature of the social space, a disequilibrium that keeps calling into question the symmetrical and reciprocal articulations of obligations and rights. A Levinasian answer to the question about the relation of ethics and history, at least on the basis of his early writings, and *Totality and Infinity* in particular, would be to say that the ethical call remains an-archic, literally, "without origin," coming as though from beyond history and the world. Manifested in/as the face of the other, ethics marks an always insufficient and "failed" relation to the other which has already curved the space of human interaction. Ethics "precedes" and disquiets the non-ethical history, which the beginning of *Totality and Infinity*, in a Hobbesian gesture, describes as war: "War does not only affect [philosophical thought] as the most patent fact, but as the very patency, or the truth, of the real."[3]

In *Otherwise Than Being or Beyond Essence*, ethics as obligation to the other has its locus in sensibility,[4] in the other's continuous evasion of my sensible and intellective "grasp" of her presence. What makes the other other remains "absent" from her presence and from my representation of it. This rupture within the world and experience marked by the other is the point of the entry of ethics, which inaugurates the very possibility of ethical relations and yet can never be "fully" translated into moral norms or satisfied by my actions. What is ethical about this moment of rupture is precisely the incommensurability of the action/attitude in relation to the demand, a disparity that keeps calling into question any sense of complacency about one's "moral character." In Levinas's approach, ethics comes from within history but signifies its "beyond," an "eschatological" call that, almost a priori, exceeds and interrogates all the (historical) possibilities of comportment toward the other: "It is reflected *within* the totality and history, *within* experience. The eschatological, as the 'beyond' of history, draws beings out of the jurisdiction of history and the future" (TI 23); and "The absolutely other, whose alterity is overcome in the philosophy of immanence on the allegedly common plane of history, maintains

his transcendence in the midst of history" (TI 40). History remains always already insufficient in relation to ethics, out of step with the ethical call to responsibility, because there is never enough time, as it were, to satisfy the other's "inexhaustible" demand. This incommensurability does not diminish but becomes intensified by the ethical response we can offer. It is this paradoxical asymmetry that renders the "essentially" non-ethical or indifferent historical time into ethical obligation beyond norms and duties. To put it briefly, ethics "inflects" history and keeps calling into question its tendency toward the violence of "sameness," toward, we might say, the same old (hi)story.[5] With its focus on exclusively human other, Levinas's ethics, even though it undoes the idea of self and turns inside out the concept of the subject, remains "anthropomorphic." More important for our considerations here, it posits the relation between history and ethics as antinomical, or, at least, as asymmetrical. History itself cannot account for ethics; even though we encounter the other historically, within time, the ethical demand exceeds time and remains a-temporal or an-archic.

Levinas's radical revision of ethics in *Totality and Infinity* explicitly relies on the notions of history and experience as a totality, as a movement of time that falls under the synoptic and totalizing vision of consciousness. History is a totalization of presence, the movement of the identification of the same with itself—it becomes a system: "The same is essentially identification with the diverse, or history, or system" (TI 40). Levinas's ethics is aimed against the Hegelian understanding of history as a movement of progressive sublation of experience and difference into a complete knowledge, which reflects the self-sameness of consciousness. This is why what makes ethics possible for Levinas is the rupture or the overflowing of history by the other: "The idea of being overflowing history makes possible *existents* both involved in being and personal, called upon to answer at their trial and consequently adult" (TI 23). The idea of excess or overflow can be taken to signify radical difference from history, an un- or ahistorical signification in the midst of historical occurrences, a mark of otherness that cannot be signified or described in terms of presence or differences that become present *in* and re-presentable *as* history. Otherness, in order to signify ethically and call the subject to response and responsibility, has to signify "otherwise than history." This ahistorical mode of signification is not a negation of history or an opening of a suprahistorical dimension of being but a sort of a glitch or a rupture in the unfolding of history, which halts and calls into question history's ability to read and understand itself by becoming present to itself as knowledge, by

producing itself as a historical account. The non-presence which the other marks in the midst of history signifies precisely by its incommensurability with historical presence, and it is this rupture that introduces into the ethically indifferent historical flux the dimension of responsibility.

Responsibility in Levinas hinges on the other's evasion of her (historical) presence, which suggests that ethics enters history when the other foils the grasping power of representation. It is this disjunction between the others' presentation in history and their way of overflowing their own presence—and, thus, inflecting history as the space of re-presentation—that renders others ethically non-indifferent. In this approach, history and experience appear unethical because they become a totality as a result of understanding being in terms of presence: each moment, every "now," is an atom or instance of presence, and the entire spectrum of history becomes conceptualized chronologically as a sequence of past, present, and future presences. These re-presentable presences leave no space for alterity: representable differences remain ethically spurious, because they relinquish their alterity to consciousness, which grasps them as a history of differences. Such history drains itself of ethical significance, of the possibility of ethical relation. One could argue that Levinas needs this notion of history as a totalizable unfolding of presence in order to mark the ethical relation that happens "otherwise than presence." Levinasian ethics requires history to happen as an unfolding of difference into the sameness of consciousness and understanding, because it is predicated on the rupture of the uniformity, of the sameness, of historical time.

On the other hand, it is possible to see in this rupture or overflowing an outline of a different structure of temporality, an ethical temporality of what Levinas describes as a certain non-synchrony, in which the alterity of the other signifies as a dissonance within representation: alterity remains unplaceable in time, in any instant of presence, whether past, present, or future. This disjunctive temporality of ethics calls into question the idea of history as a linear unfolding of events and marks an asymmetry between the ethical significance of the relation to the other and the "historical" meaning of being. Levinas himself does not develop a revised understanding of history conceived from the rupture between ethics and historical time and prefers to "signify" alterity precisely by way of this incommensurability. In this perspective, ethics becomes "the first philosophy," and the philosophies of being, experience, and history are all "secondary." History gains ethical significance specifically from the moments in which it is ruptured by the "unhistorizable" face of the other.

The historical sense of being (as presence), although first or primary in the empirical sense, remains secondary in relation to ethics: it is always already "subject" to ethical dislocation or inflection.

With the Levinasian disjunction between ethics and history in mind, I want to ask whether the notion of history against which Levinas elaborates his ethics gives a sufficient account of the dynamic of historical occurrence, whether it does not still rely on a certain metaphysical (mis)reading of temporality in terms of presence. Levinas is justified in his suspicion of the spurious otherness at work in totalizing, "self-conscious" conceptions of history. He convincingly diagnoses and critiques the "unethical" character of such a history, which, as his famous metaphor of consciousness as Ulysses returning to Ithaca suggests, continuously reenacts the sublation of otherness into the totalizing movement of knowledge. If history continues to be thought of in terms of a repetitive movement of presence, and the only differences marked within such history are those of the different forms of self-identical presence, then ethics indeed should be thought of as a rupture of history.

My interest lies, however, in fleshing out an alternative approach to history, which would rethink historical occurrence in terms of, and in relation to, the non-synchronic temporality that Levinas associates with the ethical relation to the other. In other words, I am interested in trying to see if it is possible that history gains ethical significance not from "beyond" but from "within," on the basis of a re-thought understanding of temporality. Instead of thinking of ethics as a rupture of time that occurs *within* but comes from *beyond* history, can one see temporality itself as making possible openness toward the other? Time blocks or erases alterity when it renders the other present, available to consciousness in representation. It is when occurrence is conceptualized in terms of presence that allows for no remainder, that is, when history is thought of as, in principle, making itself fully present in each instant of the "now," that time becomes equivalent to a repetition of sameness, to a war (against otherness). Such conception of time requires an intervention from beyond to make room for an other that cannot be repeated and assimilated. But to the extent that temporality can be rethought as undermining the idea of time (and history) as presence, the other might come not from "beyond" time but from within the disjoining temporality of history. As an opening toward/by radical alterity, ethics would be a matter not of rupturing time, that is, of a certain atemporality, but, instead, of a different temporality. The possibility of ethics, taken here in the strict sense of an initial

openness to the other, which makes possible ethical relation as such, might lie in temporality itself, in the "timing" of historical occurrence.

To rethink the relation between ethics and history along the lines outlined above, I will consider Heidegger's redefinition of *ēthos* and history. Like Levinas, Heidegger's thought after "Letter on 'Humanism'" can be seen as aiming at understanding what makes ethical relationality of being possible. I explored the differences and confluences between Heidegger and Levinas elsewhere,[6] and here I just want to note how both of them, although in different ways, try to rethink the force of an ethical claim apart from, and prior to, any ethical system, any reflection on moral principles, maxims, or norms. Levinas associates the force of the ethical claim that calls the subject to action with the rupture of a certain idea of history. Also critiquing the post-Hegelian, totalizing concepts of history, Heidegger, on the other hand, refashions the Greek notion of *ēthos* in a way that, as I hope to show, allows one to tie the initial claim that opens the possibility of ethical relations to the originating or freeing force of historical occurrence itself.

Heidegger's thought never offers or intends to develop an ethics, and it should not be approached with an expectation that it will provide an alternative or a new ethics. The importance of Heidegger's critique of metaphysics in relation to ethics lies elsewhere, specifically in his novel approach to how ethics both *originates* from within the historical unfolding of a world and *participates* in that unfolding. In the well-known discussion from "Letter on 'Humanism,'" Heidegger reinterprets ethics in light of his reading of *ēthos* in Heraclitus as an abode or a dwelling place (LH 256). Heidegger's rethinking of *ēthos* distances it from the idea of an ethics that originates *within* a world, or, as is the case in Levinas, in an ethical injunction that comes, as it were, from "beyond" the world. *Ēthos* is not a matter of a moral practice within a given historical and cultural world but constitutes the very praxis of unfolding or articulating that very world. Rather than coming after the "fact" of historical reality or responding to its violence against alterity, *ēthos* describes the "constitution" of such a reality. *Ēthos* refers to the everyday unfolding of the open-ended context of relations—of a world—and signifies a decision that opens up the space for, and thus "precedes," articulations of existence in terms of ethical codes and norms. This is why Heidegger cautiously refers to it as "originary ethics," an abode or a dwelling, which inaugurates ethics as such. "If the name 'ethics,' in keeping with the basic meaning of the word *ēthos*, should now say that ethics ponders the abode of the

human being, then that thinking which thinks the truth of being as the primordial element of the human being, as one who ek-sists, is in itself originary ethics" (LH 271). The idea that this way of thinking *ēthos* is "originary" does not mean that Heraclitean *ēthos* is historically the first or original ethics, which gave rise to further ethical reflection and new theories. Instead, the word "originary" refers specifically to the originating role that the thinking of *ēthos* plays in how the world unfolds in the first place. *Ēthos* is not an ethical system that suggests or prescribes ways of acting but constitutes an activity of opening up a human dwelling place within the world in a manner which in *Inflected Language* I called "ethic." Conceived this way, *ēthos* does not constitute an ethics, a separate domain of philosophical and moral reflection on the norms of conduct, differentiated from the conceptualizations of other spheres of being, for example, ontology or epistemology. This is why Heidegger writes that what he calls "original ethics" is, first of all, ontology—because it has to do with being—only to say on the next page that the thinking of *ēthos* is "neither ethics nor ontology" (LH 271).

Obviously, Heidegger's remark does not mean that there is nothing ethical or ontological about *ēthos* but, rather, that *ēthos* cannot be thought of in terms or in the language of either ethics or ontology, that is, that it cannot be explained in the language of essences and presence, or expressed in the discourse of norms and prescriptions. The reason for this incommensurability is that *ēthos* names the site of the possibility of ontology and ethics, which exceeds the scope of ethical and ontological conceptuality. I would suggest that we think of *ēthos* as the spatio-temporal play of relations, a historically unfolding and shifting context of links and bearings, which both make space for and establish the initial modality of relations among what is. We could write it this way: there is ethics as there is *ēthos*. The connection is not causal but indicates the way in which the possibility of ethical relation comes to be inaugurated by way of an *ēthos*, a relationality which places or situates human existence within a world. This world is never simply pre-given or immediate but comes to be constituted through such an ethic placing. This is why *ēthos* can be called *originary* in a temporal sense, that is, as having always already originated or opened anew, in each moment, the complex of relations which we call "world."

This sense of "originary" (*ursprünglich*) has to be carefully distinguished from the notion of origin and the original. The adjective "original" refers, in historical terms, to a past moment, object, or situation that

has been lost and that needs to be repeated and regained. Originary, on the other hand, refers not to the past but to the "present," that is, to the temporality of becoming present, which instantiates each present in terms of how it opens future (as) possibilities. The word "originary" designates the temporality of how the familiar structures of everyday being—and the various practices and orders of conceptualizing them in ordinary language, scientific rationality, or philosophical reflection—have in each moment unfolded out of the factical-historical situation of human existence. This always already-carried-out temporal "leap" (*sprung* in *Ursprung*, origin) into these structures, the disjoining slip implied in the phrase "always already," calls into question the routine practices of all that is familiar. "Original" has to do with regaining and preserving, with tradition understood as conservation and repetition, or, in other words, with foundational thinking. By contrast, "originary" refers to finite temporality which obviates the need for foundations, whether logical-scientific or existential, and shows how such a desire for origin(s) covers over and dissimulates what "constitutes" the human mode of being, or *Dasein,* namely, finitude. In other words, the term "originary" implies a critique of the idea of the original, as it calls into question origins and foundationalism, together with the concept of linear, chronological time, on which they are based. It also queries the idea of the past as an object of historiographic retrieval, as a history that can be repeated, revised, and possessed in the form of variously produced historical knowledges, which purportedly allow one to (re)gain access to the "original" meaning of past moments. "Originary" temporality brings up the past neither as knowledge nor in terms of chronological time but as what factically and historically situates the present's "leap" into the future, into the opening of futural possibilities.

To the extent that it is originary, *ēthos* needs to be thought of as futural or transformative: its temporal and historical valency is transformative, which means that *ēthos* is to be understood in terms of the possibility of enacting or deciding, always anew, as it were, world-relations in an ethic way. This valency of "originariness" and "transformation" associated with the *ēthos* constitutes perhaps the most difficult and complex moment of the thinking which "Letter on 'Humanism'" makes possible. I will return to it later, in the context of the implications that this sense of *ēthos* can have for understanding history, especially for thinking how the past becomes factically "present" in opening future possibilities. What needs to be noted at this moment is that this idea of *ēthos* re-situates and, in a

general and originary way, calls into question any system of ethics—not to evaluate or critique moral norms but, rather, to lay bare the "world boundaries," that is, the relatedness or the horizon of relations from and within which an ethics can arise. *Ēthos* concerns the form of relations that obtain as the historical occurrence of being and dispose the space where various forms of knowledge and praxis, including ethics, operate. It is a step back and beyond a particular ethics to what silently underwrites any ethics and, giving it force, continues to re-situate ethical reflection, keeping it historically in question. We could say that *ēthos*, beyond any answers which a particular context affords, keeps re-opening the world as an ethic question, that is, a question which is to be decided or carried out.[7] It thus gives force to any singular event, a force that opens it beyond the strictures of an ethics one might choose to follow, and lays bare those strictures. This moment, bringing the past with it, charges the event with a future; that is, the event occurs not as a given, "closed" instant but as a possibility, a space of difference and transformation, whose contours are not set but brought into view and situated, each time anew, as an act of existence.

This rethinking of the ethical problematic does not aim at producing critiques of specific ethical systems but, instead, looks at what makes it possible that there is an ethics in the first place. Heidegger borrows the word *ēthos* from Heraclitus in order to investigate what is often taken for granted by ethical thought itself, namely, that there is ethics at all. Heidegger's answer is interesting because it circumvents traditional ways of articulating the ethical problematic. It makes recourse neither to the idea of an intrinsically ethical human nature nor to rationality. It also sidelines the idea of the divine law introduced from beyond history. In other words, for Heidegger ethics does not arise from the presupposed goodness of the human nature or as a result of social contract, which produces a rational solution to the original Hobbesian state of war and primary egoism. The impetus for ethics does not come from beyond history but from the *ēthos*, from an ethic manner of dwelling in the world. An ethic manner of dwelling does not translate immediately into a specific ethics, it is not ethics in the sense of a code of behavior, but it does carry a sense of responsibility, a responsibility in the face of being, so to speak. This does not mean responsibility in the face of the "nothingness" or anonymity that is often mistakenly ascribed to Heidegger's rethinking of being but, as I would argue, a responsibility that originates specifically from the finite temporality of existence. The link between *ēthos*, temporality, and history may not be explicit in "Letter on 'Humanism'" but its possibility is certainly there as long as one does not forget that Heidegger

has already reframed the question of being in relation to *Dasein*, whose ontological meaning, as *Being and Time* argues, is temporality.[8] *Ēthos*, I would suggest, has to do with such an unfolding of being in which the human modality of being, *Dasein*, or "being-there," would be accessible in its etho-ontological meaning of temporality, that is, as the argument of "Letter on 'Humanism'" runs, in a manner more originary than any humanism can afford us. But since *Dasein* is in the manner of being-in-the-world, what becomes accessible as the "there" (Da) of *Dasein* is always constituted in terms of a world. In this context, *ēthos* must be thought of *historically*, as the unfolding of a nexus of relations that make up a world instituted in relation to and with a place for humans. When we push the notion of *ēthos* even further, we realize that it concerns not simply a web of relations but, rather, the very mode of relating that brings about a world and obtains within that world. The shape into which the world is formed historically depends precisely on the modality, or modalities, of relating, since these modalities never simply *operate* within the world but *take part* in the "activity" of unfolding this world in the first place. Differently put, these modalities of relating are "responsible" for how the world occurs, and the question of *ēthos* and ethic responsibility as I am presenting it here has to do with the valency of such relating.

To rethink *ēthos* in terms of a mode of relating, two issues need to be considered, difference and temporality, which both influence the structure and the modality of relation. As I will show later, it is in terms of a certain understanding of difference in its relation to temporality that the notion of *ēthos* becomes relevant for considering history. But to see this relevance, we have first to clarify what might be called the "ethic" modality of difference. It is important to make here this distinction between "ethic" and "ethical," in order to avoid misunderstanding the relations I am trying to elaborate as ethical in the strict or narrow sense of this term, that is, as having to do with moral conduct. Rather, the idea of "ethic difference" refers to such a relation (of difference) that would allow what is other to be encountered in its alterity, that is, to a relation that clears the very space in which otherness can signify at all, and, in this sense, makes ethics possible. In other words, an ethic difference is not any modality of difference but one in which the alterity of the other exceeds the specific form of difference through which it appears or signifies. It is such a relation in which the other's alterity in fact inflects the very parameters of difference, representation, or calculation, unmasking their "unethical" appropriation of otherness. In a way, the ethic difference is "more" than difference, in the sense that it remains beyond the purview

of how we experience or represent difference. In everyday life, one encounters difference constantly, in the guise of more or less familiar persons, objects, or occurrences, and these relations themselves assume the form of differences between the ordinary and the extraordinary, between the familiar and the strange, and so on. There are various representational, psychological, or scientific ways of accommodating, signifying, or even calculating such differences, but in the end, it could be argued that these differences would not be possible or thinkable *as differences* without the ethic modality of difference, that is, without the originary—always opened anew, toward a future—form of relating, in which the other is encountered in its alterity.

This ethic relating lets the other be in such a manner that the other claims and affects what relates to it with the full force of its alterity. As Levinas would say, the other's claim (of alterity) overrides or inflects the claims that representation, signification, or consciousness lay to grasping and knowing the other. It is within these openings, in which the other's alterity determines the "tone" or the shape of the relation, that encountering difference becomes possible in the first place: The ethic difference makes room for differences. What I call here the ethic modality of relation should be understood in a sort of minimal fashion as a mark of opening to the other, which any relation bears, even when it forgets it and, in the end, appropriates the other. The ethic mode of relation is originary, that is, in every moment it has already originated, laid open, the possibility of difference and relation. This "originary ethics," without ever becoming present, makes relation possible by virtue of breaking open a direction toward what is other. It singularly indexes each moment and any relation, without being encompassed or re-presented by it. As an index of openness to the other without which no relation would take place, this "originary ethics" both makes possible and defamiliarizes the ways in which differences become present, as well as the forms which representing such differences can take. The ethic import of this mode of relating lies specifically in the way it enables the alterity of the other to register itself above what becomes represented or signified of it. The ethic mode of relating "originates" each relation as a question, that is, open beyond its relata or inflected into the unfamiliar.

In *Being and Time*, Heidegger remarks that *Dasein* is "authentic" (*eigentlich*) only in the mode of *Unheimlichkeit*, that is, uncanniness or, better, "unhomeness." *Dasein* occurs authentically when it is called, by its own mode of being, out of the impersonal familiarity of its daily identifications, which Heidegger calls the "they-self": "It is Dasein in its uncan-

niness [unhomeness]: originary thrown being-in-the-world as 'not-at-home,' the naked 'that' in the nothingness of the world."[9] The use of *Un-zuhause* (not-at-home) makes clear that the semantic weight in Heidegger's notion of *Unheimlichkeit* falls on being "un-homed," which describes the modality in which *Dasein* is "its self" or "authentic." *Dasein* is "authentic" in an originary exposition to alterity, which means that it is its-self *as* unhomed toward what is other, divested of stable or substantive identities offered in its culture. When *Dasein* experiences itself as "at home" in its everyday being, it has forgotten the otherness, the "un-homing" at work in its own temporal mode of being, and has covered over its originary openness to alterity. The abode (*ēthos*) is, therefore, never cozy or homey; it is not a "home" in the usual sense but refers to a dwelling conceived as a form of originary attentiveness to otherness. The abode is ethic only when it is *unheimlich*, that is, when it unfolds in each moment as an originary opening/relating to the other. Thought of in this way, the abode becomes linked to the temporality of being and history. The originary opening to the other constitutes a temporal event in which the abode or the *ēthos* is not presupposed but, instead, brought about and co-constituted by this relation to the other: *ēthos* is brought into play as a matter of deciding. To put it differently, the shape or the form which being-in-the-world takes depends on the modality of relating to the other, on whether one does not forget that the familiarity of everyday being—with its "routine" forms of experience, understanding, and representation—takes place each moment within an originary "unhomeness." The disjunction between this *Unheimlichkeit* and the forms of relation and representation that grasp otherness infuses history with ethic significance. And it is only when the originary ethic force of this disjunction is obscured by proliferating differences, by the various ways in which these differences become schematized and articulated, that the temporality of historical occurrence becomes emptied of its ethic significance. As a result, history seems to take place as neutral, as preexisting any ethical consideration.

Heidegger's term for this ethic mode of relation is *Seinlassen* or letting-be. The term appears already in *Being and Time*[10] and its importance is later reflected in Heidegger's reinterpretation of the notion of *Gelassenheit* as releasement. It is a difficult and frequently misunderstood term, and I will not engage in a detailed explication of it here. My sense is that "letting-be" needs to be read as indicating a specifically ethic disposition of relations. Letting-be is an originary mode of relation in the specific sense that it lets what is other come forth as other, to claim relation with the "force" of its alterity. It is a mode of relating that carries out

difference as difference, that is, it allows alterity to mark its radical or unrepresentable difference—it lets the other be and affect one as other. It is only within this ethic space (of letting-be) that the other can signify as other, even underneath the mask of everyday familiarity. This ethic space has the force of a claim; it calls us to keep re-opening it as an ethic space. If the ethic mode of relation fails to be actuated, then the other's alterity is always compromised; it is not given its due or its "space" as alterity. Without this ethic openness, difference could not be carried out as difference but would totally submit to the power of representation and cease to be "other" the moment it became represented as difference. Letting-be constitutes difference as an encounter with the other in which alterity remains "beyond" representation, beyond what becomes signified of the other.

I would like to connect this manner of letting alterity be with Heidegger's notion of being *seiender* or "more in being." A relation in which someone or something occurs as *seiender*, or as *more in being*, is ethic because in this relation the other's alterity is encountered not simply as different but as the force of a claim. If to be more in being is to be "more" as what one is, then the ethic mode of relating can be explained as meeting the other in a way that lets the other be "more" other, without ever being able to register the "full" scope of such alterity, because alterity qua alterity has no scope to begin with. To let the other's alterity claim us with more force means to render our familiar comportments within the world *unheimlich*, to "un-home" them, in other words. This "letting-be" is neither passive nor quietistic; it requires one's participation in bringing about a specific mode of encountering the other; it requires an openness. In the recently published *Besinnung*, written in 1938–1939, Heidegger makes clear that letting-be is neither indifference nor not doing anything, but a carrying out of a change in how relating occurs.[11] This change (*Verwandlung*) is neither passively received nor actively produced but is, instead, brought about in the mode of the middle voice, in which *Dasein* is "active-passive." Such openness is not produced by a willful act of a subject, because willing, rather than laying the subject open to the other, takes charge, dominates the relation, and reinscribes it within the movement of self-consciousness. To use Levinas's language, the will has to be denuded, undercut in its power each time anew by letting the other be "more in being" as the other. On the other hand, letting-be cannot be conceived as passive because releasing alterity from the grasp of representation and allowing it to affect our relation to the other requires enhancing the

other's claim to being other. The words *let* and *allow* have here the reso-
nance of the middle voice, working otherwise than activity and passivity.[12]

What makes this idea of *Unheimlichkeit* most pertinent to the topic of
history and ethics is that letting-be has to be understood in terms of tem-
porality and history. Being is temporal, and if letting-be means a change in
being that allows the other to be more in being (as the other) then the
phrase "more in being" (*seiender*) indicates that temporality works as a
force of the originary openness to alterity. To let something be more in
being translates into a relation that enhances the temporality of occur-
rence: not only the temporality of the other's being but also the temporal
unfolding of the relation to the other. In other words, the claim associated
with otherness is tied here to temporality, to the historicity of occurring, as
it comes from within history rather than from its "beyond." History, how-
ever, needs to be understood here differently from my initial formulation
of the idea of history as a totalizable sequence of presences, against which
Levinas elaborates his notion of ethics as a rupture of presence and a be-
yond of history. If history signifies a totalizable succession of the instants
of "now," then the idea of history that Heidegger develops finds itself
beyond such a history; it is a history that extends beyond itself, beyond its
(hi)story, and functions as a form of a de-totalization of experience.

To clarify this difference in the approach to history, I will refer to the
distinction Heidegger repeatedly makes between *Historie* and *Geschichte*,
between history taken as historiography and the historial occurrence of
being. The German term *Historie* indeed means history in the sense of
historiography, but, more important, it relies on a certain way of concep-
tualizing historical occurrence that allows one to see what happens as an
unfolding story and to grasp it as a history. For Heidegger, history cannot
be reduced to *Historie*, that is, it cannot be grasped merely in terms of
historical processes, differences, and changes, or conceived as an object of
historiography. Rather, it has to be thought of in reference to the tem-
porality of being understood as a happening (*Geschehen*): history takes
place as *Geschichte*, as occurrence, and it matters primarily in terms of
the meaning that historicity has for the human mode of being (*Dasein*),
and only secondarily as *Historie*, or as an object of historical research.
As Charles Bambach remarks, the nineteenth-century historicism to
whose collapse Heidegger was reacting, "was synonymous, in Heidegger's
view, with the logic of linear narrative and diachronic succession which
authorized the humanistic reading of the past from the position of a tran-
scendental subject: the self-conscious, autonomous *cogito* of Cartesian

metaphysics."[13] One could show that, in conceiving history as a con-
tinuing—even though not necessarily continuous—line made up of the
instances of historical presence, the idea of *Historie* relies on the notion of
being as presence and creates the illusion of "a causally demonstrable
continuum of historical effects."[14] In this approach, history depends on
the idea of presence, and the discontinuities and ruptures that are them-
selves part of historical genealogies do not necessarily undermine this
principle. The structure of historical occurrence in historicism is that of
becoming present: all that transpires becomes present and remains re-
presentable because the space of history is constituted as homogeneous in
relation to presence. Even though in actuality things may get covered up
or events become too layered and differentiated to allow for an immediate
and full grasp, still, this conception of history operates in principle on the
assumption that historical being can become "fully" present and available.
Obviously, within specific historical contexts, such full presence tran-
spires rarely, if ever; it is often multiply differentiated, sometimes discon-
tinuous. What is, however, in question here are not particular historical
differences, geographical and cultural variables, or the specificity of his-
torical location, but the very modality of occurrence that decides what
history is and how it happens, affecting the ways in which particular
differences become historically produced.

Unlike *Historie*, the notion of *Geschichte* conceptualizes history in
terms of a historiality (*Geschichtlichkeit*) which is no longer structured by
the metaphysical ideas of presence and linear time. Heidegger's rethink-
ing of history comes as a reaction to the bankruptcy of the historicist idea
of the progressive narrative of European culture, but his response to this
totalizing narrative does not seek a counter-narrative or propose a "non-
narrative" of rupture, fragmentation, and discontinuity, which would
establish new ways of historicizing the past. In other words, Heidegger
does not replace the old historicism with a new one; rather, he begins by
revising the very ideas of temporality and historicity on which any notion
of history rests. In historicism, historicity is considered in terms of pres-
ence—as an index of a specific historical location or as the particularity of
a determined moment in history. Such a moment becomes graspable by
virtue of its relation to presence, that is, as an instant that, in its determi-
nate temporal location, was fully present and accessible, and it is the par-
ticular features of this moment, its unique historical characteristics, that
constitute its historicity. Heidegger's thought can be seen as a critique of
this notion of historicity, which, as he explains, derives from a common
concept of time and its (mis)reading of temporality in terms of presence.

For Heidegger, such approach to temporality understands historical experience in terms of isolatable instants, narrowing it to a sequence of "nows," which history organizes and interprets, establishing causal and linear—or, more recently, discontinuous and ruptured—relations between them. This particular narrowing and foreclosure of historical occurrence to the idea of presence relies on and obscures a more complex historiality (*Geschichtlichkeit*) of experience, which instantiates each moment not only as coming from what has been but as futural, that is, open to and oriented toward a future. *Being and Time* makes a distinction between *Historizität* and *Geschichtlichkeit*, between historicity in the historicist sense and Heidegger's redefinition of historicity, which, for the sake of clarity, I have been rendering here as historiality.[15]

In *Being and Time*, historiality is defined as the being-composition (*Seinverfassung*) of the very occurring of *Dasein*: "Geschichtlichkeit meint die Seinverfassung des 'Geschehens' des Daseins als solchen" (BT 20). Linking *Geschichte* (history) with the verb *Geschehen* (to happen or to occur), Heidegger indicates that *Dasein* (the human mode of being) occurs as "historizing" (as *Geschehen*).[16] That is, *Dasein* does not find itself "in history"; rather, its very occurrence "historizes," happens historially or opens itself as history. To recall the epigraph from Gadamer, "The fundamental character of historicity does not depend on the fact that the human being has a history; rather, all history depends on the originary temporality and historicity of human being." It is because humans *are* historially that they experience the world not as a static environment but as "world-history" (*Welt-Geschichte*).[17] In other words, historiality denotes a temporal mode of being, a modality of occurring, through which humans find themselves or "dwell" in the world that is historical. The key, though, is that such history is not accessible as "empty, homogeneous time," to recall Benjamin, or as a temporal succession of causally determinable historical effects, but becomes open through the de-presencing and transformative force of historiality. History is a historial occurrence which exceeds the idea of historical progression and the notion of successive events happening within an empty space-time. Such history cannot be equated with the past or conceptualized as the present's continuous recession into the past but must be thought of in terms of historiality, which carries historical and factical happening of each situation beyond the confines of a punctual "now," thus opening it onto its always already "present" futural possibilities. As such, historiality exposes the limits which the metaphysical concepts of linearity, progression, and totality, as well as the notions of scientific objectivity and epistemological certainty, place on experience.

If historicity operates according to the logic of presence, historiality has to be thought of as an event, or, in Heidegger's terms, as an *Ereignis*. *Ereignis* does not designate a specific historical event but refers to the event-character of the unfolding of what is. It refers to a manner of happening which, bringing the past with it, occurs as futural, that is, transpires by way of opening the future as possibilities: it opens the present as the space-moment of decision. This notion of "propriative event"[18] is to be differentiated from punctual presence, from the idea of the "now," because event names a way of occurring that instantiates each present as both already extended beyond itself into the future and carrying with it the past. To be more precise, the event reconceptualizes happening (*Geschehen*) in a non-metaphysical manner, in other words, beyond the metaphysical idea of presence and its opposite, absence, and in terms of a temporality of being that both makes room for and exceeds what becomes present. Heidegger often explains the event in terms of the German phrase *es gibt*: "there is" or, literally, "it gives." What is idiomatic to this structure is the empty, self-canceling grammatical subject *es*, which denotes the non-existence of origin, an empty placeholder, always already retreating or giving space to what (be)comes. The event works as a self-effacement which "gives" (*gibt*) or lets be, and it is this structural erasure that makes the event occur "outside," as it were, the play of presence and absence. Heidegger's revision of *Geschichtlichkeit* (historiality) is bound to this notion of event (*Ereignis*), whose occurrence is, one might risk saying, non-metaphysical, because it cannot be explained in terms of the logic of presence. Historiality is, therefore, not the question of the past and of *Historie* but of the modality of happening, of *Geschehen* and *Geschichte*. Any relationships to the past and understanding of the past as a history find their "condition of possibility" in the historiality of being.

As this non-metaphysical modality of occurrence, historiality arises out of an ecstatic temporality particular to *Dasein*. For Heidegger, the linear conception of time which underlies the science of history derives from and obscures the ecstatic temporality of human existence. In the linear concept of time, each instant is thought of as a separable and determinable point in a line of historical development. Heidegger, on the other hand, suggests that time unfolds as an always momentary complex of the three ecstasies of time: the has been (*Gewesenheit* or the "past"), the making present, and the coming-toward (*Zu-kunft* or the future). Heidegger provides a detailed explanation of the rise of the common concept of time out of the ecstatic temporality of *Dasein*, which is too long and complex to present here.[19] What matters for our discussion is that ecstatic tempo-

rality provides a critique of the concepts of time and history grounded in the idea of presence and its corollary notion of existence as situated "in time" and "in history." Heidegger's revision of temporality conceives of existence *as* time and as the unfolding of history; such existence is never simply *inside* history but actively constitutes the contours of historical happening. As the name indicates, ecstatic temporality is the originary mode of being outside itself, of being open to otherness: "Temporality is the originary 'outside-of-itself' [*Ausser-sich*] in and for itself" (BT 377/ 329 modified). Temporality means being always extended outside itself, beyond what becomes present. *Dasein* occurs as concerned with the "outside-of-itself," and this concern or care, as Heidegger refers to it, takes the form, especially in his later writings, of letting-be. In other words, the possibility of letting what is other be as what it is in its alterity is linked with the temporal occurrence of *Dasein* as an originary "outside-of-itself." What makes *Dasein Dasein*, or what constitutes the human mode of being, is this originary extending or openness toward otherness.

Heidegger argues that there is history (*Geschichte*) and the science of history (*Historie*) because *Dasein* occurs in the mode of historiality. *Dasein*'s historiality has its roots in ecstatic temporality, which temporalizes not as honed and limited to a "now" but as temporally extended, as futural. *Dasein* occurs as a sort of a temporal "extension" of what becomes present from what has been and into a future. Historiality names, then, a modality of occurring which is—in an *originary* way, that is, *always anew*—open toward otherness. It describes a mode of occurring that lets be and is, thus, ethic in the sense that I have explained above. In other words, the ethic sense of history comes from historiality, from the fact that, conceived as historial, occurrence is always "beyond" itself, open toward what remains other. Historiality opens history to otherness, as it were, from within. It is this originary opening of historiality that makes the experience of historical, cultural, and other differences possible. As Heidegger indicates, determining historicity in the historicist sense—as a specificity of a particular location in history—becomes possible on the basis of historiality: "But the discipline of history (*Historie*)—more precisely, the historicity (*Historizität*) underlying it—is possible only as a kind of being belonging to inquiring *Dasein*, because *Dasein* is determined by historiality (*Geschichtlichkeit*) in the ground of its being."[20]

In Heidegger's notion of *Geschichtlichkeit* (historiality), occurring itself (*Geschehen*) becomes linked to otherness: it works as an originary release of otherness into being. Historial mode of occurrence has an ethic dimension, which frees the possibility of relation to the other and, releasing the claim

of alterity, keeps inflecting the factual reality into its ethic significance. No longer signifying either presence or essence, being marks a temporalizing occurrence which actualizes itself by way of relation to what is (other). In a way, letting be works "otherwise than being" (i.e., presence) and "beyond essence." It fleshes out history in relation to non-presence and to a non-synchronic temporality. Such a modality of occurrence is a question of letting what is other be "more in being" as other. What has to be under-scored here is that the notion of *seiender* or "more in being" has a futural dimension and carries in it a force of transformation. It is originary in the specific sense that by letting be more in being, it "transforms" or brings about the world as *ēthos*. Historiality describes, then, the transformative force of being: by way of retrieving or carrying the past with it, historiality casts the present in terms of breaking open the future.

In Heidegger, historical thinking is not so much about the ideal of securing an objective and historically accurate access to the past and, as a result, gaining an understanding of history, as it is about the future. Heidegger redefines understanding (*Verstehen*) apart from the idea of the faculty of the mind and separates it from methods or procedures of obtaining knowledge. For him, understanding constitutes the movement of being, which keeps opening itself to the future through the relation between the past and the "contemporary" historical and cultural context. The past is therefore not a matter of re-membering, of piecing together or reconstructing past situations with historical exactness, but of retriev-ing it "existentially," that is, as a kind of (self)interpretive acting, which, always already, extends the present's paths into the future. History (*Geschichte*) is, then, primarily futural, and historiality describes the futural matrix of being which orients itself in terms of possibilities: "History is not a piecing together of the three different time dimensions but takes place on the occurrence-basis of the coming. The coming originates from the event as the occurring of being."[21] This temporal-izing matrix works as a disjoining structure, in which historical being becomes organized into a sheaf of possibilities. Any "rethinking" of the historical past is conditioned by such a historiality of being, which "releases" within the closures of a historical present the force of the possible. As Heidegger suggests, if we keep human existence in view of its historiality (*Geschichtlichkeit*), history as a discipline (*Historie*) should, "before" chronicling and revising the past or preserving the tradi-tion, disclose "the silent force of the possible" (*die stille Kraft des Möglichen*).[22] Heidegger repeatedly asserts in *Being and Time* that it is the idea of tradition as repetition and conservation that blinds human

being to its historiality: it keeps *Dasein* riveted to history as a story (*Historie*) or cultural heritage, and forgetful of *Geschichte* as primarily futural and transformative in its force of the possible. The idea of history as disclosing the silent force of the possible indicates that transformation is not "external" to historical happening, not merely one of the possibilities that may become historically available, but is intrinsic to the very dynamic of occurring. Hence notions of identity and subjectivity, which allow us to produce ethical claims and ascribe agency to acts, necessarily cover over the future transformative character of historiality. In a way, ethical codes are predicated on such a covering. The ethic force of historiality, then, keeps us mindful of the foreclosures of futurity intrinsic to the notions of identity and agency. It uncovers the blind spot of moralities, their unavoidable "un-ethic" moment. Paradoxically, to produce an ethics (of history), one has to foreclose the force of historiality. This transformative force is not equivalent to historical changes, which may turn out to be "for better or for worse," ethical or unethical in their outcome. Rather, it shows how occurrence in its historial dimension is accompanied or marked by a transformative force that keeps re-opening the possibility of an ethic relationality of being.

Reframing the question of history in terms of *Geschichtlichkeit* or historiality makes it possible to foreground that side of Levinas's thinking, especially in *Otherwise Than Being or Beyond Essence*, which suggests that radical otherness does not come from "beyond" history, in the form of a quasi-divine command, but remains "originary" within history as the disjunctive temporality of touch, sensibility, flesh. This negotiation between Levinas and Heidegger also opens the door to broadening the scope of ethics beyond human interaction, to indicate that an ethic openness to all that is underpins our being in the world. It might seem that such a mediation between Levinasian ethics and Heidegger's *ēthos* compromises the priority which Levinas gives to the human other.[23] Yet this is not necessarily the case. One need only to remember the priority that *Dasein* has in Heidegger's thought. But it is a priority that comes from *Dasein*'s "unique" relatedness to the finitude of being and its historial unfolding. What distinguishes the other human being from other humans and from other forms of being is how it is marked by finitude, by an always singular relatedness to how it itself happens. As Jean-Luc Nancy would say, its infinity lies in the singular "infiniteness" of its finite being. This "infiniteness" can be shared in the sense that what we have "in common" is the finitude, which, however, remains singular to each human being: "I experience the other's alterity, or I experience alterity in the other

together with the alteration that 'in me' sets my singularity outside me and infinitely delimits it."[24]

This common "infiniteness" can be shared only in a way that always already differentiates and singularizes, that makes relation among humans possible and "exceeds" this relation by virtue of its inescapably singular finitude. And unless we retain the "theistic" dimension, which is undeniably important to Levinas's texts,[25] we have no other way of "thinking" the other's "infinity." For Levinas, as John Llewellyn remarks, "moments of history are not all moments of narratable history,"[26] and the question remains how one reads these instances of the breakdown of historical narratives. One way to understand these "moments of history outside history"[27] is transhistorical, which means that they instantiate a transcendence, inflecting the otherness of other human beings with the absolute otherness (of a God). But these moments outside history can also be seen as historical "otherwise," as instances when history unfolds in a way that ruptures and overflows what one usually means by "history," signaling a temporality of the sensible encounter that remains non-synchronous with sensibility, representation, or knowledge, and, in this dissymmetry, obligates ethically. In this second reading, the force of ethical obligation comes from a certain disruption, or a mark of absence, in the linear-chronological concept of history: It is a history outside or even against history. I have tried to show that such a history beyond history can be thought of in terms of historiality, historiality that remains ethic in its force of exposing and opening to otherness. Historiality gives us a way of thinking of ethics, as relation to human others *and* to other, non-human, modes of being, from within history. No matter how expert we are in covering it over in everyday dealings, historiality "un-homes" our being. It makes history a matter of *ēthos*, that is, of an opening to the alterity in being, which is ethic in its historical mode of occurrence.

This rethinking of historicity allows us to see a link between *ēthos* and history, a connection that works on the level of occurring itself. We could say that the world unfolds in the manner of *ēthos* when what is occurs (or is let be) in its historiality, in its originary temporal openness beyond itself. Historiality in itself does not obviously guarantee an ethical stance toward history or determine what form such an ethical position might take. But this was not my purpose here, as I tried to demonstrate a way of thinking about history that would allow us to see an originary connection between history and ethics, one that would make it possible to see an ethic claim as originating *within* and even *as* history itself. The rethinking of temporality and history in connection with the idea of *ēthos* provides us

with the means to understand the historiality as instantiating an ethic mode of relation. *Ēthos* has to do with reconceptualizing the transformative and ethic force of history through the distinction between *Historie* and *Geschichte*, or between a historicist approach to history as a changing set of social and cultural circumstances and the notion of history as event. The idea of history as event regards history not as an objective continuum of historical effects but in terms of a temporal matrix of happening, which opens up being as futural. The event marks a remainder over what becomes present *in* and *as* experience, signaling the difference between historiality and its articulations into the historical and cultural circumstances. The accent is switched from historicity as an index of the specificity of past situations or events to historiality as a way of relating to history in terms of the futural matrix of happening. The incompleteness of experience is here "first" historial and "then" historical, that is, bound to the social complex of historically specific contexts, differences, and cultural formations. This is to say that without historiality, which "structures" our being, we would not be able to think historically or approach the past with a view to the historicity specific to its formations. The analysis of such historical formations, however, needs to be taken one step further, recast with a view to finding traces of historiality and its distinctive historical articulations and examining their impact (or its absence) within specific historical locations.

It is important to note, though, that historiality does not designate a permanent or a transcendental structure of being but remains bound to its historical unfolding. In other words, how and in what ways history happens and becomes accessible as futural, that is, in terms of *Geschichtlichkeit* or historiality of happening, is dependent on the historical and cultural conditions, on the historicity of the moment. Historiality always opens the "present" historical context beyond the horizons of understanding available in it, dislocating it toward the future, but whether or how the force of this dislocation inflects historical experience depends on the openness of the discourses and modes of understanding to the moment's historial matrix. Historiality operates as a quasicondition of the "exposure" to alterity, as the *Unheimlichkeit* that inaugurates the very possibility of otherness, as well as openness to historical and cultural differences that obtain within and govern specific historical contexts. Even though it remains inseparable from the "historical moment," historiality "un-homes" the historical representability accessible to and within a specific historical location. It functions in terms of an *ēthos*, that is, as the originary *ethic* vectors of (possible) relations to the other, within

which ethics becomes possible. Futural and transformative, these vectors map out and inflect the space of history as representation, re-situating articulations of historical particularities and differences—and the debates about their ethical and political significations—within an *ēthos*. In other words, I see the question of the other(s) and of the ethical demands of history not only as arising from our changed historical understanding of the past but also as opened up in their very possibility by the historiality of the event. The idea of *ēthos* lies, then, at the "root" of the possibility of ethical revisions of history, but it also questions the assumptions about history, experience, and identity at work in historical discourses. My title "The Ethos of History" suggests *ēthos* as the locus of rethinking the relation between history and ethics, as a site where the very idea of historiality acquires an ethic significance.

Notes

1. Hans-Georg Gadamer, "Geschichtlichkeit," *Religion in Geschichte und Gesellschaft* 3 (Tübingen: Mohr, 1959): 1496–1498; quoted from Charles R. Bambach, *Heidegger, Dilthey, and the Crisis of Historicism* (Ithaca: Cornell University Press, 1995), 17.
2. Martin Heidegger, "Letter on 'Humanism,'" trans. Frank A. Capuzzi, in *Pathmarks*, ed. William McNeill (Cambridge: Cambridge University Press, 1998), 271. Hereafter, LH.
3. Emmanuel Levinas, *Totality and Infinity*, trans. Alphonso Lingis (Pittsburgh: Duquesne University Press, 1969), 21. Hereafter, TI.
4. Emmanuel Levinas, *Otherwise Than Being or Beyond Essence*, trans. Alphonso Lingis (The Hague: Martinus Nijhoff, 1981), especially chapter III, "Sensibility and Proximity," 61–97.
5. For a more detailed discussion of the notion of "inflection," see my introduction to *Inflected Language: Toward a Hermeneutics of Nearness. Heidegger, Levinas, Stevens, Celan* (Albany: SUNY Press, 1994).
6. The proximities and divergences between Levinas and Heidegger structure much of my argument in *Inflected Language*. The chapter on Levinas explores aspects of his thinking in their relation/tension with Heidegger's thought. Also my reading of Celan's poetry is informed by such proximities and differences and serves as a way of recasting the Heidegger-Levinas debate. Because of the scope and focus of the present essay, it is not my intention to engage Levinas's complex critique of Heidegger, its excellent insights and radical formulation of ethics as well as its misreadings of Heidegger's thought, in particular, Heidegger's understanding of history. It is also not the place to deal with the ethical doubts or political debates that surround Heidegger's work in view of his support in the 1930s of National Socialism. In the present essay, I am interested in how Heidegger's work

opens a unique perspective on the relation between history and ethics, and it is this specific insight built on a radical rethinking of *Geschichte* and *ēthos* that I pursue here.

7. Heidegger's term for denoting this deciding and carrying out is *austragen*: a word that implies differentation and an active drawing out of differences that constitutes the *ēthos* of dwelling.

8. Die ursprüngliche Einheit der Sorgestruktur liegt in der Zeitlichkeit"; Martin Heidegger, *Sein und Zeit* (Tübingen: Max Niemeyer Verlag, 1986), 327. "The originary unity of the structure of care lies in temporality"; *Being and Time*, trans. Joan Stambaugh (Albany: SUNY Press, 1996), 301. Hereafter BT. I have changed the translation of *ursprünglich* from "primordial" to "originary," which reflects much better the futural-temporal dynamic of care.

9. *Being and Time*, 255, slightly modified. The original reads: "Er ist das Dasein in seiner Unheimlichkeit, das ursprüngliche geworfene In-der-Welt-sein als Unzuhause, das nackte 'Das' im Nichts der Welt"; *Sein und Zeit*, 276–277.

10. "Bewendenlassen bedeutet ontisch: innerhalb eines faktischen Besorgens ein Zuhandenes so und so *sein* lassen, *wie* es nunmehr ist und *damit* es so ist" / "Ontically, to let something be relevant means to let something at hand *be* in such and such a way in factical taking care of things, to let them be *as* they are and *in order that* they be such" (*Sein und Zeit* 84/ *Being and Time* 79). Letting-be is tied in *Being and Time* to *Bewendenlassen* (letting be relevant) and *Begegnenlassen* (letting be encountered), and refers to a modality of engaging/encountering what is in a way that allows it to be as and what it is, i.e., in its singular otherness. As Stambaugh remarks, in "On the Essence of Truth," "letting-be is related in principle and very broadly to *every* kind of being" (see the asterisk footnote on page 79).

11. Martin Heidegger, *Besinnung*, *Gesamtausgabe*, vol. 66 (Frankfurt am Main: Vittorio Klostermann, 1997), 103.

12. There is no direct or qualitative link between this enhancement of relation to alterity and ethical action, but it may be possible to say that the more in being the other is as other in the encounter, the stronger the ethical claim that such an encounter places on us. But what is the ethical claim in this context? Is it not tantamount here to a call to encounter the other even more as "other," a call that only keeps intensifying itself the more "ethically" one encounters the other? A call that calls on us to let the other be more in being only to question the sufficiency of this relation and urge us to intensify it, to let the other's alterity have even more "ethic" force and inflect the relation even further. Are we then not close to Levinas's idea from *Totality and Infinity* that the desire for the other keeps feeding on itself, that it is insatiable, that the ethical lies in the desire/demand to be "more" ethical and to let the other be more as other? As Levinas writes: "Beside the hunger one satisfies, the thirst one quenches, and the senses one allays, metaphysics desires the other beyond satisfaction.... A desire without satisfaction which, precisely *understands* [*entend*] the remoteness, the alterity, and the exteriority of the other," *Totality and Infinity*, 34.

13. Bambach, *Heidegger, Dilthey, and the Crisis of Historicism*, 3. For Heidegger, the collapse of the historicist narrative of progress and values indicated "the

bankruptcy of a whole metaphysical epoch constructed on the universal-rational principles of historicist metaphysics and anthropology" (3).

14. Bambach, 9.
15. Macquarrie and Robinson translate *Geschichtlichkeit* as historicality and *Historizität* as historicity (*Being and Time* [New York: Harper and Row, 1962], 41). Stambaugh's translation is reverse: *Historizität* is rendered as historicality, while *Geschichtlichkeit* becomes historicity. While the first translation captures the relation between historicity and historicism, Stambaugh follows the current way of translating and explaining *Geschichtlichkeit* as historicity. The problem is that the widely known use of historicity in historicism, cultural studies, and certain readings of Foucault follows the path of historical thinking which Heidegger complicates and critiques through his notion of *Geschichtlichkeit*. This is why I opt to use the term "historiality" to show the difference of Heidegger's notion from historicity and historicality as they are used in debates about history. This translation reflects the close association Heidegger makes between history (*Geschichte*) with the verb *geschehen*, to happen or occur, which Macquarrie and Robinson justly render as "to historize." This coined verb makes clear the distinction from the currently fashionable term "to historicize": while "to historicize" almost always means to pay attention and clarify the specificity of historical location, Heidegger's "to historize" refers to a mode of happening, which problematizes the understanding of being as presence or becoming present. In other words, the verb "historize" reflects the impact of Heidegger's rethinking of temporality on how we understand history and historical occurrence.
16. See Macquarrie and Robinson's translation, p. 41.
17. See *Sein und Zeit*, 388–89.
18. This is Krell's translation of *Ereignis* in "The Question Concerning Technology."
19. The whole of Division Two of *Being and Time* is devoted to the discussion of temporality; for Heidegger's revision of the idea of temporality see, in particular, sections I, II, and III; section VI discusses the "vulgar" concept of time.
20. *Being and Time*, trans. Stambaugh, 18, modified; *Sein und Zeit*, 20.
21. "Geschichte ist das nicht in der Zusammenstückung des dreifach verschieden 'Zeitlichen,' sondern aus dem Wesengrunde des Kommens. Das Kommen entspringt dem Ereignis als der Wesung des Seyns"; *Die Geschichte des Seyns*, *Gesamtausgabe*, vol. 68 (Frankfurt am Main: Vittorio Klostermann, 1998), 93.
22. *Sein und Zeit*, 394.
23. I am looking here at a specific strand in Heidegger's thought and not claiming that all his *oeuvre* is "ethical." In any case, Heidegger's work is far too extensive, complex, and layered to be described in a single register. If one gives priority to Heidegger's rhetoric of historical mythicization of German destiny in the 1930s or if one approaches the question of ethics through his silence about Auschwitz, these motifs and silences in his thought close down the openings that his revision of *ēthos* provides. On the other hand, the various paths which Heidegger's texts open can be read against one another: *ēthos* and its *Unheimlichkeit* against the idea of *Heimat*, *Volk*, German *Dasein*, etc. My project here is more limited, as it involves fleshing out the transformative and ethic force that animates Heidegger's rethinking of temporality and the new perspective such a reading may provide for reinterpreting the relation between history and ethics.

24. Jean-Luc Nancy, *The Inoperative Community*, trans. Peter Connor (Minneapolis: University of Minnesota Press, 1991), 33–34. Nancy defines communication and sharing in terms of an exposure and sharing of finitude: "Communication consists before all else in this sharing and in this compearance (*com-parution*) of finitude: that is, in the dislocation and in the interpellation that reveal themselves to be constitutive of being-in-common—precisely inasmuch as being-in-common is not a common being" (*The Inoperative Community*, 29).

25. In *Transzendenz und Geschichte*, Michael Mayer shows that Heidegger's idea of history (*Geschichte*) "transcends" the totalizing notion of history which Levinas's ethics contests, and forms a history beyond history. Still, Mayer argues that Levinas's notion of eschatology and the absolute other point beyond this "other" history toward a transhistorical God. Michael Mayer, *Transzendenz und Geschichte: Ein Versuch im Anschluss an Lévinas unde seine Erörterung Heideggers* (Essen: Verlad Die Blaue Eule, 1995); see, in particular, the argument in chapter 3, "Geschichte und das Denken-Gottes," for example, p. 109.

26. John Llewellyn, *Emmanuel Levinas: The Genealogy of Ethics* (London and New York: Routledge, 1995), 209.

27. Llewellyn, 209.

MERLEAU-PONTY'S CHIASM AND
THE ETHICAL CALL OF SITUATED CRITICISM

Lowell Gallagher

Though the philosophical kinship between the two thinkers would seem limited at best, Hannah Arendt and Jean-François Lyotard cross paths in at least one regard. They share an attitude of ambivalence, if not suspicion, toward the thought of Maurice Merleau-Ponty, and their shared targets are the paired concepts that have gained currency as signatures of the latter stages of Merleau-Ponty's existential-phenomenological description of embodied subjectivity: the "chiasm" and the "flesh." I want to use Arendt's and Lyotard's objections to Merleau-Ponty as a point of departure, rather like the grain of sand, or irritant, in an oyster, for constructing a way of thinking about Merleau-Ponty's chiasm as an exemplary figure for the ethical challenges faced by postmodernist critical practice— for the task of writing of and in history without foundations.

"Chiasm" and "flesh," mutually constitutive elements in Merleau-Ponty's ontology of sensible being, carry colloquial, anthropological associations that are not without relevance for Merleau-Ponty's project. "Chiasm" refers to the crossover or intersection of the optic nerves at the base of the brain, producing binocular vision, and "flesh" connotes the sheer physicality of bodies (as in the Greek root *sark*-).[1] Yet in Merleau-Ponty's vocabulary the words convey a more generalized intuition—one that is both more fundamental and more oblique—of relational situatedness and of the latent and mutable conditions of situated visibility. "Flesh" and "chiasm" are Merleau-Ponty's gestures toward the "generality of the Sensible in itself, this anonymity innate to Myself."[2] In this order of generality, categories like "distance" and "proximity" are not contraries but are "deeply consonant," and this consonance forms what Merleau-Ponty calls "the thickness of flesh between the seer and the thing," a thickness that "is constitutive for the thing of its visibility as for

the seer of his corporeity"(*VI* 135). To borrow G. B. Madison's paraphrase, "flesh," together with its chiastic texture, describes "the formative milieu of both the corporeal and the psychic, of object and subject."[3]

What concerns both Arendt and Lyotard, though for different reasons, is Merleau-Ponty's seemingly inadequate attention to the problem of incommensurability. To judge from their respective assessments, which I'll review shortly, this apparent lapse derails Merleau-Ponty's avowed project to move beyond the implicit alliance of idealist and rationalist assumptions undergirding the philosophical cultures of modernity.[4] Merleau-Ponty's reservations toward Cartesian method and Hegelian dialectic—different manifestations of what he called "high-altitude thought" (*la pensée en survol*), the movement of thought unimpeded by contingency or by unincorporable otherness—are a matter of record.[5] Yet the anchorage of his own project in Husserlian phenomenology, despite his significant departures from Edmund Husserl's transcendentalism, has lent a certain stigma to Merleau-Ponty's thought in the philosophical ethos of postmodernity.

Merleau-Ponty's place at the postmodernist table is more than a little reminiscent of the odd uncle's in a Victorian family circle: a figure to be invited, dutifully, but not expected to stay long. Thus Judith Butler's discomfort, for example, at Merleau-Ponty's residual "naturalistic" sexual ideology in his first major work, *Phenomenology of Perception*. For Butler, this trait sabotages his project to redescribe "lived experience" because of its genetic link to an "abstract metaphysical structure devoid of explicit cultural reference."[6] Though Butler's specific concerns are not anticipated by Arendt or Lyotard, the animus guiding Butler's demurral could be taken as a further development of the earlier critiques, found in Arendt's *Life of the Mind* and in Lyotard's *Discours, figure*. In turn—if Arendt may be granted a restricted visa into the ethos of postmodernism—these critiques could be taken as particular instances of postmodernity's characteristic turning away from phenomenologically inflected discourse in general, because of its reliance on "universal axioms of human experience."[7]

Thinking, the first volume of Arendt's *Life of the Mind,* addresses Merleau-Ponty's phenomenology in the course of the introductory survey of the constituents of mental activity. Arendt admires Merleau-Ponty's effort to translate interest in the "organic structure of human existence" into a topic for philosophical inquiry, a "philosophy of the flesh."[8] But the transitivity she detects in his reasoning seems misguided, notably in his use of chiastic figuration. Merleau-Ponty, Arendt argues,

was still misled by the old identification of mind and soul when he defined "the mind as the *other side* of the body" since "there is a body of the mind, and a mind of the body and a chiasm between them" [*VI* 259]. Precisely the lack of such chiasmata or crossings over is the crux of mental phenomena, and Merleau-Ponty himself, in a different context, recognized the lack with great clarity. Thought, he writes, is "'fundamental' because it is not borne by anything, but not fundamental as if with it one reached a foundation upon which one ought to base oneself and stay. As a matter of principle, fundamental thought is bottomless. It is, if you wish, an abyss [*Signs*, 21]." (*LM* 33)

Two heterogeneous figures of crossing are at issue here. In Arendt's view, the "crux" (or "cross," as in pivot or central point to be grasped) of "mental phenomena" cannot be assimilated to Merleau-Ponty's crossing figure, because the latter negates the principle on which the authenticity of thought itself rests (including the "bottomless" or "fundamental" thought to which Merleau-Ponty turned his attention elsewhere, as Arendt points out). For Arendt, thought cannot be considered authentic unless it preserves a space apart, withheld from the "world of appearances"(*LM* 75). Chiastic "crossings over" erode the boundaries maintaining the necessary *heuristic* (if not transcendental) dualisms which enable spaces apart to be imagined and made real: distinctions between inside and outside, and between different aspects of interiority (mind/soul). What is at stake here, in part, is Arendt's concern to safeguard a key element in the argument of *The Life of the Mind*: the claim that thinking, though deeply invested in the world of appearances and directed toward the forum of public discourse, requires "a deliberate *withdrawal* from appearances. It is withdrawal not so much from the world . . . as from the world's being *present* to the senses. Every mental act rests on the mind's faculty of having present to itself what is absent from sense" (*LM* 75–76). Thought's ethical entailments—willing, judging—depend on this withdrawal, because it is precisely this withdrawal which enables a counter-intuitive perception of the real, a perception endowed with both critical and therapeutic force. "Only because of the mind's capacity for making present what is absent," Arendt argues, "can we say 'no more' and constitute a past for ourselves, or say 'not yet' and get ready for a future" (*LM* 76).

Arendt's exclusion of Merleau-Ponty's chiasm from her description of mental activity seems to derive from the suspicion that the chiasm leads to a brand of philosophical monism, a monism that endorses a facile transitivity between the "illusion of pure thought," the belief that "meaning

is everywhere," and the embodiment of this belief in a universalized and totalized socio-political regime.[9] Arendt's own philosophical project was haunted by the problem of accounting for the unprecedented evils associated with Nazism and totalitarian regimes in general. The crux of Arendt's project was how to adjudicate the conflict between two convictions: on the one hand, the conviction that only a belief in the fundamental reality of appearances, as opposed to the idealist and rationalist fetishization of "pure thought," could enable people to recognize and react against evil; and, on the other hand, the conviction that there can be no refuge from collective evil without the "otherness" that thinking (characterized as "withdrawal," without a priori or transcendental justifications) introduces into the world of appearances.

Arendt's own difficulties in navigating between these two convictions illustrate the challenge to "thinking" posed by the advent of totalitarian regimes in the cultures of modernity. How, indeed, is one to "think" through such regimes—to trace their genealogy, establish criteria for judging them, and imagine and then enact mechanisms capable of preventing their recurrence—given the disturbing lesson of totalitarian ideology: that "people take their moral bearings so completely and so docilely from the world that surrounds them that the unthinkable can be transformed into the taken-for-granted almost overnight"?[10] The impasse Arendt faced and sought to resolve resulted in the controversial thesis on the "banality of evil," drawn from her assessment of the Adolf Eichmann case. Eichmann's actions, and, crucially, the pervasive and habitual "thoughtlessness" in which they were grounded, can be taken not only as evidence of the structural danger posed by the absence or refusal of the kind of thought Arendt advocates (thought as deliberate withdrawal), but also as an implicit indictment of the chiastic movement that informs Merleau-Ponty's ontology of the phenomenal world. In Merleau-Ponty's chiastic regime, as Arendt describes it, it would be virtually impossible to judge Eichmann, for there would be no clear mechanism for distinguishing his acts from his motives, or even from the motives of his judges. In Arendt's view, only a commitment to what Merleau-Ponty himself set apart as the "fundamental," abyssal, character of thought, rather than thought's chiastic identification with the world of appearance, can offer leverage against such transitivity or systemic collaboration. The specific contingencies of such thought—the risk of solipsism; the inequities of deliberation in the public sphere; and the danger of "thoughtlessness," into which deliberation can degenerate—are the price Arendt consents to pay for the possibility of human freedom.[11]

Lyotard's critique of Merleau-Ponty's "chiasma" occurs in *Discours, figure,* after he gives witness to his own critical belief system: "I have renounced the folly of unity, the folly of supplying the ultimate cause in a unitary discourse, the fantasy of an origin."[12] He takes Merleau-Ponty's essays on Cézanne, "Cézanne's Doubt" and "Eye and Mind," as prime examples of these lingering follies. Lyotard admires Merleau-Ponty's acumen in showing "that it took Cézanne's enormous immobility to clear away the rationalization of perceptual space and to perceive the primary donation [of the visible world] in its obliqueness, its ubiquity, its lateral transgression of the rules of geometrical optics." Lyotard shares Merleau-Ponty's desire to grasp Cézanne's painterly poetics—the transformation of a visual object into "an event in the visual field." He understands the appeal of Merleau-Ponty's notions of "flesh" and "chiasm" for this enterprise. "There is," he agrees, "a silent infrastructure in the life of the flesh, and it is true, as Merleau-Ponty thought, that it (the *hygieia* of the flesh) is but a chiasma in the milieu of the world, encompassed within it, and encompassing it" (*DF* 314).

But for all its novelties Merleau-Ponty's phenomenology remains "caught up in the problematic of knowledge," and so misses the significance of the "dispossession" and "disturbance" that mark the visible as an "event." "The event cannot be posited elsewhere," he writes, "than in the vacant space opened up by desire," and the question of the event's visibility cannot even be approached by Merleau-Ponty's phenomenology, because the question concerns "the visible of a vision without subject, the object of the eye of no one." What Merleau-Ponty is after, then, is "graspable only through a totally different method—deconstruction—and based on the totally unexpected results of recessus" (*DF* 318–19). Lyotard effectively places a double ban on Merleau-Ponty's thought, by conferring on it the status of an outmoded as well as suspect practice, one that is marked by an inadmissible Cartesianism.

Language supporting Arendt's and Lyotard's assessments of Merleau-Ponty's chiasm can indeed be found in Merleau-Ponty's work. This is so because much of Merleau-Ponty's vocabulary—"flesh" and "chiasm," in particular—is situated between two gravitational pulls: a residual orientation toward what is now usually called the "metaphysics of presence," and an anticipatory gesture toward postmodernist parsings of a nonpresence more "fundamental" than the truths toward which this metaphysical tradition points.[13] Though it escapes Arendt's and Lyotard's attention, the latter feature can be discerned in Merleau-Ponty's richly

allusive vocabulary for the secret choreography of the "flesh," whose composition is structured by a play of intermittent encroachments, through a "cavity," "fold," "hollow" (*creux*), "dehiscence," "hiatus," or "divergence" (*écart*) (*VI* 146–53).[14] In part a phenomenological application of Saussurean linguistics, Merleau-Ponty's descriptions of this movement mark an absenting gesture, through which the seeing and seen body participates in the generality of the "flesh of the world." This same movement informs Merleau-Ponty's idiosyncratic sense of "flesh" itself, which he describes as "segregation, dimensionality, continuation, latency, encroachment," as a "relation of transgression or of overlapping" between seer and seen, and as a chiastic "dehiscence of the seeing into the visible and of the visible into the seeing" (*VI* 248, 153).

One could say that a certain displacement occurs in Arendt's and Lyotard's writing, whereby what should be construed as a latency in Merleau-Ponty's language turns up in their characterizations as a decisive lacuna. Arendt and Lyotard detect in Merleau-Ponty's chiasm the absence of a theoretical equivalent to the particular kinds of represented absence or dispossession they deem crucial—Arendt's concept of thought as withdrawal, Lyotard's "differend." Both read this apparent lacuna as a negative image of what should be visible, but is not, in Merleau-Ponty's discourse. They see the absence of a mark, instead of a mark of absence.

These assessments can be called tactical misreadings, not because they betray Arendt's and Lyotard's deliberate substitutions of their own perspectives for what is actually in Merleau-Ponty's writing, but because their critical "re-markings" of the chiasm effectively participate in the kind of chiastic event Merleau-Ponty describes. This participation is not a corrective gesture—not a filling in of a lacuna—but rather a generative one, in the sense that Arendt and Lyotard enlarge the explicit categorical scope of the chiasm. In different ways, Arendt's and Lyotard's redescriptions make explicit what is otherwise implicit in Merleau-Ponty's language—chiasm's identity as a crossing, and mutual implicating, of generalizable *perceptual* phenomena and particularized *hermeneutic* engagements.

In other words, the chiasm is not "in" Merleau-Ponty's writing, because what Merleau-Ponty describes is not a positivity, not a stable denotative term in possession of a determinate referent. A chiasm (but not *the* chiasm, taken as a strict nomination) subsists in the rhythm of partial convergence and partial deflection between Merleau-Ponty's writing and Arendt's and Lyotard's responsive counter-writing. This chiasm becomes legible only as the inferred trace of a hermeneutic phenomenon. As such,

it could be called the reversible membrane between two noncoincident and nonsymmetrical, yet mutually enabling, gestures through which Merleau-Ponty's writing and his critics' counter-writing are constituted: the perceived absence of marking and diacritical markings of absence.

Reversibility, in fact, is Merleau-Ponty's other, perhaps more accessible, word for chiasm, and specifically for the chiastic dimension of perceptual relations: "he who sees cannot possess the visible unless he is possessed by it, unless he *is of it,* unless, by principle, according to what is required by the articulation of the look with the things, he is one of the visibles, capable, by a singular reversal, of seeing them—he who is one of them" (*VI* 134–35). This "reversibility of the seeing and the visible, of the touching and the touched," is not, however, a mimetic relation. That is, it does not presuppose conditions of reciprocity, equivalence, coincidence, or symmetry between its components, though it may include them (*VI* 147).[15] Reversibility, which Merleau-Ponty derived from Gestalt psychology, addresses what is finally an unrepresentable dynamic or rhythm of emergence and withdrawal in the perceptual field. Reversibility's visual emblem is the ambiguous cube drawing in which the smaller, inner cube appears, alternatively, as a recessed or projected space, depending on the orientation of the viewer (figure I). Here the chiastic event occurs at the switch or crossing of perceptions through which background becomes foreground, the latent or invisible becomes manifest or visible, and vice versa. What does *not* occur at the chiasm is a simultaneous grasp of alternative images, or a sovereign, planar view of the drawing's denotative possibilities. What occurs instead is a visceral experience of perceptual depth as an infolding/unfolding movement through space and time. This experience is the animated structure of the materiality of the visible world, through which the conditions of visibility as such are situated in a network of residual and anticipatory entailments with what is occluded or unthought in the perceptual field. The ambiguous cube drawing thus makes explicit a central feature of Merleau-Ponty's chiastic phenomenology: the intuition of the visible not as what is simply "there" (an object of and for perception), but rather as what compels and sustains attention (a hermeneutic as well as perceptual achievement).

Arendt's and Lyotard's own *inattention* to what is most hospitable to their thought in Merleau-Ponty's writing on the chiasm—his perceptible interest in the "écart" or "dehiscence" that occurs at the point of crossing—calls attention to the implicit questions informing both Merleau-Ponty's writing on the chiasm and their own counter-writing, but which

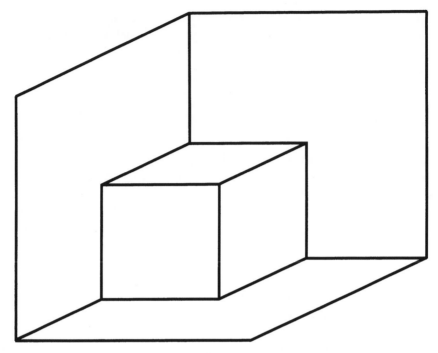

Figure 1. Source: Anthony J. Steinbock, "Merleau-Ponty's Concept of Depth," *Philosophy Today* 31 (Winter 1987): 339.

their critical responses do not specifically engage. How is the distance or distinction between latency and lacuna to be measured, and how is the critical force of what is latent to be gauged? In turn, this shared interrogatory dimension calls attention to the status of the chiasm as a figure of thought prompted less by epistemological concerns than by an ethically oriented attention to the ontology of shared values in a world shaped by language as Merleau-Ponty understood it—a world (or *ethos,* shared place) "where what counts is no longer the manifest meaning of each word and of each image, but the lateral relations, the kinships that are implicated in their transfers and their exchanges" (*VI* 125).

The fundamental unrepresentability of such "transfers" and "exchanges" is the crux—the central problem as well as constitutive trait—of chiastic crossings, in the sense that chiasmus is defined not by the components or sides it brings into patterns of reflection and opposition ("AB: B'A'" and variants), but by the interstitial scene, or event, of lapse and reversal itself (indicated graphically only by the punctuation mark ":").

This does not mean, however, that effects or traces of this crux cannot be discerned. As I've suggested, Arendt's and Lyotard's counter-writings can be seen as attempts to give critical ballast to this crux by marking it in ways that exceed—and, arguably, violate—Merleau-Ponty's own writing. Indeed, for Arendt as for Lyotard, the crux has nothing to do with the chiasm, the philosophical and political ramifications of which appear to them exhausted. Though neither Arendt nor Lyotard shows much interest in situating Merleau-Ponty's sense of the chiasm within a conceptual history of the figure, their grudging admiration for Merleau-Ponty's work suggests a shared disposition to read his thoughts on the subject as a last significant vestige of ontotheological as well as phenomenological thinking—thinking under the canopy of a belief that there exists a vantage point from which nothing is ever definitively lost, or unavailable for scrutiny. Yet, as I've also suggested, their own counter-writings emerge out of an occluded chiastic movement of recursion and supersession vis-à-vis Merleau-Ponty's own writing.

In this sense, their counter-writings participate in an oblique history of chiastic figuration. I describe it as oblique because such a history—of interstitial, chiastic rotations—is by definition not amenable to historiographic conventions of linear development and periodization. The lineaments of this history nonetheless can be outlined by naming the different cultural scenes in which the deployment of chiasmus becomes conspicuous, across the *longue durée* from premodernity to postmodernity. I want to turn now to this history because it will help place the deferred exchange between Merleau-Ponty, Arendt, and Lyotard on the subject of the chiasm in the context of an evolving attention to the problem of what it means to be situated ethically in relation to a past, as well as a future, that cannot speak for itself.

The word first: chiasmus, from the Greek *chiazein*, "to mark with or in the shape of a cross."[16] The word participates in three interrelated histories: the history of a poetic and rhetorical device, a hermeneutic problem, and an existential-phenomenological event. Though not explicitly identified as a rhetorical term until the fourth century C.E., chiasmus is formally related to patterns of "bilateral symmetry" or inverted parallelism and the figure called "hysteron proteron" ("the last first"). In these joined capacities, chiasmus is a pervasive feature of literary production in Hellenic and Latin cultures, from Homeric epic to Augustan poetry, as well as in biblical cultures, where it figures prominently in the Hebrew Bible and New

Testament texts.[17] Classicists and biblical scholars surmise that chiasmus is probably "a Semitic inheritance" in Greek culture, like the alphabet.[18] In any event, the figure commonly functions in all of these locations as a non-linear compositional technique. It can be thought of as a textual trace of embodied memory—as a mnemonic device in the practice of oral transmission, through which long blocks of material are internally linked in patterns of retrieval and elaboration. The figure also seems an early scribal technique for marking beginnings and endings of textual units—a way of "formatting" text before conventions of paragraph division, punctuation, capitalization, spacing, and so forth came into currency.[19]

The rhetorical utility of the figure, however, derives from its particular capacity to organize data concentrically around a central idea or "pivotal theme," which then recurs with incremental modifications.[20] The habit of mind it represents and enacts is not that of dialectical or syllogistic progression, but of a prismatic, nuanced concentration on a problem or topic, viewed from gradually shifting perspectives. This marshaling of emphasis produces, within the material limitations of scribal or textual practice, an effect approaching that of the three-dimensionality proposed by the cube drawing I mentioned earlier.

Chiasmus, in other words, generates effects of *rhetorical depth*, identifying a problem or topic by placing it in relief, against a selected "background" in which it is implicated. Implicitly, then, chiasmus designates an ontology of value by staging the manifestation or emergence of a problem that calls for attention within a specific frame through which assessment or judgment of the problem is to be conducted. In this regard, chiasmus exemplifies the ideological scope of rhetoric in its capacity as the privileged discipline of practical knowledge and communicative possibility (*phronesis*) in Greco-Roman and Judaeo-Christian antiquity: it bridges purely formal, structural principles (concentric parallelism), persuasive intentions (constructions of perspective and logical priority), and hermeneutic engagements (demands for the hearer/reader's exercise of critical and ethical faculties of judgment).[21]

These components of rhetorical depth can be observed in two representative examples of chiastic composition, the first from Homer's *Odyssey,* the second from Exodus. My choices are not exactly arbitrary, but they are instructive, because they suggest the range of concerns that become prominent in subsequent cultural investments in chiastic figuration. The first occurs in the encounter between Odysseus and the shade of his mother, Anticleia, in the underworld.[22] Anticleia's voice, echo-like, responds to each of her son's questions in reverse order.

Odysseus asks:

 (a) How she had died,
 (b) Was it by a disease,
 (c) Or by the gentle shafts of Artemis.
 (d) About his father,
 (e) About his son,
 (f) Whether another had assumed his royal power,
 (g) And about his wife, where does she stay.

The shade of his mother replies:

 (g') She stays in thy halls,
 (f') No man has taken thy honor,
 (e') Telemachus is a peaceful lord,
 (d') Your father remains in the fields,
 (c') Artemis did not slay me,
 (b') Nor did a disease,
(a') But I died of grief for thee.[23]

 The second example, from the eleventh and twelfth chapters of Exodus, concerns the events of Passover night:

 (a) The command to despoil Egypt (11:1–3)
 (b) The tenth plague announced (11:4–9)
 (c) Moses leaving Pharaoh in anger (11:10)
 (d) The Passover ritual described (12:1–6)
 (e) Blood on the doorposts (12:7–8)
 (f) The roasted lamb (12:9–10)
 (g) Girded loins, etc., blood on the doorposts (12:11–13)
 (f') The unleavened bread (12:14–20)
 (e') Blood on the doorposts (12:21–23)
 (d') The Passover ritual questioned (12:24–28)
 (c') The tenth plague occurring (12:29–30)
 (b') Moses called back by Pharaoh (12:31–33)
 (a') Egypt despoiled (12:34–36)[24]

 In both Hellenic and Hebraic texts, chiastic involutions orchestrate personal, social, and political concerns around a pivotal yet enigmatic crux. The Homeric passage points up the range of matters constituting

Odysseus's cultural ethos, the components of his identity and authority. The chiasm introduces a hierarchy into the sequence by giving particular emphasis to the first and last items, each a central figure from the domestic world and affective ambiance that form the "background" to Odysseus's heroic identity: Odysseus's still-living though absent wife, and the present, speaking figure of his dead mother. The chiastic relation between wife and mother also calls to mind—the poet's and the reader's as well as the represented character's—the special proximity of worlds literally absent, in different ways, from Odysseus's world. Placed in relief here is a reminder of certain limits to Odysseus's authority and knowledge and thus to his ethical being. The dissymmetrical pairing of Penelope's absence and Anticleia's presence brings into focus the difficult, ethically ambiguous correlation between Odysseus's remembered world, to which he will return, and Odysseus's new perception of the absence and mystery that lie at the heart of that world, the world and life he keeps in mind as home (*nostos*).

The crux of this narrative pattern is the pivotal empty space between the two central reminiscences of Penelope's world, which occupies the center of the chiasm. The empty space acquires a face and a voice in the speaking figure of Anticleia's shade (a *tupos* or "type" of the dead mother) and its paradoxical locution, "I died," which closes the chiasm. This face and voice, prosopopaic figures, embody the ethical ambiguity of the scene and of the poem at large. The figures honor Odysseus's world, his memory and anticipated future, even as they constitute marks of irrecoverable loss and unsurpassable limit to Odysseus's heroic ethos, in the form of belated evidence of his mother's grief and death. The mother's face and voice present themselves, then, as sentinels before an ontological hinterland. Farther along in its subsequent genealogy, this region appears again in the strangely poignant voice of Goethe's Mignon, from *Wilhelm Meister,* and in the existential trauma of Heideggerian *Dasein.* But Homer's markings of absence also serve a more tractable, anthropological interest: they stand for the forgotten or neglected stories of Homer's world, to which Homeric narrative serves, self-consciously, as the chiastic obverse.

While the world-historical significance of the Homeric passage should not be discounted, particularly in view of its gendered construction of value, the future of chiasmus, and of the figure's ideological force, appears more decisively in the Exodus text. The Passover sequence is a seminal text in the semiotics of Judaeo-Christian identity and its emplotment in providential history. Here we see chiastic figuration placed in the service of the covenantal ethos informing a pivotal cultural narrative—*in exitu*

Israel Ægypto. The outer boundaries of the chiasm define the ethically charged temporality of covenant, a temporality structured by a typological rhythm of promise and fulfillment (release from bondage in Egypt). The inner regions of the chiasm spell out the ritual components of the decisive Passover event.[25] At the center of the chiasm (Exod. 12:11–13) lies a nexus of covenantal details, ones both historically specific and endowed with transhistorical significance. Prescriptions of an exemplary hermeneutic and position of ethical responsiveness—the Israelites' attentive readiness and acceptance of risk—are situated here within a semiotics of sacrificial violence, crucially, the blood token, through which communal identity is allied to a providential yet inscrutable divine agency.

Conceptually, the chiastic narrative of Passover reinscribes one of the foundational covenantal scenes in Genesis: Abraham's sacrifice of Isaac (Gen. 22). Notably, the Passover blood token, in which signs of life and death are exchanged and mutually implicated, revisits the decisive substitution of the sacrificial ram for Isaac (Gen. 22:13). Furthermore, the blood token's particular discursive context (the series of prescriptions and covenantal promises) stands in for the sequence of interlocutory exchanges preceding Abraham's sacrifice (first the opening call and response between God and Abraham, then the call and response between the angel and Abraham at the critical moment, the knife poised over Isaac).

Like the encounter between Odysseus and the shade of Anticleia, these exchanges partly imagine a communicative possibility at the juncture between the physical, historical realm and the realm beyond, between life and death. However, in ways more profoundly disturbing than in the Homeric text, the signs of interlocutory presence—the otherworldly invocations ("Abraham") and Abraham's assertive replies ("Here I am")—also mark an estranging limit, by exposing Abraham's existential isolation and the intractable ethical crisis he faces by responding to the repeated calls. Though the shift in focus is more sharply drawn in the Exodus text, both Abrahamic and Odyssean dialogues are sites of uncanny recognitions in the sense that both encounters depict tears in the fabric of the known, or given, events which expose a non-space at the heart of things, a void around which the filaments of the everyday, and of an entire cultural ethos, have been spun.

In brief, the history of the chiasm entails a series of modifications in the perception of the force and scope of this latent, though central, point of resistance, this evacuated center. Humanist-reformist hermeneutic procedures in early modern theological and devotional cultures gravitated toward an essentially chiastic parsing of the interface between human and

divine realms. Luther's famous "theology of the cross," for example, together with the various protocols of the *imitatio Christi*, cultivated an interest in the paradox of the wounded, suffering god as the exemplary model for a Christian subjectivity and affect founded on the chiastic intertwining of justification and guilt (*simul iustus et peccator*). The hermeneutic and ethical correlatives of this intuition turned up in the reformists' difficult sitings (and sightings) of the apparently inscrutable marks of God's juridical agency and providential design, and in the vexed interface of faith and works.

With unprecedented prestige and force, the touchstone texts were Paul's epistles. Indeed, Pauline chiasmus could be said to localize the reformists' preoccupations. Consider the following example, from the fourth chapter of Galatians:

(a) The *heir* remains a *child* and *servant* (4:1)
 (b) Until the time appointed of the *father* (4:2)
 (c) When that time came, *God* sent forth his *Son* (4:4)
 (d) Made under the *law* (4:4)
 (d') To redeem those under the *law* (4:5)
 (c') Because ye are sons, God sent forth the Spirit of his *Son* (4:6)
 (b') That ye cry Abba, *Father* (4:6)
(a') That ye are no more a *servant* but a *son* and *heir* (4:7)[26]

In this passage, hermeneutic, ethical, and theological paradoxes are integrated by means of a chiastic linking of catastrophic and regenerative attributes. The absent center here, which solicited so much of the reformists' attention, is the point of searing contact between visible "law" and invisible "spirit." Luther's benchmark views on the topic go straight to the heart of the matter: the law's rigor wounds the reader/hearer, and exposes abjection as the universal lot of humanity, while abjection turns out to be the enabling condition for the regenerative agency of the divine Word within the Christian subject. So, too, the subject's ethical self-possession before the law—the habitual observance of ethical norms—gives way to a radical dispossession, an exposure to a region that exceeds the discourse of law and its ethos of dutiful observance.[27] A crucial feature of these phenomena is that they are not linear progressions leading to a point of resolution or fixed insight, but rather chiasms soliciting a condition of chronic negotiation. In the "Preface to Romans," Luther calls these tensile movements a "wrangling" between "flesh and spirit," which "continues within us as long as we live," and which identifies the "complete self."[28]

Chiastic intuitions in the reformist hermeneutic lent a new urgency to the etymological background of biblical typology: *"tuptō,"* a wounding, identifying mark—also the memorial trace of an absence, as in Anticleia's speaking figure—was now both parsed and felt as χ, the letter *"chi,"* chiastic notation and Christographic symbol.[29] Marking the difficult passage between the time of promise and the time of fulfillment, chiastic figuration summarizes what A. C. Charity has called the "existential confrontation" between reader and sacred book.[30] This confrontation, the central event of "applied typology," brings the paradoxes undergirding the reformist ethos into stark proximity: the prescribed yet impossible mirroring of abject god and sinner seeking signs of justification; and an ambivalent ethical posture, one trained toward the habitual bracketings of what is other in the rhythms of everyday experience, yet also troubled by the radical self-dispossession that both Abrahamic crisis and Christological sacrifice call to mind.

Thus situated, the chiastic posture serves as a locus of exposure to what is unthinkable in reformist culture. Here I place the word "unthinkable" in its normative philosophical frame, with Simon Critchley's apt words in mind: "the very activity of *thinking* which lies at the basis of epistemological, ontological, and veridical comprehension is the reduction of plurality to unity and alterity to identity."[31] Chiastic thinking, at the limit of such activity, traces the intuition of a latent non-presence through which the evolving fund of ontotheological, exegetical, and ethical principles articulates itself—without, for all that, being accountable as a point of origin, a developmental phase (as in Hegelian negativity), or an unincorporated remainder, because this intuited latency is not a determinate "elsewhere." It is, in Merleau-Ponty's words, a constituting "blindness (*punctum caecum*) of the 'consciousness'" (*VI* 248). In this regard, Luther's description of the "complete self" as a perpetual "wrangling" between opposing wills and desires can be thought of as a hermeneutic and existential application of the chiasm's "rhetorical depth": a coiling over the blind center of reformist culture.[32]

Together, the gradual retreat of the ontotheological canopy in post-Enlightenment thought, and the erosions to the Hegelian historical romance of dialectical progression have separated the chiasm from its traditional moorings. Disengaged from metaphysical or teleological assurances, the chiastic pivot continues to function as an incitement or call, but problematically so. It is now heard as a call that leads to a reversible absence: one that marks a kind of mourning (a trace left by something no longer present), and one that refers to the conditions of marking as such

(a generative absenting that seems to arrive before presence, both logically and temporally).

In this capacity, the chiasm has acquired the status of a symptom of modernity. In particular, it announces modernity's place as threshold to postmodernity's cult of linguistic arbitrariness—what Roland Barthes called the "liberating theory of the Signifier."[33] It is perhaps no surprise, then, that in the enormously influential *Allegories of Reading* Paul de Man should have singled out chiasmus as the "determining figure" of the poet Rilke's "ambivalent thematic strategy." In Rilke's modernist "poetics of chiasmus," messianic intuitions announce themselves in the very gesture that dissolves them in a prospect of "language entirely freed from referential constraints." Promise and retraction are sustained in a relation of incalculable reversibility—what de Man calls a "kinetic totality" (*AR* 49, 44).

De Man's own assessments of the Rilkean figure turn on a similar reversal. On the one hand, de Man describes chiasmus as a foregrounding technique, designed to "isolate the poles around which the rotation of the chiasma takes place." Implicitly (de Man does not contextualize the definition), such language recuperates the figure's ancient rhetorical function as an instrument for focalizing a pivotal theme and deepening the perception of the theme by enabling "the reader to conceive of properties that would normally be incompatible (such as inside/outside, before/after, death/life, fiction/reality, silence/sound) as complementary" (*AR* 40). It is not difficult to imagine how this function—the harmonizing of presumed incompatibles—could speak to a certain therapeutic or conservative element—the messianic promise—in Rilke's poetics.

On the other hand, de Man also asserts that chiasmus, the "ground-figure" of Rilke's poetry, "can only come into being as the result of a void, of a lack that allows for the rotating motion of the polarities" (*AR* 49). Readers of de Man know the course that this kind of language has followed, at least in mainstream Anglo-American literary criticism. It is the storyline of the perils of deconstruction, of de Man's controversial brand of deconstruction in particular, and of theorizing in general. Even one of de Man's more sympathetic critics confesses to finding a certain "confusion or contradiction" in de Man's understanding of chiasmus.[34] However, if "confusion or contradiction" marks de Man's language, perhaps it is purposive. Though de Man does not articulate it, the apparent confusion has a genealogy, and one of its defining episodes is the early modern reformists' attention to the chiastic structure of hermeneutic and spiritual

crisis, encountered at the interface of law and spirit: the crossing of abjection and redemption. Without supplying a verifiable source for de Man's language, this residual or phantom context gives a meaningful resonance to de Man's otherwise gnomic characterization of Rilke's chiastic poetics as a "genuine existential philosophy of figuration" (*AR* 49).

Closer at hand to de Man's language, though again only by implication, are the post-Hegelian efforts to rethink concepts germane to any existential problematic: cross-sections of identity, value, and meaning. Kierkegaard's refusal to honor the traditional ethics of *Sittlichkeit* is especially relevant here. In *Fear and Trembling,* Kierkegaard views what he calls the "ethical" stage as a symptom of a cultural overinvestment in the thought of abstract universality. The symptom is legible in the close identification of the ethical with the "generality of the legal order, of social institution, and intersubjective communication."[35] To this tradition Kierkegaard counterposes the "religious" stage, a deliberately provocative transcendence of the ethical, which appears as the difficult embrace of a secret and radically subjective interiority. This altered sense of the ethical emerges from Kierkegaard's particular grasp of the consequences of existential abjection: the painful recognition, faced in "complete isolation," that there is no alibi for one's actions or one's life, and the acceptance of unique responsibility in the absence of a guaranteed reward for good behavior.

As is well known, for Kierkegaard the paradigmatic instance of the dispossession and reconsecration of the ethical is the story of Abraham's impossible choice. The Abrahamic crisis is the central theme of *Fear and Trembling,* and Kierkegaard preserves the theme's essentially chiastic character. As Kierkegaard's companion discourse, *Either/Or,* indicates, the life of the ethical individual, pursued in the shadow of the Abrahamic crisis, places two opposing aspects of being—one's concrete particularity and the universal—in a chiastic, "interpenetrating," relation, which manifests the mutual implication of the particular and the universal while ensuring the survival of their difference.[36] Harking back to the Homeric and Exodus paradigms I mentioned earlier, the chiastic crux in Kierkegaard's account of the crisis is the silence out of which Abraham's voice responds to the call. This silence finds its figure in Kierkegaard's insistence on the utter solitude and secrecy of the "knight of faith," which Abraham's actions exemplify.

Kierkegaard's reading of the "secrecy and silence" at the heart of Abraham's sacrificial gesture provides a typological antecedent to the

"void" that de Man perceives in Rilke's messianic themes.[37] It also presages Arendt's intuition of the necessary withdrawal of thought from the public sphere—the kind of activity that Arendt looks for but cannot locate in Merleau-Ponty's chiasm. But Kierkegaard's reading announces as well the very difficulty that Arendt's concept of withdrawal confronts without resolving: How does one safeguard the solitary preserve of thought from the dangers, both intellectual and moral, of solipsism? Kierkegaard, in other words, anticipates the double bind that Arendt's and Lyotard's readings of Merleau-Ponty's chiasm bring to light: by whatever name you call it—*écart*, dehiscence, void—the withdrawal either has no signifying force, in which case the necessary space for critique risks being absorbed into thoughtless complacency, or it has signifying force, in which case the space for critique, in the guise of impartiality, risks the seductions of a totalizing and violent egocentricity.

Emmanuel Levinas approaches this problem in his essays on Kierkegaard in *Proper Names [Noms Propres]*. Levinas is troubled by the "intransigent vehemence" and "taste for scandal" he detects in Kierkegaard's existential reading of Abraham's sacrifice.[38] Though he appreciates what Kierkegaard accomplished—rehabilitating subjectivity as the place of "the unique, the singular"—he also suspects that Kierkegaard "bequeathed to the history of philosophy an exhibitionistic, immodest subjectivity," a legacy that includes, Levinas notes, the political ideology of National Socialism (*NP* 76). Levinas's sense of the devastating historical ramifications of Kierkegaardian subjectivity draws him, however, not away from Kierkegaard's argument but instead into a more attentive examination of the argument's exemplary figure, Abraham.[39]

I turn to Levinas because his own argument deepens one's sense of the biblical passage's chiastic sensibility by bringing out what is unthought in Kierkegaard's reading of Abraham's crisis. What interests Levinas is the fact that Abraham is called twice. Kierkegaard sees only the first call, and sees it as the crux of the story, the point at which the critical transcendence of the ethical stage occurs. Taking both calls into account, Levinas counters, enables one to "think the opposite." Abraham's obedience to the first voice is indeed "astonishing," but "that he had *sufficient distance* with respect to that obedience to hear the second voice—that is the essential" (*NP* 77, my emphasis). In effect, for Levinas, the "highest point in the drama," the crux, turns on a chiastic reversal. What Levinas calls a "rending" enables Abraham's transcendence of the ethical. But this is followed—for Levinas, necessarily so—by a second rending: Abraham's

"sufficient distance" from transcendence, an *écart* that introduces the possibility of continued openness to the voice of the Other.

Levinas enlarges the scope of this openness by introducing a further example of chiastic reversal. After Abraham's submission to God, and after God's pronouncement of the covenant (Gen. 17), God reveals a secret: the decision to destroy Sodom and Gomorrah. The revelation calls for a response, a "Here I am." Abraham provides one, a "Here I am" that takes the form of a strenuous questioning of God's decision. As Levinas notes, Abraham "intercedes for Sodom and Gomorrah on behalf of the just who may be present there" (*NP* 77). Abraham's call to God, which brings Abraham and God into dialogue, could also be called an "astonishing," perhaps "essential," event. Hearing God's voice, Abraham calls out from a recognized condition of abjection—"I am but dust and ashes" (Gen. 18:27), and it is precisely this condition that carries critical and ethical force, for it is his consciousness of his abjection that enables Abraham to speak, to assume Levinas's sense of the ethical imperative: "the infinite requirement that calls you to responsibility without your being able to have yourself replaced" (*NP* 76). The point, though Levinas does not spell it out, is not that Abraham speaks only on behalf of his familiars, of a world that mirrors his own. Abraham's call is an anxious searching—while still listening to God's voice—for the hidden face of the "just" that may be present in Sodom and Gomorrah, societies that are neither part of the Abrahamic covenant nor necessary to its survival. Thus Abraham's call is a call to rethink the parameters of ethical responsibility contained in the regulative idea of justice.

Levinas's brief mention of the Sodom and Gomorrah episode has the effect of calling attention to the chiastic structure of the ethical problem raised in the later story of Abraham's sacrifice. The story can now be parsed this way: Abraham's withdrawal from the world of traditional ethical observance can be justified only in view of the second withdrawal, the return to the ethical; in turn, the second withdrawal can be justified only in view of the place Abraham has reached through the first withdrawal. The chiastic relation between these two propositions is marked by a doubled secret: the "incognito" that enshrouds Abraham's withdrawal into existential isolation, and the mysterious, hidden quantity, the "sufficient distance," which enables a transfigured Abraham to return from his isolation. What is important to recognize is that there is no entailment between the two secrets. They are, in fact, incommensurable.

Here, within this space of secrecy, are the parameters of Levinasian

ethics. Here, Levinas is able to achieve a certain rapprochement with the intuition of the ethical that Kierkegaard broaches in *Either/Or,* especially Kierkegaard's view of the ethical as a place of difficult negotiation between the universal and the particular. Here, Levinas's thought communicates with Kierkegaard's understanding of the ethical individual's intertwined responsibilities, "to the order of the things in which he lives" and "to God" (*E/O* 260). Here, too, Levinasian ethics appears as a mutable, yet committed point of contact between two kinds of thinking, both of which are emblematic of Merleau-Ponty's chiasm.

In "The Trace of the Other," written during the same period as his writings on Kierkegaard, Levinas opposes "Odyssean" and "Abrahamic" thinking. The myth of Odysseus, "who through all his peregrinations is only on the way to his native land," is the myth of the rationalist philosophy of being. In this tradition the "autonomy of consciousness" is always "returning home itself," and "philosophy reduces to this return not only theoretical thought, but every spontaneous movement of consciousness."[40] Odyssean thought, as Levinas describes it, speaks to the recuperative element that Arendt and Lyotard detect, and criticize, in Merleau-Ponty's chiasm. To this myth Levinas opposes the story of Abraham "who leaves his fatherland forever for a yet unknown land, and forbids his servant to even bring back his son to the point of departure." For Levinas, Abraham's departure from Ur figures the "heteronomous experience" of ethical work, "whose movement unto the other is not recuperated in identification" (*TO* 348). Conducted without the expectation of reciprocity or recognition, this "one-way action is possible only in patience, which, pushed to the limit, means for the agent to renounce being the contemporary of its outcome, to act without entering the promised land" (*TO* 349). Recalling Arendt and Lyotard, one would be hard-pressed to find a connection between this "heteronomous experience" of the ethical and Merleau-Ponty's chiasm.

Levinas's critique of Kierkegaard, however, indicates where such a connection would be found. The "sufficient distance" that Levinas sees, but does not explain, in Abraham's return to the ethical order is a cognate of the incalculable measure posed by Merleau-Ponty's ambiguous *écart.* Levinas sees that the distance between Odyssean and Abrahamic myths is also, strangely, the gauge of their rapprochement. For Levinas, Abraham's return is neither a flight into radical arbitrariness—what Kierkegaard mockingly called "in the wild blue yonder *[ins Blaue hinein]*"—nor is it an absorption into the generality of law (*E/O* 258). The return includes the

discovery that "to be myself means to be unable to escape responsibility"; it is a "putting in question of the *I* by the Other" (*TO* 73). Dwelling on Abraham's story, Levinas in effect fleshes out the ethical dimension to Merleau-Ponty's intuition of the "anonymity innate to Myself," which abides in the chiastic rhythm of the "flesh."

If the deconstructive element suggestively drawn out by de Man is hard to detect here, now is perhaps a good time to recall that Jacques Derrida has occasionally found a place for the chiasm in his writing. The preface to *Dissemination,* for example, includes the observation that chiasmus "can always, hastily be thought of as the thematic of dissemination."[41] Generally, though, Merleau-Ponty's writing seems to have remained on the periphery of Derrida's thought. A provocative convergence between the two thinkers can nonetheless be located, as David S. Ferris suggests, in their shared interest in the "movement of reversal" in writing or painting, which produces "an incalculable divergence whose effect cannot be accounted for *avant la lettre.*"[42] The implied question of accountability here does not mean that chiasmus can easily be reduced to the familiar calculus of deconstruction's "endless deferral" of meaning and viewed as the exemplar of a naively utopian or nihilist practice (take your pick). To be sure, the question of accountability remains, but it remains in the form of a reminder that Derrida's evolving project has itself been increasingly preoccupied by the question of ethics, its conditions of possibility and its lived parameters.

To this end Derrida's project has frequently turned to the thought of Levinas. Simon Critchley recently has shown how both Levinas and Derrida "strive towards a certain point of exteriority with respect to conventional philosophical conceptuality, and they both seek this point by giving a privilege to an 'infrastructural' matrix of alterity."[43] From this imagined "point of exteriority," both try to show the conditions under which ontology, philosophy, and ethics (Levinas's "first philosophy") are possible. Critchley's word for this point of exteriority, where the projects of Levinas and Derrida converge without collapsing into a single identity, is "chiasmus."[44] Critchley does not invoke Merleau-Ponty's name, but surely it would not be wrong to see Merleau-Ponty's chiasm as the presiding, if latent, spirit of the dialogue Critchley detects.

One can, in any case, detect its movement in one of Derrida's trenchant, Levinasian descriptions of the "unequal" character of ethical responsibility in *The Gift of Death*:

> Guilt is inherent in responsibility because responsibility is always unequal
> to itself: one is never responsible enough. One is never responsible enough
> because one is finite but also because responsibility requires two contradic-
> tory movements. It requires one to respond as oneself and as irreplaceable
> singularity, to answer for what one does, says, gives; but it also requires
> that, being good and through goodness, one forget or efface the origin of
> what one gives.[45]

If this passage has a presiding spirit, it is the *écart* of which Merleau-
Ponty speaks. This divergence takes on flesh in the incalculable yet
"sufficient distance" Levinas detects in Abraham's return to the ethical
order, a return that means facing up to the contradictory responsibilities
Derrida describes.

Merleau-Ponty's *écart*, the heart of chiastic relationality, speaks to the
implied ethical stance in the concept of "interactive universalism," which
Seyla Benhabib has recently called for in her diagnosis of the challenges
facing postmodernist social criticism.[46] Interactive universalism is in part
a corrective to the weaknesses in the schools of "situated criticism" now
generally favored in postmodernist thought. To make a long story short,
the principal weakness of situated criticism is its tendency to rely willy-
nilly on a "hermeneutic monism of meaning," a kind of Cheshire-cat
critical practice: the more local or immanent one gets, the more self-
legitimizing the normative judgments, both in the situations one reads
(i.e., local narratives from the realm of everyday practices) and in the
situation one reads from (the "view from here").[47] Benhabib, however,
does not propose a withdrawal from situated criticism. Nor, to be sure,
does she advise a return to the suspect universalism of "transcendent
criticism," the kind of "high-altitude thought" which Merleau-Ponty
criticized, and from which postmodernist critical practice has withdrawn,
with good reason. Instead, she reclaims the notion of universalism, in a
critical gesture that follows the contours of Abraham's double movement.

What Benhabib calls, suggestively, the "vocation" of a social criticism
is in effect a call to accept the risk of a certain divergence from the
received truths of situated criticism, in order to find a point of exteriority
from which to see better the complex and often contradictory character of
those "situated" practices with which one identifies—their depth and tex-
ture, if you will. The word Benhabib uses to describe such divergence is
"exile." The word's residual biblical connotations continue to resonate in
Benhabib's argument, but this resonance is not a symptom of a relapse

into ontotheological thinking. It is a typological reclaiming of the exilic drama. In this capacity the word conveys both the difficulty and the possibility of an interactive universalism: a mental withdrawal from the prospect of the local, a divergence that leaves open the possibility of returning eventually to one's "everyday certitudes," to reaffirm them "at a higher level of analysis and justification."[48]

The mention of possibility is key here. Possibility does not efface the problem of "thoughtlessness," which Arendt faced in her advocacy of the notion of thought as withdrawal. Understood chiastically, though, possibility also speaks to a deeper, more critical engagement with the certitudes one sees from afar. This vantage point is not, as Benhabib argues, the "view from nowhere." It is the "view from outside the walls of the city." Not unlike Abraham's view of the endangered cities of Sodom and Gomorrah in Genesis 18, this distanced viewing, committed yet parenthetical, remains in touch, chiastically intertwined, with the "practical-moral imperative" of utopian thinking: the "longing for the 'wholly other,' for that which is not yet."[49]

This vantage point concerns postmodernist turns to historicist critical practice as well, a concern that Merleau-Ponty makes explicit:

> It is necessary that the deflection *(écart)*, without which the experience of the thing or of the past would fall to zero, be also an openness upon the thing itself and of the past itself, that it enter into their definition. What is given, then, is not the naked thing, the past itself such as it was in its own time, but rather the thing ready to be seen, pregnant—in principle as well as in fact—with all the visions one can have of it, the past such as it was one day *plus* an inexplicable alteration, a strange distance. What there is is not a coinciding by principle or a presumptive coinciding and a factual non-coinciding, a bad or abortive truth, but a privative non-coinciding, a coinciding from afar, a divergence, and something like a "good error." *(VI* 124–25)

The implication for situated historicist criticism is a call for more particularized styles of acknowledging the personal stakes and idiosyncratic "errors" in critical practices as they cross paths with institutionalized habits of critique and communication. The point, of course, is not to retreat from the linear, logical unfolding of arguments—from the dominant articulation, that is, of "critical space." The point, rather, is to engage a more fully situated criticism: to enlarge the received sense of what counts as argument, to let critical thought also represent its course through recursive and oblique movements which convey an ungeneraliz-

able sense of historicity, a historical quotient both found and constituted. The emblem of this practice would be Merleau-Ponty's chiasm, especially as it pertains, in Eleanor Godway's words, to the process of historical understanding: "to participate in history is to be drawn into a gesture which allows a meaning to be born, creates possibilities, and, by making the present a turning point, opens up a future and changes the meaning of the past."[50]

Chiastic participation is not mortgaged to endless deferral—we've been there already. Instead, it accrues interest by openly showing how the achievements of situated criticism entail gestures of incalculable risk: crossings over between accumulated data, professional training, speculation, loving attention, and institutional constraint before the object that we collaborate, with divergences, in producing.

Notes

1. In morphological terms, "the nerve emerges from the eye [at the optic disk, or "blind spot"] and parses along the underside of the brain to the optic chiasma, an X-shaped structure in which the optic nerves from each eye converge. Half the nerve fibres from each eye continue to the visual cortex on the same side of the brain and half cross over at the chiasma to join fibres from the opposite eye and continue to the visual cortex on that side, producing binocular vision" ("Optic Chiasma," *Brittanica*, 970).
2. Maurice Merleau-Ponty, *The Visible and the Invisible*, trans. Alphonso Lingis (Evanston: Northwestern University Press, 1968), 139. Hereafter *VI*.
3. G. B. Madison, *The Hermeneutics of Postmodernity* (Bloomington: Indiana University Press, 1988), 64–65.
4. See the introduction to Merleau-Ponty, *Sense and Non-Sense*, trans. Hubert L. Dreyfus and Patricia Allen Dreyfus (Evanston: Northwestern University Press, 1964), xvii–xviii.
5. Madison, 70.
6. Butler, "Sexual Ideology and Phenomenological Description: A Feminist Critique of Merleau-Ponty's *Phenomenology of Perception*," in *The Thinking Muse: Feminism and Modern French Philosophy*, ed. Jeffner Allen and Iris Marion Young (Bloomington: Indiana University Press, 1989), 97. In Butler's view Merleau-Ponty leaves us "with a metaphysical obfuscation of sexual experience, while the relations of domination and submission that we do live are left unacknowledged" (ibid.). For a less skeptical view, one that shows what a feminist appropriation of Merleau-Ponty's thought would look like, see Iris Marion Young, "Throwing Like a Girl: A Phenomenology of Feminine Body Comportment, Mortility, and Spatiality," in *The Thinking Muse*, 51–70.
7. Derek Taylor, "Phantasmic Genealogy," in *Merleau-Ponty: Hermeneutics and Postmodernism*, ed. Thomas W. Busch and Shaun Gallagher, 157. Arguably the

most decisive turnings away from Merleau-Ponty's thought in postmodernist philosophical culture have been Foucault's and Derrida's. For a discussion of Foucault's ambivalent relationship with Merleau-Ponty's work, see Nick Crossley, *The Politics of Subjectivity: Between Foucault and Merleau-Ponty* (Aldershot, England: Avebury, 1994).

8. Hannah Arendt, *The Life of the Mind: Thinking* (New York: Harcourt Brace Jovanovich, 1977), 33. Hereafter *LM.*

9. What Laura Boella calls Arendt's "refusal of ontology" seems in part a refusal of the kind of transivity I describe. "Ultimately, for Arendt," writes Boella, "the point is to move away from the totalization of the activity of thinking; the movements of thought—the quest for the 'meaning' of Being—always reproduce a rupture between Being and thinking. Hence they lead to a boundary, to the limit of what thinking can no longer think. This defeat of thinking is the only path that allows the human to free himself or herself of the illusion of pure thought and to turn back to the real world, finally actualizing his or her freedom." See Laura Boella, "Phenomenology and Ontology: Hannah Arendt and Maurice Merleau-Ponty," in *Merleau-Ponty in Contemporary Perspective* (Dordrecht: Kluwer Academic Publishers, 1993), 172.

10. John McGowan, *Hannah Arendt: An Introduction* (Minneapolis: University of Minnesota Press, 1998), 104. For a helpful discussion of Arendt's encounter with the "moral phenomenon" disclosed by the advent of totalitarianism, see McGowan, 100–108.

11. As John McGowan points out, citing Arendt, "contingency is 'the ultimate of meaninglessness' for 'classical philosophy' [*Willing*, volume 2 of *The Life of the Mind*, 31], but for Arendt contingency is the necessary correlate of freedom. Only if circumstances and results could have been otherwise, only if action makes a difference in the realm of how things are (the realm of worldly appearances, for her), does it make sense to claim that humans are free," McGowan, 101.

12. Jean-François Lyotard, *Discours, figure*, trans. Michael B. Smith, excerpted in *The Merleau-Ponty Aesthetics Reader: Philosophy and Painting*, ed. Galen A. Johnson (Evanston: Northwestern University Press, 1993), 310. Hereafter *DF.*

13. For a discussion of this ambiguity in Merleau-Ponty's thought, see Madison, 57–81.

14. See also the helpful discussion in Robert Vallier, "Blindness and Visibility: The Ruins of Self-Portraiture (Derrida's Re-reading of Merleau-Ponty)," in *Écart & Différance*, ed. M. C. Dillon (New Jersey: Humanities Press, 1997), 202–203.

15. For a helpful discussion of the difference between the chiasm and reversibility, see Sue L. Cataldi, *Emotion, Depth, and Flesh: A Study of Sensitive Space* (Albany: SUNY Press, 1993), 75.

16. Welch, "Chiasmus in Ancient Greek and Latin Literatures," in *Chiasmus in Antiquity*, ed. John W. Welch (Hildesheim: Gerstenberg Verlag, 1981), 250.

17. For a discussion of "bilateral symmetry" in antiquity, see Charles H Talbert, "Artistry and Theology: An Analysis of the Architecture of Jn 1, 19–5, 47," *The Catholic Bible Quarterly* 32 (July 1970): 360–66. On the relation between chiasmus and hysteron proteron, see Welch, "Chiasmus," 250–68. G. A. Kennedy takes the paucity of theoretical discussion of chiasmus in antiquity as evidence of the figure's sedimentation in cultural habits of thought. See Kennedy, *Rhetorical*

Criticism, 28–29, cited in Charles D. Myers, Jr., "Chiastic Inversion in the Argument of Romans 3–8," *Novum Testamentum* 35 (1993): 32, n. 14.

18. Hans Kosmala, "Form and Structure in Ancient Hebrew Poetry," *Vetus Testamentum* 14 (October 1964): 445.

19. A discussion of the possible origins of chiastic patterns as a mnemonic device is in Welch, "Chiasmus," 256–58. The place of the figure in typographic convention is addressed in John Breck, *The Shape of Biblical Language: Chiasmus in the Scriptures and Beyond* (Crestwood, N.Y.: St. Vladimir's Seminary Press, 1994), 59.

20. Breck also describes the rhetorical specificity of the figure: "*Authentic chiasmus produces balanced statements, in direct, inverted or antithetical parallelism, constructed symmetrically about a central idea.* The uniqueness of chiasmus, as distinct from other forms of parallelism, lies in its focus upon a *pivotal theme*, about which the other propositions of the literary unit are developed" (Breck, 18).

21. In this regard, chiasmus testifies to the centrality of rhetoric in the expression of philosophical and ethical problems in antiquity (before the split between rhetorical and philosophical discourses in modernity). See Tzvetan Todorov, *Theories of the Symbol*, trans. Catherine Porter (Ithaca: Cornell University Press, 1982), 61–110.

22. Homer, *The Odyssey*, trans. Richmond Lattimore (New York: Harper and Row, 1967), 172–73.

23. Cited in Welch, "Chiasmus," 252–53.

24. I take this passage from Yehuda T. Radday, "Chiasmus in Hebrew Biblical Narrative," in *Chiasmus in Antiquity: Structures, Analyses, Exegesis*, ed. John W. Welch (Hildesheim: Gerstenberg Verlag, 1981), 93–94.

25. See Radday, 93.

26. Cited in Welch, "Chiasmus in the New Testament," in *Chiasmus in Antiquity*, 214.

27. See Gerhard O. Forde, "Law and Gospel in Luther's Hermeneutic," *Interpretation* 37 (July 1983): 240–52.

28. Luther, "Preface to Romans," in *Martin Luther: Selections from His Writings*, ed. John Dillenberger (New York: Doubleday, 1961), 31.

29. "*Typology* derives from the Greek *tupos* + *logos*. *Tupos*, which is related to *tuptō* (to strike), means both a blow and the mark or trace left by a blow or the application of pressure, e.g., the mark of the nails in Christ's hands (John 20:25)," Mark C. Taylor, *Erring: A Postmodern A/theology* (Chicago: University of Chicago Press, 1984), 56.

30. A. C. Charity, *Events and Their Afterlife: The Dialectics of Christian Typology in the Bible and Dante* (Cambridge: Cambridge University Press, 1966), 148–64. For a reading that instead emphasizes the formalist and reifying aspect of the typological imagination, see Sanford Budick, "Cross-Culture, Chiasmus, and Manifold of Mind," in *The Translatability of Cultures*, ed. Sanford Budick and Wolfgang Iser (Stanford: Stanford University Press, 1996), 239–42. A psychoanalytically inflected reading of typology's repetitive structure is in Julia Reinhard Lupton, *Afterlives of the Saints: Hagiography, Typology, and Renaissance Literature* (Stanford: Stanford University Press, 1996).

31. Simon Critchley, "The chiasmus: Levinas, Derrida and the ethical demand for deconstruction," *Textual Practice* 3 (1989): 95.

32. More broadly, the alternative tradition of "negative theology" testifies to the presence of this chiastic intuition in the corridors of theological discourse. See Kevin Hart, *The Trespass of the Sign: Deconstruction, Theology and Philosophy* (Cambridge: Cambridge University Press, 1989). The phenomenon can be seen as well in the institutionalized armature of philosophical skepticism, a mental discipline which is never far from cultural investments in paradox, and to which chiastic figuration is frequently allied. See Thomas Mermall,"The Chiasmus: Unamuno's Master Trope," *PMLA* 105 (March 1990): 246.

33. Roland Barthes, *S/Z*, cited in Paul de Man, *Allegories of Reading: Figural Language in Rousseau, Nietzsche, Rilke, and Proust* (New Haven: Yale University Press, 1979), 48. Hereafter *AR*.

34. See Sanford Budick, "Chiasmus and the Making of Literary Tradition: The Case of Wordsworth and 'The Days of Dryden and Pope,'" *ELH* 60 (1993): 984, n 6. Budick rightly points out that de Man's description gives unwarranted privilege to chiasmus as a "characteristically modern phenomenon" (965).

35. Hent de Vries, "Adieu, à dieu, a-Dieu," in *Ethics as First Philosophy: The Significance of Emmanuel Levinas for Philosophy, Literature and Religion*, ed. Adriaan T. Peperzak (New York and London: Routledge, 1995), 212–13.

36. "Not until the individual himself is the universal, not until then can the ethical be actualized. This is the secret that lies in the conscience; this is the secret the individual life has within itself—that simultaneously it is an individual life and also the universal, if as such not immediately, then nevertheless according to its possibility. The person who views life ethically sees the universal, and the person who lives ethically expresses the universal in his life. He makes himself the universal human being, not by taking off his concretion, for then he becomes a complete non-entity, but by putting it on and interpenetrating it with the universal," Søren Kierkegaard, *Either/Or, Part II*, ed. and trans. Howard V. Hong and Edna H. Hong (Princeton: Princeton University Press, 1987), 255–56. Hereafter *E/O*.

 Calvin O. Schrag's assessment of Kierkegaard's stages of existence (aesthetic, ethical, religious) suggestively elaborates their chiastic aspect: "it is a mistake to view the three stages or existence-spheres as successive developments, each supplanting the other in a linear progression toward a denouement in the attainment of a religious level of existence. They are to be understood rather as co-present and intercalated dimensions of selfhood ... the aesthetical, the ethical, and the religious are constitutive and complementary cross-sections of the self in its historical becoming." See Schrag, *The Self After Postmodernity* (New Haven: Yale University Press, 1997), 122, 144.

37. "For all the strictness of the [Hegelian] ethical requirement of disclosure, it cannot be denied that secrecy and silence, as determinants of inner feeling, really make for greatness in a man," Kierkegaard, *Fear and Trembling*, trans. Alastair Hannay (London and New York: Penguin, 1985), 114.

38. Emmanuel Levinas, *Proper Names*, trans. Michael B. Smith (Stanford: Stanford University Press, 1996), 72. Hereafter *NP*.

39. For a discussion of the relation between the Abrahamic story and Levinas's concepts of "face" and "trace," see Jill Robbins, "Tracing Responsibility in Levinas's Ethical Thought," in *Ethics as First Philosophy*, ed. Adriaan T. Peperzak, 173–83.

40. Levinas, "The Trace of the Other," trans. Alphonso Lingis, in *Deconstruction in Context: Literature and Philosophy*, ed. Mark C. Taylor (Chicago: University of Chicago Press, 1986), 346. Hereafter *TO*.

41. Cited in David S. Ferris, "Chiasmatic Differences: The Separation of Sight in Merleau-Ponty and Derrida," in *Ecart & Différance*, 40.

42. Ferris, 41. For a reading of Merleau-Ponty's *écart* that emphasizes its difference from Derridean *différance*, see Leonard Lawlor, "Eliminating Some Confusion: The Relation of Being and Writing in Merleau-Ponty and Derrida," in *Ecart & Différance*, 71–93.

43. Simon Critchley, "The chiasmus: Levinas, Derrida and the ethical demand for deconstruction," *Textual Practice* 3 (1989): 103.

44. Critchley, 91.

45. Derrida, *The Gift of Death [Donner la mort]*, trans. David Wills (Chicago: The University of Chicago Press, 1995), 51.

46. Seyla Benhabib, *Situating the Self: Gender, Community and Postmodernism in Contemporary Ethics* (New York and London: Routledge, 1992), 228, and, more generally, 203–41.

47. Benhabib, 225–30.

48. Benhabib, 227.

49. Benhabib, 227–29.

50. Eleanor Godway, "Toward a Phenomenology of Politics: Expression and Praxis," in *Merleau-Ponty: Hermeneutics and Postmodernism*, ed. Thomas W. Busch and Shaun Gallagher, 165.

HETEROLOGY AND POST-HISTORICIST ETHICS

Howard Marchitello

A [Paul] Klee painting named "Angelus Novus" shows an angel looking as though he is about to move away from something he is fixedly contemplating. His eyes are staring, his mouth is open, his wings are spread. This is how one pictures the angel of history. His face is turned toward the past. Where we perceive a chain of events, he sees one single catastrophe which keeps piling wreckage upon wreckage and hurls it in front of his feet. The angel would like to stay, awaken the dead, and make whole what has been smashed. But a storm is blowing from Paradise; it has got caught in his wings with such violence that the angel can no longer close them. This storm irresistibly propels him into the future to which his back is turned, while the pile of debris before him grows skyward. This storm is what we call progress.

—Walter Benjamin[1]

"The other," Tzvetan Todorov asserts, "remains to be discovered." This is a fact he considers "worthy of astonishment, for man is never alone, and would not be what he is without his social dimension." These words appear in the epilogue to Todorov's important book *The Conquest of America* and serve to remind us of both the heterological task before us— the non-appropriative apprehension of the other—and the grave costs of any failure to realize it.[2] As this sentence suggests, in Todorov's heterology, the relation to the other is immediately and fundamentally a matter of knowledge (cast here in the language of discovery), grounded in a defining fact of human sociality: we are what we are by virtue of our embeddedness in a particular "social dimension" made up precisely of ourselves *among other people*. This notion of a social context that serves (more or less) to construct our selves—*as if the social preceded the individual*—serves in turn to construct Todorov's moral(ist) historiographical

practice. This is perhaps inevitable in any rationalist theory of the other: history—or, more precisely, the writing of history—becomes entirely a matter of characterizing the productive "social dimension." The other surely exists—but only to the extent that he or she becomes the object of our knowledge, whether that knowledge is put to good (i.e., "moral") use or not. This marks exactly the limits of rationalist heterology: if the other exists only rationally—only (in effect) in the aftermath of (my) thought— have we in fact succeeded in the heterological task? Have we in fact articulated a viable heterological and historical ethics?

In this essay I want to suggest—if only tentatively and provisionally— an alternative model of heterology, one that does not so much *lead to* ethics but *arises from* a model of ethics with which it is also synchronous. I do not take this to be a paradox. The discourse of heterology I will elaborate here is, strictly speaking, "post-historicist." By this I mean, in the first instance, that this heterology arises in the aftermath of recent forms of historicism that have posed the question of otherness in strong and compelling ways (I am thinking, for instance, of Stephen Greenblatt's book *Marvelous Possessions: The Wonder of the New World*). But in another sense, I mean the term "post-historicist" to suggest, in effect, the *next* phase of inquiry into the question of the other, a phase that arises *out of the wake* of historicism and that at times cites historicism and at other times tries to push through it. As such, this heterology accepts the force (and, perhaps, the utility) of historicism without necessarily accepting all of its "truths."

To suggest now in outline what I will develop at greater length let me offer the following reading of just my title: "Heterology and Post-Historicist Ethics." To begin, I will identify what I take to be perhaps the most important (though perhaps the least obvious) aspect of this title: its three principal terms—"heterology," "post-historicist," and "ethics." These three terms are deployed in the title sequentially (because the logic of language requires it, we read the word "heterology" first, "post-historicist" next, etc.) as if these terms emerge in the world sequentially, which they do not. Nor do they emerge so in my understanding of the model of heterological discourse I hinted at just a moment ago. In fact, my three terms are offered as a site of resistance to just such temporal and linguistic sequencing.

Borrowing from the philosophy of Emmanuel Levinas, I proceed on the conviction that ethics constitutes a *first* philosophy: when presented with the figure of the other, my first responsibility, my first obligation, is always

to that other before it is to myself. In this we reverse the traditional understanding of the priority of the self and the belatedness of the other. Such a philosophy is necessarily post-rational, as I have already invoked that term. It is also post-historicist in the sense that the other is emphatically *not* posited as an initial epistemological object but rather exists both prior to and in excess of my own knowledge. You will have noticed that in thus describing two of my three terms—"ethics" and "post-historicist"—I have at the same time defined my third (or, technically, my first term): "heterology." We can now summarize this deliberate—and, I think, inevitable—implosion of these three terms into something like an identity:

- "Heterology" precedes the possibility of historicism
- "Post-historicist" is a term that defines the inaugural mode of ethics, and
- "Ethics" is a system for the articulation of heterology

But these three terms can emerge as synonymous only by way of an operation that suspends their distinction, which is rendered apparent in the very phrase "Heterology and Post-Historicist Ethics" itself. In other words, I want to collapse a series of temporalities that conventionally conditions our understanding of the other—temporalities in the initial experience of the other, temporalities in our description of such an encounter, and, lastly, temporalities in understanding the *space* of the other. To this end I suggest that a necessary first step toward a new-model heterology must be a careful re-theorization of the notion of space and, more specifically, the relation of space to the traditional forms of its representation. I will argue that these traditional methods of conceiving space and the space of the other are determined by an overriding faith in sequence and temporality. It is this carefully policed distinction between time and space that I will work here to problematize.

By way of an agenda I can say that I will proceed in this work first by instancing what a temporally and spatially collapsed world would look like as presented in a pair of short stories, one by Jorge Luis Borges, another by Italo Calvino. I turn then to an analysis of two powerful discussions of ways to map our contemporary experience of the other *as other* and at the same time figure the other as the relation between time and space: first, Walter Benjamin's attempts to renegotiate the relation between self and time and space, and secondly, Fredric Jameson's account and critique of postmodernism. In the next section I turn to a discussion of a particular discourse that, I argue, attempts to reify the

traditional distinctions between time and space against which a hetero-logical practice must work (let me call it for now "ghosting"). I con-clude—quite improbably, perhaps—with a short scene from a recent film by Mel Brooks.

I turn, then, to two versions of a temporally and spatially collapsed world.

First. In the 1945 story "The Aleph," Borges imagines a single point (located on the nineteenth step of a basement stairway in Buenos Aires), "one of those points in space," he writes, "that contains all other points."[3] The first—and, as it happens, perhaps the *least*—of the epipha-nies the story relates has to do with what Borges sees:

> The Aleph's diameter was probably little more than an inch, but all space was there, actual and undiminished. Each thing (a mirror's face, let us say) was infinite things, since I distinctly saw it from every angle of the uni-verse. (Borges 26–27)

Borges goes on to suggest the infinity of objects he sees:

> the teeming sea . . . the multitudes of America . . . bunches of grapes, snow, tobacco, lodes of metal, steam . . . [his] empty bedroom . . . A terrestrial globe [in a closet in Alkmaar] between two mirrors that multiplied it end-lessly . . . horses with flowing manes on a shore of the Caspian Sea at dawn . . . the delicate bone structure of a hand . . . bisons, tides and armies . . . I felt dizzy and wept, for my eyes had seen that secret and conjectured object whose name is common to all men but which no man has looked upon—the unimaginable universe. (Borges 27–28)

The next—and greater—epiphany Borges relates actually comes *first* in the story's narrative, though it occurs only *after* and as a reaction to the first, for it arises not as part of the experience of seeing the Aleph, but out of the realization that such an experience is *de facto* inexpressible due precisely to the radical incommensurability of the spatiality of the Aleph and the temporality of language:

> Really, what I want to do is impossible, for any listing of an endless series is doomed to be infinitesimal. In that single gigantic instant I saw millions of acts both delightful and awful; not one of them amazed me more than the fact that all of them occupied the same point in space, without over-lapping or transparency. What my eyes beheld was simultaneous, but what

I shall now write down will be successive, because language is successive. (Borges 26)

Second. In a story published nearly twenty years later, "All at One Point," Calvino offers a narrator (and a few other characters) who had inhabited exactly that single point in space from which the entire universe was created and emerged at incalculable speed and with nearly infinite force, creating with it and *at the same instant* both space and time:

> Naturally, we were all there,—*old Qfwfq said*,—where else could we have been? Nobody knew then that there could be space. Or time either: what use did we have for time, packed in there like sardines?
>
> I say "packed like sardines," using a literary image: in reality there wasn't even space to pack us into. Every point of each of us coincided with every point of each of the others in a single point, which was where we all were.[4]

"Contrary to what you might think," Qfwfq continues, "it wasn't the sort of situation that encourages sociability" (Calvino 43). Now, years later, the universe filled with the objects we have come to recognize: parts of astronomy ("like the nebula of Andromeda"), geography ("like the Vosges") and chemistry ("certain beryllium isotopes"), Qfwfq encounters now and again someone from that time. They meet, say hello, perhaps reminisce about "the old days ... the old disputes, the slander, the denigrations" until the mention of Mrs. Ph(I)NK°:

> and then, all of a sudden, the pettiness is put aside, and we feel uplifted, filled with a blissful, generous emotion. Mrs. Ph(I)NK°, the only one that none of us has forgotten and that we all regret. (Calvino 45)

Qfwfq remembers Mrs. Ph(I)NK°, the fact that she never aroused the jealousy of anyone, that she didn't gossip. And then he tells of her founding act of selflessness and generosity:

> We got along so well all together, so well that something extraordinary was bound to happen. It was enough for her to say, at a certain moment: "Oh, if I only had some room, how I'd like to make some noodles for you boys!" And in that moment we all thought of the space that her round arms would occupy, moving backward and forward with the rolling pin over the dough, her bosom leaning over the great mound of flour and eggs which

cluttered the wide board while her arms kneaded and kneaded, white and shiny with oil to the elbows. (Calvino 46)

Qfwfq and the others imagine the space the flour would occupy, the fields necessary to grow the wheat and the mountains to drain water to irrigate the fields, the space for a sun to ripen the wheat, the space required for the sun to condense from clouds of stellar gases, then the galaxies, then the space to hold and suspend the countless galaxies:

> And at the same time we thought of it, this space was inevitably being formed, at the same time that Mrs. Ph(I)NK⁰ was uttering those words: " ... ah, what noodles, boys!" the point that contained her and all of us was expanding in a halo of distance in light-years and light-centuries ... and she, dissolved into I don't know what kind of energy-light-heat ... she who in the midst of our closed, petty world had been capable of a generous impulse, "Boys, the noodles I would make for you!" a true outburst of general love, initiating at the same moment the concept of space and, properly speaking, space itself, and time. (Calvino 47)

I offer these two stories because they strike me as apt—uncannily apt— figures for the issues I would like to discuss: the Borges text foregrounds the problem of the fundamental incommensurability of language as thought deployed across time, on the one hand, and pure or total space, on the other, while the Calvino story depicts the prime (and, perhaps, the *primordial*) act of selflessness which, in the story, serves as that act that produces the entire universe and which, for us, might well stand as the model for an ethics predicated upon just such selfless—and founding— acts. Both issues converge, then, in the following discussion of history and ethics and the discourse of otherness that I will want to argue serves not only to link history and ethics together, but moreover serves as their very grounding. I also take Borges's concern for the inevitably sequential nature of language as something of a warning—and this for two reasons. First, language by its very nature prohibits any representation of the synchronic *on its own terms,* that is to say, all at once. Secondly, this inability of language to signify all at once, without the movement through time, serves as the fundamental model for the construction of a set of conceptions and generally untested assumptions regarding the place—and the role—of the "I" in the social world. As an example let me cite the obvious: no "I," no speaker of a sentence, can properly be said to conceive himself or herself as posterior to the observation he or she seeks to

convey; it would seem that in order for there to have been an experience in the first place (something always encoded on the model of language) there would necessarily have to have been a pre-existing subject. It is a very small step, I would say, from this linguistic-temporal model of experience and communication to what the history of human contact with otherness has demonstrated to be a failed system of ethics—the rationalist model of ethics in which the other exists only after I do. I could perhaps make the same assertions concerning rationalist historicisms erected upon the same linguistic-temporal paradigm.

Similarly, I have two points regarding Calvino's story that I would like to stress. First, "all at one point" suggests that in any system—whether it is a solar system we recognize as our own, or a system of ethics, or a system of historicism—the founding act needs always to be selfless and for the other, first. My second point concerns Calvino's very idea of the *belated* nature of time and space, both of which utterly depend upon the ethical discourse of the other embodied in the figure of Mrs. Ph(I)NK°.

Taken together, these two stories, with their particular theoretical concerns about time and space and language and ethics offer a rubric within which I, in turn, offer this discussion. I can admit, for example, that one of my failures is that it will have to rely upon a model of temporality—reflected in language itself—that I mean to critique. But I also can say that to the extent that I resist the exclusively linear and sequential nature of language I have inherited, I present at least the approximation of an alternative. Let us say that—only in part as homage to Calvino but largely as an attempt to rethink the temporality of language and the spatiality of the universe—I will offer this essay *as if* it were written "all at one point." What this means for us is that what follows needs to be apprehended (after the fact, of course, since it cannot literally be read this way) without sequencing. In fact, much of what I will argue here is dedicated quite explicitly to resisting sequence, to an "all-at-one-pointness" that seeks to reverse the traditional privilege accorded to that which seems to come first.

1

My suggestion that we consider this discussion as if it were all at one point in the spirit of rethinking spatiality has further precedent in the work of a number of theorists and critics. But before I turn to these particular sites for this renegotiation, I would like to offer a brief word concerning the *order* in which I will offer them, an order I will call here

"ante-chronological." This order is neither in step with a strict chronology, nor is it, like the "anti-chronological," in any sense opposed to the very idea of chronology. Rather, the "ante-chronological" is meant to suggest an order that can be said to exist *prior* to chronology and the chronological, but that *today* takes some of its significance from its insistent "return" to a "time" or *chronos* that is anachronistic. In other words, the ante-chronological returns to us from time *in the manner of remembrance*.

The first of these sites marks the emergence of the materiality of space in contemporary critical social theory. In *Postmodern Geographies,* Edward W. Soja discusses the effects of the inexorable occlusion of the idea of space in recent social theory and the subsumption of space represented by both the very notion of the synchronic and in the problematical absence of an equivalent concept of the synchoric.[5] This first site, then, proposes the idea of the synchoric in critical practice, much like the (literary) all-at-one-pointness remarked above.

The second site emerges from the work of Michel Foucault on the question of space, a discussion that makes explicit the particular mechanisms for the obvious absence of space as a concept for philosophical consideration and interrogation. "Since Kant," Foucault argues, "what is to be thought by the philosopher is time."[6] "Did it start with Bergson," Foucault asks, "or before? Space was treated as the dead, the fixed, the undialectical, the immobile. Time, on the contrary, was richness, fecundity, life, dialectical."[7] We live, Foucault suggests, in

a moment ... when our experience of the world is less that of a long line developing through time than that of a network that connects points and intersects with its own skein. One could perhaps say that certain ideological conflicts animating present-day polemics oppose the pious descendants of time and the determined inhabitants of space.[8]

The third site marks a particularly powerful theorization and articulation of the notion of remembrance—Walter Benjamin's narrative, "A Berlin Chronicle":

Reminiscences, even extensive ones, do not always amount to an autobiography. And these quite certainly do not, even for the Berlin years that I am exclusively concerned with here. For autobiography has to do with time, with sequence, and what makes up the continuous flow of life. Here, I am talking of a space, of moments and discontinuities. For even if months and

years appear here, it is in the form they have at the moment of recollection. This strange form—it may be called fleeting or eternal—is in neither case the stuff that life is made of.[9]

These three sites—some would say "these three moments"—are aligned together not by virtue of the progression of chronology (indeed, our first is last, and our last is first). Rather, they are aligned by virtue of the inexorable loss of spatiality that each for its part marks (though all of them differently), the gradual but sure erasure of space from the realm of the thinkable and its subsequent (re)inscription into the realm of the "natural." Soja offers the insightful observation that we simply lack the vocabulary for the analysis of spatiality, a lack for which we can compensate, he suggests, by a new discourse of the "synchoric." Foucault—writing here, I suppose, as "ante-historian"—locates the loss of spatiality within a particular historical context: it was at some point perhaps late in the eighteenth century that space was so forcefully erased ("The great obsession of the nineteenth century," Foucault writes, "was ... history: with its themes of development and of suspension, of crisis and cycle, themes of the ever-accumulating past, with its great preponderance of dead men and the menacing glaciation of the world" ["Of Other Spaces" 22]). It is in the work of Foucault, I believe, that we come closest to a thorough retheorization of space—always the preliminary and enabling step toward any discussion of power (it was Foucault who said in "Questions on Geography" that, "the spatializing description of discursive realities gives on to the analysis of related effects of power" [70–71]).

But perhaps Foucault's notion of such a "spatial[ized] description of discursive realities" was in an important sense anticipated—or, more precisely, was *remembered*—by Benjamin (whose profound prescience may well be a function of a profound memory) in "A Berlin Chronicle" and elsewhere. The "strange form" Benjamin imagines in the passage quoted above—a form that resides somehow precisely *between* "chronicle" (or, in this case, "autobiography") and something like "topography"—is entirely structured upon what I would suggest is in fact the very old idea of the "synchoric," and as such its "strangeness" may be a function of our having forgotten about it in the first place.

In this regard, Benjamin's "A Berlin Chronicle" can be understood as the expression of a will to memory, the desire to remember not only a certain content, but a particular form as well—somewhere between chronicle and topography—that is ante-chronological and is dedicated to

the (re)construction of meaning from place and space and the depth they can hold through time. Benjamin writes:

> Language shows clearly that memory is not an instrument for exploring the past but its theater. It is the medium of past experiences, as the ground is the medium in which dead cities lie interred. He who seeks to approach his own buried past must conduct himself like a man digging. . . . Fruitless searching is as much a part of this as succeeding, and consequently remembrance must not proceed in the manner of a narrative or still less that of a report, but must, in the strictest epic and rhapsodic manner, assay its spade in ever-new places, and in the old ones delve to ever-deeper layers. ("A Berlin Chronicle" 25–26)

With this "strange form" of discourse, Benjamin moves one step closer to a kind of self-knowledge understood ante-chronologically, articulated topographically, and one step nearer to the realization of a long-held dream:

> I have long, indeed for years, played with the idea of setting out the sphere of life—bios—graphically on a map. ("A Berlin Chronicle" 5)

But at the same time that this "strange form" moves Benjamin toward the fulfillment of this dream, it moves him closer to the past, closer to a form of discourse that (strictly speaking) preceded Benjamin but toward which he travels with the expectation of an arrival *as if* for the first time. This is even the case when the issue at hand is time and the very idea of the "chronicle." Benjamin tells us that he had begun "A Berlin Chronicle" as an attempt to write "in a loosely subjective form, a series of glosses on everything that seemed noteworthy in Berlin," but that such an atypical use of the subjective "I" produced a profound change in the very form of his text: "The 'I' accustomed for years to waiting in the wings would not so easily be summoned to the limelight." But rather than an absolute refusal of this subjective "I" to speak the text, Benjamin claims that the "I" employs a trick—a "ruse" (as he calls it)—so successfully that "I believed a retrospective glance at what Berlin had become for me in the course of years would be an appropriate 'preface' to such glosses." As a result, Benjamin admits, the so-called preface has grown to exceed the glosses it was meant to introduce, a fact Benjamin attributes to two factors, both of which are important for us here: First, the excessive nature of the "preface" is a mark of the true nature of remembrance—"which," Benjamin writes, "is really the capacity for endless interpolation into what has been." Secondly, the production of such prefatory excess is in fact "the precaution of the subject represented by the 'I', which is

entitled not to be sold cheap" ("A Berlin Chronicle" 16). Therefore, remembrance is the deployment of interpolation across a specific space, and the writings of remembrance—far from enabling or constituting the autobiographical—serves to shield the presumptive subject of autobiography. But if "A Berlin Chronicle" fails—or refuses—to present the subjective "I" without disguise, it also fails—or refuses—to eradicate it altogether. What Benjamin's text does succeed in doing, I suggest, is the *staging of the place of the "I."* It is these two discourses together—remembrance as potentially interminable interpolation, and the staging of place—that constitute Benjamin's "strange form" of a spatialized history. Our contemporary movement toward a poststructuralist geography leads us to a rereading of Benjamin. This conjunction of place and time on the model of recollected space is Benjamin's loved object of nostalgia. It is also his breakthrough—not to something wholly new, but to something already partially forgotten: his breakthrough to a remembered past and its form preserved in the discourse of the "synchoric." Benjamin writes (as the passages from Foucault I quoted above suggest) after the "fall" into history, though his imagination is essentially spatial in nature.

If this reading of Benjamin's critique of progressivist history has been successful, the possibility of an understanding of space and our movement through it as merely a matter of *strictly* linear time begins to seem less possible. Benjamin offers an alternative image: the labyrinth. In "A Berlin Chronicle," he tells of one particular afternoon in Paris to which he claimed to "owe insights into my life that came in a flash, with the force of an illumination":

> Now on the afternoon in question I was sitting inside the Café des Deux Magots at St.-Germain-des-Prés where I was waiting—I forget for whom. Suddenly, and with compelling force, I was struck by the idea of drawing a diagram of my life, and knew at the same moment exactly how it was to be done. With a very simple question I interrogated my past life, and the answers were inscribed, as if on their own accord, on a sheet of paper that I had with me. ("A Berlin Chronicle" 30–31)

Benjamin tells us, in the very next sentence, that within a year or two this paper bearing his diagram became lost. In spite of his efforts Benjamin was never able "to restore it as it arose before me then, resembling a series of family trees." But subsequently, through *remembrance*, the diagram has become transformed "in thought without directly reproducing it" into a labyrinth:

I am not concerned here with what is installed in the chamber at its enig-
matic center, ego or fate, but all the more with the many entrances leading
into the interior. These entrances I call primal acquaintances; each of them
is a graphic symbol of my acquaintance with a person whom I met, not
through other people, but through neighborhood, family relationships,
school comradeship, mistaken identity, companionship on travels, or other
such—hardly numerous—situations. So many primal relationships, so
many entrances to the maze. ("A Berlin Chronicle" 31)

It is, I want to say, upon just such a diagram—map—that the work of a
post-historicist heterology begins. The understanding of the complex
issues of space, time, history, and ethics as Benjamin deploys them here
could well serve as a model for subsequent articulations of a "politics of
the spatial" for contemporary readers. However, one of Benjamin's read-
ers who also happens to be an equal sharer in Benjamin's Marxist philoso-
phy—Fredric Jameson—identifies Benjamin's work on the urban space of
the city as, in the end, if not out of order, then at least out of fashion, and
perhaps out of date in the face of our postmodern world and its cities and
their articulations (or, *disarticulations*) of space. I have in mind here
Jameson's now-famous discussion of John Portman's Bonaventura Hotel.

2

Jameson's "Postmodernism, or The Cultural Logic of Late Capitalism"
stands as a thorough-going critique of what he claims is the more or less
bankrupt postmodern culture of the simulacrum characterized by a
"wholly historically original consumers' appetite for a world transformed
into sheer images of itself"—a critique, that is, of

this whole "degraded" landscape of schlock and kitsch, of TV series and
Reader's Digest culture, of advertising and motels, of the late show and the
grade-B Hollywood film, of so-called paraliterature with its airport paper-
back categories of the gothic and the romance, the popular biography, the
murder mystery and science-fiction or fantasy novel.[10]

Jameson identifies the passing of the high modernist moment as the
"waning of affect" and the related abandonment in postmodern culture
(and theory) of what he calls the hermeneutical reading "in the sense in
which the work [of art or of culture] in its inert, objectal form, is taken
as a clue or a symptom for some vaster reality which replaces it as its

ultimate truth" (Jameson 59). It is this notion of reading what Jameson calls the "depth-model" whose loss in postmodernism triggers both a profound nostalgia and a rather savage attack on its lesser replacements which are said to offer only "practices, discourses and textual play" and "intertextuality"—all of which are characterized by a concern for (mere) surface. This "depthlessness" arises as a consequence of the lack in postmodernism of a viable idea of expression, since in order to express, one must possess some notion of a self that functions as the source from which the expression can be said to emanate. Jameson offers what he terms the "historicist argument" that this loss results from the dissolution of the "once-existing centered self [of] classical capitalism and the nuclear family" within today's world of organizational bureaucracy (Jameson 63).

Jameson argues that the waning of affect in postmodernism has been accompanied by a corresponding waning of the "high-modernist thematics of time and temporality" and the subsequent shift, signaled in postmodernism's emphasis on the synchronic, toward space. My real interest in Jameson's argument arises in response to just this sort of theorizing about time and space within postmodernity—especially as it figures in Jameson's reading of Portman's Bonaventura Hotel—an example, Jameson asserts, of a "full-blown postmodern building" (Jameson 80).

Jameson prefaces his discussion of the Bonaventura with the assertion that the postmodern (at least in architecture, but perhaps in other areas as well) represents an evolutionary transformation—though he calls it a "mutation"—in built space. What produces the virtual confusion Jameson goes on to describe as the lived experience of a visitor to the hotel, however, does not result exclusively from this "mutation" in built space, but equally from an uneven process of evolution that has so decisively impacted buildings such as the Bonaventura but has not (or not yet) affected humans; "there has been a mutation in the object," Jameson says, "unaccompanied as yet by any equivalent mutation in the subject: we do not yet possess the perceptual equipment to match this new hyperspace" (Jameson 80). The discussion of the Bonaventura that follows is complex and very often quite compelling—as when, for example, Jameson declares that the hotel "aspires to being a total space, a complete world"; or when he notes Portman's "downplaying and reduction of the entrance function to a minimum" as the consequence of a covert desire of the building to deny its linkage—for that is what entrances provide—to the rest of the city because "it does not wish to be a part of the city, but rather its equivalent and its replacement or substitute" (Jameson 81). It is this notion of the "total space" of the hotel that Jameson identifies as symptomatic of

the building's profoundly "*apolitical*" nature, an issue I will take up in a moment. But to me the most striking comment in the discussion comes when Jameson observes the hotel from the outside and sees in what he calls the hotel's "great reflective glass skin" a confirmation of his "diagnosis" of the building's firmly held "apolitical" disposition: First, the reflective exterior is said "to repel" the city (much like mirror sunglasses "achieve a certain aggressivity towards and power over the Other"). Second—and this is far more interesting—Jameson suggests that the reflective skin of the building achieves a "peculiar and placeless dissociation of the Bonaventura from its neighborhood":

> it is not even an exterior, inasmuch as when you seek to look at the hotel's outer walls you cannot see the hotel itself, but only the distorted images of everything that surrounds it. (Jameson 82)

The Bonaventura, one could say then, has from the outside—as the object of a certain gaze—only a *ghostly* presence: it is there, just there, where you can't quite see it, though you cannot quite ignore the force of its apparition, either. This "hyperspace" haunts space itself. This is so for both the outside and for the inside of the hotel: Jameson offers as proof of this latter the fate of the shops that line the various balconies within the hotel and the symmetry of the hotel's four towers in which it is notoriously difficult to negotiate one's way:

> It has been obvious, since the very opening of the hotel in 1977, that nobody could ever find any of these stores, and even if you located the appropriate boutique, you would be most unlikely to be as fortunate a second time; as a consequence, the commercial tenants are in despair and all the merchandise is marked down to bargain prices. (Jameson 83)

This depiction of the visitor—Jameson, say—lost in space serves to point precisely to the crucial problem: the postmodern has "succeeded in transcending the capacities of the individual human body to locate itself, to organize its immediate surroundings perceptually, and cognitively to map its position in a mappable world." This fact, Jameson concludes, stands as an analogue of what he calls "that even sharper dilemma which is the incapacity of our minds, at least at present, to map the great global multinational and decentered communicational network in which we find ourselves caught as individual subjects" (Jameson 83–84).

It is a passage such as this one in which Jameson charts a contemporary incommensurability between the perceiving body and the world now

thought to exist in excess of that body's ability to apprehend it, that offers to make literal (though only, of course, on the level of fantasy) the suggestion earlier in his analysis that

> the newer architecture . . . —like many other . . . cultural products—stands as something like an imperative to grow new organs, to expand our sensorium and our body to some new, as yet unimaginable, perhaps ultimately impossible, dimensions. (Jameson 80)

In the absence of such a body (by Jameson's terms we would have to call it a "post-postmodern body"), perception—both as sensuous and intellectual—is utterly disallowed. In other words, Jameson suggests that by virtue of its "depthlessness," its one-dimensionality, its pure linearity, postmodernism leaves in its wake disabled perceptual bodies that are characterized by nothing so much as their flatness and their constitutional inability to lift themselves off the surface of the simulacral world so as to produce an enabling "critical distance." "Our postmodern bodies," Jameson writes, "are bereft of spatial coordinates and practically (let alone theoretically) incapable of distantiation" (Jameson 87).

For Jameson, then, postmodern space is quite literally no space at all, the disabling reduction of depth and plentitude to nothing more or less than pure surface and image. In such a hopelessly flat world the only possible redemption of postmodernism's uni-dimensionality is to consider postmodernism itself exactly as a historical phenomenon and not merely as one "stylistic option" among many. This means that postmodernism "has genuine historical (and socio-economic) reality as a third great original expansion of capitalism around the globe" (Jameson 88). It is this "historicist" argument that allows Jameson to equate the term "postmodern" with the term "multinational." It is this argument, too, that allows a reconsideration of cultural productions within postmodernity (such as Portman's Bonaventura) as "peculiar new forms of realism" and as such may not be (simply) simulacral gestures of questionable coherence and worth but realistic reflections of a fragmented and simulacral world.

Citing what he calls "one of the age-old functions of art—namely the pedagogical and the didactic," Jameson argues that *if* there is any possibility for a *politics* of or within postmodernity—within a world that seems by its very nature to disallow "ideological critique [and] . . . indignant moral denunciation"—it obtains (as it always has) in the embrace of our own historical aesthetic practices (Jameson 86, 89). Since such practices emerge from our own historical moment—specifically for us, a moment

that foregrounds spatiality—then the new model Jameson proposes for a "political culture" appropriate to postmodernism is one that takes spatiality (and spatial issues) "as its fundamental organizing concern." Jameson proposes "cognitive mapping" as this new aesthetic cultural form.

One of the chief characteristics that recommends cognitive mapping to Jameson is that it is insulated from poststructuralist critiques of the ideology of representation or mimesis: "The cognitive map," Jameson writes, "is not exactly mimetic" and as such allows for a more rigorous and sophisticated analysis of representation (Jameson 89). Jameson cites the work of Kevin Lynch, whose book, *The Image of the City*, offers first a discussion of the alienated city that disallows mental maps (Jersey City is offered as an example of such an alienated city in which "none of the traditional markers [monuments, nodes, natural boundaries, built perspective] obtain"). Jameson, following Lynch, asserts that the only route to disalienation lies in the direction of "the practical reconquest of a sense of place and the construction or reconstruction of an articulated ensemble which can be retained in memory and which the individual subject can map and remap along the moments of mobile, alternative trajectories" (Jameson 89). All we need do to disalienate global space is extend this model outward from the city into the postmodern space of multinational capitalism and its problematic spatiality. This constitutes what Jameson calls "the need for maps" and leads, in the end, to his consideration of "social cartography and the symbol." Our cognitive mapping of our (lamentable) postmodern world, Jameson argues, partakes of just what Louis Althusser describes as the work of ideology—"the representation of the subject's *Imaginary* relationship to his or her *Real* conditions of existence." Always the historicist, Jameson reminds us that *any* negotiation of "functioning and living ideologies is particular to different historical situations and that our own postmodern moment may well represent a condition of the *impossibility* of achieving the Althusserian production of living ideology" (Jameson 90). It is, in fact, only by a rather mystifying invocation of Jacques Lacan's category of the *Symbolic* that Jameson projects a potential resolution—but one that exists only in our future: we can't yet draw the hypothetical postmodern map.

In Jameson's critique, the map exists as imagined but as yet blank: a ghost-map whose return is foretold. For Jameson's map of postmodernity has already inhabited a place in the world: the place of the prepostmodern; it has been (effectively) killed by simulacral culture and it is precisely for this reason that it alone—in its guise as ghost-map (which is, after all, the only form left to it)—can offer properly any guidance to all

those who suffer under postmodern fragmentation and the related corporal failure of perception. This is the discourse of the ghost.

3

I have written elsewhere about the (covert) politics of cartography and mapping.[11] Across the wide range of maps (Roman itinerary maps, global maps, sixteenth- and seventeenth-century allegorical and religious maps) and what one could call map-products (AAA Triptiks, scientific maps, LANDSAT photo-cartographs, and local contemporary maps), at least one feature has remained the same: each of these cartographic expressions *believes* itself to have as its ultimate referent a world (or a part of the world) that exists, that is real—even though, of course, no map of whatever technological sophistication ever really maps the world. Or tells the truth. What I would like to consider here, however, as part of my discussion of heterology, history, and ethics—while certainly cartographic—breaks with all the other maps I've mentioned. Unlike those maps—let's call them provisionally "referential maps"—the maps I want to consider here move along an exactly contrary trajectory. Instead of proclaiming a referential status, instead of acting as if they really can situate legibly places in space, these maps—"ghost maps," I'll call them—are dedicated to situating in space places that not only do not exist, but (and now I have to place this word—"places"—in quotation marks) "places" that are remarkable precisely because they are *not there*. These maps are, of course, no truer than any other map, just untrue in a perhaps rather more interesting way. I'm talking about maps of ghost towns.

I had no idea when I looked at my first map of ghost towns, but there is something of a ghost-town and ghost-town-map industry in America today (headquartered, as best I can tell, in Norman, Oklahoma). There is a series of map-and-travel-pamphlet hybrids dedicated to ghost towns: one title of which is "The 25 Best Ghost Towns in Texas!" Other notable titles in the field include:

- *Texas Ghosttown Encyclopedia*
- *This Was East Texas: An Anthology of Ghost Towns*
- *Ghost Towns of Robertson County, Texas*
- *New Mexico's Best Ghost Towns: A Practical Guide*
- *Here It Is!: Route 66, the Map Series*
- *Ghost Towns of New Mexico: Playthings of the Wind*

- *Ghost Towns of New England: Their Ups and Downs*
- *I Paint the Ghost Towns*

There is also an actual (that is to say, an *official*) Library of Congress subject heading, too—though it is not "Ghost towns" (which is, perhaps, too "gothic" for the LOC), but instead "Extinct Cities." And there is an entire publishing interest, "Ghost Town Press," also located in Oklahoma. Eventually, one supposes, there will be a website.

In his book *Ghost Towns of Texas*, T. Lindsay Baker bears witness to the ghost town phenomenon. Baker's brief preface to his collection of verbal, cartographic, and photographic descriptions of nearly ninety Texas ghost towns begins with a profession of Baker's long-standing interest in the ghost town—an interest that, he says, "goes back almost as far as my interest in history," a fact reflected in Baker's story of a boyhood visit to Kimball, a ghost town on the Brazos River, in the company of his grandfather.[12] What is striking about this, it seems to me, is not that Baker's interest in ghost towns is embedded within a fragment of familial history—we learn, for example, that his grandfather, George A. Baker, knew Kimball "when it was still alive" and that a Kimball physician (a Dr. Ezell) had crossed the Brazos on horseback to reach the Baker home when George A., as an infant, lay seriously ill from influenza in the great epidemic of 1919. Rather, what is remarkable in Baker's account is the professed asymmetry of his interests in history and ghosts, with an alleged temporal priority of history followed, only belatedly, by the ghost.

Baker's methodology attests to the evidently dead status of the ghost town sites he visits and catalogues—eighty-eight in all, selected from over one thousand identified by preliminary research:

> From this multitude I selected approximately three hundred for actual site documentation. Unless they were complete "washouts" with no visible remains or were impossible to locate, I prepared detailed photographic and written documentation, creating a morgue of photographs numbering in the thousands. (Baker vii)

But there is a perhaps obvious tension in Baker's project: those towns that are completely dead (Baker's "complete 'washouts' ")—that is to say towns which have died and remained dead and utterly lost to us—have failed a certain test: "The first requirement was that the site had to offer something for visitors to see—ruins, abandoned buildings, cemetery, interpretive markers—something tangible" (Baker vii). The ghost town cannot be entirely void of traces of what is a clearly constitutive materiality.

Those that die, decay, and completely disappear have no place—not only in Baker's book but (evidently) "in" the world (Texas), too. They are, strictly speaking, nothing—except anonymous, lost, non-locatable. Were this the common fate of all abandoned towns, then the ghost town—that town that persists even beyond its own death—would be entirely unthinkable. Texas may well be quite crowded with ghost towns (as Baker's figures would certainly suggest) but it is only once they are ghost towns—once they refuse to remain dead—that they enter our world. The priority Baker suggested in the opening sentence of his book—that his interest in ghost towns is almost as old as his interest in history—would appear, then, quite curious. And perhaps quite unfounded precisely because it is *out of order*: it is the ghost that not only precedes history, but that makes history possible. Before the ghost there is nothing.

Baker's second and third requirements for selecting ghost towns to include in his book deserve brief mention here. These two additional criteria are 1) that the site have public access and 2) that his final selection of sites "give the entire state of Texas equal treatment geographically" so that "there are ghost towns in the book that are within a day's drive from any point in the state" (Baker viii). The reason for these terms—similar, in fact, to the reasoning behind his first requirement—is to insure that his book becomes an actual travel guide. For Baker (and this is the logic of the ghost more generally) in order for ghost towns to signify—or, in order for there to be history—it is not sufficient that the ghosts return; they must also be seen and witnessed. "The purpose of this book," Baker writes, "is to get people out of their easy chairs and into the field where they can see, smell, and touch Texas history where it was made" (Baker ix).

Before I leave *Ghost Towns of Texas* I'd like to take note of two further features of this text that are really quite interesting: first, the map of Texas with Baker's eighty-eight ghost towns, each indicated on the map with a number. The map legend identifies the map's theme, "GHOST TOWNS OF TEXAS," and an indication of a scale of miles [fig. 1]. The only other information provided—apart from the general topographical outline of Texas itself—is the appearance of county names and boundaries. What is remarkable about the map is its clear insistence upon referring readers away from itself. To begin with, the encircled numbers have no evident (nor real) coherence. They are out of order and as such really do not do the work numbers are typically intended to achieve: sequencing. Number 56, for example, appears in the extreme northwest of the panhandle, nearest to sites number 2, 71, and 81. In other words, these encircled numbers have virtually no practical use and their failure to

Figure 1. Source: T. Lindsay Baker. *Ghost Towns of Texas.* Norman: University of Oklahoma Press, 1986.

mean anything except a lack of order and precision sends us scurrying to the following page, which lists the ghost towns effectively obscured and all but lost by the encircled numbers:

1 Acme

2 Adobe Walls

3 Avenger Falls

4 Belcherville

The list proceeds in this fashion through Zella at number 88. The intent of this catalogue is to locate ghost towns on the preceding map. It would certainly be conventional for us to read the catalogue in this fashion. But even as we do we should note that the order imposed in this reading is only allegedly topographical and cartographical and, at its

heart, is really a matter of the alphabet. Only the catalogue, then, makes any sense, while the map is revealed, in the end, to be not a map at all but rather a signal to convey Baker's own egalitarian interests in opening all of Texas to tourism.

Secondly: the bulk of Baker's book is composed of eighty-eight short chapters, each one devoted to one of the eighty-eight encircled numbers found on both the map and the list, though *locatable* on the list alone. The organization of the book, then, is structured entirely on the alphabet, a fact that renders the geography of ghost towns and of Texas, even, entirely beside the point. The particular narratives within these chapters typically tell the story of early settlement followed first by gradual expansion and prosperity, then by the inevitable decline (the railroads, with an almost equal inevitability, play the villains here), and finally by a near-total disappearance. These stories usually are accompanied by a few evidential photographs—some from the archives depicting prosperity, some taken by the author himself documenting collapse, loss, and absence.

Let's consider the chapter on number 30: Independence. We learn of John P. Coles, first settler in 1824, whose house, we are told, still stands. We learn of Sam Houston's brief residence in Independence, from 1853 to 1858. We learn of the birth of Baylor University in 1845. Then the railroads enter the picture; or, rather, they don't enter the picture. At least they don't enter Independence. Baylor becomes segregated by sex (the role of the railroads in this is unclear), then it (Baylor) leaves for Waco. Sometime after (never mind how long, precisely) Independence declines into what Baker calls "only a rural community," and then, by the mid-1980s, Independence makes it into Baker's *Ghost Towns of Texas*.

Baker's description is bracketed by a cartographic representation (at the beginning) and directions on how to drive to Independence (at the end). The map [fig. 2] is curious and I can't resist a brief glance at it. There is, in fact, much one could say about this map if there were time enough—its roads, for instance, that begin and end precisely nowhere. But I'll look now only at the interesting contrasts the map encodes within its semiotic between Brenham (which exists as an actual—and therefore unimportant, uninteresting, and, finally, empty—town) and Independence, a town that exists only as a ghost and is therefore located nowhere *in particular* on the map. Its significance, however, is beyond doubt. Though the map has no title or legend it signals the importance of Independence by the word's font—and also, in fact, by its very refusal to locate it in space; its absence therefore becomes its defining feature and the characteristic that holds our attention. Brenham, on the other hand, certainly is located on the map,

Figure 2. Source: T. Lindsay Baker. *Ghost Towns of Texas.* Norman: University of Oklahoma Press, 1986.

but is depicted as nothing *but* location—and a location that is utterly empty: we're given merely a box surrounding yet more of the white noise of the map's blank spaces. Based upon the codes of the map, Independence—which exists only under erasure—matters because it holds meaning, while Brenham—which does exist, though we're either unsure why it should or utterly indifferent to it—doesn't matter at all. We're looking at a strange and remarkable map here: an image of negative space and purely positive meaning, a photo-cartographic film negative in which all our traditional spaces and meanings are reversed and as such constitute only a spectral—a ghostly—representation of the space of the world.

4

I would like to close this discussion by considering—both as a testimonial and as something of a test case—what strikes me as a wonderfully apt fragment of the kitsch culture identified by Jameson in his repudiation of postmodernism as typical of contemporary simulacral America. Let's turn, then, to what is (after a sort) the "grade-B Hollywood film" utterly dedicated to surface, schlock, and sheer images: from Fredric Jameson to Mel Brooks; from "The Cultural Logic of Late Capitalism" to (perhaps inevitably) *Spaceballs*.

On the one hand (and I speak this as a true fan of films such as *Blazing Saddles* and *Young Frankenstein*), *Spaceballs* is, well, mostly a pretty poor version of its more successful forebears, with only one of its liabilities being the fact that it is not really very funny. On the other hand, *Spaceballs* is interesting *as an idea* because it is *deliberately* schlock: that is its point. At the same time it is a more or less vulgar film about the vulgarity of American films—especially in the era of late capitalism—particularly, of course, the *Star Wars* films (still further evidence, if any were needed, that some things will not stay dead). One feature of Brooks's parodic remake (which should perhaps be called his "un-make" of the *Star Wars* films) is his obvious disgust at the Lucasfilms notion of the film as a method of merchandizing—which for many of us (especially those of us who have miniature Skywalkers and Vaders lying about in plastic bins in our own homes) is entirely on-target. Brooks's film, then, is exactly that sort of thing Jameson's critique could not quite imagine: the self-conscious and parodic simulacrum. On some level, perhaps, Brooks finds our culture's obsession with filmic images nearly as disturbing as Jameson does (though perhaps because *not enough* of those images are Brooks's own). I won't quite claim that *Spaceballs* is the film version of "The Cultural Logic of Late Capitalism," but the critiques each offer of "consumers' appetite for a world transformed into sheer images of itself" are quite compatible.

There is one scene in *Spaceballs* in particular that warrants, I think, a further moment of consideration. Let me quickly set the scene. Lord Dark Helmet has just witnessed the escape of the royal Princess Vespa who, along with her rescuers, has disappeared from the scanning screens of the Imperious Fleet's mothership, leaving no trace behind. Quite literally in the face of the blank radar screen, he is unsure of how to locate the rebels. Then, the ship's commander, Colonel Sanders, begins the following astonishing exchange:

COL. SANDERS: I have an idea. [*To the Corporal operating the radar station*] Get me the videocassette of *Spaceballs, The Movie.*

[*The Corporal goes to a set of shelves, labeled "Mr. Rental," where he finds an entire row of Mel Brooks's films on videotape. He searches for* Spaceballs.]

LORD HELMET: Colonel Sanders, may I have a word with you?

COL. SANDERS: Yes, sir.

LORD HELMET: How can there be a cassette of *Spaceballs, The Movie?* We're still in the middle of making it!

COL. SANDERS: That's true, sir. But there's been a new breakthrough in home video marketing.

LORD HELMET: Yes?

COL. SANDERS: Yes. Instant cassettes. They're out in stores *before* the movie is finished.

LORD HELMET: No.

CORPORAL: Here it is, sir.

COL. SANDERS: Good work, Corporal. Punch it up.

[*The video screen displays the FBI warning.*]

COL. SANDERS: That's much too early. Prepare to fast forward.

CORPORAL: Preparing to fast forward.

COL. SANDERS: Fast forward.

CORPORAL: Fast forwarding.

[*The video screen displays fast-action sequences from the film.*]

COL. SANDERS: Try here. Stop.

[*Video screen goes to real-time display: all three characters are visible both in the frame of the film and on the video display. Lord Helmet and Colonel Sanders alternately turn from the screen toward the camera, then back again.*]

LORD HELMET: [*Facing the camera, with back to video screen and other characters*] What the hell am I looking at? When does this happen in the movie?

COL. SANDERS: Now. You're looking at now, sir. Everything that happens now, is happening now [*pointing to the video screen*].

LORD HELMET: What happened to then?

COL. SANDERS: We passed it.

LORD HELMET: When?

COL. SANDERS: Just now. We're at now-now.

LORD HELMET: Go back to then.

COL. SANDERS: When?

LORD HELMET: Now?

COL. SANDERS: Now?

LORD HELMET: Now!

COL. SANDERS: I can't.

LORD HELMET: Why?

COL. SANDERS: We missed it.

LORD HELMET: When?

COL. SANDERS: Just now.

LORD HELMET: When will then be now?

COL. SANDERS: Soon.

There are, I find, many things to think about and many things to say in response to this moment of postmodernity (if that's what it is—if it isn't, in other words, just "mere" schlock): for instance, the way in which Brooks conflates the movement through space with the movement through time—both are a figured on the model of the "fast-forward" function; or, what I take to be the truly astonishing moment when Lord Helmet and his men (by the function of a button) can in fact fast-forward *past* the "now-now," to the future of the film's present, which they succeed in occupying seemingly unknowingly for the rest of the film—or, I suppose, for the rest of time (this makes me wonder what is to become of the "now-now" that "now" becomes, in effect, the "now-then"? Perhaps there will be a sequel?).

But what I find most striking in this scene—in this staging of the collapse of the distinction between temporality and spatiality—is the way in which in order to confirm what they suspect as they look at a screen displaying themselves "even now" looking at a screen, Lord Helmet and Colonel Sanders turn immediately and repeatedly *to the camera* to see (somehow) if what they are looking at is actually the instantaneous visualization of the present moment. But this gesture is more complicated than this initial formulation allows, for in looking "behind" themselves at the camera, they are also looking at us viewers. This is just the gesture identified at the beginning of this discussion in Klee's "angel" who—at least in Benjamin's reading—is looking with something like horror at the endlessly accumulating junk of history. But the angel also looks out at its viewers, who are then cast alongside—if not literally within—the historical debris. Moreover, in looking at the place of the viewer, the angel also looks outside the frame of the painting to the very place of the artist who produces such images as the "Angelus Novus." This dense and over-determined dynamic of positionality and image—producer (if you will), produced (or product), and consumer—can serve as an emblem for the sort of post-historicist heterology toward which I have been gesturing. Such an ethics envisions (and perhaps requires) a world outside or beyond what Michel de Certeau called the "tyranny of chronology" and (I would add) the terror of a failed system for the encounter with otherness. This gaze across a newly re-theorized spatiality, I want to say, is the gaze that we offer to ourselves—for it is we, after all, who occupy the very place figured here of the producer and the consumer of aesthetic images,

and it is an unwillingness to see this that disallows Jameson from under-
standing that even as we are the consumers of postmodern (simulacral)
culture, we are also necessarily its producers. In the end, the gaze across
time and space of Klee's angel is the gaze of the ghost, that figure of the
past that returns to us—as does ethics—in the form of memory and that
serves to fix us and ground our own responsibility to otherness in history
and otherness in itself. But is this not also the beginning?

Notes

1. Walter Benjamin, "Theses on the Philosophy of History," in *Illuminations*, ed. Hannah Arendt, trans. Harry Zohn (New York: Schoken Books, 1969), 257–58.
2. Tzvetan Todorov, *The Conquest of America: The Question of the Other*, trans. Richard Howard (New York: HarperPerennial, 1984), 247.
3. Jorge Luis Borges, "The Aleph," in *The Aleph and Other Stories, 1933–1969*, ed. and trans. Norman Thomas Di Giovanni (New York: Dutton, 1978), 23. Subsequent references appear parenthetically.
4. Italo Calvino, "All At One Point," in *Cosmicomics*, trans. William Weaver (New York: Harcourt & Brace, 1968), 43. Subsequent references appear parenthetically.
5. Edward W. Soja, *Postmodern Geographies: The Reassertion of Space in Critical Social Theory* (London and New York: Verso, 1989). See especially chapters 1, 2, and 5.
6. Michel Foucault, "The Eye of Power," in *Power/Knowledge: Selected Interviews and Other Writings, 1972–1977*, ed. Colin Gordon (New York: Pantheon Books, 1980), 149.
7. Michel Foucault, "Questions on Geography," in *Power/Knowledge: Selected Interviews and Other Writings, 1972–1977*, ed. Colin Gordon (New York: Pantheon Books, 1980), 70.
8. Michel Foucault, "Of Other Spaces," *Diacritics* 16:1 (1986): 22. Subsequent references appear parenthetically.
9. Walter Benjamin, "A Berlin Chronicle," in *Reflections: Essays, Aphorism, Autobiographical Writings*, ed. Peter Demetz, trans. Edmund Jephcott (New York: Schoken Books, 1978), 28. Subsequent references appear parenthetically.
10. Fredric Jameson, "Postmodernism, or The Cultural Logic of Late Capitalism," *New Left Review*, no. 46 (1984): 55. Subsequent references appear parenthetically. See also Jameson's book *Postmodernism, or The Cultural Logic of Late Capitalism* (Durham: Duke University Press, 1991), especially chapter 1.
11. See the third chapter ("Political Maps: The production of cartography in early modern England") in my *Narrative and Meaning in Early Modern England: Browne's Skull and Other Histories* (Cambridge: Cambridge University Press, 1997), 63–91.
12. T. Lindsay Baker, *Ghost Towns of Texas* (Norman: University of Oklahoma Press, 1986). Subsequent references appear parenthetically.

MEXICO'S GAS, MEXICO'S TEARS
Expositions of Identity

David E. Johnson

Para Margarita

Mexico repeats itself. It is haunted by bad breath, by the stillborn self–exhalation that returns one to oneself as a corpse, dead. Mexico's self–expression, in other words, threatens to release itself as an unwanted cultural effluvium, a gas that no one wants, to which no one confesses: the hot breath that leaves others cold, that expiration of life. Some critics figure such repetition as a return that adds up to the malodorous expression of a derivative European identity. For others, this repetition, once acknowledged, makes possible the formation—out of thin air—of a properly Mexican identity that waves off the lingering remains of Amerindian spirit.

This essay maps these two relations to Mexican cultural identity by briefly reading the figures of repetition, imitation, and translation in José Vasconcelos, Samuel Ramos, Octavio Paz, and Carlos Fuentes, in order to think of the problem of *lo mexicano* as the problem of understanding the relation between Europe and Amerindia. From these principal articulations of cultural criticism to two recent—and ongoing—attempts to reground the fundamental place of Indianness in the discourses of Mexicanicity: Guillermo Bonfil Batalla's *México profundo* and the *documentos y comunicados* of the Zapatistas, the EZLN (*Ejército Zapatista de Liberación Nacional*). These revolutionary documents elaborate different, but related, definitions of Indian identity that make a claim for grounding national political reform in Mexico in more inclusive—Indian—notions of democracy. In their calls for democratization, Bonfil Batalla and the Zapatistas mime the pleas of Fuentes and Paz and, indeed, most critics of Mexican culture and politics. No doubt Mexico awaits democratization; yet, to the

extent calls for democratization depend on uncritical claims for dialogue and an unproblematized notion of representation, the Indian democracy heralded in Bonfil Batalla and practiced in the Zapatista texts in no way jeopardizes the formation of an exclusive cultural identity. Indeed, such democratization repeats, albeit from another "place," the problem that currently plagues Mexico's political system and its exposition of culture: namely, an unethical relation to the other. Finally, the essay turns toward what is routinely considered the watershed of post-Revolution Mexican history, October 2, 1968, the massacre at Tlatelolco, and a reading of the seminal text of that event, Elena Poniatowska's *La noche de Tlatelolco*, in order to consider the future of Mexico and Mexican history.

In short, "Mexico's Gas, Mexico's Tears" presents the barest outline of a strategy for reading twentieth-century Mexican critical discourse; it is, then, prolegomenon to a longer, as yet unwritten, essay that would take up, much more rigorously, the sites and cites of Mexican cultural identity. As the schema for an essay to come, it begins by polarizing, by remarking on and marking out, two views of Mexico in two of its most popular novels: Juan Rulfo's *Pedro Páramo* and Laura Esquivel's *Como agua para chocolate*.

The most celebrated Mexican novel of the twentieth century, *Pedro Páramo* takes place on an arid plain, in Comala, scorched by an incessant wind, *un viento interminable*, that isn't simply meteorological: Comala, then, "*donde se ventila la vida como si fuera un murmullo; como si fuera un puro murmullo de la vida* [where life is aired as if it were a murmur; as if it were a pure murmur of life]."[1] In Comala, Juan Preciado, who will have returned to fulfill an obligation to his dead mother—to find and charge his father, Pedro Páramo—claims, "*me mataron los murmullos* [murmurs killed me]" (Rulfo, 196; 58, translation modified). Murmurs, whispers, that breath, will finally explode, release itself: "*Y cuando me encontré con los murmullos se me reventaron las cuerdas*" (Rulfo, 196). It is an unfortunate translation of this sentence that would lose its connection to voice and spirit. *Cuerdas* are not, as Margaret Sayers Piden reads them, a "dam" (Rulfo [trans.], 58). They are chords, vocal chords; within the context of vocal music, which Hegel understood to be the most perfect expression of spirit, *cuerdas* means, simply, voice.[2] Overburdened with murmurs, the voice bursts, *se me reventaron las cuerdas*. This bursting is akin to a fart, a burp. When conjugated in the first-person singular, as it is later in the novel when Padre Rentería, not feeling well, goes outside, "*A ver si así reviento*" (Rulfo, 209). *Reviento* means "I burst" or "I

explode"; but it is constructed of the prefix "*re*" and the word for wind, "*viento*." *Reventar*, in short, implies the return (again) of a certain hot air, a breath, a *mal oliento*. This gas we will call the voice, its bursting forth as the expression, *en voz alta*, of a murmurous and deadly spirit. The return of spirit, its repetition.

Pedro Páramo addresses this return, the question of what one gives to others, of what one owes to oneself. From the first page, *Pedro Páramo* accounts for debts, obligations: a mother obligates her son, upon her death, to collect from his father what he will have owed her all his life. "Don't ask him for anything. Just what's ours. What he should have given me but never did. . . . Make him pay, son, for all those years he put us out of his mind" (Rulfo, 149; 3). With this as its point of departure, *Pedro Páramo* pursues debts everywhere, and in so doing, it gives an account of the expression of Mexican spirit in the *darse cuenta*, the reflexive idiom that articulates consciousness as the remainder of an apparently closed economy of encounter.

Consciousness is the by-product of a scene of encounter, of a certain *rescate*, the giving to oneself of the bead and the bill. An accounting for ourselves that, *a fin de cuentas*, indebts us to others, to others ourselves. The *cuenta* is this account that is also the bill and the bead. This incalculable circulation of beads and bills casts off consciousness: *darse cuenta* means "to be aware," "to realize."

Everyone in *Pedro Páramo* is dead. If Rulfo's novel amounts to a comment on post-revolutionary Mexican culture, the implications are dire: Mexican cultural consciousness is deadly. The possibility of cultural identity, consciousness of self, is the death of cultural identity. The exchange that would save (*rescata*) culture, kills it. Mexico returns to itself in *Pedro Páramo*, repeats itself, as a ghost, as an "*eco . . . encerrado*" (Rulfo, 175; 33). The history of twentieth-century Mexico will be less a chain (*una cuerda*) of events shot through with a particular spiritual identity, than the repetition *ad infinitum* of *darse cuenta*, of that scene, that event at which we are not yet present, at which we will present ourselves only as an echo in an empty room. The history of Mexico, if there is one, Rulfo suggests, will be a still-birth to presence in which "*se detuvieron el mismo ruido de la conciencia* [the very sound of consciousness had been still]" (Rulfo, 174; 32).

More recently, in *Como agua para chocolate*, Laura Esquivel rewrites Rulfo's criticism, indicting the cultural tradition that threatens to destroy the love that could save us. Rosaura, who would pass to her only daughter the legacy that effectively condemned the youngest to the sterile life of

caring for her mother, literally passes away: "*cuerpo desinflado, ojos desencajados, mirada perdida, que daba su último y flatulento suspiro.*"[3] The air will have gone out of her, and, too, out of a tradition that denied the emotional ligatures between people.

If Rulfo privileges the inhuman voice—rumor, murmurs, whispers—in the "*valle de lágrimas*" (Rulfo, 174) that is *Pedro Páramo* and Mexican history, Esquivel subordinates that voice to the articulated immediacy of emotional experience: the blood drawn from a breast pricked by the thorns of roses that will, in *codornices en pétalos de rosas*, excite orgasms; tears shed over a bad marriage that fall into the batter of *pastel chabela*, which will in turn provoke mourning and fits of vomiting. And if Rulfo suggests there is no hope for Mexico, no salvation, only the endless circulation of indebtedness, Esquivel points in another direction, away from the materiality of the economy of *cuentas*—a tradition, Tita claims, she will break as long as it does not take her into account ("*esa maldita tradición no me tome en cuenta*")—and toward the immateriality not of a mediated voice but of a more immediate sensory perception, *el olfato. Como agua para chocolate* recounts, then, a double history: it is, on the one hand, the chronological sequence of events that leads to the dismantling of a family tradition and, on the other hand, a manual for preparing the dishes that would enable the production of the *smells* that literally save not Tita, but *Esperanza. Como agua para chocolate*, in short, saves *esperanza* in and for Mexico.

Although the cookbook is written, its origin is other, not alphabetic and western, but immediately spiritual and native: all the recipes for Mexico's salvation come from Nacha, the Amerindian cook who raises Tita in the kitchen, pacifying her sorrow, calming her heart, and from *Luz de Amanecer*, the Native American grandmother of the Anglo doctor, John Brown. *Como agua para chocolate* thus prescribes the immediate return to Mexico's origin: an Amerindian experience. The immediacy of Amerindian experience will restore Mexico to itself, cure and heal her, give her *Esperanza*, if only, as in *Como agua para chocolate*, in order to marry her to a North American youth.

Rulfo and Esquivel thus mark the two extremes of post-revolutionary Mexican history: the one, written under the aegis of the *darse cuenta*, comprehends Mexico's past and its future, perhaps, as the economy of encounter, an exchange that even as it gains consciousness, loses life; the other, written within the horizon of Amerindian hope, rejects that economy and dreams instead of a return to an immediate experience of others, of ourselves, that will save us for the future. In both cases it is a question

of a return: the return of the *cuenta* that returns (to us) both consciousness and death; and the return to a happy origin, before consciousness, perhaps, before the mediating effects of an economy of encounter, in order to rescue Mexico from debilitating exchange.

Mexican cultural criticism, both before and after Rulfo, has been concerned to avoid the effects of Rulfo's elaboration of Mexican cultural identity, of Mexican cultural history; it has in large measure attempted to restore *Esperanza* to Mexico, to write her back into Mexican identity. In every case the question of repetition, of Mexico's derivation from, or imitation and importation of, European cultural forms has troubled Mexican cultural critics. From European spirit to Mexican gas, from voice to flatulence: Mexican cultural identity owes itself to Europe, performs itself as the second-coming, appearing always "as if"—*como si*—it were Europe.

In *El perfil del hombre y la cultura en México*, one of the principal texts in the thought of *lo mexicano*, Samuel Ramos argues that "Mexico has fed itself, during its entire existence, on European culture."[4] Although he will not agree with Ramos's argument, Carlos Fuentes nevertheless follows its general outline in *Tiempo mexicano*: "Perhaps the cultural history of independent Mexico could be divided into three stages. The first, until the end of Díaz's dictatorship, shows a marked tendency ... to what Antonio Caso called '*la imitación extralógica*': an imported culture."[5] For his part, Ramos notes that "Mexicans have imitated for a long time without realizing what they were imitating" (Ramos, 98). Unconscious imitation would be a "national vice" the knowledge of which Ramos considers "indispensible as a point of departure to undertake seriously spiritual reform in Mexico" (Ramos, 89). Imitation, then, does not trouble Ramos about Mexican identity; rather, the lack of self-consciousness disturbs him. Indebtedness to Europe is not the problem; not accounting for such indebtedness is. Indeed, Ramos calls self-conscious imitation "assimilation," and argues that it is a "better procedure for deriving by natural means one culture from another" (Ramos, 102). Again, like Ramos, but in a different direction, Fuentes indicates the end of imitation in the violent birth of self-consciousness: "near the end of Porfirio Díaz's reign, the novels of Rabasa and Frías, the poetry of Othón, and the etchings of Posada announced a discovery: that of Mexico by itself. The Revolution, in essence a period of nonexistence, of being alienated, being for itself, was the act itself of that discovery" (Fuentes, *Tiempo*, 83).

For Ramos, assimilation enables the construction of a cultural identity that brackets any Indian contribution to *lo mexicano*: "it is true that there was *mestizaje*, but not of cultures; when the conquerors came into contact

with the Indians, Indian culture was destroyed" (Ramos, 102). Mexico becomes itself, according to Ramos, "with the infusion of foreign materials that come from a past culture, which it, rejuvenated by the new vitality [*savia*], changes into another living form of the human spirit" (Ramos, 103). This transformation takes place via what Ramos calls "the intimate assimilation of culture" (Ramos, 102).

Ramos emphasizes the life (*savia*) of this new spirit that translates itself from Europe without becoming, in the repetition, dead. Life comes from Europe. Nothing lives in the Americas before Columbus. He writes that Mesoamericans "let themselves be conquered [*se dejó conquistar*] perhaps because their spirit was already disposed to passivity. From before the conquest, the Indians were disinclined toward any change, toward any renewal" (Ramos, 107). Their art, he argues, "notes in a clear way the propensity to repeat the same forms" (Ramos, 107): "The monumental artistic style of the pre-Cortesian epoch reveals a scarce imagination [*fantasía*], dominated almost always by a ritual formalism. . . . The expression of the art of the Mexican plateau is the rigidity of death, as if the hardness of stone had conquered the fluidity of life" (Ramos, 108). Remarkably, Ramos sustains a version of the Quetzalcoatl myth that claims Amerindians welcomed Cortés as a returning deity, that the conquest appeared to Amerindians as a kind of homecoming: "In order for us to be able to say that a derivative culture has been formed, it is necessary that selected elements of the original culture already be unconsciously part of the spirit of that country" (Ramos, 103). In other words, according to Ramos, the essential part of Europe was hiding in Mesoamerica all along; exposed by conquest, it will appear degraded in the Americas, as an imitation of what (it) perhaps came before.

El perfil del hombre y la cultura en México responds to and perhaps radicalizes José Vasconcelos's dream of the future of humanity in *La raza cósmica*. Vasconcelos argues that the current epoch of humanity—dominated by reason—ultimately will give way to the aesthetic era, in which, according to Didier T. Jaén, "There will be no norms to regulate conduct, since actions will be based on feelings, dictated by the pathos of aesthetic emotion."[6] The new epoch will coincide with the appearance of the cosmic race, "a new human type," Vasconcelos writes, "composed of selections from each of the races already in existence" (Vasconcelos, 43; 3). The aesthetic era is, accordingly, *una etapa mestiza* (Vasconcelos, 44; 4). Such *mestizaje*, however, is not indiscriminate because only "the mixture of similar races is productive," the most productive coming from the mixing of races of European origin: "The mixture of dissimilar ele-

ments," in fact, "takes a long time to mold" (Vasconcelos, 45; 5). Although he argues that "no contemporary race can present itself alone as the finished model that all the others should imitate," pointing out that "the mestizo, the Indian, and even the Black are superior to the White in a countless number of properly spiritual capacities," Vasconcelos nevertheless remarks that "the White race has brought the world to a state in which all human types and cultures will be able to fuse with each other" (Vasconcelos, 72; 49; 32; 9). Yet, because the epoch following the age of reason will be defined by aesthetics and governed by aesthetic feeling, it appears initially that the white race will have prepared the ground for its own eclipse. Vasconcelos makes clear, however, that such is not the case:

> The lower types of the species will be absorbed by the superior type. In this manner, for example, the Black could be redeemed, and step by step, by voluntary extinction, the uglier stocks will give way to the more handsome. Inferior races, upon being educated, would become less prolific, and the better specimens would go on ascending a scale of ethnic improvement, whose maximum type is not precisely the White, but that new race to which the White himself will have to aspire with the object of conquering the synthesis. The Indian, by grafting onto a related race, would take the jump of millions of years that separate Atlantis from our times, and in decades of aesthetic eugenics, the Black may disappear. (Vasconcelos, 72; 32)

On the one hand, *mestizaje* improves Amerindians and redeems—by obliterating—blacks; on the other hand, it presents whites only a challenge. This despite Vasconcelos's understanding that the aesthetic era will be regulated according to "the laws of emotion, beauty, and happiness," that in spiritual capacities, "the mestizo, the Indian, and even the Black are superior to the White" (Vasconcelos, 70, 72; 30, 32).

The engine of mixing, for Vasconcelos, is love, Christian love, which will, he writes, act upon a race "full of vices and defects," whose graces nonetheless include "malleability, rapid comprehension, and easy emotion" (Vasconcelos, 77; 37). Vasconcelos proposes the work of a nonviolent, bio-spiritual conversion that will change the world: "in the new order, by its own law, the permanent elements will not support themselves on violence but on taste, and, for that reason, the selection will be spontaneous, as it is done by the artist when, from all the colors, he takes only those that are convenient to his work" (Vasconcelos, 77; 32). The analogy is apt, but it does not indicate the color the artist chooses except, perhaps, to the extent the essay in its entirety clarifies the places of the races in the mixture. Put simply, as Vasconcelos sees it, mixing whitens. Vasconcelos

leaves in place, as the agent of mixing, Christian love. Because love governs mixing—and thus selection and extinction—those who do not share the value of Christian love will not feel the pain of their exclusion; they will not suffer the violence of a "primitive biological Darwinism," which Vasconcelos calls "simple and brutal" in its "exterminat[ion] of the weak" (Vasconcelos, 77; 37). Everything will be mixed except Christian love, except, then, a certain Western relation to the other.[7]

Although he admits that "civilizations cannot be repeated," Vasconcelos nonetheless understands the possibility of the cosmic race within the frame of a return or a second-coming (Vasconcelos, 74; 34). For two reasons: first, because due to the purity of Christian love and the challenge mixing presents to whites, the result will be, again, a certain conquest of others; second, because he locates the birthplace of the cosmic race in the Americas, which, he argues, "is the fatherland of gentility, the true Christian promised land" (Vasconcelos, 75; 35). With the genesis of the cosmic race, civilization returns to the Americas after a long absence. Early in *La raza cósmica*, Vasconcelos remarks that Atlantis was "the cradle of civilization that flourished millions of years ago in the vanished continent and in parts of what is today America" (Vasconcelos, 47; 7). "Traces of this civilization," he claims, "are still visible in Chichén Itzá and Palenque" as signs of the "red men who, after dominating the world, had the precepts of their wisdom engraved on the Emerald Table, perhaps a marvelous Columbian emerald, which at the time of the telluric upheavals was taken to Egypt, where Hermes and his adepts learned and transmitted its secrets" (Vasconcelos, 48; 8). From the moment of its foundation, Western civilization will be the translation of a "civilization" always already-vanished. Vasconcelos writes that "after its extraordinary flourishment, after having completed its cycle and fulfilled its particular mission, it entered the silence and went into decline until being reduced to the lesser Aztec and Inca empires, totally unworthy of the ancient and superior cultures" (Vasconcelos, 49; 9). The decline in the Americas signals the translation of this spirit to the East: "The intense civilization was transported to other sites and changed races: it dazzled in Egypt; it expanded in India and Greece" (Vasconcelos, 49; 9). On the one hand, Atlantis was the site of the oldest civilization, its veritable birthplace; on the other hand, the Atlantic is the newest ocean and the sea across which civilization (Christian love) will move to establish itself in the fatherland (America) of the cosmic race, thus opening "the era of universality and cosmic sentiment" (Vasconcelos, 75; 35). The new epoch marks a return to the location, the home, of that civilization that will have made possible

civilization in the West, even as its departure from the Americas precipitated Amerindian decadence.

Ramos is already legible in this effort to point toward an American (Atlantean) origin of the civilization that nonetheless flourishes in and ultimately returns to the Americas from Europe, from Greece. Vasconcelos, like Ramos, promotes assimilation to European values, even though for Ramos such values are rational, whereas for Vasconcelos they are grounded in Christian sentimentalism. The result is the same: the inclusion of Indians as the *dead* weight of the Americas. Ramos's hard stone of Indian culture that defeats the fluidity of life is, in Vasconcelos, "a few carved stones piled upon each other" that threaten to disturb any hope for the progress of human civilization (Vasconcelos, 48; 8).[8]

Nearly half a century later, Paz recovers this ground. In the aftermath of Tlatelolco, the violent suspension of the *movimiento estudiantil* in the *Plaza de las Tres Culturas* on October 2, 1968, Paz takes a position not unrelated to Ramos's understanding of a self-aware assimilation when he writes that without self-consciousness actualized as *autocrítica*, "*no hay posibilidad de cambio* [There is no possibility of change]."[9] Paz reads Tlatelolco, which, Luis González de Alba writes, divides Mexico from itself,[10] as the repetition—the twentieth-century translation—of the "so-called 'disturbances of 1692,'" which exposed the fragile underpinnings of an apparently prosperous New Spain, the centerpiece of which, Mexico City, appeared to Alexander von Humboldt to rival Paris, Berlin, and Saint Petersburg.[11] Indeed, like Ramos before him, Paz imagines a double Mexican spirit, one European or Western, "developed"; the other, Indian or "underdeveloped." Mexico's developed half, according to Paz, does not correspond to "our true historical, psychic, and cultural reality"; it is, rather, "a mere copy (and a degraded copy)" (Paz, *Posdata*, 107–8; 286). And like Ramos, Paz understands that the interred other maintains an estranged relation to the superficial Mexican self: "*el espíritu no se ha ido: se ha ocultado*" (Paz, *Posdata*, 108; 286). Tlatelolco, Paz explains, has a double reality: "it is a historical fact and it is also a symbolic representation of our subterranean or invisible history" (Paz, *Posdata*, 114; 291). Yet, whereas Ramos writes to untie Mexico's *vinculación* to Indian cultural identity, Paz remains more ambivalent, marking instead the constitutional indebtedness to the other, the dialogical production of the self that recognizes the other within: "As with the Moebius strip, there is neither inside nor outside, and otherness is there, beyond, but here, within: otherness is ourselves"; and, "The other Mexico, the submerged and repressed, reappears in the modern Mexico: when we talk

with ourselves, we talk with it; when we talk with it, we talk with ourselves" (Paz, *Posdata*, 109; 287–88).

Paz concludes by calling for "self-criticism": he explains that "to communicate with others we must first learn to communicate with ourselves," which means, "we" must "listen" "to what Mexico is really saying" (Paz, "Introduction," xvii). Otherwise, Mexico is doomed to repeat itself once more, to have to await, Paz predicts, another century, another *manifestación*; to await, then, the violent reappearance of Mexico's buried other self, that "gaseous reality of beliefs" (Paz, *Posdata*, 109; 287). For Paz, dialogue with the other ourselves adds up to the self-consciousness (*darse cuenta*) that would disarticulate the repetition of historical events like those of 1692 and 1968. Dialogue thus makes possible the reconciliation of the invisible Mexico and the visible one, and thus produces *unidad*. Moreover, according to Paz, it enables the construction of models of "development" appropriate to Mexico, relieving Mexico of its uncritical imitation of North American economic and governmental models. Dialogue would thus be the political strategy or method that would save Mexico.

This is not a hope unique to Paz. Since 1968, at least, dialogue has been the key term, the principal demand pursuant to any democratization of Mexican politics. Elena Poniatowska's *La noche de Tlatelolco*, the testimonial account of the *movimiento estudiantil* and the massacre at Tlatelolco on October 2, 1968, reports that the students sought a "public dialogue" with the government (Poniatowska, 37). "*Diálogo*" was one of the principal chants during the many *manifestaciones*, demonstrations, that summer of 1968. In the calls for dialogue, there is, moreover, the unstated assumption that dialogue enables access to truth and that the truth will set us free. In short, dialogue would be the minimal condition for democratization. In *Días de guardar*, Carlos Monsiváis suggests as much when, after observing that the student movement of 1968 depended only on the students' faith in their own efforts to democratize the country, he quotes the slogan, "*Libertad a la verdad. ¡Diálogo!*"[12] According to Beth E. Jörgensen, beyond the specific demands of the student movement, for many "it embodied broad hopes for a more open, democratic society . . . and a freer dialogue between those in power and those who, fifty years after the revolution, remained powerless."[13] In the wake of 1968, dialogue remains elusive. In *Tiempo mexicano*, Fuentes writes that "fifty years after the Madero-inspired revolution, Mexico still has no system for democratic expression" (Fuentes, *Tiempo*, 70). He argues that the absence of democratic expression owes itself to the lack of a "free" press: "Mexico's newspapers have consecrated the insult with exclusion from the debate

... of objectivity (understanding by objectivity, in its impossible purity, the plurality of reasonable points of view, dialogue, conviction, informed debate)" (Fuentes, *Tiempo*, 74). In sum, the "radical absence of intelligent dialogue or of constructive debate," Fuentes notes, "has been one of the principal factors of civic death in Mexico" (Fuentes, *Tiempo*, 75).

The value of dialogue lies in its apparent immediacy: it amounts to a seemingly transparent, face-to-face encounter with others at an ostensibly inclusive table. Indeed, there is a too-easy identification of dialogue and democracy, perhaps because dialogue suggests open-mindedness and open-endedness in service of consensus. There are, of course, any number of representations of dialogue, including those that remain unrecognizable to at least some of the participants.[14] Whether there is or is not dialogue thus depends on what counts as dialogue among us. In 1968, when students called for public dialogue, the government, in a certain way, obliged, at least enough so that during a meeting of the National Strike Committee (CNH), someone had to ask, "Can a telephone call be considered a public dialogue?" (Poniatowska, 38; 30). And although Jan Poniatowski Amor claims "The PRI doesn't go in for dialogues, just monologues," that monologue, too, is figured as dialogue: "The government has been talking *to itself* [*que el gobierno monologa con el gobierno*] for fifty years now" (Poniatowska, 90; 38; 86; 30, emphasis added).

If, as Fuentes suggests, "*política es diálogo*," then politics—and not only democratic politics—happens, if it ever does, always and only in the representation of sides, in the production of opposition.[15] If, in other words, there is only dialogue, if that is the only political possibility, the question of dialogue is no longer—indeed, never was—of starting it, but of controlling it. It is a question of the frame, then. The issue is how it is represented. Dialogue is perhaps never open, never the transparent space of correspondence without representation. In 1968, for example, Tlatelolco perhaps will have been the last word in a public dialogue: it will have been the PRI's response to student demands.[16]

So, too, the problem of the Zapatista request for dialogue with the Salinas de Gortari administration in 1994 is one of recognition. The federal government ultimately sends former mayor of Mexico City Manuel Camacho Solís as commissioner for peace to Chiapas to discuss with representatives of the EZLN (including *el subcomandante* Marcos) the terms of a political—as opposed to military—solution to the conflict. Although there will be *diálogo*, its limits are decided on both sides independently of the other, including the Zapatistas' decision to suspend the dialogue, both in order to consult with *el pueblo indígena* and in order to report, along

with the results of the *consulta*, the EZLN's continued openness to dialogue "*en el tránsito a la democracia.*"[17] On the same day, the EZLN dismisses the government's efforts as a "vain attempt" to reduce "the importance of our just struggle to local, Indigenous concerns, including to limit it to four townships in the southeastern state of Chiapas" (*EZLN* 260; *Zapatistas* 324). The EZLN then renews its demand that Salinas de Gortari renounce the presidency and that a transitional government be installed to effect democratic reforms. Subsequently, on June 27, 1994, Marcos invites Fuentes to participate in the *Convención Nacional Democrática* in Aguascalientes, Chiapas, which the EZLN would "recognize . . . as the authentic representative of the interests of the Mexican people in their transition to democracy" (*Zapatistas* 335). Fuentes responds on July 5, remarking that "in 1994, Salinas de Gortari admits that Mexico's problems are the responsibility of Mexicans and instead of exterminating, he dialogues. Give Salinas at least this recognition and abandon your absurd petition that he renounce his office" (Fuentes, *Nuevo tiempo*, 174). Then Fuentes seeks to rewrite the Zapatista invitation, broadening it to include "*un grupo plural de mexicanos y mexicanos distinguidos,*" a group with which Fuentes identifies.

Put simply, rather than taking place prior to democratization as that which opens the ground of democracy, dialogue, from the beginning, is marked by the problem of democratic politics: Who will represent "us" at the dialogue that will have to be represented and representative? Who will "we" recognize as representing "them"? In sum, who speaks when I say that I do? Ernesto Laclau points out that "at the heart of the notion of democratic control we find the paradoxes inherent in the notion of representation. The category of representation presupposes the *fictio iuris* that somebody is present in a place from which he or she is materially absent."[18] Democracy, then, is troubled by displacement, by the foundation of the subject in the subject's absence from the place of its articulation. Dialogue works the same way: we are never where we are said to be—even if we say so. The "locus of enunciation" is always already trespassed, crossed over and crossed out. Laclau testifies that "the unity of the people is only the negation of what opposes it," which implies that the "we" constituted in opposition to a negated other position also and necessarily fades away: "The negation of an identity does not involve within it the forms of identification that are going to open the way to a culture of resistance—that is to say, of those discursive forms that are going to provide a principle of reading that restores the intelligibility of

the whole situation" (Laclau, 227). The "whole situation" will be constituted in and over the *hole* in and of the situation: the whole supplies the hole, fills that lack; but it does so only by continually marking out the place of the hole. The question, then, for democracy, is how to effect representation of the whole on the (absent) ground of the hole, on the place of the absence of what will have been represented?

Laclau moreover indicates that the problem of representation indicts even extreme cases in which representation would appear not to be at issue:

> But let us take an extreme case, one in which there is apparently no representation at all—that is, one in which the same social agent whose basic identity is constituted in point *A* of society has to be present in point *B* in order to defend his or her interests. We would tend to say that here there is no representation at all, given that there is no duality representative/ represented. Nevertheless, we cannot avoid the impression that something such as a representation is taking place, even in this extreme case. The interest of the agent in situation *B* cannot simply be read off from the mere consideration of the starting point *A*. It requires a new interpretation that redefines the meaning of both *A* and *B*. (Laclau, 229)

"I" am (not) "I": in the representation of I, I slip away. The dislocation of representation spells trouble for democracy.

To the extent democracy's representationality parallels that of dialogue, dialogue becomes suspect. Not, however, because interlocutors do not present themselves from positions—as positioned subjects—and not because, perhaps, the other—subaltern or not—cannot speak, but simply because we can never be certain that we are in the place we represent ourselves to be. As with democracy, dialogue depends on correspondence, which means it necessarily runs the risk of noncorrespondence. We can never be sure that the address from and to which we respond agrees with us. Agreement here indicates that an other takes our side, that it confirms our place by occupying it with us. Such agreement or correspondence would be the minimal condition of dialogue, of interlocution. Dialogue is always interlocution, a movement between *loci* that necessarily assumes correspondence.

Derrida takes up such correspondence in "Restitutions," which he calls a "'polylogue' (for *n* + 1—female—voices)."[19] "Restitutions" is a dialogue between unidentified and finally unlocatable interlocutors on "the correspondence between Meyer Shapiro and Martin Heidegger" on Van Gogh's

shoes (Derrida, *Truth*, 270). It is impossible to know at any particular place in the dialogue how many participate or exactly where any one participant stands. The text states only that "we should wait until there are more than two of us before we start" (Derrida, *Truth*, 257); that another one of "us," perhaps already present, arrives late: "I've arrived late" (Derrida, *Truth*, 291); that another—again, one of "us"—has been excluded: "And you keep me at a distance, me and my request, measuredly, I'm being avoided like a castastrophe" (Derrida, *Truth*, 261) and "I came here [as a woman] to ask this question which nobody, since a moment ago, seems to have heard" (Derrida, *Truth*, 325); and, finally, that another of "us" returns late: "I've returned late" (Derrida, *Truth*, 379). All these others are in every case figured as "I." I speak in every place; indeed, I speak so often, "we no longer know whose turn it is to speak and how far we've got" (Derrida, *Truth*, 358). It would be a mistake, however, to infer that, in its failure or inability to determine—identify—the places in which others (I's in every case) speak, "Restitutions" reinscribes a transcendental subject. These I's, which perhaps add up to no more I's, are rigorously positioned at the moment of their articulation; yet, to the extent I (and all other I's, too) speak in every place, the question becomes to what extent any place corresponds to any particular I. It is, in short, a question of belonging, of property, of the "natural" relation between any I and the locus in which it speaks and is spoken. In "Restitutions" every I speaks in a specific place, but that place cannot be distinguished except perhaps at the moment of this particular articulation, which means, effectively, that every I is absolutely singular and that every I endures only as long as the articulation that exposes it. I belong to the exposition, which also exposes me to the possibility of no longer being exposed.[20] Interlocution, in short, is allocution.

Put simply—and this "Restitutions" performs—every I speaks someplace, but there is no place to which any I necessarily belongs. It is impossible, then, to know on which *side*, in which place, any I will show up. I always appear here and there. I am both monotopic and pluritopic, utopic and heterotopic. At the "same" time and in the "same" place. This is not to say that decisions are not made, that it is not decided by others where I stand; on the contrary, such decision decides for—determines—"us" and "them" in the same stroke.

For example, in *The Darker Side of the Renaissance: Literacy, Territoriality, and Colonialism*, a book that collects essays written over the course of a decade, Walter Mignolo elaborates his understanding of the locus of enunciation and the way in which the European Renaissance is

inscribed within early modernity's discourses of New World colonialism. Although his is not a "historiographical study proper," Mignolo nonetheless is interested in "trying to understand the past" as much as he is interested in "speaking the present."[21] He asserts, moreover, that "this understanding is a communal and dialogic enterprise, not solitary and monologic; the drive toward understanding arises not only from disciplinary and rational, but also from social and emotional, imperatives" (Mignolo, 5). He insists that "scholarly discourses . . . acquire their meaning on the ground of their relation to the subject matter as well as their relation to an audience, a context of description . . . and the *locus* of enunciation from which one 'speaks' and, by speaking, contributes to changing or maintaining systems of values and beliefs" (Mignolo, 5). Thus, Mignolo argues, "from the perspective of the locus of enunciation, understanding the past cannot be detached from speaking the present" (Mignolo, 5–6).

The paragraph following his account of the relation between understanding the past and speaking the present offers an interpretation of Mignolo's locus of enunciation: "The book has been written from the perspective of a literary scholar born and raised in Argentina" (Mignolo, 6). The locus of enunciation imports (auto)biography, the personal, into the previously methodologically separatist domain of scholarly work; yet, Mignolo writes, "by bringing this piece of autobiography into the foreground, I have no intention of promoting a deterministic relationship between place of birth and personal destiny. I do not believe that someone born in New York will be a broker, anymore than someone born in San Luis Potosí will be a miner or someone born in Holland a miller" (Mignolo, 6). On the contrary, far from being deterministic, Mignolo imagines that his autobiography makes clear what he brings to the labor of scholarly work: "I bring to the work those parts of my background that make me particularly sensitive to issues of bilingualism and of cross-cultural understanding" (Mignolo, 6). This explanation smacks of a certain voluntarism: Mignolo professes to be able to bring those "parts" of his experience that make him more sensitive to a bilingual and cross-cultural past and perhaps better able, therefore, to speak a similar present. What of those other parts of his experience, however, the ones that might precisely limit his ability to understand the past and speak the present? These parts Mignolo does not mention. In fact, with the importation of only those parts of his experience useful to the task at hand, Mignolo demonstrates the limit of interdisciplinary work, which *The Darker Side of the Renaissance* exemplifies: namely, Mignolo's rigorous disciplining of

experience enables him to keep separate the disciplines, to mark out the useful, to import it, leaving behind all that might not apply. What guarantees, finally, that Mignolo can limit his experience to those parts that are useful for this or that attempt to understand the past and speak the present? The guarantor is the authority of the *auto*: the transparency to the I of the I's autobiography enables the adequation of the I to this or that locus of enunciation. The transparency of itself to itself makes possible the I's particular stability at the same time that it displaces the other.

Although Mignolo claims that the locus of enunciation is nondeterministic, he nevertheless uses a certain biographical explanation to dismiss Derrida's critique of Western phallogocentrism. In the afterword Mignolo notes that "Derrida's concern with writing merged a dominant linguistic and semiotic tradition defining the sign as a compound of signifier and signified as well as a philosophy of language that conceived of writing as a surrogate of speech" (Mignolo, 318). In order to "demolish" the "conception of writing that impinges on epistemology as well as on metaphysics" (Mignolo, 318), Derrida exposes the operation of what Rodolphe Gasché calls the "infrastructures" that trouble philosophical discourse.[22] "Among his examples," Mignolo complains, "there is a big chronological leap: from Plato and Aristotle, at one end of the spectrum, to Rousseau, in the eighteenth century, before reaching Saussure and Lévi-Strauss in the twentieth century" (Mignolo, 318). The problem, however, lies not in Mignolo's description of Derrida's project, but in his attempt to relate Derrida's engagement with a certain philosophical tradition to what he passes off as Derrida's locus of enunciation: "Being a French philosopher himself (born in Algeria), it is natural that Derrida preferred to begin with the history of metaphysics in Greek philosophy and to skip over the Italian and Spanish Renaissance in order to arrive at Rousseau and the French Enlightenment and Hegel and German philosophy" (Mignolo, 318). Mignolo reads backwards from a *corpus*, from a bibliography, to a "nature" and an identity, that of an Algerian French philosopher. He asserts the transparency of another's nature on the basis of an entirely unproblematized identity. There is no effort, in short, to complicate the assumption of, one, Derrida's Frenchness and, two, the "natural" relation between a certain French philosopher-identification and a certain trajectory of examples. There would appear to have been only one possibility for Derrida: his nature, the nature of French philosophers in general, determines his "place."

One might say that Mignolo puts Derrida in his place, but it is a strange exercise for a critic invested in the notion of a pluritopic herme-

neutics that "calls into question the positionality and the homogeneity of the understanding subject" (Mignolo, 12). Indeed, Mignolo objects to Enrique Dussel for not "questioning the understanding subject itself," something Mignolo fails to consider as he locates Derrida within a transparently French philosophical locus of enunciation (Mignolo, 12). It also amounts to a facile explanation of the relation of Derrida's "place" to his work and it denies to the Derridean text what Mignolo argues is constitutive of disciplinary practices: "Constructing such loci of enunciation implies that the rules of the disciplinary practices (literary studies, philosophy, history, anthropology, etc.) are grounded in the personal (auto)biography of the scholar or social scientist. This brought to scholarship the heavy load of participation in everyday life that was chased out on the glorious day when scholarly and scientific pursuits were conceived as detached from the personal story of the scholar and the scientist" (Mignolo, 329). Mignolo's characterization of scholarly practice thus denies to Derrida "participation in everyday life"—as an Algerian Jew among other things;[23] rather, he locates Derrida within the horizon of a French philosophical tradition that determines examples without reference to everydayness, without reference to (auto)biography, without reference, then, to either history or the present. For Mignolo, everything is already decided for Derrida.

There is always the temptation to dismiss critical work like Mignolo's as monological; but, in fact, it seems all the more dialogical for its determination of the place of the other: indeed, the dismissal of the other makes dialogue possible among us, a dialogue that is, moreover, in its originary gesture of exclusion, very much akin to monologue. In sum, dialogue, no less than monologue, brackets what Derrida calls "the experience and the experiment of the undecidable," and thus closes itself to the other—in order to open the space of/for (the) itself.[24] We represent ourselves in dialogue only to the extent that before us is another. This other does not take sides; it is neither for nor against: it is always before us, before our representation and representability. This other is before our election without ever having been representative.

Whereas Elena Poniatowska's *La noche de Tlatelolco* considers representation obliquely, in terms of the representation of both the student movement "itself" and of its relation to other identities and events, Fuentes's *Tiempo mexicano*, Bonfil Batalla's *México profundo*, and the Zapatista documents and communications directly confront it: they attempt to calculate democractic representation by increasing the number of participants. This more inclusive democracy does not comprehend just anyone,

however. The additional participants will have to be identified—not just by a body count, but a positive ID. We are still close to 1968, to Tlatelolco, to the "open wound" that Lorenzo Meyer claims continues to hurt Mexico. Indeed, he writes that "the desireable thing would be to see '68 as history, as a trauma overcome, but unfortunately that is not the case [*lo deseable sería ver al 68 como historia, como un trauma superado, pero desafortunadamente no es el caso*]."[25] Mexico will not yet have gotten past Tlatelolco. Tlatelolco still occupies its present. It names, for Meyer, the present before us: it institutes a pause that effectively retards Mexican history. History for Meyer is the exhausted present, used up, past, and passed on. Tlatelolco has not yet spent itself, but Meyer suggests a way to be done with it: Mexico can close the wound, heal itself, by closing the books on Tlatelolco, by accounting for the dead: "The dead of that time— who and how many were they?—still do not rest in peace in the collective memory" (Meyer, "68 Como Herida," 1). *La noche de Tlatelolco* covers the same ground, citing testimony that asks, "Who's going to pay for all this blood [*¿Quién cobrará esta deuda de sangre?*]" and recording Poniatowska's certainty: "It is quite certain that even today the precise death toll has not yet been determined" (Poniatowska, 210; 170; 252; 207).

Mexico will be accounted for, in other words, in a new democracy that will include others, represent them to and for "us," to and for "themselves." This new democracy will not be derivative; it will not repeat any other. In *Tiempo mexicano* Fuentes writes: "The democracy of the future will be neither the formal parliamentarianism of the bourgeoisie nor the equally formal bureaucratism of Stalism; it will be the democracy born of work [*la democracia de la autogestión del trabajo*] in which political liberty and economic liberty coincide in a concrete way" (Fuentes, *Tiempo*, 191). It will thus be local, not imposed by the government, from above, but organic, organizing itself from below. It will be "*una democracia local*," according to Fuentes, "that knows the real problems and solutions of our geographic and human multiplicity" (Fuentes, *Tiempo*, 178).

Certainly the Zapatista texts emphasize the spread of democracy. When the *Comité Clandestino Revolucionario Indígena—Comandancia General del EZLN* suspends the dialogue with the federal government, it explains: "Now we have the obligation to reflect well on what his words mean. Now we need to speak with the collective heart that governs us. We need to listen to its voice in order to walk again. The next signal to take the next step on this road whose destiny will or will not be peace with justice and dignity, will come from them, from our side, from the Indigenous in the mountains and ravines" (*EZLN* 187; *Zapatistas* 247).

Then, on June 10, 1994, when the results of the *consulta* have been calculated, the Clandestine Committee issues a statement: "The CCRI-CG of the EZLN, as we have recently reported, has finished its consultations in all of the communities that make up and support the EZLN. By means of official reports from assemblies in the *ejidos* and communities, we have learned the opinions that are in our people's hearts" (*EZLN* 257; *Zapatistas* 321). The Zapatista texts make clear that the EZLN is a broadly inclusive, democratic movement and that those who speak do not decide, do not "order" (*mandar*) for themselves; rather, the CCRI-CG del EZLN "*manda obedeciendo*," which amounts, finally, to a Zapatista definition of democracy (*EZLN* 176).

At stake in these texts is the localization of representation, the decentralization of the *pueblo*, the place of "our" *hermanos*. The Zapatista texts represent the *consulta* as the period during which the word (*la voz*) of the *pueblo* passes from the scene of the dialogue along a circuit that ultimately would include *every ear* and *every mouth* of the people. This would be a democracy that begins from the assumption that everyone has the right to represent him- or herself and that those who speak for them have the responsibility (*deber*: obligation, debt) to obey their word (*voz*).[26] The Zapatistas thus heed Bonfil Batalla's warning in *México profundo*: "It is imperative that we let the *México profundo* speak, and that we listen to its words."[27] In Chiapas, then, they practice a deep democracy, an Indian democracy, which, according to Lorenzo Meyer, is the most genuine kind.[28] Indeed, Zapatistas certify that the new democracy is, in fact, already very old, perhaps older than the West: it is the gift of "*los ancianos de nuestras comunidades, guardianes verdaderos de la palabra de nuestros muertos*" (*EZLN* 175; *Zapatistas* 236). What distinguishes Indian democracy from Western democracy is the non-occlusion of the place of the minority. The CCRI-CG explains that the elders who preserve the word of the dead believe that "*lo que es bueno para los más para todos es bueno. Pero que no se acallen las voces de los menos, sino que sigan en su lugar, esperando que el pensamiento y el corazón se haga común en lo que es voluntad de los más* [What's good for the majority is good for all. But, the voices of the minority must not be silenced. They should continue in their place, waiting for hearts and minds to come together in the will of the majority and the desires of the minority]" (*EZLN* 175; *Zapatistas* 236).

In contrast to Zapatista democracy, Bonfil Batalla argues that Western-style democracy makes virtually impossible the "authentic representation" of "the peoples of the *México profundo*" (Bonfil Batalla, 243; 174). "There is a deep irrationality," Bonfil Batalla notes, "in the fact that there

are two senators for each one of the many recent states, which were often created in an authoritarian way in the heat of momentary circumstances. At the same time there are millions of inhabitants of Indian communities who have no assured representation in the legislative bodies" (Bonfil Batalla, 174; 243). He proposes that "their representation should be as differentiated peoples with their own historical legitimacy, and not based on the fictitious 'universal' individual vote" (Bonfil Batalla, 174; 243). Bonfil Batalla considers Western democracy a vestige of colonialism and writes, "It is imperative that we break the colonial mediation" (Bonfil Batalla, 244; 174).

Like the Zapatistas after him, Bonfil Batalla remarks that prior to European contact and, thus, prior to the importation of Western democracy of the minority, there had been a democracy in Mesoamerica. But with the institution of the Triple Alliance and Tenochtitlán's conquest of Azcapotzalco, "democracy in Mexican society was lost" (Bonfil Batalla, 114; 71). This is the story, one we know too well, of once-noble Indians, nonviolent and democratic, now fallen.[29] Their conquest—from within—makes possible European conquest and their present exclusion from Western society. Vasconcelos's dream of Atlanteans—their flowering in the Americas, their subsequent withdrawal, leaving only traces of themselves and their civilization behind, their later reappearance in Persia and Greece, stimulating the birth of Western civilization—remains legible in Bonfil Batalla. The Indians left behind, however, are of little interest to Vasconcelos in the formation of the cosmic race.

The democracy that will heal Mexico will be and will have been indigenous, buried but recuperable. Mexico will need to unearth what has always lain beneath her. To that end, the Zapatistas calculate the results of the *consulta* and discover that "*Del total de la población zapatista consultada . . . el 100 por ciento son indígenas*" (*EZLN* 256). It is, then, a purely Indian movement invested in an authentic—Indian—democracy. Yet, the identification of *zapatismo* on the basis of a totalizing calculation, far from securing democracy, indicates the crisis of democracy. Joan Copjec contends that the "founding fact of democracy" is the impossibility of being able "completely to determine the social whole." Following Freud's attempts "to theorize the modern . . . phenomenon of the crowd," she cautions that "some . . . fraction always remains as left-over to de-complete each image, that of the individual ego as well as that of 'the people.'"[30] "*Todos somos zapatistas,*" then; and if we all are Zapatistas, we all are Indians as well (Fuentes, *Tiempo*, 146). But perhaps we should already be wondering about the left-over, the left-out.

We all are Zapatistas, even those of us who do not recognize the Indian in us, even those of us who deny the Indian in us: "Mesoamerican civilization is present and alive," Bonfil Batalla writes, "and not only in the peoples who maintain their own identity and affirm the fact of being different. It is also present in a broad majority of sectors of Mexican society that do not recognize themselves as being Indian, but that organize their collective life on the basis of a cultural matrix of Mesoamerican origin" (Bonfil Batalla, 244; 174). Yet, beyond the dream of a cultural matrix of Mesoamerican origin, he cannot specify what an Indian *is*. *México profundo* arrives at Indian identification only by passing through the negative: "The Indian does not define himself in terms of a series of external cultural traits—dress, language, customs, and so on—that make him different in the eyes of outsiders. Rather, he defines himself as belonging to an organized collectivity, a group, a society, a village that possesses a cultural heritage formed and transmitted through history by successive generations. In relation to one's own culture, one knows and feels oneself to be Maya, Purépecha, or Huastec" (Bonfil Batalla, 48; 21–2). A feeling of belonging is handed down; even so, the chapter "*El Indio Reconocido*" begs the question of those Indians who remain Indian without recognizing themselves as such, without *feeling* themselves to be Indian. The identification of Indianness on the basis of inclusion in a collectivity that itself can be recognized only on the basis of legislated and legislating differences, customs that can be violated, ultimately makes possible the loss of Indian identity. Bonfil Batalla writes that "there are ways to join and ways to be accepted. There are also ways of losing one's membership" (Bonfil Batalla, 48; 21). These ways will have nothing to do with how one feels. It is always possible, in sum, that Indianness will not be passed on from generation to generation; it will, rather, have passed away. Indianness will be something passed (away, on), past.

Yet, Bonfil Batalla later asserts that there are Indians who do not recognize themselves as such, but who nonetheless have not lost their Indian identity. What survives as Indian in those "Indians" who will have *passed* on living in Indian communities? Bonfil Batalla writes, "At a deeper level a spectrum of sentiments are also transmitted. Because they are shared, they allow us to participate, to accept, and to believe. Without them personal relations and collective effort would be impossible" (Bonfil Batalla, 47; 21). "All this is culture," Bonfil Batalla warrants. Culture is thus grounded on that which makes community possible, the universal common sense that enables personal relations and collective effort. Bonfil Batalla does not write of identifiable emotions—of pity, hope, love,

or hatred—for those would be emotions that anyone might have and, moreover, that anyone might feign. In other words, such emotions would make possible the passing on of Indian identity; they would make possible a non-Indian's passing for Indian. The history of "European"/ "Amerindian" contact is littered with the troubled interpretations of the other's emotional displays, interpretations that make clear, even as they posit cultural difference, the tenuousness of such distinctions, of such certainty. Rather, he writes of a still more "profound" feeling that we— Indians, one and all—cannot forget and cannot know either, for this feeling makes possible emotions and emotional identification. He neither names nor identifies this sentiment, except as the unalloyed and transparent mechanism of Indianness, particularly, and of culture, generally. In other words, Bonfil Batalla eats at Esquivel's table; he shares her taste.[31]

In taking a place at this table, however, Bonfil Batalla inadvertently seats himself next to Descartes, who will have invoked just such an affective possibility as the animating principle of the soul. For Descartes, "the internal emotions of the soul . . . which are produced in the soul only by the soul itself," distinguish the living from the dead, human beings from automata.[32] These "internal emotions of the soul" are unalloyed emotions, which may be related to the passions—either those of the soul or those of the body—but do not have to be. Unlike the passions, these internal emotions are neither produced by nor related to the animal spirits, to those mere bodies, extremely small, that move very quickly (Descartes, 3:959; 1:331–32). In the internal emotions the soul exercises itself. In them, our humanity, as opposed to our automaticity, becomes manifest. "These internal emotions," Descartes explains, "affect us more intimately, and consequently have much more power over us than the passions which occur with them but are distinct from them" (Descartes, 3:1064; 1:381–32).

Recourse to this deeper *sentimiento* amounts to recourse to spirit—that which is nothing, but which we nonetheless share. Indian identity—and who is not Indian, finally, in Bonfil Batalla's conception?—will be grounded upon this nothing, this feeling that cannot be identified but that nevertheless distinguishes us in a way that it draws us together. No doubt this spirit makes Bonfil Batalla nervous. After its invocation as the deepest sense of Indian identity, he moves away from it and toward more material manifestations of Indian community and culture. With good reason, for in attempting to secure Indian identity, Indian difference, to provide it with a stable ground, he effectively locates it in a gas field. Although Indian identity will be, according to Bonfil Batalla, essential, it will also be mean-

ingless, with an unremarkable absence at its base. Finally, we won't be able to distinguish, not at its ground, Indian identity from, say, Christian identity. Indian agency is no different from "European" or "Western" agency; it bears the mark of the same desire, the same "want" or lack. In its most profound sense, Indianness means Europeanness. Perhaps the desire to avoid this conclusion leads Bonfil Batalla to posit an authentic Indian democracy only as something always already-vanished, even before European contact, as a spiritual effluvium parallel to the *sentimiento* without name, that cannot be felt except as the possibility of feeling in general.

By the time Bonfil Batalla arrives at the concluding pages of *México profundo*, in which he argues for an indigenous democracy, he will have forgotten this spirit of community, perhaps because such a spirit cannot be represented, neither to oneself nor to others. This spirit is the end of democracy, the aporia at the "heart" of community that makes any democratic representation violent, a necessary transgression of others.

The same essentialist gesture disturbs even "postmodernist" revolutionary work. Arguing on behalf of the inclusion of the "Declaration from the Lacandon Jungle" in the book version of *The Postmodernist Debate in Latin America*, John Beverley and José Oviedo claim that the "sudden explosion of the Zapatista National Liberation Army . . . onto the scene of Latin American politics" opens up "dramatic possibilities" for the politics of resistance. The Zapatista revolt, they attest, is only one of many possible "postmodernist, but still explicitly socialist, forms of political agency."[33] Undoubtedly the Zapatista texts engage a certain postmodern strategy, not least those signed by *subcomandante* Marcos, and perhaps most of all Marcos's *posdata* to the communication dated May 28, 1994, which begins, "The Majority disguised as the untolerated minority," and in which Marcos exposes his identity in the interval of resistance:

About all of this whether Marcos is homosexual: Marcos is gay in San Francisco, a black person in South Africa, Asian in Europe, a Chicano in San Isidro, an anarchist in Spain, a Palestinian in Israel, an Indigenous person on the streets of San Cristóbal. . . . In other words, Marcos is any human being in this world. Marcos is every untolerated, oppressed, exploited minority that is resisting and saying, "Enough!" He is every minority who is now beginning to speak and every majority that must shut up and listen. He is every untolerated group searching for a way to speak, their way to speak. Everything that makes power and the good consciences of those in power uncomfortable—this is Marcos. (*EZLN* 243; *Zapatistas* 312–13)

"Marcos" will be the name of the oppressed, both any oppressed majority disguised within the dominant culture as a "minority" and any oppressed minority comprehended by the majority as a "threat" to the status quo. In the words of a typical Mexican grafito, *todos somos Marcos*: "we are all Marcos." All who resist will be *Marcos*.[34] All who resist without surrender, without rendering anything to the other, to the dominant culture; all who resist without return. These *Marcos* never pay, never render account, never give up: *no se rinden*. With the exception, perhaps, of Rulfo's *Pedro Páramo*, no twentieth-century Mexican text understands so well the economy of consciousness. Certainly the Zapatista texts surpass Rulfo in their commitment to understanding the history of Mexico within the metaphoric of indebtedness. This indebtedness, moreover, is imported, foreign: it comes from Europe, from Spain, from the United States, which perhaps explains the Zapatista refusal of any *outside* assistance, their insistence on nativity, on indigenousness. In other words, resistance—the identifying trait of all these *Marcos*—will be a lack, the absence of a word to translate *rendir*. Zapatista identity will be founded on that essential nothing. *Todos somos Marcos* means, finally, we are all "frames" enclosing nothing: empty. *Marcos* without features, only borders, enclosures. The lack will be provided in an afterthought, a *posdata*:

> P.S. In the Committee we argued all afternoon. We looked for the word in [our] language [*en lengua*] to say "SURRENDER" [*rendir*] and we didn't find it. It doesn't have a translation in Tzotzil or in Tzeltal; no one remembers that this word exists en Tojolabal or in Chol. They've been looking for equivalents for hours.... In silence old Antonio approaches me, coughing with tuberculosis, and he whispers in my ear: "That word doesn't exist in the true language [*en lengua verdadera*], thus ours never surrender [*nunca se rinden*] and they would rather die, because our dead order that words that don't walk [*no andan*] shouldn't be lived."
>
> ... Someone arrives, his hat and rifle dripping water. "There's coffee," he informs. The Committee, as is customary in these lands, takes a vote to see if they drink coffee or keep looking for the equivalent of "SURRENDER" [*rendirse*] in the true language [*lengua verdadera*]. Coffee wins unanimously. No one surrenders [*Nadie se rinde*].
>
> Will we remain alone? (*EZLN* 268)

In play in this postscript is the dream of purity: the absolute of that which cannot be thought from the inside, from within our Indianness.

We, Marcos reports, cannot think this; we cannot render ourselves. Only in translation, only in another language, which will not be the true one; only in another place can we surrender, give up, return. At the center, the heart, perhaps, of Indianness in Chiapas, there is nothing, not even this word: Its absence saves us from others.

Indian identity in Chiapas, Zapatista identity, founds itself on an essentialism without reserve. Empty essentialism: resistance predicated on absolute autointerdiction. This interdiction, moreover, occurs within the context of the call for a deeper, more inclusive democracy that would afford "authentic representation" to those who historically have been denied it. But that representation will be restricted to the extent Zapatistas cannot say "I surrender." For sure, no Zapatista wants to say this; or, perhaps, there is only the *want* of saying it: the desire has always already been circumscribed. Not impossible, in general, but impossible for Zapatistas. The translation by any Zapatista that would produce the effects of *rendir* would literally translate that Zapatista outside the *marco* of *zapatismo*. Democracy is all about representation, but what democracy cannot risk is the chance of the impossible possibility. There is always something that, from within democracy, cannot be elected. Something is always off the table in order that there be a table in the first place. At issue is democracy's horizon. Yet, while the unthinkability of *rendir* within "native" languages appears absolute, there nevertheless remains a certain tension within Zapatista ranks.

The ghost of a brother haunts the Zapatistas—brothers who will have been disavowed. On February 2, 1994, the Zapatistas address themselves to other Indians and peasants, addressing them as *hermanos*, inscribing democracy within the limits of fraternity.[35] Although *rendir* will be unheard in the family tongue, we will nonetheless discover that Indians will have found a way to sell out. In a text addressed to our brothers and signed "fraternally," in a text, moreover, that addresses accusations of a lack of respect for human rights leveled at the EZLN, the CCRI-CG responds in kind, accusing "Indians"—but not Zapatistas—of being complicitous in the exploitation of the indigenous population. Incredulously, the CCRI-CG asks: "*¿No son indígenas pobres también?*" (*EZLN* 123). Although they will be accused of working against "*sus hermanos de raza y sangre,*" they will soon be expelled from the fraternity: "Brothers, dismiss [*alejen*] from your presence those traitors, don't listen to their words, they come from a politics of 'two faces' to deceive everyone [*a unos y a otros*] and obtain personal benefits" (*EZLN* 123). Thus, the text marks out the

possibility of the non-identification of Indian and Zapatista identities. It thus describes, in order to reinscribe, the outer limit of Indianness. No Indian, no brother, will be able to elect to sell out: not because the election to sell out is not possible; indeed, it is always possible. But because selling out is the border of Indianness: The EZLN is one hundred percent Indian. Marc Shell's critique of liberal humanism's disturbing tolerance applies, then, to Zapatista practices of inclusion: all Indians are my brothers; only my brothers are Indians.[36] Such would be the limit of Indian democracy.

The Zapatistas cannot but struggle with the problem of representation and, in doing so, they cannot but re-mark, however obliquely, the limits of any democratic politics, limits that are from the first day violated. Thus we read the tension over the right to represent the Zapatistas. Early in the campaign—not at the very beginning, not in the first communications, but as the fifth item to the document dated January 11, 1994—the CCRI-CG "declares that the only valid documents as emitted by the EZLN and recognized by all the Zapatista combatants will be those that have the signature of comrade *subcomandante insurgente* Marcos" (*EZLN* 80; *Zapatistas* 86). Marcos's will be the only authorized voice of the EZLN, but immediately thereafter documents released without his signature express EZLN positions and, subsequently, Marcos "himself" will be silenced: on February 16, 1994, Marcos suggests that he will not be elected/appointed to represent the EZLN at the dialogue with the government. He concludes, "Whatever happens, whether I go or not, the CCRI-CG has ordered me to written silence, thus I put away my powerful machine for 'making communication' [*'hacer comunicado'*] (a pen) until this ends" (*EZLN* 154). The communication announcing his silence is followed by a section called "the mercantilist postscript"—nine postscripts that place an economic value on his texts, suggesting that they have been "devalued by 'external' pressures" (*EZLN* 155). This from an army that refuses any outside help. Marcos, too, signs from outside: "*El sup en el ostracismo*" (*EZLN* 155).

Nevertheless, during the dialogues with the government, Marcos speaks as the voice, *la voz*, of the EZLN, daily opening his discourse, "through my mouth speaks the *Comité Clandestino Revolucionario Indígena, Comandancia General del Ejército Zapatista de Liberación Nacional . . .* " (*EZLN* 162). Yet, there remains the desire to supplement this singular voice: other voices will want to represent themselves themselves, not in Marcos's voice, which will be that of the EZLN, but in their

"own" (*EZLN* 172). Whether or not the desire to represent oneself *outside* the voice in and through which the *comité* speaks has anything to do with jealousy, as certain reporters suggest, or with misrepresentation, the issue remains the mediatization of immediacy (*Zapatistas* 203). A mediatization, moreover, that appears all the more immediate, all the more transparent, as it appears to announce itself as the expression of "public interest" and "public opinion." Marcos addresses this apparent interest when, in response to the statement, "You do have a beard Marcos," he argues, "what happens is that the press itself, in its dialectic movements, turns against itself. First it's Marcos, Marcos, Marcos. And now, goddamn Marcos, goddamn Marcos, goddamn Marcos, because all we hear is Marcos. And the truth is that Marcos didn't say anything. The whole mess was made up by the press, and now they're complaining that why is Marcos the protagonist?" (*Zapatistas* 210). In fine, Marcos suggests that public interest and public opinion never take place, that the moment a public interest or opinion is represented—the moment it appears as such, then—it is already a media event, an effect of mediatization.[37]

There is no public interest in Marcos, Marcos tells us; no public opinion about him. It is the ruse of a "free" press that would pursue and represent the interests and opinions of a public that, according to Carlos Monsiváis, cannot represent itself. In his account of the National Democratic Convention (CND), Monsiváis reports, "the foreseeable and unforeseeable contingent has come from every part of the country: highly representative persons and those who with difficulty represent themselves alone" (*EZLN* 313). Perhaps this is the definition of the present, of the presence of any public, always full of the highly representative—certain stock figures—and those who only with difficulty can represent themselves, those for whom self-representation, if there is any, exhausts them. The exhaustion of the autorepresentationality is itself the effect of calculation, which, according to Claude Lefort, contributes to the "erasure of the markers of identity."[38] Elsewhere, writing of the metro system, the sine qua non of post-apocalyptic Mexico City, which Richard Rodriguez calls the postmodern capital of the world, Monsiváis details the vanishing horizon of any identity grounded in a relation to the representation of the body as the extensive limit of "our" difference. In the metro there is only in-difference: "*El metro*," according to Monsiváis, "annuls singularity, anonymity, chastity, lust; all those personal reactions in the horizon where the many are the only antecedent to the too many. Here entering and leaving is the same thing. . . . In the Metro, the borders between one body

and another dissolve, and there, yes, all are accommodated."³⁹ Everyone finds a place in the Metro; everyone finds a seat, but we do so by adjusting to others, by forgetting to remember the horizon of the self, the edges of a corporeality that would distinguish one from others, that would make us indifferent to others.

In his description of this unlimited relation among others, Monsiváis comes close, too close for his own, personal comfort, perhaps, to Richard Rodriguez, who writes that in Mexico City, "Each face looks like mine. No one looks at me."⁴⁰ There is no rejoinder of the gaze, no eye contact among others. There is only this in-difference, this being among others without interest. Encounter, if there is any, is without consequence: nothing lost, nothing gained. No accounting for others, for selves among others. No exchange, no *darse cuenta*. Writing after Rodriguez and before Monsiváis in the Metro, writing in and of a certain Mexico and of *"la lógica de los muertos,"* Marcos explains in a postscript, "Soon people stop and take out their calculators or pencils, and they look at each other. They're confused; they don't know whether they're adding ... or subtracting" (*EZLN* 243–44; *Zapatistas* 313–14). This text situates the production of self-consciousness within the metaphorics of the gaze and accounting: they look at one another, are confused, and cannot decide, finally, the value of all those bodies, whether they add up or subtract. Accounting, recounting, discounting: addition without sum, subtraction without reduction. A certain valueless economy: the positive of self-consciousness in the negative of community; the formation of community in the reduction of self-consciousness. We cannot be sure what those bodies represent, whether they represent us, expose us to ourselves or, perhaps, to others.

Zapatista uncertainty recalls Tlatelolco, locates us in its particular jointure or eruption of culture, for Tlatelolco is, finally, all about the exposition of culture, the accounting for others and selves, and the meaning of that presentation. The "experience" of Tlatelolco is all about ethics, the response and the responsibility to and among others. The key text in any approach to Tlatelolco remains Poniatowska's *La noche de Tlatelolco*, which Cynthia Steele calls "the definitive account of 1968 and the massacre."⁴¹ In its display of personal testimony, *La noche de Tlatelolco* appears to present unmediated reflection on the events leading up to and including October 2, 1968; yet, the particular constellation of these texts problematizes any attempt to get close to Tlatelolco: Tlatelolco remains to be determined, not least because there is no way to comprehend the plurality of identities, of positions, of participants. Competing interpretations of particular identities remove any chance of totalizing identity.⁴²

But the indecision of Tlatelolco does not depend, finally, on subjects arguing for or against their experiences of the day, of the movement in general, or, simply, of others. No doubt all these trouble any attempt to account for 1968, but more problematic will have been the difficulty of determining the *marco* of any subject of encounter, of any eyewitness. In sum, rather than there being too many subjects to decide what happened at Tlatelolco, to determine its particular status as an event, there are, perhaps, too few. Perhaps there are none.

Testimony mandates the presence, the *manifestación*, of a witness to events. It is all about the presence to itself of the subject, its being-there. To the extent events happen in testimonial accounts, they do so within the horizon of the subject, within the subject's self-presence. This would be the history of presence and the history of subjectivity. *La noche de Tlatelolco* jeopardizes such presence even as it would appear to secure it. Even as it appears to expose the subject of culture, even in its plurality, it dissolves the subject and the culture(s) it figures. At stake, then, will be the status of encounter, the ethics of the relation to and among others—of whatever sort—that would be historical, the possibility of history.

From the beginning, Tlatelolco will have been comprehended as an exposition of culture, perhaps not least by those looking on from "outside," by those who will arrive in Mexico looking for snapshots of Mexican culture to frame and hang on a wall back home, snapshots that, perhaps, reflect us.[43] For example, Daniel Guian, visiting from France, claims, "The eyes of the entire world were focused on Mexico" and the students "were attempting to exploit an international event for their own personal ends.... The presence of foreign journalists who are always on the lookout for sensational news and lurid stories made them behave all the worse.... They had to show the foreign journalists that they were real *machos*; they invited them to their demonstrations [*a presenciar manifestaciones*]" (Poniatowska, 258; 306–7). The eyes of the world look down on Mexico: Guian thinks certain appearances should be maintained—for the sake of the Olympics and a certain foreign experience. Lola d'Orcasberro, another French visitor, argues, "What happened was that the students wanted to steal the spotlight [*cámera*] from the Olympics" (Poniatowska, 259; 307). They wanted not to steal the spotlight, but literally to steal the camera, that lens and optic, that attention and frame; they wanted to abscond with the mechanism for framing the event.

One *manifestación* of culture displaces (ex-poses) another. It is not, according to these witnesses, a question of sharing the spotlight. It is not a question of multiple experiences of Mexican culture, of any number of

demonstrations occupying the same frame. The *movimiento estudiantil* threatens to dislocate what a certain foreign, first-world camera wants to see. So claims Douglas Crocker, a museum curator from North America, someone deeply invested in cultural expositions: "People should wash their dirty linen in private. The students wanted to wash theirs in full view of the Olympic contestants, who had come to Mexico from all over the world, and to take advantage of their being there to get them involved in the country's domestic politics" (Poniatowska, 260; 308).

On the one hand, in 1968, the Mexican government argued that the *movimiento estudiantil* resulted from external influence, outside sources. Foreign corruption, the argument goes, exposes itself in internal Mexican cultural demonstrations. On the other hand, foreigners in 1968 argued that the inside should hide from the outside. Or, perhaps, the internal politics of culture should occlude themselves while the external politics of culture occupy the frame. The world will have come to Mexico to see itself; it turns its eyes on Mexico in order to verify its (own) presence. What is before the camera is behind it.

In testimonial narrative, events depend on the presence of the witness: the student movement—if there is one—does not take place without the presencing presence of witnesses, of others, of lenses and optics that mark (frame) an outside, a perspective, and a border.[44] The internal composition of the event, the *manifestación* of culture, appears to require an external eye, even when the outside subject would appear to reject mediating technology in order to come close to the object.[45]

History thus dictates an unethical relation to others, for history, understood as the representation of events, mandates the border-effects that would secure the place (outside the frame) of the subject-of-history. And there is no history of the subject that is not invested in representation, in precisely this ex-posure. This is perhaps nowhere more true than in those historical and anthropological accounts of events and of others that ground themselves on personal experience, that thus attempt to describe an immediate relation to others without objectification or subjugation. Such accounts, such histories and testimonials, manifest the dream of a subjective tolerance without borders, of an ever-expanding community of subjects without objects, selves without others. Already a long time ago, Bataille described the nightmare of such a vision, explaining in *The Accursed Share* that any subject-subject encounter requires the destruction of the object, the absolute subjection and objectification of an other that does not count within the dialogue.[46] Dialogue will be located in this ex-position. Over a dead body.

The camera is the technological metaphor of choice: on the one hand, it allows the transparent appearance of events, of objects as if they were subjects, uncomposed; on the other hand, it mediates such immediacy, framing it from an irreducible distance, composing subjects for us. Monsiváis notes the authority of the camera when, after Marcos's offer to remove his mask is enthusiastically rejected by those present at the National Democratic Convention in Aguascalientes, Chiapas, he writes: "Marcos without a ski mask is not admissible, is not photographable" (*EZLN* 323). The camera cannot admit, cannot frame, an unmasked Marcos; there will be no place for that in this history. Inadmissible: beyond the horizon, the scope, of a certain optics. Without the mask Marcos does not appear to be—*no se presencia*—for us, does not manifest himself to us.

La noche de Tlatelolco also troubles the camera, its mediation of subjects and objects, and in so doing it suggests the chance, perhaps the risk, of an other community. Mary McCallen, a press photographer, testifies:

> Everything was a blur—I don't know if it was because I was crying or because it had started to rain. I watched the massacre through this curtain of rain [*Presenciaba la matanza a través de esa cortina de lluvia*], but everything was fuzzy and blurred, like when I develop my negatives and the image begins to appear in the emulsion [*como mis fotografías en la emulsión, cuando empiezan a revelarse*].... I couldn't see a thing. My nose was running, but I just snuffled and went on shooting pictures, though I couldn't see a thing: the lens of my camera was spattered with raindrops, spattered with tears. (Poniatowska, 187–88; 227)

The camera occupies the center of this witnessing, but we won't know what's before it, what's behind. The I, the eyewitness, sees nothing, but "witnesses" nonetheless, photographs events that will not yet have appeared, that will, in fact, only now, still, be revealing themselves and that will also appear "tomorrow," in the newspaper, evidence of history. "*Presenciaba la matanza a través de esa cortina de lluvia*," McCallen reports, "*pero todo lo veía borroso*": the question will be of the subject of this presencing, this witnessing that presents what will appear unclear, murkily, indeed, illegibly (*borroso*). McCallen cannot yet read these events, cannot yet comprehend their distance from her: tears or raindrops, she cannot tell which, veiling and unveiling, at the same time, the presencing of events not to her, but to a lens. The text recounts the non-subjective presencing of events: these events never quite come clear, "*como mis fotografías en la emulsión, cuando empiezan a revelarse.*" They never arrive to or for us, perhaps they never make sense. This testimony

registers a certain in-different inscription of difference. The world is clouded, subjects and objects, their difference obscured; the lens of the camera, the lens of the eye; tears, raindrops; emotional affect, meteorological effect: nothing determined, everything to come, before us.

La noche de Tlatelolco leaves us to think this suspension of difference, this in-difference of history, which would "add up to" the suspension of the determined difference between "us" and "them," between "before" and "after," between the "living" and the "dead." Tlatelolco perhaps names this suspension, this not-yet-instituted presencing, which is also an *estallido*, a bursting that unsettles all relations among others. Writing of Tlatelolco, Juan García Ponce noted its inexhaustibility; *contra* Meyer's understanding of Tlatelolco as a pause that needs to be overcome, García Ponce thinks Tlatelolco will be with "us" always: "One must always speak of it. And all that is said is too little. It is an event that nothing exhausts, neither political explanations nor literary creation, no kind of reason, because its horror will always be unreasonable; inexplicable, it has remained fixed and unmoveable [*inconmovible*] as that, as a pure horror that appears behind all reasons, behind whatever attempt to explain it, of tracing the coordinates that can lead us to its meaning. It is precisely senseless."[47] Tlatelolco names the "event" that remains inexplicable, suspended before us, forever opening "itself" to us. The reading of Tlatelolco as the perpetual opening of itself, the continuous coming to presence of what cannot be comprehended or grasped, repeats the unstable exposition of the not-yet-fixed photographs. Tlatelolco names the unreasonable horror that underpins and undermines reason.

Tlatelolco reveals itself/is revealed—*se revela*—to us. In the Spanish lexicon of photography, *revelarse* translates what in English is called the process of development: in Spanish, photographs "reveal themselves" rather than develop. Photographs thus appear to us out of a certain reserve: they come to presence out of a reserve of absence, of abeyance. Interestingly, and in a way that "develop" cannot sustain, *revelar* indicates that appearing happens as a return or repetition: the prefix "re-" suggests that what "reveals" itself does so always as the second-coming, after the fact. Further, *revelar* invokes the concealment or withdrawal of the event: *velar* means "to veil." The appearance of the event, then, takes place as the doubling of withdrawal, the doubling of the veil, which means that the exposure of the event depends on its double ex-position, on its repetitious—but always for the first time—displacement.[48] The foundation of appearance grounds itself on the unstable site of citation; the presence of the present, of the event as such and of any experience of it, thus takes

place (articulates itself) in translation, in the (dis)placement that would reveal/re-veil the origin. Tlatelolco is, then, a vigil (*velar* means to watch over the dying) of culture. In this displaced place of translation, we remain in suspense, awaiting "our" arrival.

In *Con él, conmigo, con nosotros tres*, María Luisa Mendoza writes, "One more day and tell me, tell me, what has happened since October? Nothing ... nothing more important than tears ... perhaps what happens is that I should tell another story, the story of the nothing that has been left to me."[49] This nothing, which the narrator nonetheless is obligated to recount (*contar*), to tell, is Tlatelolco. Since October 2, 1968, Mendoza asserts, *nothing* has happened, *nothing* keeps happening, every day. Days of tears without sum, without summation. *Nothing.* The history that will have been left to me, Mendoza writes, an inarticulate history of nothing. Tlatelolco: our present, given to us in-differently, *un tiro del dado* that arrives like *un tiro de gracia*.

No one will be ex(-)posed in/from this present. Tlatelolco is left to us all. This present is not *una herida abierta*; it is not public dialogue or the murder of students, women, and children; it is not simply or necessarily the site of an oppositional drama of domination and resistance—although it can be any or all of these. It is, rather, the vanishing horizon between our birth and our death. It is the opening of possibility and, at the same time, of hopelessness.

> But it smells of October in the air, it tastes of October now, in the year 1969—and I try to pretend that October this year is just like October of '68, before we all died—because all of us died a little there in the Plaza de las Tres Culturas.
> —Ernesto Olvera, *profesor de Matemáticas* (Poniatowska, 152; 160)

> All of us were reborn on October 2.
> —Raúl Alvarez García, *del CNH* (Poniatowska, 267; 316)

October 2, 1968: the day of our death, the day of our birth. All of ours. But not the birthday of our self-consciousness. Indeed, what Tlatelolco leaves behind will be without sense: "*Son cuerpos, señor.*" These are not only the last words, the last testimony of *La noche de Tlatelolco*, they also add up to the only sentence repeated in the text. Three times, always attributed to the same person, a soldier, and addressed to the same witness, José Antonio del Campo, a journalist, who will perhaps not know what he sees in this "valley of tears." "*Son cuerpos, señor*": not necessarily living, not necessarily dead, bodies in the plural. Among us, ours among

others. These bodies are not going anywhere; this is in-different repetition, citation without summation. There will be no spirit lost, no expression or cultural exhalation. No gas. These are bodies "left"—presencing themselves, revealing themselves—at the border of indication, only barely exposed. "*Son cuerpos, señor*": their ex(-)position always will have to be pointed out, marked and re-marked. Such would be the form of another community, one that never will recognize itself as such, one without name, without sense: a community without subjects that, in its absolute inclusivity, would be the blind cite—if not the place—of community without representation.

Notes

1. Juan Rulfo, *Obras* (Mexico City: Fondo de Cultura Económica, 1987), 196. Subsequent references will appear parenthetically. Translations of Spanish originals, unless otherwise indicated via the citation of an already published English translation, are my own. After citing published translations of Spanish originals, I provide page references to both the original and translation. For Rulfo: *Pedro Páramo*, trans. Margaret Sayers Piden (New York: Grove Press, 1994), 58 (translation modified).
2. Hegel writes: "Speech, after all, or *language* is a self-manifestation of spirit in externality, but in an objectivity which, instead of counting as something directly and concretely material, is a communication of spirit only as sound." G. W. F. Hegel, *Aesthetics*, trans. T. M. Knox (Oxford: Oxford University Press, 1975), 701.
3. Laura Esquivel, *Como agua para chocolate* (Mexico City: Editorial Planeta, 1989), 234. Subsequent references appear parenthetically.
4. Samuel Ramos, *Obras completas*. I (Mexico City: UNAM, 1975), 97. Subsequent references appear parenthetically.
5. Carlos Fuentes, *Tiempo mexicano* (Mexico City: Joaquín Moritz, 1971), 83. Subsequent references appear parenthetically.
6. José Vasconcelos, *The Cosmic Race: A Bilingual Edition*, trans. Didier Tisdel Jaén (Baltimore: The Johns Hopkins University Press, 1997 [1925]), ix. Subsequent references appear parenthetically.
7. For the flipside to Vasconcelos's Christian love, see Vine Deloria, Jr., *God Is Red: A Native View of Religion* (Golden, CO: North American Press, 1992 [1972]). Deloria argues that Christianity is inextricably linked to Western/European expansion precisely because it has no experiential relation to the land: to the extent Christianity is utopic—no place—it assumes the manifest truth of its revelation for all humanity. Deloria notes that "the question that the so-called world religions have not satisfactorily resolved is whether or not religious experience can be distilled from its original cultural context and become an abstract principle that is applicable to all peoples in different places and at different times" (66).
8. For a reading of Amerindian temporality as figured in major texts of Mexican

cultural criticism, including Ramos and Paz, see Roger Bartra, *La jaula de la melancolía: Identidad y metamorfosis del mexicano* (Mexico City: Grijalbo, 1987). Bartra concludes, "La cultura del hombre moderno requiere de mitos: los hereda, los recrea, los inventa. Uno de ellos es el mito del hombre primigenio, que fecunda la cultura nacional y al mismo tiempo sirve de contraste para estimular la conciencia de la modernidad y progreso nacionales" (77).

9. Octavio Paz, *Posdata* (Mexico City: Siglo Veintiuno, 1970), 40; Paz, *The Labyrinth of Solitude and The Other Mexico*, trans. Lysander Kemp et al. (New York: Grove Press, 1985), 236. Subsequent references appear parenthetically.

10. Quoted in Elena Poniatowska, *La noche de Tlatelolco: Testimonios de historia oral* (Mexico City: Ediciones Era, 1971), 16; Poniatowska, *Massacre in Mexico*, trans. Helen Lane (Columbia: University of Missouri Press, 1975), 6. Subsequent references appear parenthetically.

11. Octavio Paz, "Introduction," in Poniatowska, *Massacre in Mexico*, trans. Helen Lane, ix.

12. Carlos Monsiváis, *Días de guardar* (Mexico City: Ediciones Era, 1970), 267.

13. Beth E. Jörgensen, *The Writing of Elena Poniatowska: Engaging Dialogues* (Austin, TX: University of Texas Press, 1994), 74. Jörgensen also concludes that "by portraying the student movement as representative of a broad spectrum of Mexican society, the editor [Elena Poniatowska] has confirmed from the outset the democratic claims made by the students, and she has thus already invested the text with meaning, creating an image of democracy in action. In contrast to the lively dialogue carried out among the recorded voices of the movement, the official line is often conveyed by quoting written documents, legalistic language, or formally delivered speeches. All of which are monologic discourses that refuse dissent" (83–84).

14. These would include, among other examples, Plato's dialogues, in which Socrates always manages to come out on top, and of which Walter Benjamin wrote: "The Socratic inquiry is not the holy question which awaits an answer and whose echo resounds in the response.... Rather, a mere means to compel conversation, it forcibly, even impudently, dissimulates, ironizes—for it already knows the answer all too precisely. The Socratic question hounds the answer, it corners it as dogs would a noble stag" (*Selected Writings: Volume 1: 1913–1926*, ed. Marcus Bullock and Michael W. Jennings [Cambridge: Harvard University Press, 1996], 53); Hegel's dialogues, which Lyotard explains are only the ruse of monological reason (*The Differend: Phrases in Dispute*, trans. George Van Den Abbeele [Minneapolis: University of Minnesota Press, 1988], 86); Descartes's dialogue on the search for truth that ends up in the same place as his isolated meditations; and the 1524 dialogues between Franciscan friars and Mexica in Tenochtitlán.

15. Carlos Fuentes, *Nuevo tiempo mexicano* (Mexico City: Aguilar Nuevo Siglo, 1994), 154. Subsequent references appear parenthetically.

16. For example: "We were fools enough to believe that the government was willing to have a dialogue with us—I say that because when the granaderos hit us over the head with nightsticks and truncheons they kept saying, 'Go ahead and have your dialogue, go ahead and have your dialogue!' So we thought we should be prepared to have a discussion about legal technicalities, but what happened was that they gave us an illegal and antidemocratic clubbing over the head and

the dialogue turned out to be a monologue in the form of a sixteen-year prison sentence" (Poniatowska, 62; 56). In a larger but not unrelated context, Paz writes that "even under the best of conditions these dialogues [between the United States and Latin America] are difficult: as soon as a conversation between North Americans and Latin Americans moves beyond informative and quantitative matters, it becomes a hazardous walking-in-circles among quibbles, ambiguities, and errors. The truth is that they are not dialogues at all, they are monologues: neither of us ever hears what the other is saying" (Paz, *Posdata*, 64–65; 253).

17. *EZLN: Documentos y comunicados. Tomo 1* (Mexico City: Ediciones Era, 1994), 259; *Zapatistas: Documents of the New Mexican Revolution*, trans. Eugenio Aguilera et al. (Brooklyn, NY: Autonomedia, 1994), 323. Subsequent references appear parenthetically.

18. Ernesto Laclau, "The Signifiers of Democracy," in *Democracy and Possessive Individualism: The Intellectual Legacy of C. B. Macpherson*, ed. Joseph H. Carens (Albany: State University of New York Press, 1993), 229. Subsequent references appear parenthetically.

19. Jacques Derrida, *The Truth in Painting*, trans. Geoff Bennington and Ian McLeod (Chicago: University of Chicago Press, 1987), 256. Subsequent references appear parenthetically.

20. Giorgio Agamben comes to much the same conclusion in his reading of Descartes: "In its original pure state, the Cartesian subject is nothing more than the subject of the verb, a purely linguistic-functional entity, very similar to the 'scintilla synderesis' and the 'apex of mind' of medieval mysticism, whose existence and duration coincide with the moment of its enunciation" (*Infancy and History: Essays on the Destruction of Experience*, trans. Liz Heron [London: Verso, 1993], 22).

21. Walter D. Mignolo, *The Darker Side of the Renaissance: Literacy, Territoriality, and Colonialism* (Ann Arbor: University of Michigan Press, 1995), 5. Subsequent references appear parenthetically.

22. Rodolphe Gasché, *The Tain of the Mirror: Derrida and the Philosophy of Reflection* (Cambridge: Harvard University Press, 1986), 142–54, passim.

23. For Derrida's attempts both to construct loci of enunciation and to problematize such positioning, see "Circumfession," in Geoff Bennington and Jacques Derrida, *Jacques Derrida*, trans. Geoff Bennington (Chicago: University of Chicago Press, 1993), and Jacques Derrida, *The Monolingualism of the Other* (Palo Alto: Stanford University Press, 1998). Also, for a brief reading of the possibility of personal experience in "Circumfession," see David E. Johnson, "Anthropology's Embrace," *Centennial Review* 42:3 (1998): 627–48.

24. Jacques Derrida, *The Other Heading: Reflections on Today's Europe*, trans. Pascale-Anne Brault and Michael B. Nass (Bloomington: Indiana University Press, 1992), 116.

25. Lorenzo Meyer, "68 Como Herida Abierta," *Excélsior*, 5 August 1993, sec. A.

26. For Marcos's description of the process of Zapatista democracy, see *Zapatistas* 299. Also, see Pablo Latapí, "La democracia del EZLN," in *Chiapas: El evangelio de los pobres: Inglesia, justicia y verdad* (Mexico City: Ediciones Temas de Hoy, 1994).

27. Guillermo Bonfil Batalla, *México profundo: Una civilización negada* (Mexico City: Grijalbo, 1990), 244; Bonfil Batalla, *México Profundo: Reclaiming a Civilization*, trans. Philip A. Dennis (Austin: University of Texas Press, 1996), 174. Subsequent references appear parenthetically.

28. Lorenzo Meyer, *La segunda muerte de la revolución mexicana* (Mexico City: Cal y Arena, 1992), 46.

29. Fuentes suggests as much when he writes of Amerindians that they "are the only aristocrats in a country of mock [*remedos*] country gentlemen, second-rate colonial noblemen, arrogant creoles of the Independence, cruel bourgeoisie, corrupt and ignorant" (*Nuevo tiempo*, 38). Oren Lyons knows this story in its North American version. Writing of the influence of the Six Nations on the framers of the U.S. Constitution, Lyons remarks that "They could not, and did not, fail to notice that the Indians maintained a fairly stable and violence-free society even though they had no police or state organs of coercion" ("The American Indian in the Past," in *Exiled in the Land of the Free: Democracy, Indian Nations, and the U.S. Constitution*, ed. Oren Lyons and John Mohawk [Santa Fe: Clear Light Publishers, 1992], 32). A substantive abhorrs a modifier: the "fairly" belies Lyons's certainty, no less, finally, than does his remark that the basis for Iroquois government was the Great Law of Peace, which Lyons claims is "the earliest surviving governmental tradition in the world that we know of based on the principle of peace" (33); such a "law" amounts to a regulatory pre- or proscription. A determined peace is inevitably the effect of an organ of control.

30. Joan Copjec, "The Subject Defined by Suffrage," *Lacanian ink* (1993), 48.

31. And not just Esquivel's, of course; recourse to affect is symptomatic of much of recent cultural anthropology's sentimental turn. For example, for engagements with anthropology's desire to read the tears of others, see David E. Johnson, "Anthropology's Embrace," and David E. Johnson and Scott Michaelsen, "Border Secrets: An Introduction," in *Border Theory: The Limits of Cultural Politics*, ed. Scott Michaelsen and David E. Johnson (Minneapolis: University of Minnesota Press, 1997).

32. René Descartes, *Oeuvres Philosophiques de Descartes*, 3 volumes, ed. Ferdinand Alquié (Paris: Editions Garnier Freres, 1973), 3:10663; Descartes, *The Philosophical Writings of Descartes*, 3 volumes, trans. John Cottingham et al. (Cambridge: Cambridge University Press, 1985), 1:381. Subsequent references appear parenthetically.

33. John Beverley and José Oviedo, "Introduction," in *The Postmodernism Debate in Latin America*, ed. John Beverley et al. (Durham: Duke University Press, 1995), 12.

34. After hearing a version of this paper, Louis Kaplan pointed out that in the end Marcos will thus resist Marcos: the inclusivity of *todos somos Marcos* necessarily entails, to the extent that it depends on the definition of Marcos as resistance, the resistance of Marcos by Marcos. If Marcos is the name of resistance, any community grounded upon the identification of Marcos will be empty.

35. For democracy's inscription within the metaphorics of fraternity, see Jacques Derrida, *Politics of Friendship*, trans. George Collins (London: Verso, 1997).

36. See Marc Shell, *The End of Kingship: Measure for Measure, Incest, and the Ideal of Universal Siblinghood* (Baltimore: The Johns Hopkins University Press, 1995).

37. See Jacques Derrida, *The Other Heading*, where he writes: "How does one here identify public opinion? Does it take place? Where is it given to be seen, and as such? The wandering of its proper body is also the ubiquity of a specter. It is not present as such in any of these spaces. Exceeding electoral representation, public opinion is de jure neither the general will nor the nation, neither ideology nor the sum total of private opinions analyzed through sociological techniques or modern poll-taking institutions. It does not speak in the first person, it is neither subject nor object ('we,' 'one'); one cites it, one makes it speak, ventriloquizes it" (87).

38. Quoted in Copjec, "The Subject Defined by Suffrage," 49. See also Copjec, *Read My Desire: Lacan Against the Historicists* (Cambridge: MIT Press, 1994), 157–61, for a slightly different reading of Lefort's understanding of the "no one" of democracy and the "dissolution of the markers of certainty" (160). Indeed, Copjec explains, Lefort's "'no one' is attached not to the fact that the law guarantees itself but to the fact that *there are no guarantees*.... The discourse of power—the law—that gives birth to the modern subject can guarantee neither its own nor the subject's legitimacy. There where the subject looks for justification, for approval, it finds no one who can certify it" (160). One of the problems, then, of the Zapatista movement is precisely its desire to guarantee freedom and democracy (see *EZLN* 260).

39. Carlos Monsiváis, *Los rituales del caos* (Mexico City: Ediciones Era, 1995), 112–13.

40. Richard Rodriguez, *Days of Obligation: An Argument with My Mexican Father* (New York: Viking, 1992), 24.

41. Cynthia Steele, *Politics, Gender, and the Mexican Novel, 1968–1988: Beyond the Pyramid* (Austin: University of Texas Press, 1992), 8.

42. A longer, more detailed study of *La noche de Tlatelolco* would have to consider, one, the multiple determinations of the "workers"; two, the problem of identifying the opposition; and, three, the too-easy determination of Sócrates, the name par excellence of dialogue, as a traitor to the student movement.

43. Paz argues in *Posdata* that the 1968 Olympic Games were awarded to Mexico as a reward for economic development, which means, quite simply, that Mexico had begun to look like us, so-called developed, first-world nations (32–33).

44. The recent struggle over the "experience" of Rigoberta Menchú—including her own denials of the "I" of *Me Llamo Rigoberta Menchú*—is a case in point. See David Stoll, *Rigoberta Menchú and the Story of All Poor Guatemalans* (Boulder: Westview Press, 1999).

45. For an unproblematic reading of the camera's mediation of the scene of contact, see Ruth Behar, *The Vulnerable Observer: Anthropology That Breaks Your Heart* (Boston: Beacon Press, 1996). For a more troubled but still unsatisfactory account of technology's place in tourist/anthropological scenes, see James Clifford, *Routes: Travel and Translation in the Late-Twentieth Century* (Cambridge: Harvard University Press, 1997).

46. Bataille writes: "That man who assumes in the eyes of each participant of a community the value of the *others* can do so, as I said, insofar as he signifies the *subjectivity* of the others. That presupposes the communication from *subject* to *subject* of which I speak, in which *objects* are the intermediaries, but only if they are, in the operation, reduced to insignificance, *if they are destroyed as objects*"

(*The Accursed Share*, vols. 2 & 3, trans. Robert Hurley [New York: Zone Books, 1993], 3:243).

47. Juan García Ponce, *Las huellas de la voz* (Mexico City: Ediciones Coma, 1982), 130.

48. The prefix "re-" also invokes the Latin *res* or "thing"; for an interesting account of the "re" of "representation" that considers the necessary relation between repetition and thingliness, see Stephen Gingerich, "Arte y el dominio de la representación," in *Rostro@representación.com: Hombres y máquinas; realidad y representación*, Stephen Gingerich et al. (San Sebastián: Diputación Foral de Guipuzkoa, 1998), 54–55. Along the same lines, see David E. Johnson, "The Time of Translation: The Border of American Literature," in *Border Theory: The Limits of Cultural Politics*, ed. Scott Michaelsen and David E. Johnson, 129–65, for a reading of Borges's "Pierre Menard, Autor del *Quijote*" that foregrounds the invisible visibility of translation. Also, see Jacques Derrida, *Dissemination*, trans. Barbara Johnson (Chicago: University of Chicago Press, 1981), who writes of the possibility of the text, of its appearance, that it must "hide from the first comer" (63).

49. María Luisa Mendoza, *Con él, conmigo, con nosotros tres* (Mexico City: Joaquín Moritz, 1971), 53.

Reports of the Death of Cultures
Have Been Exaggerated

Marshall Sahlins

It is the ironic fate of Western people, who had thought to complete themselves in the Edenic landscapes of the Americas and the South Seas, to cure their souls in the Near East and their bodies (and bodies politic) in the Far East, that their very presence seemed to destroy what they dreamed would preserve them.[1] Instead of redemption, they found a non-Western world that always appeared to be "vanishing and modernizing"—vanishing just as their anthropologists, Malinowski lamented, were gaining intellectual purchase on it.[2] Ever since its beginnings anthropology has been a kind of "archaeology of the living," as Lévi-Strauss once said, a salvage effort haunted by the decline of indigenous cultures and the loss even of their memories.

"Sentimental pessimism," Stephen Greenblatt called this tragic anthropological mood, the assimilation of other people's lives in global visions of European domination.[3] Or again, one might think of it as "despondency theory," the logical and historical antecedent of dependency theory.[4] In the 1950s and '60s it had seemed a lugubrious certainty that the centuries of Western imperialism, the long development of underdevelopment, had devastated the cultural institutions, values, and consciousness of the world's once-aboriginal peoples. Modernization theories had the same presuppositions. Indeed, modernization would take the process of deculturation to a final solution, insofar as traditional custom was perceived to be an impediment to "development." Here is a typical statement of the underlying despondency theory, cited by Paul Stoller from a 1963 text on French colonial history in West Africa:

[People] had their old life broken by the shock of European contact: the old order of tribal society, with its cohesion based on the unquestioned rule

of custom, has been forced into the background; and the native, uprooted by the shattering of everything which has previously guided him, drifts disillusioned and despairing, now knowing no hope, and now with the insane joy of the iconoclast aiding the outside forces in rending his life from top to bottom.... The future is unclear because the native, here a French citizen and there a mere "subject," does not know where he can fit in. Seeing neither a place for himself nor hope for his children, he drifts in reckless despair or gives way to carefree insouciance.[5]

Until very recently, the usual anthropological complement of "despondency theory" was a serious concern with the destruction of the Other. For it was certainly (and monstrously) true that too many peoples had gone to the wall. But many were still standing. And struggling. The problem with despondency was that in denying any cultural autonomy or historical agency to the indigenous others, the anthropologies of the world system became too much like the colonization they justifiably condemned. So something had to be said for the recalcitrant ethnographic reports of indigenous peoples who were refusing either to go away or to become just like us. It turns out these societies were not merely disappearing a century ago, at the beginnings of anthropology, they are *still* disappearing. For at least those peoples who physically survived the colonial onslaught are still taking cultural responsibility for what has been inflicted on them.

I quote Bruno Latour:

The presumably vanishing cultures are, on the contrary, very much present, active, vibrant, inventive, proliferating in all sorts of directions, reinventing their past, subverting their own exoticism, turning to their own good the very anthropology so disavowed by postmodern criticism, "reanthropologizing" if I can use this term, whole regions of the earth which were supposed to have faded into the monotonous homogeneity of a global market and deterritorialized capitalism.... The newly animated cultures are much too strong to dwell on our past misdeeds or present lack of heart. What the current situation needs is an anthropology willing to embrace its formidable achievements and to push further its many valuable insights.[6]

Rather than the Grand Narrative of Western Domination—a narrative that is, paradoxically, one of the last sanctuaries of cultural essentialism—another way of handling the common anthropological report that other peoples are not so easily deculturated would be to recognize the simultaneous development of global integration and local differentiation. Integration

and differentiation, globalization and indigenization, are going on together, in some sort of co-evolutionary dialectic. Or as Jonathan Friedman remarks: "Ethnic and cultural fragmentation and modernist homogenization are not two arguments, two opposing views of what is happening in the world today, but two constitutive trends of global reality."[7] Within the global ecumene are many new forms of life: syncretic, translocal, multicultural, and neotraditional forms, largely unknown to a too-traditional anthropology.[8] It is almost as if we had found life on another planet, this history of the past three or four centuries out of which have been forged other modes of life on this planet—a whole new cultural manifold.

The Transcultural Society

I talk of only one such novel form, which I call "transcultural society"— or sometimes, "translocal culture." I mean the dispersed communities that have recently developed out of the huge worldwide phenomenon of "circular migration," the cyclical movement of people between the hinterlands and metropoles of world capitalism. But I start with the experience of one expatriate, the brilliant Tongan sociologist and anthropologist, novelist and essayist, Epeli Hau'ofa.

Born in New Guinea of Tongan parents, educated in Papua-New Guinea, Tonga, Fiji, Canada, and Australia; formerly deputy private secretary to the King of Tonga and recently professor and head of the School of Social and Economic Development, University of the South Pacific in Suva, Fiji; with a Ph.D. in Anthropology from the Australian National University based on ethnographic field work with Mekeo people of Papua; author of notable works of fiction as well as technical monographs on Mekeo society and Tongan economic development; Epeli Hau'ofa incarnates in his own biography the vision of an Oceanic space of life created by the free movement of island peoples that he articulated in 1993—in defiance of neo-colonial conceptions of Pacific societies as doomed to underdevelopment by their isolation and their multiple lacks: of land, of population, of resources, and, not least, of enterprise. As a professor in a university serving twelve Pacific island countries, Hau'ofa said he could no longer continue to peddle this European discourse of belittlement to his students. The occasion was a public lecture, "Our Sea of Islands," delivered during celebrations of the twenty-fifth anniversary of the USP.[9] The immediate result was a small volume—*A New Oceania: Rediscovering Our Sea of Islands*—which featured Hau'ofa's lecture, the responses to it by nineteen colleagues, and his reply to the latter.[10] Some

were quite taken aback by Hau'ofa's "romantic idealism." Here were arguments about the cultural autonomy of ordinary people, even mytho-practical allusions that attributed their current freedom of movement to the legendary travels of ancestral heroes to the heavens above and the underworlds below, while seeming to ignore the this-worldly system of neo-colonial domination transmitted locally by comprador ruling classes and multinational corporations. Yet in a final reflection on the criticism, Hau'ofa drew attention to the people's own cultural consciousness—a self-reflexive use of "culture" now breaking out the world over.[11] He regretted that local intellectuals were ignoring their cultural traditions in favor of the apparently universal languages of political economy and political science. The indigenous scholars were speaking in an alien tongue—while ordinary islanders were busily adapting their ancestral discourses to their current situation:

> It is a pity that we seem to have so ignored the importance of our cultures that whenever some of us try to look at our own heritage, to the achievements of ancestors, for inspiration and guidance, we bring down on ourselves charges of romanticism, mythical consciousness, speciousness and valorization, especially from our own people. We cringe when our culture is mentioned because we associate our traditions with backwardness and unenlightenment.... By deliberately omitting our changing traditions from serious discourses, especially at the School of Social and Economic Development [of the USP], we tend to overlook the fact that most people are still using and adapting them as tools for survival. (Hau'ofa, "Beginning," 129)

Even Hau'ofa's retort thus drew upon traditional cultural resources. For as many of his writings show, he knows very well the underlying scepticism that attends Polynesian systems of authority: the contradictions of kinship and power whose traditional complement is a popular and cunning disposition to subversion. In something of the same popular spirit, Hau'ofa would also undermine the foreign-imperialist theories of "dependency" and "modernization," according to which the island societies were too poor to achieve any semblance of autonomous "development"—or then, any self-respect. "MIRAB societies," as they were unhappily known at the USP, subsisting on migration, remittances, aid, and (overblown) bureaucracies. The notion of MIRAB societies, as developed by Bertram and Watters, had the historical virtue of situating the islands in a system of international relations—if it did not also conceive them as the creators of international societies of their own.[12] The problem

was the merely reactive cultural role that the MIRAB-concept allowed the island peoples. "The decisive forces have ... come from outside rather than any internal dynamic and [the islanders] have responded by making local adjustments."[13] Here was an "externally driven process" that "increasingly and decisively dominated the respective island societies and largely determined their evolution."[14]

Through the 1980s, Hau'ofa had been a reluctant accomplice of this ideology of despair. In 1986 for a seminar on "development" he wrote a paper on Pacific societies called "The Implications of Being Very Small." It was a veritable catalogue of the economic laments occasioned by this uninteresting condition. Moreover, Hau'ofa argued, the islands' geographic situation in combination with their lilliputian proportions made their sovereignties as vulnerable to the machinations of Pacific superpowers as their environments were to nuclear testing "and other things large countries dare not do at home." Small might be beautiful to some people, Hau'ofa said, "but the world at large has made our smallness and our geographical location the roots of our predicament."[15]

Still, in this work and others there had always been a certain ambivalence in Hau'ofa's pessimism. Even the report on marketing he compiled for the Tongan government is punctuated by gently ironic descriptions of how the people's customary inclinations manage to undermine various development schemes of foreign inspiration.[16] In analogous ways, "The Implications of Being Very Small" perceived the so-called development— urbanization, expansion of the monetary sector, and the like—as a *threat of impoverishment*, inimical to the traditional "subsistence affluence" enjoyed on the islands. In certain passages, the tragic notions of smallness and insufficiency amounted to an external ideological trip laid on the island peoples by self-appointed experts in economic development:

> in any publication on aid and development in the region, you will most likely read that we are tiny, scattered, resource poor, and incapable of standing on our own feet in the modern world. This idea has been so consistently inculcated into us that our own leaders and people are convinced of our insignificance and therefore, general helplessness.[17]

Yet it was in his fiction, especially the *Tales of the Tikongs*, that Hau'ofa's populist resentments came out in their strongest and most Polynesian form.[18] I say "populist," although precisely what is Polynesian about these hilarious send-offs of "development" is that the common people do not speak from a position of class dependency; on the contrary, they are the true people of the land, by contrast and in opposition to

ruling chiefs who would trace their origins to the heavens and other such foreign places. Just so, the useless bureaucrats of the tiny fictional island of Tiko are continuously off to conferences in Wellington, seminars in Geneva, and training courses in London, while expatriate technical experts sent out by the "Great International Organization" naively fail to cope with local knowledges and subterfuges.[19] So in "Our Sea of Islands" he speaks of:

> ordinary people, peasants and proletarians, who, because of the poor flow of benefits from the top, scepticism about stated policies and the like, tend to plan and make decisions about their lives independently, sometimes with surprising and dramatic results that go unnoticed or ignored at the top. Moreover, academic and consultancy experts tend to overlook or mis-interpret grassroots activities because these do not fit in with prevailing views about the nature of society and its development. Thus views of the Pacific from the level of macroeconomics and macropolitics often differ markedly from those of the level of ordinary people. (Hau'ofa, "Our Sea of Islands," 2–3)

We need not suppose, then, that Hau'ofa's conversion to a defiant view of the islanders' plight was quite as dramatic as he claims. I say "conversion" because in "Our Sea of Islands" Hau'ofa describes a trip he made in 1993 across the Big Island of Hawai'i, between Hilo and Kona, as his "Road to Damascus." Rising from the fiery depths and expanding into the sea, the flow of Kilauea volcano under the aegis of the goddess Pele seemed to him a better metaphor of the islanders' cosmos than the political boundaries and "mental reservations" to which they had been too-long confined by Western determinations of their existence. We do not now, he said, nor did we ever, live imprisoned on "tiny islands in a far sea," the way it looks to Europeans. The sea is our home, as it was to our ancestors. The ancestors' world "was anything but tiny. They thought and recount-ed their deeds in epic proportions" (Hau'ofa, "Our Sea of Islands," 7). They lived in great associations of islands linked by the sea—as in the kula ring, or the regional community of Tonga, Fiji, Uvea, Samoa, Rotuma, Futuna, and Tokelau—*linked* by the sea, not separated by it.

Since World War II, Hau'ofa continues, the Pacific peoples have been able to resume this traditional mastery of ocean space, if by new means, for new purposes, and to an ever-greater extent. They now expand their islands in novel forms:

Everywhere they go, to Australia, New Zealand, Hawai'i, mainland U.S.A., Canada and even Europe, they strike roots in new resource areas, securing employment and overseas family property, expanding kinship networks through which they circulate themselves, their relatives, and their stories all across their ocean; and the ocean is theirs because it has always been their home. (Hau'ofa, "Our Sea of Islands," 10)

By contrast to the Western development notions of their minuteness, the islanders are embarked on an unparalleled "world enlargement." Rather than fixed and insufficient resources, they have gained access to the products of an international division of labor. For their "homes abroad" (Hau'ofa's term) are connected by kinship ties and an interchange of personnel—not to forget the connections of telephone, fax, and soon e-mail—to the island homeland which still defines their identity. Nor need one speak the Western-economistic language of "remittances." The exchanges are two-sided, something like the customary reciprocity between kinsmen, including the elements of total prestation that add certain social values to the transactions.[20] Hau'ofa tells of Tongan goods and foods flowing to Auckland and Honolulu against the reverse movement of cash, or it may be refrigerators or outboard engines. Yet the apparent "remittances" and "repayments" are the material dimension only of an ongoing circulation of persons, rights, and regards between the home islands and the homes abroad. The international boundaries and oceanic distances, which in the White man's construction of planetary space signify difference and isolation, are traversed by a specifically Tongan set of social and cultural relationships. Tongans—as also Samoans, Tuvalans, or Cook islanders—live in multilocal communities of global dimensions. They have expanded their cultural scope and potentialities in ways that cannot be conceived by the development-economics of their insignificance.

George Marcus has given some informative examples of the Tongan oceanic kinship networks.[21] These kindreds are typically headed by a personage of the old aristocracy, or else by a member of the newer commoner elite, who in either case normally resides in the main island of Tonga. The local, Tongan complement of a commoner elite network described by Marcus included one high-level bureaucrat, three middle-level civil servants, one executive of the radio station, one employed Ph.D., and three teachers. This group had a hereditary interest in three cultivable lands, as well as leases on five others, and were engaged in considerable commercial agriculture. They also had two town lots and two retail

businesses. Members of the kindred in Hawaii were engaged in the hand-icraft business; they also owned rental property and three were attending university. Relatives in California included the owner and operator of a gas station and two people employed at the San Francisco airport; this branch had two residential properties. Three members of the kindred in Utah were employed as unskilled laborers; another was a teacher. In New Zealand there was one kinsman in transport work, two at secondary school, and one in university. The New Zealand branch had one rental property and one residence.

All in all, Marcus speculated that in the early 1980s some 30,000 Tongans were "permanently" abroad, by comparison with a home popu-lation of about 100,000. The largest overseas concentrations of Tongans were in New Zealand (especially Auckland), Australia, Fiji, and the United States (especially Hawaii, California, and Utah). Still, information on the Tongan diaspora is not as accessible as similar materials from neighboring Samoa, so it will be worthwhile to consider the latter for illustration—and cross-cultural comparison.

In F. K. Sutter's pertinently titled volume *The Samoans: A Global Family*, there is a map of modern Samoa.[22] By means of photographs and texts, including brief autobiographies of many of the people depicted, Sutter presents a fascinating account of the Samoan diaspora. It should be noted that by the mid-1980s, some one-third of the Western Samoan pop-ulation was living overseas; while more than 60 percent of the population of American Samoa had left for Hawaii and the U.S. mainland. Altogether, Samoans could be found in some twenty states of the United States and thirty different nations around the world.

In the autobiographies of this diaspora collected by Sutter, a detective in Wellington writes:

> I consider myself a true blue Samoan and am very proud of it.... I've managed to get home to Samoa every 2 years. Presently I'm conducting courses at the Royal New Zealand Police College on Samoan language and culture. (Misiotele, qtd. in *The Samoans*, 167)[23]

The Sumo wrestler Konishiki, the first foreigner to achieve champion rank in Japan, recounts the difficulties he has had with the media estab-lishing his identity:

> For the longest time they insisted on calling me a Hawaiian. But that's finally changing. They now report I'm a Samoan born in Hawaii, and that makes me proud. (qtd. in *The Samoans*, 173)

Sutter's saga of Samoans also includes a shepherd in Invercall, New Zealand; a pastor in Zambia; a nun in Rome; an international civil servant working at UNESCO in Paris, to whom God granted "the gift of being born Samoan—body, mind and soul"; a brewmaster in Munich; an engineer in Norway; a clergyman in Jamaica; an F.B.I. agent in Florida; and a doctoral student in theology in Montpelier, France, who does not forget the *aiga* (the kindred group):

> I hope that my writing in the first person will not obscure the communal support I have had from my family, my wife and her family, friends and village people. My life's tracks rest on a broad base of communal support, Samoa. (qtd. in *The Samoans*, 181)

There is much more here than personal nostalgia. As individuals, families, and overseas communities, the emigrants are part of a dispersed transcultural society centered in the homeland and united by a continuous circulation of people, ideas, goods, and money. Moving between foreign and indigenous cultural loci, adapting to the former while maintaining their commitment to the latter, Tongans, Samoans, and numerous other peoples like them have been able to create the novel formations we are here calling transcultural societies. "In many ways," notes an ethnographer of northern California Samoans, Craig Janes, "Samoa and San Francisco constitute a single social field in which there is a substantial circulation of members."[24] Moreover, in many regards, "Samoan migrants think they are 'more Samoan than the Samoans in Samoa'" (Janes, "Migration," 62). Janes describes the San Francisco *aiga* or extended family network as taking a particular functional shape, adapted to the exigencies of the diaspora. The overseas *aiga* is marked by the solidarity of close kin of the same generation—as contrasted to the intergenerational hierarchies of the homeland—and by more frequent formal interaction with distant kin than in Samoa. The Samoan village is also adaptively reproduced: that is, as the congregation of an overseas church.[25]

Here is a whole new field of comparative anthropology: not merely comparison between the differently situated homeland and overseas communities of the same translocal society, but between different kinds of multilocal cultural formations such as the Samoan and Tongan. George Marcus remarks on the contrasts between the Samoan overseas *collectivities*, their members moreover strongly linked to their villages of origin in Samoa, and Tongan kindred *networks*, dispersed in overseas locations and tied to persons rather than to places in Tonga—in the most successful

cases, to the noble and commoner elite gathered about the royal capital of Nuku'alofa. Marcus suggests that the difference "might have something to do with the extension abroad of fundamentally different kinds of local organization at home in Tonga and Samoa."[26] Indeed, following Marcus's description, the contrastive Tongan principle is the hierarchical focus of kinship order on an elite personage—he or she in turn focused on and located about the kingship—which is what gives definition and coherence to the group as a whole. The same hierarchical principle permits the consolidation of the network's dispersed and diversified resources at its elite homeland center. When Marcus further suggests that overseas kinship networks tend to break down if they cannot convert their resources into elite status at home, the continuity with the analogously dispersed, chiefly centered lineages of ancient Tonga is plain to see (Marcus, "Globalizing Strategies," 29). Compare Gifford's remarks on the traditional *haa* (lineage), often distributed over the archipelago but always with "a chief as a nucleus":

> Everything points to the necessity of a line of powerful chiefs for a nucleus about which the lineage groups itself. Without such chiefs it appears to wilt and die and its membership gradually aligns itself with other rising lineages.[27]

Epeli Hau'ofa was no doubt correct in asserting that Polynesians had their own structures of world-enlargement well before Europeans tried to exile them to forsaken little islands set in a distant sea.

Since the late nineteenth century, moreover, translocal cultures similar to the Tongan and Samoan have been evolving all over the Third World, among peoples supposedly incarcerated by imperialism and without hope of "development."[28] Mostly taking shape as urban ethnic outposts of rural "tribal" homelands, these synthetic formations were long unnoticed as such by the Western social scientists studying them.[29] No doubt the stranglehold of European history on the anthropological imagination has been a main reason this novel cultural structure of modernity remained empirically and conceptually under-determined. The general presumption of Western social science was that urbanization must everywhere put an end to "the idiocy of rural life," as had happened in early modern Europe. By the very nature of the city as a complex social organism, relations between people would become impersonal, utilitarian, secular, individualized, and otherwise disenchanted and detribalized. Such was progress. Such was the trend in Robert Redfield's famous "folk-urban

continuum." As the initial and final stages of a qualitative change, countryside and city were structurally distinct and opposed ways of life.

True that strong empirical arguments against this rural-urban discontinuity already had been voiced by the early 1960s, based on studies of migrant communities in non-European cities. Edward Bruner explicitly criticized the Redfieldian perspective—"After the rise of cities men become something different from what they had been before"[30]—by demonstrating the continuities of identity, custom, and kinship between highland villages of Toba Batak and their urban relatives in Medan (Sumatra). Bruner offered a description of Batak unity of a kind we have already heard echoed for Samoans—indeed that was destined to be repeated the world over: "Examined from the structural point of view, the Toba Batak communities in village and city are part of one social and ceremonial system."[31] All the same, the received wisdom about the historic antithesis of village and city has made it difficult to change the gestalt, to perceive the possibility of a translocal population that could inhabit both situations and remain an interdependent social and cultural whole.

British social anthropology in Africa was long hung up on the same dualist a priori. In 1960, in an influential article that purported to sum up twenty years' research by staff of the Rhodes-Livingstone Institute, Max Gluckman made the distinction of "townsmen" and "tribesmen" an issue of basic theoretical principle. "An African townsman is a townsman, an African miner is a miner: he is only secondarily a tribesman."[32] Gluckman and his colleagues always were prepared to deny the colonial prejudice that African townsmen were altogether "detribalized."[33] But the tribal "classifications" one observed in the cities were distinct in function and behavioral implication from tribalism in the country, a distinction that reflected two different social systems. "The African in the rural area and in town," said Gluckman, "is two different men" (Gluckman, 69).

Meanwhile many of Gluckman's students and associates were describing something quite different: a synthesis of "townsmen" and "tribesmen" in a single socio-cultural field which took its identity from and otherwise privileged the rural homeland—and inhibited or precluded the transformation of the migrants into a typical urban proletariat. Thus Watson on Mambwe, Mayer on Red Xhosa, Van Velsen on Tonga of Nyasaland, among others. Watson's *Tribal Cohesion in a Money Economy* also initiated the comparative study of translocal structures by showing how the patrilineal system of the Mambwe was able to develop higher material returns from migrant labor, while maintaining greater social

integrity, than the matrilocal-matrilineal order of the nearby Bemba.[34] The conceptual status of such observations, however, is signified by their relegation to a footnote in Clyde Mitchell's 1967 review article on African urban studies. Said Mitchell: "I am excluding here those studies of migration which look upon town and country as integral parts of one social system in which townsmen and tribesmen are linked in networks of relationships in the town, in the rural areas, and between the two."[35]

But as they were remarked upon more and more frequently, the translocal systems soon became difficult to ignore.[36] Explicit criticisms were made of the townsman-tribesman dualism of the Rhodes-Livingstone School, analogous to the early empirical objections to the folk-urban continuum.[37] For one problem, the antithesis of townsmen and tribesmen was not generally known (as such) to the people themselves: not even to long-term residents of the city, members of labor unions or other urban associations—they did not forsake their tribal affiliations or their relations to rural homelands. Accordingly study after study, and not only in Africa, spoke of the union of village people and their city relatives in "a bilocal society," "a common social field," "a social village spread over thousands of miles," a "social structure that encompasses both donor and host locations," or some species of the like.[38] Indeed many researchers perceived a tendency for the metropolitan and hinterland sectors of this unified system to become more alike, although not merely because the flow of ideas and commodities from the town was transforming the countryside.

Modernization has not been the only game, even in the town. The inverse effect, the indigenization of modernity, is at least as marked—in the city and country both. In the complex dialectics of the cultural circulation between homelands and homes abroad, customary practices and relations acquire new functions and perhaps new situational forms. J. Van Velsen came to the interesting conclusion for Nyasaland Tonga that returning migrant workers, by competing for local political positions and taking up local land rights, while relying on kinsmen in the process, were "actively stimulating the traditional values of their rural society" (Van Velsen, "Labour Migration," 278).[39] For the African Tonga as much as the Polynesian, kinship is often a beneficiary of modernization rather than its victim—by contrast again to the European experience and its normal social science. Wealth from the city subsidizes relationships in the village, while relatives in the city organize migration from the village. In perceptive and prescient researches undertaken in the 1960s, Keith Hart was able

to show that the integration of rural and urban Frafras (Tallensi and related peoples of Ghana) was largely effected through their classic lineage system. From this Hart concluded the necessity of a new anthropological perspective, one that would transcend the correlated oppositions of the modern and the traditional, townsman and tribesman, urban and rural. He spoke rather of an "expansion of the horizons of the community":

> This expansion of the horizons of the community, in terms of the physical distribution of those who claim membership in a socially defined aggregate such as a lineage, makes it no longer easy to dichotomise, at least spatially, the traditional and the modern or even the rural and urban in Frafra life today. The world of the migrant and that of the homeland are not separable entities.... The difficulty of separating the old and the new in the analysis of present day Frafra society, either in the national context of modern Ghana or even in the local context of the home tribal area, is illustrated by the simultaneous participation by most Frafras in both cultures, the exchange of personnel on a reciprocal basis between the home compound and southern city, the internal urbanisation of the Frafra district itself, the pervasiveness of the market economy, and especially the ease of communication between all parts of the country. When the discontinuities between town and village life have been diminished, what meaning can we legitimately give to types such as "townsmen" and "country men"?[40]

I hazard a few generalizations on the structure of these translocal systems as described by Hart, Hau'ofa, and many others. Culturally focused on the homeland, while strategically dependent on the peripheral homes abroad, the structure is asymmetrical in two opposed ways. Taken as a whole, the translocal society is centered in and oriented toward its indigenous communities. The migrant folk are identified with their people at home, on which basis they are transitively associated with each other abroad. These denizens of the town and the larger world remain under obligation to their homeland kinsmen, especially as they see their own future in the rights they maintain in their native place. Accordingly the flow of material goods generally favors the homeland people: they benefit from the earnings and commodities acquired by their relatives in the foreign-commercial economy. As one researcher put it, the village succeeds in reversing "the parasitic function traditionally ascribed to cities" (Hugo, "Circulation," 264). In such respects, the indigenous order encompasses the modern.

I stress the homeland focus of transcultural societies, the spatially centered character of the life-form, as against a tendency to speak of "deterritorialization" and a "merely symbolic" or "imaginary" attachment of diasporic populations to their places of origin. A number of anthropologists in recent years, impressed by the way these multilocal communities are able to transcend territoriality, indeed extend across national boundaries, have argued that they are best perceived as non-spatial orders, wherein lies their novelty. Roger Rouse makes the interesting suggestion that the community, so far as Mexican migrants to the United States are concerned, consists in and of the circulation itself: what he thus calls a "transnational migration circuit" (Rouse, *Mexican Migration*). Others, such as Arjun Appadurai, fixing on the empirical, off-the-ground reality of population movement, accordingly devalue the continuing identification with the homeland. The homeland, writes Appadurai, "is partly invented, existing only in the imagination of the deterritorialized groups, and it can sometimes become so fantastic and one-sided that it provides the fuel for new ethnic conflicts."[41] The observation is at least refreshing for its reversal of the usual "bottom-line morality demonstrations" of objective reality, to the effect that such-and-such a social fact or identity is sufficiently real for people really to be dying because of it.[42] Another example of the implicit empirical realism of the deterritorialization perspective is provided by Achil Gupta and James Ferguson, for whom the apparent freedom from place is so "actual" that the valuation of the homeland seems by contrast symbolic, if not also ironic:

> The irony of these times ... is that as actual places and localities become ever more blurred and indeterminate, *ideas* of culturally and ethnically distinct places become perhaps even more salient.... "Homeland" in this way remains one of the most powerful unifying symbols for mobile and displaced persons.... We need to give up naive ideas of communities as literal entities (cf. Cohn 1985), but remain sensitive to the profound "bifocality" that characterizes locally lived lives in a globally interconnected world.[43]

One can see that recognition of the transcultural society has taken some effort on the part of the anthropological imagination. Without getting into the metaphysics of spatiality or entity, it should be noticed that the extended community also has a necessary quality of temporality—from which it derives its cultural consistency. It is precisely as a place of origin that the homeland remains the focus of a far-flung set of cultural relationships. A source of inherited values and identities, the home community transcends cultural boundaries to inform the actions and attitudes

of its people living in urban and/or foreign contexts. Commenting on a study of Siane people in Port Moresby (New Guinea), Richard and Mary Salisbury observed that, contrary to the received wisdom on the "urbanization" of migrants, many of these highlanders successfully adapted to the city while remaining oriented toward the country:

> Their goals remain the same as before. Their strategies of choice between alternative behaviors while in town continue to aim towards ultimate success in a rural context and are conditioned by the alternative courses of action open to them in their villages. ("Rural-Oriented Strategy," 59)

People feel the worth of village life, the Salisburys discovered, and they want to return, "bringing the advantages of the town with them" (59).

"The advantages of the town": this is the complementary asymmetry in the transcultural society, involving a certain invidious superiority of the modern, external sector. Even beyond the material virtues of foreign goods, the things and experiences of the outside world are incorporated in homeland communities as cultural powers. They have positive influences on local relationships and critical roles in the reproduction of homeland societies.[44] Foreign migrations are thus articulated to local ambitions. All this can be seen precisely when the exchanges between the homes abroad and people of the homeland are assimilated to traditional practices of reciprocity (as Hau'ofa insists is the appropriate understanding of these transactions). For insofar as the goods from abroad reciprocally evoke rights and regards at home, beyond any return gifts of indigenous goods or hospitalities, it is because the contributions from the migrants have powerful effects on local relationships. Key traditional functions such as marital and mortuary exchanges, feasts and rituals of various kinds, descent and title transmissions, are subsidized by earnings in the external, commercial sector. The indigenous center thus becomes dependent on the people abroad for its own cultural reproduction.[45]

Prestigious values and powers reside in the foreign sphere: in its beings, its objects and the things that are done there. So it seems relevant to the development of transcultural societies that many peoples had already accorded such virtues to external spheres and modes of existence well before colonialism introduced them to more draconic versions. A number of modern ethnographers, working as far apart as Mexico, the Amazon, Indonesia, New Guinea, and Vanuatu, have made interesting associations between ancient and modern circular migrations. Traditionally the expeditions may have been rites of manhood—an observation made for South Africa by Schapera in 1947 (Macpherson, "Public and

Private," 242).[46] From exploits that transcended the community and cultural boundaries, men returned with trophies of war or the chase, with commodities gained in raid or trade, with visions, songs, dances, amulets, cures and cults, things familiar or novel that could be consumed, sacrificed, exchanged or otherwise distributed to renew and develop the indigenous forms of life. Certain dispositions of cultural encompassment that are now known as imperialism were not born yesterday. Nor were non-Western societies as bounded and self-contained as postmodernism pretends that modernism pretends. "Just as the blind Homer sang of the journeys and exploits of Ulysses and the heroes of Troy," remarks Roderic Lacey, "so recent Enga poets [of New Guinea] have praised their heroes and immortalised their deeds through images of commemorative chants" (Lacey, "Journeys," 93). If the poetry persists it is because Europeans have "opened new pathways for indigenous travellers." One could say that from the initial diaspora of the colonial period, through the "epic journeys and visions growing out of the war in the Pacific," to the diversification of opportunities and destinations in postcolonial times, New Guinea has seen an exponential development of the traveling tradition. In this regard the young people setting off to the coastal towns or foreign lands in search of education, employment, and adventure will, in something of the same way as the odysseys of the ancients, be the sources of innovation and transformation in the indigenous existence.[47] Likewise in Indonesia, the custom of *merantu* continues unabated. Young men still undertake long voyages whose object is the experiences that make them worthy of adulthood. Or again, in Oaxaca, migration to and the return from North America rehearse certain "subversive popular stories" whose heroes "were often rustlers, smugglers and artful lovers, all notable for cunning ability to transgress the boundaries upheld by those more powerful than themselves" (Rouse, *Mexican Migration*, 124). Thus does this discussion itself make full circle to the Tongan migrants described by Epeli Hau'ofa, who like their ancestral gods and heroes come and go through their sea of islands, willfully crossing the international borders as well as the ideological barriers to their "development" erected by the global powers-that-be.

Yet the modern transcultural society also generates its own ideological forces, folklores of the internal and the external with similar capacities of distributing people and goods between them. Both city and country know their contradictions: social tensions which are exacerbated by their interdependence—and then give complementary positive values to the alternative way of life. The reproduction of the homeland through emigration is

often accompanied by intergenerational stresses. The young break away to the larger world. In addition to the attractions of modernity, the city is perceived in the countryside as a place of freedom—freedom notably from old men and traditional constraints. Yet the centrifugal cultural and social effects are likely to be checked by the urban experience. As victims of discrimination, proletarianization, and pauperization, some important proportion of the "tribal" people in the modern sector develop a nostalgic view of their ancestral places. From the vantage of the foreign metropole, the homeland is idealized as the site of a "traditional" lifestyle: where people share with one another, where no one starves, where money is never needed. Ideological products of the inter-cultural system, the respective visions of each other formulated in the modern and traditional sectors keep up the circulation between them.[48]

Will it last? Can it last? Supposing the migrants settle permanently abroad, would not the translocal society have a sort of generational half-life, the attachments to the homeland progressively dissolving with each city-born or foreign-born generation? Will not the acculturation of the people abroad sooner or later make the diaspora irreversible, thus breaking apart the translocal society? Probably these outcomes often happen, but perhaps not as rapidly or easily as we are predisposed to believe. In Java, circular migration seems to have been in vogue since 1860; a Dutch scholar, Ranneft, who studied it in 1916, thought it impeded the formation of a stable local proletariat, as the migrants who entered into the capitalist mode of production remained "traditional men" with a strong stake in their villages of origin (Prothero and Chapman, *Circulation*, 6).[49] Walter Elkan came to very similar conclusions about recent African migration systems. Many of the African rural-urban tribal orders were already in their second or third generation by the time they were noticed by Western researchers, having begun in the 1920s or earlier (Elkan, "Proletariat"). And although in recent years, "tribesmen" have been working in the cities for longer periods, perhaps for their active lifetimes, they may remain as committed as ever to their native places—socially, morally, and economically. If anything, studies of Luo and Kikuyu in Nairobi show that interest and investment in the rural homelands is greater in proportion to the higher status, stability, and remuneration of a person's urban employment. The most successful people in the city are the most engaged in the traditional order of the country—as indeed they can best afford.[50] Or, consider a New Guinea example: the Uritai villagers in Port Moresby that Dawn Ryan has been working with since the 1960s. By the 1990s three-fourths of them were either born in a city or had long

been absent from the village. Their native land rights had gone cold, and Ryan thought they realistically had no option to return to the village. Nevertheless, they were still "Uritai" and had intensive interaction with home villagers—some of whom, for their part, were still migrating to the town: "There has not been a progressive withering away of primary links between the village and the town" (Ryan, "Migration," 232). And this seems to be a very widespread phenomenon. A large anthropological literature on culture and development indicates that "migrants have not been proletarianized in any deeply ideological sense."[51]

I think the secret of the seeming failure to urbanize is that there has not been a progressive withering away of the village. The translocal society may well persist so long as there is a cultural differential between the rural and the urban, or more generally between the indigenous homeland and metropolitan homes abroad. The two sectors will then remain interdependent and culturally focused on the homeland. While it is true that some fraction of the migrant population may slacken connections to their original communities, they will be replaced by fresh arrivals from the villages; at the same time, some of the urban or overseas people, disabused by discrimination or unemployment or else ready for retirement, will be content to "return to the source."[52] All in all, the translocal system could manage to reproduce itself for a considerable period. The history of Western urbanization does not necessarily repeat itself, especially considering that since classical times this history has proceeded on an invidious distinction between the civil(ized) and barbarian which is nearly the opposite of the cultural value of the hinterland in modern translocal communities.

In this regard we have already seen some of the mischief of the corollary illusion of Western history to the effect that certain characteristics of urbanization—impersonal relationships, individualism, decline of extended kinship, secularization, and so on—give the illusion that these were inherent effects of the city as a social-cultural order. But was not the cultural dissolution of rural life, idiocy though it may have been, a necessary condition for the city thus to work its modernizing magic? Whether through enclosures or other forms of disenfranchisement and depopulation, or by the economic and political integration of the countryside, the original homeland may no longer function as a distinct identity and a valued option. The persistence of a distinct rural culture rather than the existence of a hegemonic urban culture is the apparent key to the continuity of translocal communities. And if by virtue of the destruction rained on the countryside, certain regimes such as the South African have

managed to produce a sufficient alienation to urbanize and proletarianize their traditional populations, for most indigenous peoples of the Third World, the modern cities into which they temporarily move are doubly or triply alienated from themselves. Foreign in culture, alien too as the sites of state institutions, the cities are also spaces of the classic estrangements of capitalist production. Given these cleavages, the translocal culture, as a distinctive life-form of modernity, could be in for a long historical run.

Perhaps very long, because translocal communities are associating themselves with the powerful movement of cultural self-consciousness now sweeping the planet. All the paradoxes of contemporary world history, all the oppositions we had believed were exclusive—as between tradition and modernity, or mobility and continuity—are coming together in new cultural syntheses.

Notes

1. See Louis Dermigny, *La Chine et L'Occident: Le commerce a Canton au XVIII siecle, 1719–1833*, v.1. (Paris: S.E.V.P.R.N., 1964), 1.12ff., and Renato Rosaldo, "Imperialist Nostalgia," *Representations* (1989) 26:107–22.
2. See James Clifford, *The Predicament of Culture* (Cambridge: Harvard University Press, 1988), and Bronislaw Malinowski, *Argonauts of the Western Pacific* (London: Routledge & Kegan Paul, 1992).
3. Stephen Greenblatt, *Marvelous Possessions: The Wonder of the New World* (Chicago: University of Chicago Press, 1991), 152.
4. See Marshall Sahlins, "Two or Three Things That I Know about Culture," *The Journal of the Royal Anthropological Institute* 5 (1999): 399–421.
5. Roberts, quoted in Paul Stoller, *Embodying Colonial Memories: Spirit Possession, Power and the Hauka in West Africa* (New York: Routledge, 1995), 73–74.
6. I quote from an essay by Bruno Latour in manuscript (1996).
7. Jonathan Friedman, "Being in the World: Globalization and Localization," in *Global Culture*, ed. Mike Featherstone (London: Sage Publications, 1990), 311.
8. See Ulf Hannerz, *Cultural Complexity: Studies in the Social Organization of Meaning* (New York: Columbia University Press, 1992).
9. Hau'ofa's lecture was first read at the University of Hawaii, Hilo, then rewritten and delivered at the East-West Center in Honolulu, before being revised again and presented some weeks later at the University of the South Pacific.
10. Eric Waddell, Vijay Naidu, and Epeli Hau'ofa, eds., *A New Oceania: Rediscovering Our Sea of Islands* (Suva: School of Social and Economic Development, University of the South Pacific, in association with Book House, 1993). Hau'ofa's articles in this volume—"Our Sea of Islands" (2–16) and "A Beginning" (126–39)—will be cited parenthetically within this text.
11. This self-consciousness of "culture" is another important aspect of modern cultural formations among erstwhile dependent and despondent peoples.

12. See I. G. Bertram and R. F. Watters, "The Mirab Process: Earlier Analyses in Context," *Pacific Viewpoint* 27 (1986): 47–59.

13. Ray Watters, "Mirab Societies and Bureaucratic Elites," in *Class and Culture in the South Pacific*, ed. Anthony Hooper et al. (Suva: Center for Pacific Studies, University of Auckland and Institute of Pacific Studies, University of the South Pacific, 1987), 35–37.

14. I. G. Bertram and R. F. Watters, "Mirab Process," 55, 47. In the island countries analyzed by Bertram and Walters (mainly Niue, Cook Islands, Tokelau, Kiribati, and Tuvalu), the principal incomes came from wages in the public sector, followed by remittances and cash-cropping. The first two derived from overseas sources—notably the aid that sustained the large local bureaucracy—and the greatest part by far went into current consumption. Hence there was no good prospect of "development," but rather a "permanently transitional" system of dependency: an "incongruous" (to outsiders) amalgam of a neo-traditional village sector, a modern public sector, and an import-dominated commercial sector. Given the relative weight of aid and the public service bureaucracy, Watters speaks of a "'bureaucratic comprador' regime" ("Mirab Societies and Bureaucratic Elites," 49).

15. Epeli Hau'ofa, "The Implications of Being Very Small." Paper delivered to the Tokai University/Friedrich-Ebert-Stiftung Seminar on "Cooperation in Development," Tokyo, November 1986.

16. Epeli Hau'ofa, *Corned Beef and Tapioca: Food Distribution Systems in Tonga* (Canberra: Development Studies Center, Australian National University, 1979), 4–5, 8, 119.

17. Hau'ofa, "The Implications of Being Very Small" (MS, 7).

18. Epeli Hau'ofa, *Tales of the Tikongs* (Honolulu: University of Hawaii Press, 1983).

19. In his editor's note to the lately reprinted *Tales of the Tikongs*, Vilisoni Hereniko draws attention to the popular defiance of the potential tidal wave of development: "These are not stories of fatal impact so much as upbeat tales of indigenous responses to cultural and economic imperialism" (Vilisoni Hereniko, ed., *Tales of the Tikongs* [reprint 1994], vii).

20. Watters, one of the authors of the MIRAB concept, also recognized that remittances expressed "the enduring two-way relationship of reciprocity" ("Mirab Societies and Bureaucratic Elites," 37).

21. George Marcus, "Power on the Extreme Periphery: The Perspective of Tongan Elites in the Modern World System," *Pacific Viewpoint* 22 (1981): 59.

22. Frederic Koehler Sutter, *The Samoans: A Global Family* (Honolulu: University of Hawaii Press, 1989), overleaf.

23. Cluny Macpherson ("Public and Private Views of Home: Will Western Samoan Migrants Return?" in *Modernity and Identity in the Island Pacific*, ed. Murray Chapman, a special issue of *Pacific Viewpoint* 26 [1985]: 243) appropriately warns that Samoans are likely to mask reservations about their own society in the presence of Europeans. For another part, the enthusiasm for the homeland—not merely a Samoan disposition—is part of an idealization of life at home and life abroad typically expressed in the complementary sector (see below).

24. Craig R. Janes, *Migration, Social Change, and Health: A Samoan Community in Urban California* (Stanford: Stanford University Press, 1990), 58.

25. See Lydia Kotchek, "Migrant Samoan Churches: Adaptation, Preservation, and Division," in *New Neighbors: Islanders in Adaptation*, ed. Cluny Macpherson, Bradd Shore, and Robert Francs (Santa Cruz: Center for Pacific Studies, University of California, Santa Cruz, 1978).

26. George E. Marcus, "Tonga's Contemporary Globalizing Strategies: Trading in Sovereignty Amidst International Migration," in *Contemporary Pacific Studies*, ed. Victoria S. Lockwood, Thomas G. Harding, and Ben J. Wilson (Englewood Cliffs: Prentice-Hall, 1993), 28.

27. Edward Minslow Gifford, *Tongan Society*, Bernice P. Bishop Museum Bulletin 61 (Honolulu: Bishop Museum Press, 1929), 30.

28. Perhaps similar intercultural formations have existed since antiquity in the cities of non-national states. Another kind would be the dispersed communities of Arab and Indian traders that set up residences in China and Indonesia in the first millennium A.D.

29. See, for a sampling, Joel Bonnemaison, "The Tree and the Canoe: Roots and Mobility in Vanuatu Societies," in *Mobility and Identity in the Pacific Islands*, ed. Murray Chapman, a special issue of *Pacific Viewpoint* 26 (1985): 30–62; Caroline B. Brettell, *Men Who Migrate, Women Who Wait: Population and History in a Portuguese Parish* (Princeton: Princeton University Press, 1986); Edward M. Bruner, "Kinship Organization among the Urban Batak of Sumatra," *Transactions, The New York Academy of Sciences* 22 (1959): 118–25; Walter Elkan, "Is a Proletariat Emerging in Nairobi?" in *Circulation in Third World Countries*, ed. R. Mansell Prothero and Murray Chapman (London: Routledge and Kegan Paul, 1985), 367–79; George Gmelch, "Return Migration," *Annual Review of Anthropology* 9 (1980): 135–59; Graeme Hugo, "Circulation in West Java, Indonesia," in *Circulation in Third World Countries*, ed. R. Mansell Prothero and Murray Chapman, 75–99; J. A. Jackson, ed., *Migration*, Sociological Studies 2 (Cambridge: Cambridge University Press, 1969); Roderic Lacey, "Journeys and Transformations: The Process of Innovation in Papua New Guinea," in *Modernity and Identity in the Island Pacific*, ed. Murray Chapman, a special issue of *Pacific Viewpoint* 26 (1985): 81–105; Ronald Lucardie, "Spontaneous and Planned Movements among the Makianese of Eastern Indonesia," in *Mobility and Selectivity in the Island Pacific*, ed. Murray Chapman, a special issue of *Pacific Viewpoint* 26 (1985): 63–78; Philip Mayes, *Townsmen or Tribesmen: Conservation and the Process of Urbanization in a South African City* (Cape Town: Oxford University Press, 1961) and "Migrancy and the Study of Africans in Towns," *American Anthropologist* 64 (1962): 576–92; P. A. McAllister, "Work, Homestead and the Shades: The Ritual Interpretation of Laborer Migration among the Gealeka," in *Black Villagers in an Industrial Society*, ed. Philip Mayer (Cape Town: Oxford University Press, 1980), 205–53; Clyde J. Mitchell, "Urbanization, Detribalization and Stabilization in Southern Africa: A Problem of Definition and Measurement," in *Urbanization in Africa South of the Sahara* (London: UNESCO, 1956), 693–711; Tim O'Meara, "The Cult of Custom Meets the Search for Money in Western Samoa," in *Contemporary Pacific Societies*, ed. Victoria S. Lockwood, Thomas G. Harding, and Ben J. Wallace (Englewood Cliffs: Prentice Hall, 1983), 135–55; David Parkin, ed., *Town and Country in Central and Eastern Africa* (London: Oxford University Press for the

International African Institute, 1975); R. Mansell Prothero and Murray Chapman, eds., *Circulation in Third World Countries*; Roger Rouse, *Mexican Migration to the United States: Family Relations in the Development of a Transnational Migration Circuit*, Ph.D. Dissertation in Anthropology, Stanford University (Ann Arbor: University Microfilm, 1992); Michael Rumbiak, "Nimboran Migration to Jayapura, West Irian," in *Modernity and Identity in the Island Pacific*, ed. Murray Chapman, a special issue of *Pacific Viewpoint* 26 (1985): 206–20; Dawn Ryan, "Home Ties in Town: Toaripi in Port Moresby," *Canberra Anthropology* 12 (1989): 19–22; Richard Salisbury and Mary E. Salisbury, "The Rural-Oriented Strategy of Urban Adaptation: Siane Migrants in Port Moresby," in *The Anthropology of Urban Environments*, ed. R. Weaver and D. White (Boulder: The Society for Applied Anthropology, 1972), 59–68; G. A. Smith, "Huasicanchino Livelihoods: A Study of Extended Domestic Enterprises in Rural and Urban Peru," *Canadian Review of Sociology and Anthropology* 17 (1980): 357–66; Constance Sutton, "The Caribbeanization of New York City and the Emergence of a Transnational Socio-cultural System," in C. Sutton and E. Chaney, eds., *Caribbean Life in New York City: Sociocultural Dimensions* (New York: Center for Migration Studies, 1987), 15–36; Douglas Uzzell, "Conceptual Fallacies in the Rural-Urban Dichotomy," *Urban Anthropology* 8 (1979): 333–50.

30. Robert Redfield, *The Primitive World and Its Transformations* (Ithaca: Cornell University Press, 1953), ix.

31. Edward M. Bruner, "Urbanization and Ethnic Identity in North Sumatra," *American Anthropologist* 63 (1961): 515; cf. Bruner, "Kingship": taking on Redfield, Bruner remarked in introducing the arguments from Sumatra: "Contrary to traditional theory, we find in many Asian cities that society does not become secularized, the individual does not become isolated, kinship organizations do not break down, nor do social relationships in the urban environment become impersonal, superficial, and utilitarian" (508). Bruner went on to show not only the similarities of urban and village Batak, but the systematic relations between them, including their interconnected economies.

32. Max Gluckman, "Tribalism in Modern British Central Africa," *Cahiers d'Études Africaines* 1 (1960): 57.

33. See J. Clyde Mitchell, "Urbanization" and A. L. Epstein, *Politics in an Urban African Community* (Manchester: Manchester University Press, 1958). Mitchell cites and criticizes D. F. McCall on African urbanization: "Class formation tolls the knell of tribalism in the urban environment. The marks of class are independent of tribal membership; classes comprise people of various tribes" (15). Among Mitchell's other objections to this notion is the observation that class and tribal statuses tend to correspond, by virtue of occupational tendencies, and that both tribal and class identities are situational, not corporate or total. But "the essential fact is that the Africans as a whole represent one political class and Europeans another" (17). Taken together with Mitchell's observations on the imitation of European fashions and manners as marks of "civilisation," his celebrated work on the Kalela dance makes a fine complement to Amilcar Cabral's analysis of the dynamics of class and the "return to the source" (Amilcar Cabral, *Return to the Source: Selected Speeches by Amilcar Cabral* [New York: Monthly Review Press,

1973] and "The Role of Culture in the Battle for Independence," *UNESCO Courier* [November 1973]: 12–20).

34. William Watson, *Tribal Cohesion in a Money Economy: A Study of the Mambwe People of Northern Rhodesia* (Manchester: Manchester University Press, 1958). See also Mayes, *Townsmen* and "Migrancy," and J. Van Velsen, "Labour Migration as a Positive Factor in the Continuity of Tonga Tribal Society," *Economic Development and Cultural Change* 8 (1960): 265–75.

35. J. Clyde Mitchell, "Theoretical Orientations in African Urban Studies," in *The Social Anthropology of Complex Societies*, ed. Michael Banton (London: Tavistock, 1967), 161.

36. So in West Africa, "it was impossible to escape the prime significance of these data: they show, without exception, that immigrants in a variety of urban settings maintain quite strong ties with their area of origin, with what they consider their 'homes'" (Josef Gugler and William G. Flanagan, "Urban-Rural Ties in West Africa: Extent, Interpretations, Prospects, and Implication," *African Perspectives* 1 [1978]: 67).

37. Marc Howard Ross and Thomas Weisner, "The Rural-Urban Migrant Network in Kenya: Some General Implication," *American Ethnologist* 4 (1977): 359–75. Ross and Weisner write, *Pace* Gluckman:

> Gluckman considered it more productive to see city and country as analytically distinct. Thus two different theoretical explanations of behavior could be developed: one which was appropriate for rural life and one for urban life. We are suggesting that social theory must account for behavior in both settings at the same time, partly because the migrants themselves see their behaviors in the two fields as interdependent and partly because the patterns of interaction and psychological ties between the two areas are important factors that account for attitudinal and behavioral variations throughout Africa today. (370–71)

See also Mayes, *Townsmen* and "Migrancy."

38. Dawn Ryan, "Migration, Urbanization and Rural-Urban Links: Toaripi in Port Moresby," in *Contemporary Pacific Societies*, ed. Victoria S. Lockwood et al., 326; Ross and Weisner, "Rural-Urban Migrant Network," 371; Uzell, "Conceptual Fallacies," 343; and Philip F.W. Bartle, "Cyclical Migration and the Extended Community: A West African Example," in *Frontiers in Migration Analysis*, ed. R. B. Mandal (New Delhi: Concept Publishing, 1981), 105.

39. Similarly, Caroline B. Bretell writes of northwest Portugal that circular migration "has indeed served to perpetuate a way of life" (*Men Who Migrate*, 263).

40. Keith Hart, "Migration and Tribal Economy among the Frafras of Ghana," *Journal of African and Asian Studies* (1971): 26. Also, speaking of the extended communities set up by circular migration in Peru, Bryan Roberts provides a characteristic description of the complementarities thus entailed between the city and the provinces:

> To find or create work in the city, to obtain housing or secure other forms of assistance, migrants use kinsmen or fellow villagers previously established or with work experience in the city. Migrants receive agricultural produce from

villages to meet the high cost of foodstuffs in the city. Aged kinsmen and other
dependents [of migrants] are provided for within the social and economic
arrangements of the village. In these ways village organization remains impor-
tant to the ways in which migrants cope with their environment. Likewise, vil-
lages continue to be organized on the expectations that migrants finance
celebrations and other projects, supply city-produced consumer goods, or serve
as essential elements in [rural] economic enterprises. ("The Interrelationships
of City and Provinces in Peru and Guatemala," *Latin American Urban Research*
4 [1974]: 218)

41. Arjun Appadurai, "Global Ethnoscapes: Notes and Queries for Transnational
 Anthropology," in *Recapturing Anthropology*, ed. Richard G. Fox (Santa Fe:
 School of American Research Press, 1991), 193.
42. See also Malcolm Ashmore, Derek Edward, and Jonathan Potter, "The Bottom
 Line: The Rhetoric of Reality Demonstration," *Configurations* 2 (1994): 1–14.
43. Achil Gupta and James Ferguson, "Beyond 'Culture': Space, Identity, and the
 Politics of Difference," *Cultural Anthropology* 9 (1972): 1–17.
44. I mean to include, not to ignore, situations such as those of the red Xhosa, where
 immiseration of the countryside has increasingly made circular migration a stark
 material necessity for maintaining of the rural order (cf. McAllister, "Work").
45. The remittances sent to home communities provide many a good example of the
 differences between development and developman: for as they obviously enhance
 local relations and thus promote developman, they are characteristically pro-
 nounced irrelevant to development by their "social" as opposed to "productive"
 nature. Thus a recent discussion of remittances from Jayapuru, West Irian, to the
 home community of Nimbor Island:

 > Few remittances contributed towards village development or rural economic
 > growth; most were directed towards establishing or preserving long-term inter-
 > dependence with relatives and others, enhancing social prestige as symbols of
 > reciprocation, self-respect, and identity and constituting a form of repayment
 > of social debts. (Rumbiah, 219)

46. Xhosa performed rituals of departure and return for migrants that assimilated
 their journeys to exploits of war (McAllister, "Work," 213, 215, 219). Songs sung
 by Lesotho as they crossed the boundary with South Africa had the same import
 (T. Dunbar Moodie, *Going for Gold* [Berkeley: University of California Press,
 1994], 56).
47. Bonnemaison has made the same argument from ethnographic work in Vanuatu.
 He sees circular migration to a large extent shaped by the "traditional framework
 of mobility." "A Melanesian journey," he says, "was experienced in traditional
 society as a cultural odyssey, rich in the values of freedom, encounter, new expe-
 rience, and creativity" ("The Tree and the Canoe," 62).
48. We already have seen some of the apparent idealization of the homeland in the
 statements of Samoan overseas people. Macpherson speaks generally of popular
 views of the island among Samoans in New Zealand:

 > Popular culture is highly positive about Western Samoa. Musicians write and
 > perform songs expressing fondness for Samoa and its culture, a desire to return

to the homeland and to known sweethearts. In more formal contexts, these are dotted with references to our revered culture (*lo tatou aganu'u*), our beloved nation (*lo tatou atunu'u pele*) and the moral superiority of the Samoan way (*fa'a Samoa*)—which is in turn based on the assertion that Samoa is founded on God (*Ua Fa'avae ile Atua Samoa*). Those returning to Samoa are consoled with the prospect of being reunited with their loved ones; freed from the drudgery of early rising and boring factory work dominated by *palagi* (European) supervisors; released from endless bouts of colds and influenza and reprieved from a generally inhospitable host society. ("Public and Private," 247)

For a complementary but less complimentary view from the village, see O'Meara, "The Cult of Custom."

49. See also Hugo, "Circulation," 72.
50. Reflecting on the high incidence of Nairobi Luo in workers' association, the fact that many have wives and children with them at least part of the year, that many have significant economic interests in the city, and other indices of successful adaptation to urban life, David Parkin remarks:

> But there is no evidence that this intense social and economic involvement of Luo in Nairobi is resulting in a lessening of rural relationships and commitments. In fact, as Ross has noted for a different area of Nairobi, the higher-status and more securely placed townsmen among all groups are most likely to have made a number of corresponding rural commitments. They may have bought more farming land, built a house ... and even branched out into a rural "business," such as a shop or transport service. It is clear, as we might expect, that those who most succeed in town are most likely to exploit new economic opportunities available in their home areas. This is a familiar enough phenomenon in modern Africa which hardly needs to be elaborated. ("Migration, Settlement and the Politics of Unemployment: A Nairobi Case Study," in *Town and Country in Central and Eastern Africa*, ed. David Parkin [London: Oxford University Press for the International African Institute, 1975], 148)

See also Ross and Weisner, "Rural-Urban."
51. Michael Kearney. "From the Invisible Hand to the Visible Feet: Anthropological Studies of Migration and Development," *Annual Review of Anthropology* 15 (1986): 352.
52. See Cabral, *Return*.

A Moral Dilemma

Gayatri Chakravorty Spivak

How is it possible to reconcile what I learn in the field with what I teach for a living? This paper shows how an answer seems to have formulated itself in practice. The reconciliation is fractured. The problem could have been more easily solved if I had decided to "teach" (transcode for academic use) what I learned in the field. I hope you will work out from what follows why this is not an option for my stereotype of myself, why that solution would have been more a part of the problem, for me, than this incoherence. I give you the dilemma, as its reconciliation. The first section is about what I learn in the field: other women. The second about how that has changed what I teach for a living: literary criticism.

To begin with, some presuppositions.

Radical alterity—the wholly other—must be thought and must be thought through imaging. To be born human is to be born angled toward an other and others. To account for this, the human being presupposes the quite-other. This is the bottom line of being-human as being-in-the-ethical-relation. By definition, we cannot—no self can—reach the quite-other. Thus the ethical situation can only be figured in the ethical experience of the impossible. This is the founding gap in all act or talk, most especially in acts or talk that we understand to be closest to the ethical—the historical and the political. We will not leave the historical and the political behind. We must somehow attempt to supplement the gap. To try to supplement the gap that founds the historical-political is a persistent critique. I believe it is in that spirit that Susan Bazilli, editor of *Putting Women on the Agenda*, writes: "In the present South African climate we are faced with the task of determining the future of law and its relationship to women. To do so we must always be cognizant of narrowing the gap between law and justice."[1]

I. What I Learn in the Field: Other Women

Narrowing the gap between law and justice has something like a relationship with supplementing the founding gap between the historico-political and the ethical in a persistent critique. Let me get at this by way of a historico-political scenario. Let us consider a specific imaging of the other—not the general impossible figuration of the quite-other. Let us think rather of interested modern constructions of the other woman. "Modern" in this formulation would mean the period of "modernization" opened up by the end of World War II. It began with the establishment of the Bretton Woods Organizations, of the United Nations, of the General Agreement on Tariffs and Trade—between 1945 and 1948. It was the beginning of the end of European colonialism. The middle of our century is the initiation of neocolonialism. Colonialism had a civilizing mission of settlement. Neocolonialism had a modernizing mission of development. In the '70s, the circuits of dominant capital became electronified. We entered the phase of "post-modernization." Robert B. Reich, the former U.S. secretary of labor, has called this "electronic capitalism."[2]

Territorial colonialism is not at an end, of course. But national liberation struggles and their image-making are no longer the dominant mode. As Raymond Williams suggested, whether these residual discourses, the discourses of national liberation in the era of "modernization," emerge as alternative or oppositional is case-specific.[3] This has become particularly true since the inauguration of the new economic world order, a new phase—the phase of post-modernization—since 1989. The Report on the World Conference on Women in Mexico City which led to the Declaration of Mexico issued by the United Nations in the name of women in 1975 declares that "true peace cannot be achieved unless women share with men the responsibility for establishing a new international economic order."[4] A decade later, the Nairobi Forward-looking Strategies for the Advancement of Women consolidated a plan which I have heard Bella Abzug describe as "the beginning of global feminism."

I believe the intent of the Declaration and the Strategies to have been generally equitable toward women. But the task of *establishing* a new world economic order could only devolve upon women in a dominant position. And, if it is correct to insist that "because a form of production that does not correspond to the capitalist mode of production can be subsumed under its forms of revenue (and up to a certain point this is not incorrect), the illusion that capitalist relationships are the natural condi-

tion of any mode of production is further reinforced,"[5] then it cannot be denied that, without sufficient understanding of this, these international efforts have not necessarily created an ethical relationship between the feminists of the dominant and the object of their goodwill.

In 1985, we had not yet fully acknowledged our access to a postmodern electronic capitalism in the field of gender ideology. International feminist politics was still in the condition of modernizing. The condition and effect of constructing other women was "women *in* development." In the globalizing postmodern, she is embedded in the more abstract frame of "gender *and* development," which is the current slogan of the agencies inaugurating our "modernity" that I mention above.

Modernization was international. Postmodernization is global. The boundaries of nation-states are now increasingly inconvenient, yet must be reckoned with, because the limits and openings of a particular civil society are state-fixed. The globalization of capital requires a post-state system. The use of women in its establishment is the universalization of feminism of which the United Nations is increasingly becoming the instrument. In this re-territorialization the collaborative international non-governmental organizations (NGOs) are increasingly being called an international civil society, precisely to efface the role of the state as agent of social redistribution. Saskia Sassen has located a new "economic citizenship" of power and legitimation in the finance capital markets.[6] Thus, elite, upwardly mobile, generally academic women of the new diasporas join hands with similar women in the so-called developing world to celebrate a new global public or private "culture" often in the name of the underclass or the rural poor as "other."

This is one location of "the problem of thinking ethics for the other woman." How can we invite the operators of "gender and development" to experience ethics as the impossible figure of a founding gap, of the quite-other?

The hero of the colonial adventure was Europe, understood as Britain, Holland, Belgium, Spain, France, Portugal, Germany, Italy (roughly in that order). At the moment of neocolonialism, the relay passed to the United States. In postmodern electronic capitalism, even the United States, conceived homogeneously, cannot be specified as the place of the self that causes the other. The self that runs the other machine has become so diversified that you can hardly give it the name of a continent or country. In Robert Reich's words: "Electronic capitalism enables the most successful to secede from the rest of society. It is now possible for

top-level managers, professionals and technicians to communicate directly with their counter-parts around the world."[7] North and South, Self and Other are made indeterminate in this conjuncture.

Although Eurocentric economic migration continues to rise, as the new North-South divide is exacerbated by the forces of economic restructuring, instituted to consolidate a uniform system of exchange the world over, ostensibly to establish a "level playing field," the assumption of a narrative continuity between colonialism and postcoloniality is not what belongs to globalization proper, which is more finance than trade. It was the detritus of the old colonialisms that were pushed out by the ravages of neocolonialism into global labor export. Those tendencies made "multiculturalism" an issue in northwestern Europe as never before. Each nation-state in the European union confronted the issue in its way, referring either to its old colonial experience or its position on the refugee circuit. Austria has its Albanians; Holland its Surinamese; Sweden its Estonians. The "cultural shortfall" of this is showing itself in the inauguration of "postcolonialism" in these areas, academically.

If we want to track this slightly earlier field in the United States, we note that the inception of postcolonialism in this country was initially in response to the coming-of-age of so-called new immigration after Lyndon Johnson relaxed the quota system in 1965. It has mingled, of course, with the regular waves of economic migration and asylum-seeking that follows basically the same trends as in the case of northwestern Europe. The results of U.S. postcolonialism (more academic), and multiculturalism (more sociopolitical), have, however, been perceived to be in conflict with the demands of older minorities, especially African Americans and Hispanics. Thus, the value coding of postcolonialism and multiculturalism cannot be the same in the European Community and the United States, although both are restricted phenomena where dominant images of the subordinate can still be color-coded, which is not the case, of course, in the global South. It is by way of a critique of this that I mention the postmodern global frame where Europe, the United States, and its others are no longer a clear-cut issue.

In Eurocentric economic migration rather than in electronic globality, as we travel down in class, the denial of the *cultural* subjectship of the abstract *rational* structures of "democracy" to the felicitous Euro-U.S. agent becomes active rather than reactive; patriarchal rather than analytic; and becomes transvalued and displaced into demands for preserving the inscription and superscription of the woman's body as an image of a cultural "self"—as the other in the self. These abyssal shadow games also

involve woman, but they are not necessarily European images, or Euro-U.S. images. It takes place within indigenous patriarchy, and, however intimately they might be related to modernity, they are consolidated in the name of tradition. And although the women themselves are ambivalent about these moves, they are seen as mute victims. As such, they provide an alibi for cultural absolutists who want to save them from their "culture."

In quite another way, the representation of "Europe" or the United States in the place of the self in such situations becomes suspect. For though the women and men demanding the inscription and super-scription of the woman's body as cultural icon are themselves the recently hyphenated, they *are* the new Europe or the new United States. In the United States this is even more problematic since the so-called Euro-Americans are themselves hyphenated and the natives have been "oth-ered." Even this is not the whole story. For the hyphenated European or American is, of course, gender- and class-divided. Since it is the woman who is most citational, put within quotation marks in order to sanction all kinds of social actions—from automobile commercials to war—the upwardly mobile, European or American, hybrid female can negotiate the class divide, and even the race divide, in the name of the gendered cultural subject acting for a fantasmatic Europe or, as the case may be, the United States. Whereas in the underclass, disappointed in the expectation of justice under capitalism, the migrant falls back upon "culture" as the originary figuration of that founding gap between the quite-other and the other, in patriarchy, this cultural figuration is a gendering internalized by both male and female, differently. This too is part of "the problem of thinking ethics for the other woman." How can we, in the face of discrimination from above—and alas, from minorities with a longer history of U.S. nationalization, however unjust—persuade the migrant or refugee that a systemic figuration of the violence of the founding gap closes the (im)possibility of ethics, especially given the his-tory of patriarchal figurations, the (im)possibility of an ethics of sexual difference?[8] How can we, their academic champions, remind ourselves that the depredations of globalization—indiscriminate dam-building, patenting indigenous knowledge, pharmaceutical dumping, trade-related intellectual property measures, biopiracy, culture-fishery, and the like—touch those who stayed in one place? that today, as Roberta Cohen of the Brookings Institution Project on Internal Displacement tells us: "The most realistic count of internally displaced persons is . . . 20 to 25 million: nine to ten million in Africa, five million in Asia, five million in Europe, and two million in the Americas. Their number now exceeds that of

refugees."[9] How can we say to Joan Tronto, when she writes: "I start from the assumptions about the need for a liberal, democratic, pluralistic society in order for all humans to flourish,"[10] that such societies can flourish in one part of the world at the expense of another and capitalism has exacerbated this. I therefore fear that the more "late twentieth century American society ... take[s] seriously ... the values of caring ... traditionally associated with woman," the less it will want to learn these virtues shining, under all the garbage of domination and exploitation, in societies where the welfare state is now not allowed to emerge as the barriers between national and international economy are removed; and where, in the name of "gender training," precisely these virtues must be impatiently undermined.

There is a difference, almost a fracture, between globality and development on the one hand, and immigration and multiculturalism on the other. The located gendered subaltern, often less viciously gendered than the underclass migrant, but facing the global directly, falls through the fracture. The upper-class, hybrid female is, first, "woman" for the international civil society serving today's "economic citizen"—the finance capital market in the business of development. Secondly, she is "woman" as subject of postcolonial, multiculturalist theory. And finally, she is "woman" as trainer of other women to become "woman," eligible for benevolence, for "development," coded loosely as ethical-political action.

It is in the interest of the coalition between these women and metropolitan feminism that we are obliged today to forget the economic narrative. These women originally from the global South, the hybrid postmodern North, are indistinguishable from the indigenous elite women of the South upon whom—by a crude and classless theory of national identity and the universalist politics of feminist solidarity that is hand-in-glove with biased cultural relativism—the donor agencies are relying more and more. Twenty-five years ago, Samir Amin, writing about what he called "Levantine merchant princes," mentioned the difficulty of assigning a country to them. These women are their modern ideological counterparts. Their economic counterparts, female and male, with the glass ceiling and the feudalism of heterosexist "love" worked in, are the secessionist community described by Robert Reich.

If it were my plan today simply to recount the economic narrative, I would draw a sharp contrast between the triumphalism of the sixth volume of the United Nations Blue Book series, a 689-page document entitled *The Advancement of Women, 1945–1995* (from which I have

already cited), and parenthesis-ridden, unedited versions of the Platform for Action by which women's oppression had to be codified by the World Women's Conference in 1995. I would comment on the parentheses that marked all of the things said by all of the "consensus-breaking" women who came from all over the world, ironed out in the final version. I would comment on the procedures by which governmental and non-governmental delegations and spokespersons have been and are organized. I would analyze the efficacy of women's credit-baiting without infrastructure in the name of micro-enterprise. But our task is supplementation. I will backtrack to the road not taken with a request to you to keep this narrative framing in mind.

Radical alterity, if one can say it, appears to require an imaging that is the figuration of the ethical as the impossible. If ethics are grasped as a problem of relation rather than a problem of knowledge, it is not enough to build efficient databases, converting the "gift," if there is any, to the "given" (datum), upon which calculating "aid" can be based. It is necessary to imagine this woman as an other as well as a self. This is, strictly speaking, impossible. Imagination is structurally unverifiable. Thus, the image of the other as self, produced by imagination supplementing knowledge or its absence, is a figure that marks the impossibility of fully realizing the ethical.[11] It is in view of this experience of the figure (of that which is not logically possible) that we launch our calculations of the political and the legal. The gift of time grasped as our unanticipatable present, as a moment of living as well as dying, of being hailed by the other as well as the distancing of that call, is launched then as reparation, as responsibility, as accountability.

This is an account of the aporia of the ethical as spelled out in the thinking of Melanie Klein, Emmanuel Levinas, Jacques Derrida, Luce Irigaray.[12] When one decides to speak of aporias, one is haunted by the ghost of the undecidable in every decision. One cannot be mindful of a haunting, even if it fills the mind. Let me then describe a narrower sense in which I am using the word. When we find ourselves in the subject position of two determinate decisions, both right—or both wrong of course—one of which cancels the other, we are in an aporia which by definition cannot be crossed. Yet, it is not possible to remain in an aporia. It is not a logical or philosophical problem like a contradiction, a dilemma, a paradox, an antinomy. It can only be described as an experience. It discloses itself in being crossed. For, as we know every day, even by supposedly not deciding, one of those two right or wrong decisions gets taken, and

the aporia remains. Again, it must be insisted that this *is* the condition of possibility of deciding. In the aporia, to decide is the burden of responsibility. The typecase of the ethical sentiment is regret, not self-congratulation. In the aporia, *to decide* is the burden of responsibility.

I have given an account of the general aporia of the ethical. Let me now describe an only seemingly more restricted aporia, thoroughly foregrounded in the postmodern global, between capital and culture. Globalization is the implications, as I have said, of financialization of the globe, the establishment of a uniform system of exchange. This is a computation of the globe into the abstract as such. Marx already knew this when he placed capital in the place of the idea in the Hegelian system. But in postmodern electronic capitalism, globalizing capital—finance capital—is also virtual. You cannot be against globalization; you can only work collectively and persistently to turn it into strategy-driven rather than crisis-driven globalization.

In this particular situation, in other words, globalization is also the site for a potentially right decision. In order to operate this critique one must tangle with the abstract, with the virtuality of "virtual money."[13] The benevolence of the global feminism that I describe above is usually satisfied with the coding of this abstraction as "development" and does not learn to decode.

In this rarefied and Marxist understanding, globalization, capital financializing the globe, is the abstract as such, the abstract as virtual, pure structure. By contrast, culture is the irreducible text-ile where the edge of the cloth where we are woven always unfurls ahead, in a future forever anterior. Culture alive is always on the run. For the sake of a continuous contrast we can call it the concrete as such. But, in fact, it is discontinuous with capital as the electronic virtual. It is caught always abreactively, after the fact, in a hybrid tangle of idiom, less organized than language. It always serves to code the economic, which is always lent its structure. How is it foregrounded in the postmodern global and how does it connect to imagining the other woman?

Let us take a step back and narrativize ruthlessly. The construction of the colonial subject, to code colonialism as administration and civilization, was predominantly the forging of a class alliance with the colonized (the kind of alliance that produced Edward Said and Gayatri Spivak). The tragedies of gender and nationalism allow us to conclude that questions of gender were subsumed there. I discuss family law and "custom" briefly below.

The construction of the postcolonial subject was to code the failure of decolonization as multiculturalism, in metropolitan space, to race, itself rewritten as a fantasmatic national identity as its subject. So if the first was class, the second is race as multiculture—cultural rights. Identitarian politics succeeds insofar as class and gender remain subsumed to this notion of a national and postnational identity.

The construction, on the other hand, of the globalized subject is through the manufacturing of a gender alliance. The female subject/agent of globalization often collectively legitimatizes itself in the name of a generalized ethical agenda. This is where she crosses the capital/culture aporia on the side of capital. Yet to work for global justice as a principle is as right a decision as to work for strategy-driven globalization. But the interests of globalization from above and from below cancel each other. This too contributes to the problem of thinking ethics for the other woman.

A recent *National Geographic* shows pictures of women saluting the male field workers of the Grameen Bank as they vow not to have too many children.[14] Will mainstream feminism ever think critically of this model of cultural indoctrination?

Different officers of Women's World Banking repeatedly invoke Chandra Behn, a member of the celebrated Self Employed Women's Association, or SEWA, as their legitimation. At the same time, they speak of opening "the huge untapped market of poor Southern women to the international commercial sector." When SEWA was founded in the early sixties, Ella Bhatt, the founder, had no such ambition. "The World Bank's [Consultative Group to Assist the Poorest] ... appears to be narrowly focused on microlending as an end in itself. And the means to that end, critics charge, may do more damage to 'empowerment leaders' like SEWA than good."[15]

This was the placing of the poorest women of the South upon the spectral grid of finance capital. "Pay up every week or else ... " is once again the instrumentalization of body and the money-form in the interest of the abstract. SEWA had made the subaltern women cooperative owners of their own bank, precisely to bypass the predations of commercial capital as they started life changes: driving by strategy, not driven by crisis-management. Under the initiator Ella Bhatt's fierce left-labor Gandhianism, the free-choice cultural-identity slot was anti-Fordist, bi-religious (Muslim/Hindu) worker's pride, which lasts to this day, although one senses a certain unease now, among the working class Hindu women, in pronouncing the "*la ilaha* ... "—there is no God but God—the Muslim credo.

Grameen Bank had initially started lending to women allegedly because the repayment rate was higher. I have as research here fifty-odd rural women's testimonies, spontaneously offered because I had agreed with their skepticism.

Bangladesh, established in 1971–72, fell into the beginnings of electronic capitalism and became a little-noticed U.S. military and political "colony of expediency." It is in this arena, in 1976, that Grameen, indigenous enterprise, made its pitch. Ella Bhatt was a women's activist labor lawyer. Muhammad Yunus, the initiator of Grameen, was a professor of economics at the University of Chittagong. In the Grameen Bank loan camps the coding of women was into "discipline": up-and-down exercises (even for women in advanced pregnancy, according to my rural informants) and salutes, the bank's field workers always two Bangladeshi men in Western clothes. There was no freedom-of-choice coding here; the curious training into "discipline" did not catch; just as, somewhat later, the hygienic habits imposed inside Export Processing Zones were not carried over into daily habit—a real contrast to rural primary health care practiced by rural female paramedical field workers. This is what the *National Geographic* is recoding as reproductive rights.

SEWA was about the conscientization of women as self-employed workers—recoding work-situations they already inhabited—somewhat like Marx's recoding of the factory worker as the *agent* of production. Grameen was a bank that initially established itself upon women's good repayment record. Like the nimble-fingered lacemakers moved into electronic worker-positions without identity, entailing cultural coding as "women in development"—women's feudal loyalty was here moved into loyalty as bank-borrower (and now as free choosers of reproductive freedom). The connection between credit and micro-enterprise was not necessarily perceived unless directed externally from governmental and non-governmental sources. It was in the wake of the possibility of full globalization that women's micro-credit came into its own, an "untapped market for the commercial sector." The World Bank has factored gender into all its projects now. Women's micro-credit organizations are springing up all over. The "cultural" recoding of that postitioning is a culture of woman-ness. As I have mentioned above, the key phrase now is therefore "gender *and* development," for the word "woman" is being "culturally" negotiated as these very poor women blink on and off with their "200,000 loans averaging $300 each" and their "over 95% repayment rate" upon the grid of the spectral network, with the extra-fast turnover of finance capital, emptying money again and again of its money-being.[16]

The field workers of Women's World Banking preach women's liberation as a quick fix—more accessible as "free choice of free femininity" than the mysterious rituals of "discipline" could be, although they too are now being brought into line. Now Professor Yunus too can speak in terms of women's liberation.

It is hard for feminist cultural studies to access this circuit without falling into global-local binarities or banalities, a substitute for the older modernity-tradition patter. I am suggesting their constant displacement by paying attention to women's positioning on the axis of abstract capital needing "cultural" coding.

This much at least is clear: to imagine or figure the other as another self, you need to engage the moving edge of culture as it leaves its traces in idiom. Even to reduce it to language—to semiotic systems that are organized as language—was a structuralist dream. But at least, whatever the subject-position of the structuralist investigator, there was rigor in the enterprise. Its tempo was different from the impatience of a universalist feminism recoding global capital. From existing evidence, it is clear that individual-rights or universalist feminists infiltrate the gendering of the rural South to recast it hastily into the individual rights model. They simply take for granted that colonized cultures are inevitably patriarchal. I will not enter into historical speculation. I will take shelter in a figure—the figure or topos, that in postcoloniality, the past as the unburied dead calls us. This past has not been appropriately mourned, not been given the rites of the dead, as the other system brought in by colonialism imposed itself. There was no continuous shedding of a past into an unmarked modernity.

I am not necessarily suggesting that there can be such continuity. It is just that when a sense of that continuity is absent, in different ways, in an entire culture, there are immense problems in the practice of freedom in a modernity not marked by a locational adjective.

In the field of political culture, to engage in a strategy-driven globalization, to step into a modernity not forever marked by the West and contrasted to a tradition necessarily defined as static, it is to the past as the call of the unburied dead that the postcolonial must strain to gain access. Men and women are both in this situation, of course, but not equally. For, first, across the classes, it is women who are generally asked to hold the marks of a necessarily stagnating traditional culture. And, second, unable to confront the real source of domination, it is upon the domesticated woman, in the private sphere, that the colonized underclass man vents his frustration. And, finally, to keep indigenous patriarchy satisfied,

the colonizing power allows a strictly codified—rather than dynamically flexible—version of precolonial laws to flourish as family law. Thus it is possible to argue that unequal gendering is exacerbated under colonialism and subsequently in underclass migrancy. To undo this is not a matter of quick-fix gender training, bringing the international feminist into the fragility of the family.

As it happens, the difference between the male and female typecases here is figured rather conveniently in a bit of poetry and a bit of prose that I often place together. Farhad Mazhar, the Bangladeshi poet, contrasts the contemporary Bengali archaeologist working in the restricted arena of academic freedom, more "British" than the Royal Asiatic Society, to the poet persona forever guarding the unburied corpses of the so-called Indian Mutiny, the first battle of independence on the sub-continent.

> Lord, Dhaka's mosque is world-renowned
> Much varied work on pillar and cloister. In British days
> the Whites, right or wrong, put in place
> th'Asiatic Society and researched it all
> Here. In the white eyes
> Of whites the new Bengalis dig now
> And look for things we see.
> I wish them good luck. But doctor's degrees,
> Make them twice
> As wily as their White forebears.
>
> Lord, I'm an unlettered fool,
> Can't grasp the art of architecture, paint,
> Yet my heart aches empty
> As I stand by the old Ganga.
> The Sepoys seem to hang still on hangman's ropes
> Waiting for last rites, the ropes uncut,
> Their bodies still aloft, none to mourn,
> To perform *zannat*.
> Don't you mock me with minaret and arcade,
> Me, the corpse-keeper of revolt.[17]

Assia Djebar, the Algerian feminist writer, complicates the metaphor with the double difficulty of regaining an active perspective for women in the unperformed burial rites for the dead, old culture, when the colonial

culture seemingly gave access to the new. In anguish, Djebar's fictive persona raises a cry in turn. "If only," she writes, "I could occupy with desire one of those singular women."[18] Here is a figure as an experience of the impossibility of recapturing a cultural past in order to mourn it so that new life can begin.

Yet, I have also argued that the figure of experience of the impossible *is* the condition of possibility of deciding. In the aporia, to decide is the burden of responsibility. What can the mourning work of postcoloniality look like when it slips from figure to accountability? Let us reopen Susan Bazilli's book: "We must always be cognizant of narrowing the gap between law and justice." With this in mind we turn to Mary Maboreke's essay "Women and Law in Post-Independent Zimbabwe: Experiences and Lessons."[19] Mary Maboreke teaches in the faculty of law at the University of Zimbabwe in Harare and is involved in gender-sensitive constitutional law. She, like other feminist constitutionalists in Southern Africa, is engaged in reinventing customary law so that the constituent subject of the new nation can insert the subaltern into the circuit of hegemony. Her project is the exact opposite of the hasty gender training undertaken by today's globalizing feminists. It is with respect to this that I insist on working with the cultural idiom, as in invisible mending. Reinventing gendered "custom" is rather different from coercing into rights-claims. This is particularly apposite for Central and Southern Africa, since "custom" there was a colonial construct meant not only to regulate women but to keep power frozen in the hands of tribal chiefs.[20]

The way in which customary law had constructed the woman as a separate subject created a wedge through which the failure of decolonization could begin to fester. The examples can be multiplied all across formerly colonized countries. To heal this wound, the violence of the founding gap mentioned in my opening words must be a reminder of the importance of the quite-other in being-human. There is no trace of the ethical in from-above do-gooding to sustain the commercial sector.

The figure produced by the cultural topos of an unfinished mourning, an unburied dead, inhabits a fractured modernity in an altogether quotidian way:

> Most African people have neither completely moved away from the customary [as in customary law] way of life nor have they remained squarely rooted within it. In most cases, [Maboreke writes] they have a foot in each world. Very often the modern executive, moving sleekly along the streets of the capital city is "transfigured" into an ancestor-worshiping

traditionalist overnight when he or she goes "home" to the rural area to appease some disgruntled ancestor or avenging spirit believed to be manifest in some misfortune.[21]

You cannot engage one without engaging the other.

II. What I Teach for a Living: Literary Criticism

What is to be done here, now, with what we are as agents? I use a working definition of agency: institutionally validated action. At the limit, the distinction between subject and agent breaks down, for the coming-into-being of a subject across that founding gap—the programming of the synthesis with the quite-other (which my ancestors, incidentally, located in the synchronicity of the pulmonary system using the air of alterity or *atman*)—may well be an instituting that keeps us in subjectship. Short of that marginal general moment, present in each thought of agency, we can say, in the narrowest possible sense, that we are validated by the academic institution, in the United States, as teachers of English literature, to act upon the sensibilities of our students, uncoercively, by their consent. As such, what is to be done? If I do not look at the problem of thinking ethics for the other woman in this practical way, I contribute both to its ghettoization and its development into an instrument of intellectual blackmail, a travesty of the ethical angle.

What I am interested in here is promoting the habit of mind that can be open to experience ethics as the impossible figure of a founding gap, of the quite-other. The companion task, of reading material by and on other women, can lead to self-aggrandization unless the habit of mind is produced at the same time. Two formidable problems are faced by people like me who have a foot in both worlds. First, that serious students in the "Brit. Lit." classes are generally not the serious students in the "other women" classes. And second, that the relevant material by other women in their counter-globalizing other-womanly role is in activist field reports in the idiomaticity of the many languages of the world, rather than in the interviews of well-vetted oral history.

I proceed in the faith that it is not only the past of the colonized that has to be laid to rest and mourned. I have already suggested that the situation of the person in metropolitan space, of the politically correct woman in metropolitan space, is also endangered. It is not possible to be good anymore because it is preferable to be ignorant, especially in a place like New York. There is so much seemingly benign encouragement to think

that New York *is* the world. The entire global situation can be turned into the situation of the migrant in New York. New York is not even a mega-city if one considers the ratio between the heights of buildings and the way in which the subdivisions are localized at ground level. Confronted by this benign yet unjust triumphalism, I begin to teach by choice the sequence courses in literary criticism in the English-major curriculum: teaching the canon, otherwise; using the beginnings of modern British criticism as an instrument.

These are undergraduates. I start with the *Preface* to *Lyrical Ballads*, Chapters 13 and 14 of the *Biographia Literaria*, and "A Defence of Poetry."

We try to understand these three texts (and there were others) as wanting to say, at the inception of the ravages of an economic system attendant upon the industrial revolution, that the imagination, which is our inbuilt capacity to other ourselves, can lead perhaps to understanding other people from the inside, so that the project would not be a complete devastation of the polity and of society through a mania for self-enrichment.

Coleridge allows us to plot the literary-critical agent's access to the esemplastic Imagination as a barred rupture or founding gap;[22] Wordsworth, to broach the topic of the importance of connective passion with little stimulus—imagination as real virtuality. We can go on then to Shelley's wonderful analysis of the information explosion—"we cannot imagine what we know"—and contrast the real virtuality of the Imagination with the existential impoverishment of virtual reality as it is devised today, until we learn to "'upload' ourselves into a suitable computing machine as a way of extending our lives and acquiring a more robust physical constitution.... You will pass from sentient being to insentient robot."[23]

Even as we touch upon the colonial connections of these figures to establish parity with our own connections with globalization, I spend time demonstrating how the textual figure "Wordsworth"'s genuine admiration for the imaginative proficiency of rustic culture is, however distanced, not a species of primitivism. Shelley's expansion of the "poetic" function (which we later contrast with Jakobson's), seeing the metaphor, establishing connections between dissimilars, as the instrument of the Imagination and the very name of the "love" that is the secret of morals, allows the class to see how far metropolitan literary criticism had gone to think that othering, another name for the ethical angle, might save their world from the moral impoverishment otherwise signaled by economic growth. I keep alive the connection with the students' own desire to do good in the

world. When turned off by Shelley's ecstatic tone, a student is asked to describe something s/he really enjoyed recently. I mimic the student's ecstatic tone as exactly as I can (no dissing) and then read the offending Shelley passage. And so on. Any trick to train them into a mental habit of othering rather than merely provide them with tools to describe.

And yet, the great experiment didn't work. The poets had no real involvement with infrastructure. Our situation is even worse because we don't even have as much enthusiasm. We are in a conjuncture which is rather like theirs: at the inception of globalization. If you think that Coleridge, Wordsworth, and Shelley are just dead white men, remember that you are becoming chromatists—using skin color only as color. There are anglo-clones in this classroom who are not the pinky-brown that we normally call white. And you are being genitalists and reducing feminism to the kind of genitals that we are sitting on. If you look at what they are doing, you should learn from them today. Poetry has become a sort of narcissism. But in terms of visual arts, we still think this. I am constantly asked to help curators launch shows in museums where they invite the street in and make the barrio (or Brick Lane) into a show. It is exactly like the earlier attempt—except somewhat less well theorized than Wordsworth's and Shelley's belief that you could with poetry exercise the imagination, train in ethics—in the othering of the self and coming as close as possible to accessing the other as the self.

Then we read Arnold and Pater. What has happened between the first three and these two is the institutionalization of English literature as a subject that can be taught at a university. The first large-scale teaching of English literature, as a subject, as a faculty (as it were), was in India, not in Britain. And not only was it in India, it was at my college. I tell them I am their native informant. The first group of poet-critics were figuring the impossible. People like Arnold yoke the power of the imagination to the indigenous upper class in the colonies. Under the impetus of a pedagogic incentive much stronger than merely academic, my ancestors othered themselves and became colonial subjects. When Wordsworth wants to become transparent so that he can enter the minds of persons who have been uncontaminated by the industrial revolution and become a conduit and actively enter the passions of the reader so that by exercising this othering through the imagination, the person who can no longer be excited without external stimulation because of the horrible factory life in cities, will get training in ethics, by robustly imagining the other, and Shelley says Roman law is "poetic" in his enlarged sense, they are still figuring an experience of the impossible if we read the way I am reading. But, by the

time Arnold and Pater write, that figure has been transformed into the institutional practice of producing the colonial subject. We have moved from figure to calculus. When Wordsworth or Shelley uses poetry as the subject of a proposition, or Coleridge uses imagination thus, they are describing faculties of the mind or mental phenomena. They are making a critique of individual will. They talk about the poetic sensibility as something which can in fact be unlike the individual will because it is given over to a principle and faculty of the subject which is larger than the outlines of the will.

On the other hand, when Arnold uses the word "culture" as a subject of propositions, he does not have a theory of the mental theater at all. The study of perfection does not involve tapping a different *faculty* of the mind but a change in the reading list. When Arnold uses the word culture as a subject, in fact it occludes the requirement that there be custodians of culture. The verbs are all verbs of coercion; there is no verb of othering. There are no non-individual subjects that are names of super- and supra-individual, indeed sub-individual faculties of the mind. Poetry being emotion recollected in tranquility is a psychological phenomenon. Here is Arnold; notice the verbs of coercion and notice the use of culture as a subject which clearly occludes (not very much, but nonetheless does) the collectivity of the custodians of culture. Perfection managing a restricted democracy:

> Perfection, as culture conceives it, is not possible while the individual remains isolated. The individual is required, under pain of being stunted and feebled in his own development if he disobeys, to carry others along with him in his march towards perfection, to be continually doing all he can to enlarge and increase the volume of the human stream sweeping thitherward.[24]

This notion of the individual coerced by perfection as conceived by culture to draw people along in a stream is quite different from the poetic sensibility as an othering mediator between those subjects that are still uncontaminated by the industrial revolution or the past and our world which cannot imagine what it knows, which then can learn this way. I tell the students: if you want to see how much this has come full circle, you'll notice that it is not as if people don't believe this anymore; today it is done by patenting the DNA of so-called primitive tribes that are quite uncontaminated by the narrative of the industrial revolution that leads finally to globalization so that our bodies can recover from the environmental ravages of this history. Whereas these folks are in fact trying to

deal with it in terms of the mind—and that's why they fail because they did it only in terms of the mind—nonetheless they figured the impossible, whereas after institutionalization it comes into Arnold. Arnold's project of providing better reading material resembles our attempts to do no more than expand the canon. Arnold's success in producing the colonial subject is like the conviction shared by the global feminist dominant that feminist aid is to make the rest of the world like us.

I love Pater. I certainly teach him with gusto and affection. But I do point out that he was supported by his fellowship at Brasenose College. He was not a rich man, he was not even a very important man; he was a little mouse of a man, he was not like old Matthew Arnold. He was just a very smart man. It was possible to burn like a hard gem-like flame while drinking from the college cellars and eating at High Table, just as we save the world from Columbia U.

"To maintain this ecstasy, is success in life. In a sense it might even be said that our failure is to form habits: for, after all, habit is relative to a stereotyped world, and meantime it is only the roughness of the eye that makes any two persons, things, situations, seem alike."[25]

Now, this passage—that our failure is to form habits—is quite reminiscent of Shelley's chat about de-familiarization, that poetry takes the veil of familiarity away from reality. Shelley's final point, however, is to show us how, by metaphorizing our humanity, we can perceive others as similar, when they are not in fact similar, not in reason similar, not by database similar. This is the flipside of de-familiarizing the familiar—because our very well known self and environment is othered. This is Shelley's argument: by restoring the metaphoric nature of common language, by taking the veil of familiarity away, you are able to metaphorize the connection between all human beings; whereas Pater's argument has become that by de-familiarizing you will see that no two persons are alike.

It has gone full circle.

Now when these students ask me why I am teaching the canon, I say to them it is not to excuse the canon, but not to accuse it either. We must see our complicity, we are in the same kind of situation in the bosom of the super-power, wanting to be good. We are where Arnold is: we want to be the custodians of culture, we want to expand the canon. We know that unless this multicultural material, this feminist material, is introduced into the canon, culture will not be perfect. Thus our usual radical project is not all that different. Therefore we should learn from this. We must at least try not to get involved, like Arnold, in the repeated construction of the colonial subject, the construction of, the consolidation of, or the

expanding and changing the composition of the upper classes in Britain. Rather than repeat Arnold's project, learn from the difference between the figuring of the impossible in imagination in Shelley, Wordsworth, and Coleridge, and then Arnold's echoing of the colonial institutional experiment for the upward mobility of the new middle class. From the production of the colonial subject we should not move to the postcolonial subject, the benevolent and trivial humanist subject in the super-power. For us the multicultural, feminist counter-canon is Arnold's "sweetness and light." Tell me next time, how you can lay your past to rest so that your project, your institutional project, can look a little bit different?

Of course I teach them Derrida and Barthes, Lacan and Irigaray, Hortense Spillers and Jacqueline Rose, Saussure and Jakobson, et cetera. But in order to channel them into thinking the other through idiomaticity, I have to involve them in revising for gender and race what was best in British literary criticism. For the only language that I share with them, in which they are "responsible," is English. My students cannot help believing that history happened in order to produce them. I invite them into the history of the noble failed experiment of the Romantics to think of themselves as not the best, not the worst, but somewhere in between. The literary imagination is programmed to fail but it can figure the impossible.

For gender-sensitivity *within this tradition* I open Virginia Woolf. I recite a move from Virginia Woolf here to show that the opening of this "perhaps" for readers to come is not confined to some essentialized or naturalized hybrid. "'I' is only a convenient term for somebody who has no real being," Woolf writes in one of her most persuasive texts. "Lies will flow from my lips, but there may *perhaps* be some truth mixed up with them; it is for you to seek out this truth and to decide whether any part of it is worth keeping."[26]

Woolf places us in the classic paradox—"I will lie"—and writes the reader in the "perhaps." It is in this mode that she gives a random name to that "I" that is merely a convention: Mary Beton or Mary Seton. And it is also within this mode that she acknowledges the compromised foundations of metropolitan agency. Mary Beton owes her £500 to imperialism, her eponymous aunt "died by a fall from her horse when she was riding out to take the air in Bombay," and she herself sees money as a better alternative to democracy (RO 37). In the final movement, Woolf takes us into the impossible possible of the "perhaps," only as fiction can. She puts Mary Beton to rest and speaks "in my own person" (RO 104–5). She inaugurates a ghost dance, asking all aspiring woman writers to be haunted by the ghost of Shakespeare's sister, and quite gives up the

"room of one's own and £500 a year" in her closing words: "I maintain that she would come if we worked for her, and that so to work, *even in poverty and obscurity*, is worth while" (RO 114).

For race-sensitivity *within this tradition* I open, first, for cultural studies, the W. E. B. DuBois who wrote, as African American metaphorizing the other, "I sit with Shakespeare and he winces not," and went on to describe the colonial (rather than the enslaved) subject in "The Negro Mind Reaches Out."[27] Next, from within the framework of reverse-othering described by DuBois, I read what I consider to be the first significant essay of postcolonial criticism, Chinua Achebe's "An Image of Africa."[28] It is the othered subject asking for the redress which we are trying to teach as a mental reflex.

And so I go, asking the students to enter the two-hundred-year-old idiomaticity of their national language in order to learn the change of mind that is involved in really making the canon change. I follow the conviction that I always have had, that we must displace our masters, rather than pretend to ignore them. Teaching English, I must use its history to undo its problems, one of the greatest today being the one mentioned in my title.

A word in conclusion, a reminder of the fracture or incoherence in this essay in another way. What I describe in Part II is an obstinate attempt at a formal training of the imagination in the classroom. Filling it with substance would take us back to Part I. The obvious gap between the two cannot be filled by only academic labor, not to mention an academic lecture.

Notes

1. Susan Bazilli, *Putting Women on the Agenda* (Johannesburg: Ravan Press, 1991), 15. Some reading-work has to be deployed in order to discover the practical agreement between Bazilli and myself.
2. Conversation between Robert Reich and David Bennahum on "Into the Matrix" (http://www.reach.com/matrix/meme2-02.html). The next quotation from Reich is also from this source.
3. Raymond Williams, *Marxism and Literature* (New York: Oxford University Press, 1977), 121–27.
4. *The United Nations and the Advancement of Women: 1945–1995* (New York: United Nations, 1995), 180.
5. Karl Marx, *Capital: A Critique of Political Economy*, trans. David Fernbach (New York: Vintage, 1981), 3:1015.

6. Saskia Sassen, *Globalization and Its Discontents* (New York: New Press, 1998).

7. Conversation between Robert Reich and David Bennahum on "Into the Matrix" (http://www.reach.com/matrix/memez-02.html). I quote this passage often because it is so succinct and from so authoritative a source.

8. I am trying to condense the thinking in my opening paragraph in the typography of (im)possible.

9. "Forum," *National Geographic* 195.2 (February 1999), n.p.

10. Joan C. Tronto, *Moral Boundaries: A Political Argument for an Ethic of Care* (New York: Routledge, 1993), x. The next passage is from 2–3.

11. It is in view of this experience of the figure of that which is not logically possible—that my love is not a red rose, logically not red, yellow, or pink in color, or soft round things all over and standing on a long green thing that is long, and so on.

12. I have explicated my understanding of the Kleinian position in "Translation As Culture," in Isabel Carrera Suárez et al., eds., *Translating Cultures* (Oviedo: Dangaroo Press, 1999), 17–30.

13. "Virtual Money," the inter-diction between telecommunication and finance capital, invites a reworking of Marx's theory of value. That is part of my work in progress. Elinor Solomon Harris, *Virtual Money* (New York: Oxford University Press, 1997), already out of date because of the extreme dynamism of the field, offers a simple and useful explanation, with never a hint that the Third World exists, and strong doses of social Darwinism.

14. Erla Zwingle, "Women and Population," *National Geographic* 4 (October 1998): 44–45. The general sentiment of the piece is altogether admirable: "'Don't look at people like an ant heap,' one expert urged. 'These are individuals'"(p. 38). My remarks can only signal at the responsibility attendant upon such statements.

15. *Ecologist* 27:2 (March–April 1997): 42. Resistance to this is already afoot. In order to keep abreast of it, we need to read local newspapers, quite in the same way as old-fashioned area studies researchers do. *The Daily Star* and *Inkilab*, both Dhaka-based, carry news items reporting peoples' retaliation upon a microlending, World Bank–supported NGO (Proshika) after the death of three women and an infant, arrested for microloan default (July 6, 1997).

16. Women's World Banking publicity flier, 1998.

17. Farhad Mazhar, "The Corpse-Keeper of Revolt," in *Ebadaindmā 2* (Dhaka: Prabartanā, 1989): 36. Translation mine.

18. Assia Djebar, "Forbidden Gaze, Severed Sound," in Marjolijn de Jager, trans., *Women of Algiers in Their Apartment* (Charlottesville: University of Virginia Press, 1992), 141.

19. Bazilli, *Putting*, 217–47.

20. See Mahmood Mamdani, *Citizen and Subject: Contemporary Africa and the Legacy of Late Colonialism* (Princeton: Princeton University Press, 1996).

21. Bazilli, *Putting*, 220. Gordon Brotherston comments on such innovative hybrid existence in Guatemala in "Debate regarding the Evidence in *Me llamo Rigoberta Menchú*," *Journal of Latin American Cultural Studies* 6:1 (1997): 93–103; Peggy Rockman Napaljarri and Lee Cataldi speak of this among the Warlpiri in Central Australia in their introduction to *Yimikirli: Warlpiri Dreamings and Histories* (San Francisco: HarperCollins, 1994), xvii–xxiv.

22. It helps that I had written of this long ago in "'The Letter As Cutting Edge,'" in Spivak, *In Other Worlds: Essays in Cultural Politics* (New York: Methuen, 1987), 3–14.

23. Colin McGinn, "Hello HAL," *The New York Times Book Review* (January 3, 1999), retrieved from the *New York Times* Internet archives. The article reviews Ray Kurzweil, *The Age of Spiritual Machines: When Computers Exceed Human Intelligence* (New York: Viking, 1999); Hans Moravec, *Robot: Mere Machine to Transcendent Mind* (New York: Oxford University Press, 1999); and Neil Gershenfeld, *When Things Start to Think* (New York: Henry Holt, 1999). I do not necessarily accept the binary between human and robot as the last instance that is being offered here. But that is another story.

24. Matthew Arnold, *Culture and Anarchy* (New York: Bobbs-Merrill, 1971), 37.

25. Walter Pater, *The Renaissance* (London: Collins, 1961), 222.

26. Virginia Woolf, *A Room of One's Own* (New York: Harcourt, 1929), 4–5, emphasis mine. Hereafter cited in text as RO, with page references following. The bit on Woolf is poached from Spivak, "Arguments for a Deconstructive Cultural Studies," in Nicholas Royle, ed., *Deconstructions* (Oxford: Blackwell, 2000).

27. W. E. B. DuBois, *The Selected Writings* (New York: Mentor, 1970), 51; and "The Negro Mind Reaches Out," in Alain Locke, ed., *The New Negro: An Interpretation* (New York: Arno Press, 1968), 392–97.

28. Chinua Achebe, "An Image of Africa: Racism in Conrad's *Heart of Darkness*," in *Hopes and Impediments* (New York: Doubleday, 1988), 1–20.

CONTRIBUTORS

LOWELL GALLAGHER is Associate Professor of English at the University of California at Los Angeles. He is the author of *Medusa's Gaze: Casuistry and Conscience in the Renaissance* (Stanford University Press, 1991), as well as numerous articles on early modern literature and culture. He is currently completing a book on configurations of postmodern ethics, phenomenology, Lot's wife, and other biblical stigmas.

RICHARD J. GOLSAN is Professor of French in the Department of Modern and Classical Languages at Texas A&M University. He is author of (most recently) *Vichy's Afterlife: History and Counterhistory in Postwar France* (University of Nebraska Press, forthcoming). He also has edited several collections of essays on European politics and history, including *The Trial of Maurice Papon: History, Memory, and France's Complicity in the Holocaust* (Routledge, forthcoming), *Memory, the Holocaust, and French Justice: The Bousquet and Touvier Affairs* (University Press of New England, 1996), and *Fascism's Return: Scandal, Revision, and Ideology Since 1980* (University of Nebraska, 1988).

DAVID E. JOHNSON is Assistant Professor of Humanities in the Center for the Americas at State University of New York, Buffalo, and is coeditor (with Scott Michaelsen) of *Border Theory: The Limits of Cultural Politics* (Minnesota, 1997). He has also published numerous articles on literature, historiography, ethnography, and anthropology in such journals as *Arizona Quarterly*, *American Literary History*, and *The Americas Review*. He is currently completing a book on anthropological discourse.

HOWARD MARCHITELLO is Associate Professor of English at Texas A&M University and author of *Narrative and Meaning in Early Modern England: Browne's Skull and Other Histories* (Cambridge University Press, 1997), as well as articles on early modern English literature and culture in *English*

Literary History and *English Literary Renaissance*. He is currently completing a book on the culture of science in early modern England.

KELLY OLIVER is Professor in the Departments of Philosophy and Women's Studies at State University of New York, Stony Brook. She is the editor of *The Portable Kristeva* (Columbia University Press, 1997) and *Ethics, Politics, and Difference in Julia Kristeva's Writings* (Routledge, 1993), and the author of *Reading Kristeva: Unraveling the Double Bind* (Indiana University Press, 1993), *Womanizing Nietzsche: Philosophy's Relation to the "Feminine"* (Routledge, 1995), *Family Values: Subjects Between Nature and Culture* (Routledge, 1997), and *Witnessing: Beyond Recognition* (University of Minnesota Press, 2000).

MARSHALL SAHLINS is the Charles F. Grey Distinguished Service Professor of Anthropology Emeritus at the University of Chicago. He is the author of numerous books, including *Islands of History* (University of Chicago Press, 1985), *Anahulu: The Anthropology of History in the Kingdom of Hawaii* (University of Chicago Press, 1992), and *How "Natives" Think About Captain Cook, For Example* (University of Chicago Press, 1995).

GAYATRI CHAKRAVORTY SPIVAK is the Avalon Foundation Professor in the Humanities at Columbia University and author of numerous books on postcolonialism and theory, including *In Other Worlds: Essays in Cultural Politics* (Methuen, 1987), *The Post-Colonial Critic: Interviews, Strategies, Dialogues* (Routledge, 1990), *Outside in the Teaching Machine* (Routledge, 1993), and *A Critique of Postcolonial Reason: Toward a History of the Vanishing Present* (Harvard University Press, 1999).

TZVETAN TODOROV is Director of Research at CNRS, Paris. He is the author of numerous books, including *The Conquest of America: The Question of the Other* (Harper and Row, 1984), *On Human Diversity: Nationalism, Racism, and Exoticism in French Thought* (Harvard University Press, 1993), *The Morals of History* (Minnesota, 1995), *Facing the Extreme: Moral Life in the Concentration Camps* (Henry Holt, 1996), *A French Tragedy: Scenes of Civil War, Summer 1944* (New England University Press, 1996) *Benjamin Constant. La Passion Démocratique* (Hachette, 1997), and *Le Jardin Imparfait. La pensée humaniste en France* (Grasset, 1998).

KRZYSZTOF ZIAREK is Associate Professor of English at the University of Notre Dame. He is the author of *Inflected Language: Toward a Hermeneutics of Nearness: Heidegger, Levinas, Stevens, Celan* (SUNY Press, 1996) and *The Historicity of Experience: Modernity, the Avant-Garde, and the Event* (Northwestern University Press, 2000) and co-editor of *Future Crossings: Literature Between Philosophy and Cultural Studies* (Northwestern University Press, 2000).

INDEX

aboriginal peoples. *See* cultural identity; migration; translocal societies; *and specific peoples, regions, and nations*
Abraham (biblical character), 107, 111–113
The Abuses of Memory (Todorov), 36
Abzug, Bella, 216
acculturation, 205–206. *See also* cultural identity; Mexican cultural identity: *mestizaje*; migration
Achebe, Chinua, 234
acting-out, 44, 65n2
Africa
 internal displacement, 219
 translocal societies, 199–200, 201, 205, 210n33, 211nn36–27, 212n44, 212n46, 213n50, 227–228
 women and law in, 227–228
Agamben, Giorgio, 184n20
aigas, 197. *See also* kinship networks
"The Aleph" (Borges), 126–127
Algeria, 30, 34–35
"All at One Point" (Calvino), 127–128, 129
Allegories of Reading (de Man), 110
Althusser, Louis, 138
Alvarez García, Raúl, 181
Amerindian cultural identity
 Bonfil Batalla's definition, 169–171
 Fuentes on, 185n29
 Indian democracy, 167, 171
 mestizaje (mixing), 153–156
 in Mexican cultural criticism, 153–158
 in Mexican novels, 152, 153–154
 myths of pre-conquest Indians, 153–154, 156–157, 168, 171, 185n29
 and the Zapatista movement (*see Ejército Zapatista de Liberación Nacional*)
Amin, Samir, 220

"Angelus Novus" (Klee painting), 123, 147–148
anthropology
 despondency theory, 7, 189–190
 rural-urban distinction, 199–200, 206–207, 210n31, 210n33, 211nn36–37 (*see also* translocal societies; urbanization)
 of translocal societies, 197, 201–203 (*see also* translocal societies)
aporias (of the ethical), 221–222, 227
Appadurai, Arjun, 202
Archive Fever (Derrida), 48
archives and archivization, 48. *See also* Video Archive for Holocaust Testimonies
Arendt, Hannah
 contingency as correlate of freedom, 119n11
 Merleau-Ponty's "chiasm" critiqued by, 95, 96–98, 99–100, 101, 103, 112
 thought in Arendt's work, 97–98, 112, 117, 119n9
Armenians, 20
Arnold, Matthew, 230, 231, 232–233
assimilation. *See* cultural identity; Mexican cultural identity: *mestizaje*; migration; translocal societies
Atlantis, 155, 156, 168
atomic bomb, commemorations of, 17
Augenblick, 52
Auschwitz, 41. *See also* Holocaust
Austin, J. L., 51, 61

Baker, T. Lindsay, 140–144
Bakhtin, Mikhail, 59
Bambach, Charles, 81–82
Bangladesh, 224, 226. *See also* Grameen Bank; Self Employed Women's Association